INTERPLAY

INTERPLAY

~~Neo-Geo~~ Neoconceptual Art of the 1980s

AMY L. BRANDT

The MIT Press Cambridge, Massachusetts London, England

MIT Press books may be purchased at special quantity discounts for business or sales promotional use. For information, please email special_sales@mitpress.mit.edu.

This book was set in Helvetica Neue by the MIT Press. Printed and bound in Canada.

Library of Congress Cataloging-in-Publication Data
Brandt, Amy L., 1978–
Interplay : neo-geo neoconceptual art of the 1980s / Amy L. Brandt.
 pages cm
Includes bibliographical references and index.
ISBN 978-0-262-02753-3 (hardcover : alk. paper) 1. Neo-geo (Art). I. Title.
N6512.5N35B73 2014
709.04'075—dc23
 2013046627

10 9 8 7 6 5 4 3 2 1

Selected East Village Art Galleries in 1985

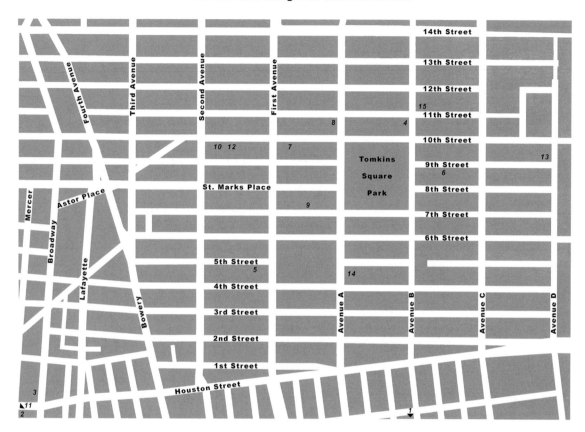

KEY

1. **ABC NO RIO**
 156 Rivington Street

2. **Baskerville + Watson Gallery**
 578 Broadway (opened this location in 1985)

3. **Cable Gallery**
 611 Broadway

4. **Cash/Newhouse Gallery**
 170 Avenue B

5. **Christminster Gallery**
 336 E. 5th Street

6. **Civilian Warfare**
 614 E. 9th Street

7. **FUN Gallery**
 254 E. 10th Street

8. **Gracie Mansion Gallery**
 167 Avenue A

9. **International with Monument**
 111 E. 7th Street

10. **Jay Gorney Modern Art**
 204 E. 10th Street

11. **Metro Pictures Gallery**
 169 Mercer Street

12. **Nature Morte**
 204 E. 10th Street

13. **Pat Hearn Gallery**
 735 E. 9th Street

14. **Postmaster's Gallery**
 66 Avenue A

15. **Sharpe Gallery**
 175 Avenue B

CONTENTS

ACKNOWLEDGMENTS

The origins of this book span several institutions, professors, and mentors who provided support and guidance at critical stages and inspired the passion and drive necessary to finish this project. While I was completing my M.A. at Tufts University, Eric Rosenberg introduced me to painting of the 1980s and the writings of Paul de Man in a phenomenal graduate seminar. This course piqued my interest in neoconceptual art, ultimately leading to further work on this topic in the form of a dissertation and this book. I am grateful to Eric and to Amy Ingrid Schlegel for their encouragement and for guiding my initial research on Peter Halley and Sherrie Levine.

I owe a great deal to the Art History department and faculty at the Graduate Center, City University of New York, for nurturing my academic growth. Comprising extraordinary academics, counselors, and role models, the department's focus on reconsidering the conventional paradigms of modern and contemporary art have deeply informed my approach to research. In particular, I would like to extend a heartfelt thanks to my thesis advisor, Anna C. Chave, for her teaching and leadership, thoughtful counsel, and support. When I approached her with this topic as an incoming student, she enthusiastically supported my ideas, and provided much-needed supervision at critical points in the research and writing process. Her publications and course on minimalism provided a platform for my own critical thinking on neoconceptualism. Also at the Graduate Center, Harriet Senie offered keen insights into the relationship between neoconceptualism and pop. Her responses and suggestions were important to my research. Finally, I am grateful to Kevin Murphy, Mona Hadler, and in particular Katy Siegel, whose comments proved critical to the reworking of the manuscript into book form.

Additionally, I would like to extend a sincere thanks to the individuals who took the time to speak with me and shared their valuable insights and experiences from the early 1980s, including Clarissa Dalrymple, Jay Gorney, Eleanor

Heartney, Ken Johnson, Carole Ann Klonarides, Michael Schwartz, and Simon Watson. Many of the artists were particularly supportive; I would like thank Ashley Bickerton, Peter Halley, Allan McCollum, and Haim Steinbach for their thoughtful responses to my questions. I would also like to extend thanks to Dustin Struckmeyer, LEED AP, interior design instructor at Madison College in Madison, Wisconsin, and member of the American Society of Interior Designers, who provided insights into the history and use of Roll-a-Tex, which aided my analysis of Peter Halley's paintings.

Several libraries provided help and support for my research. I would like to thank the staff of the library of the Museum of Modern Art, New York; the Fales Library at New York University; the Harvard Research Libraries; the Boston Public Library; and the New York Public Library.

Several colleagues, friends, and family members provided emotional support and motivation throughout my writing and editing. I would like to thank the Chrysler Museum of Art and my dedicated interns, Elizabeth Duntemann and Zach Wampler. I am especially grateful to Maura Reilly for her friendship, her boundless encouragement, and for sharing her own graduate experiences. My dear friends Jody Ross and Marc Arranaga provided much support, for which I am obliged. I owe a great deal to Jillian Russo, Emily Newman, Midori Yamamura, Maxwell Stevens, and Vittorio Colaizzi, each of whom was a solid sounding board for ideas and provided me with vital motivation. Special thanks go to Roger Conover, whose editorial expertise greatly improved this project, and to his wonderful colleagues at the MIT Press including Matthew Abbate, Paula Woolley, Susan Clark, Yasuyo Iguchi, and Justin Kehoe. Most importantly, I would like to extend a profound thanks to my loving husband, David Arthur, whose endless humor, patience, and optimism kept me going.

Finally, I would like to thank my mother, Suzanne Marguerite Brandt, for passing along her intense passion for art and for her unrelenting enthusiasm, love, and support. Had she not taken me to many museums throughout my childhood and encouraged me to enroll in philosophy and art history undergraduate courses at the University of Michigan, I would not be where I am today. This book is dedicated to her.

INTERPLAY

INTRODUCTION: NEOCONCEPTUALISM'S
VARIOUS LABELS

In a panel organized by the journal *Flash Art* at Pat Hearn Gallery on May 2, 1986, Peter Halley explained the deconstructive underpinnings of his work:

> My relationship to previous geometric art has both an analytical and a synthetic aspect. It's analytic, because I think of my work as being a deconstruction of themes of Mondrian or Donald Judd. … It's synthetic, because I'm not so much appropriating motifs from such art as hyperrealizing them—in other words, taking themes that have a certain reality in one social setting and sort of boosting them up into another reality.[1]

Moderated by Peter Nagy, the *Flash Art* panel included Halley, Jeff Koons, Haim Steinbach, Philip Taaffe, Sherrie Levine, and Ashley Bickerton. Although not intended as such, the event and the subsequent publication of its transcript in the magazine's summer issue effectively helped to launch neoconceptual work and to consolidate the artists' reputations. The artists' statements drew connections between their working methods and their strategic use of art historical and cultural references. This included an ironic and critically minded citation of previous movements, artists, and styles. "Hyperrealization" served as a strategy for aggrandizing or hyperbolizing art historical source materials, formal modes, and social themes. The neoconceptual artists demonstrated an awareness of the increasingly pervasive structures of the media and commodity capitalism and, in reaction to the photography-based work of the Pictures generation, created paintings and sculptures with a strong aesthetic sensibility. Using these time-honored mediums, Halley and other neoconceptual artists investigated the notion of aesthetics and the development of fine art in the twentieth century.

In Steinbach's work *ultra red #1* (1986), for example, the precise numerical arrangement of red objects, including four lava lamps, seventeen enamel pots, and six digital clocks, relies on the permutational aspects of conceptual work such as Sol LeWitt's *Red Square, White Letters* (1962) or Mel Bochner's works based on the Fibonacci sequence, such as *Three-Way Fibonacci Progression* (1966)—both of which visually relay mathematical concepts. Yet Steinbach pulled his unmanipulated materials from stores and placed found objects on hand-crafted shelves. While the visual forms contain an underlying theoretical thrust rooted in conceptualism, these mass-produced objects link Steinbach's sculpture to the world at large and the intricate mechanisms of commodity capitalism. Halley's and Steinbach's analytical processes entailed new juxtapositions, put into the service of both sociocultural and artistic commentary.

Several months following the *Flash Art* panel in October 1986, Sonnabend Gallery in New York exhibited the work of four of the East Village artists, including Bickerton, Halley, Koons, and Meyer Vaisman. With its cool, clean lines, the work collectively demonstrated a conceptual prowess that represented a clear departure from neoexpressionism's emotive persistence and energetic brushwork. As Roberta Smith remarked at the time, Halley's paintings "[conjure] up the same old 60s purities—bigger scales and brighter perhaps—but corrupted mainly by

FIGURE I.1
Haim Steinbach, *ultra red #1*, 1986. Plastic-laminated wood shelf, seventeen enameled cast-iron pots, six plastic and metal digital clocks, and four glass, metal, and colored-oil "Lava Lites," 65 × 107 × 19 in. Ileana Sonnabend collection. Image courtesy the artist and his studio.

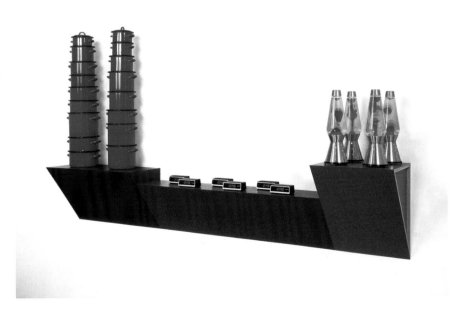

references to other earlier purities, to Barnett Newman's zips, Kenneth Noland's stripes and Ellsworth Kelly's monochromes."[2] The Day-Glo colors and roughly textured surfaces of Halley's four large paintings imbued them with a strongly object-like quality that evoked minimalist painter Frank Stella's *Black* (1959–1960), *Irregular Polygons* (1966–1967), and *Protractor* (1967–1969, with additional works until 1971) series. At the same time, their intense luminosity reflected on commercial culture and advertising in a way that paralleled pop art's commentary on the American experience of billboards, blinking neon lights, and product labels.

FIGURE I.2
Installation view, "Ashley Bickerton, Peter Halley, Jeff Koons, Meyer Vaisman," Sonnabend Gallery, October 18–November 8, 1986. Photograph by Fred Scruton. Courtesy Sonnabend Gallery, New York.

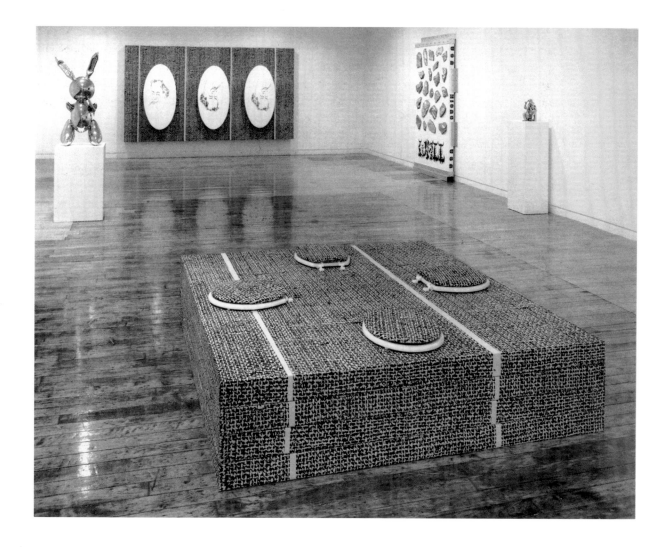

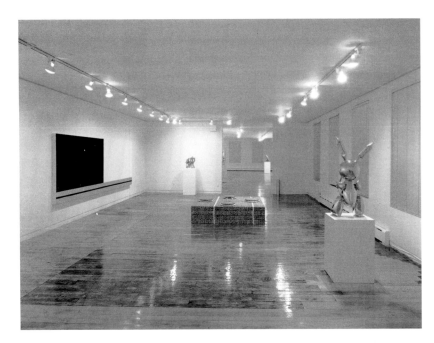

FIGURE I.3
Installation view, "Ashley Bickerton, Peter Halley, Jeff Koons, Meyer Vaisman," Sonnabend Gallery, October 18–November 8, 1986. Photograph by Fred Scruton. Courtesy Sonnabend Gallery, New York.

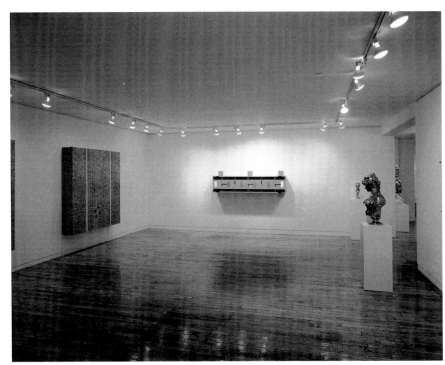

FIGURE I.4
Installation view, "Ashley Bickerton, Peter Halley, Jeff Koons, Meyer Vaisman," Sonnabend Gallery, October 18–November 8, 1986. Photograph by Fred Scruton. Courtesy Sonnabend Gallery, New York.

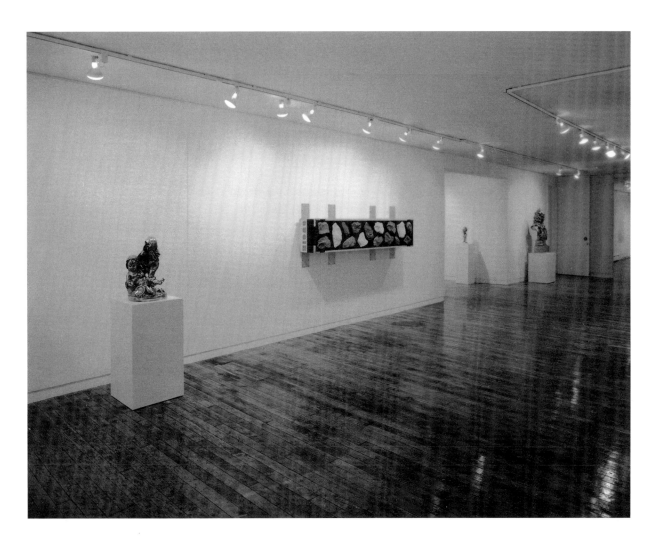

Bickerton's work at the Sonnabend show included *Abstract Painting for People #2*, *Gugug*, *Ugohk, Wall Wall #6*, and *Wall Wall #7* (all works 1986), all over-size, boxlike paintings that vaguely resembled the minimalist sculpture of Donald Judd. Bickerton's *Wall Wall* paintings, fabricated with white gypsum cement, resin, acrylic, wood, Formica, Chromatic sign paint—a high-gloss, fast-drying, profes-sional-grade enamel—and aluminum, consisted of large hanging reliefs that imi-tated the stone walls surrounding outdoor gardens. The nonsensical title of *Gugug* references language formation and semiotics, derived perhaps in part from Bicker-ton's upbringing by a psychologist and a linguist-anthropologist, while the title *Abstract Painting for People* and that work's nonrepresentational subject matter

FIGURE I.5
Installation view, "Ashley Bickerton, Peter Halley, Jeff Koons, Meyer Vaisman," Sonnabend Gallery, October 18–November 8, 1986. Photograph by Fred Scruton. Courtesy Sonnabend Gallery, New York.

refer to the rise of abstraction in the early twentieth century—Giacomo Balla, Constantin Brâncuşi, Wassily Kandinsky, Kazimir Malevich, Piet Mondrian, and Robert and Sonia Delaunay, to name only a few practitioners. Created in acrylic and metal, *Abstract Painting for People #2* has a mechanical quality and highly polished appearance that undermine the material sensuality of earlier abstract art, while the abstract forms affixed to the face of the painting suggest mass-produced commercial vinyl logos and letters. Metal rims and brackets outline the edges and attach to the wall, giving it a strong industrial quality. *Abstract Painting for People #2* reduces the earlier avant-garde abstractions, imbued with radical intentions and, for some, profound esoteric beliefs, to a hackneyed grid of repeated generic shapes; nevertheless, Bickerton called his high-tech boxes "contemplative wall units," signaling the philosophical enterprise of the paintings. Bickerton's painting functions self-referentially, raising questions about his own artistic production as well as the impact and accessibility of nonobjective painting.

The other works in the Sonnabend show also probed the history of art both visually and conceptually, investigating the terms and conditions of traditional mediums such as painting and sculpture. Koons's shiny, stainless steel *Rabbit* (1985) stared at the viewer with an empty, featureless regard that conjured spacesuits in science fiction movies. Yet it also loosely recalled the smooth reflective surfaces of Brâncuşi's polished bronze sculptures, such as *Prometheus* (1911) or *The Beginning of the World* (1924). The show included three paintings by Vaisman, *Filler*, *The Uffizi Portrait*, and *Painting of Depth*, and one sculpture, *The Whole Public Thing* (all works 1986). Each painting consists of two or more stacked canvases covered with a photomechanical reproduction of magnified canvas weave, a self-referential gesture that underlines the painting's physical structure. The weave came from a Letratone pattern sheet, a readymade set of forms used by illustrators and commercial artists to create advertising and computer graphics. Part painting, part sculpture, *The Whole Public Thing* comprises four canvases covered in the magnified canvas weave and stacked on the floor, topped with four actual toilet seats. Having removed the canvases from the wall, Vaisman conflated painting and sculpture in a manner reminiscent of Donald Judd's argument in his 1965 essay "Specific Objects."[3] *The Whole Public Thing* also commingles the theatrical, public display of art with the most personal of acts in a thought-provoking yet absurd manner. And of course Vaisman's use of the toilet seat points to precursors that investigated the terms and conditions of the work of art, such as Marcel Duchamp's notion of the readymade as seen in *Fountain* (1917) and Piero Manzoni's bodily violation of the separation between art and life in *Artist's Shit* (1961).

Overall, neoconceptual work judiciously combined the sensibilities of pop, minimalism, and conceptualism with an underlying attention to the role of painting

FIGURE I.6
Ashley Bickerton, *Abstract Painting for People #2*, 1986. Acrylic and metal paint on plywood and aluminum, 24 × 48 × 6½ in. Image courtesy the artist and Lehmann Maupin, New York and Hong Kong. © Ashley Bickerton.

and sculpture in the 1980s, as well as to contemporaneous discussions on critical and postmodern theory. *New York Times* critic Roberta Smith appropriately declared that the exhibition showed a "bumptious, youthful aggressiveness" that "[brought] some of the best and brightest young talent of the East Village art scene to prominent light in the SoHo emporium of Ileana Sonnabend."[4]

The term *neoconceptualism* emerged in the early 1980s to describe one aspect of New York's nascent East Village arts scene. Other terms applied to a similar range of work included *neo-geo*, *simulationism*, *neo-pop*, *neo-op*, *neominimalism*, and *postabstraction*. In general these terms encompassed a primary group of eight independent-minded artists. In addition to Bickerton, Halley, Koons, and Vaisman, early critics, writers, and curators designated the other *Flash Art* panel participants—Levine, Steinbach, and Taaffe—as well as Allan McCollum and Meyer Vaisman as "neo-geo" in 1986. Koons and Steinbach were also labeled "commodity artists" beginning in the winter of 1986–1987 for their use of mass-produced objects in sculpture.[5]

Neo-geo referred to the geometric motifs predominantly found in the work of Bickerton, Halley, Levine, and Taaffe, while *neo-pop*, *neominimalism*, and *postabstraction* referenced the artists' sampling of styles and motifs from well-established artists and art historical movements. The name *simulationism* connected

the group with Jean Baudrillard's 1981 treatise *Simulacra and Simulation* and the French theorist's ideas on sign systems and contemporary society. The simulationist moniker came about mainly as a result of Peter Halley's 1984 essay in *Arts Magazine*, "The Crisis in Geometry," in which Halley discussed Koons's, Levine's, and his own work in relationship to Baudrillard's ideas.[6]

From the beginning, collecting these artists under one name, as if they constituted a singular movement, has been problematic. Several of them, such as Levine, McCollum, and Steinbach, began their careers in the mid to late 1970s, whereas others, such as Halley and Koons, had been a part of the East Village scene since 1980 or earlier. Yet these artists were not labeled as a group by the art press until their work had gained significant popularity among prominent collectors and dealers. The diverse epithets for what I will call neoconceptualism represented critics' attempts to understand and classify the broad range of mediums and appropriative methodologies employed by the artists. Although some of the names had been circulating informally around the East Village, Hal Foster publicly proposed "Neo-Op" in his 1986 essay "Signs Taken for Wonders," and Eleanor Heartney quickly followed suit, listing many of the above names and citing "Neo-Geo" as her preference. Foster's and Heartney's articles themselves followed the *Arts Magazine* special section "Neo-Geo: Altering Abstraction," published in March 1986. Only one year later, as many East Village galleries began to close and several of the artists had moved on to more prestigious SoHo galleries, Grace Glueck published an article in the *New York Times* on the continued difficulty of labeling this group with one cohesive name.[7] The inclusion of Halley, Koons, and Taaffe in the 1987 Whitney Biennial under the rubrics of "Smart Art," "Simulationism," and "Neo-Geo" shows that, at that point, curators and critics had still not come to a consensus.[8] Several articles in the *New York Times* in this year underscore a deep uncertainty about how to refer to this group and the artwork they produced. For Vaisman, neoconceptualism "was not a movement, but a mental set." In the same year, Lisa Phillips, then associate curator at the Whitney Museum of American Art, agreed, calling this group of artists "a generation." Her comment parallels Douglas Eklund's description, years later, of the "Pictures Generation" in his 2009 exhibition of that title at the Metropolitan Museum of Art in New York.[9] A desire to characterize the groundswell of work being produced in the East Village led to a rather divergent roster of artists being initially considered neoconceptual. The eight artists discussed in this book represent those most consistently classified as such, whose paintings and sculptures do in fact demonstrate formal and conceptual affinities.[10]

The wide range of artistic production taking place in the East Village at the time was and continues to be somewhat difficult to characterize, since the artists and their work do not fit into neat compartments. For this reason, serious attempts

to assay the period have often avoided strictly categorizing the artists. Helen Molesworth's survey exhibition "This Will Have Been: Art, Love, and Politics in the 1980s" (2012), for example, avoided a chronological organization, instead focusing on a set of overarching themes as organizing principles. With the works arranged by aesthetic sensibility, Dan Cameron's ambitious exhibition "East Village USA" (2004) offered a more concise survey that emphasized the multifarious, hybrid practices of the artists.[11]

Neoconceptualism's market success in the 1980s and critics' deep-seated differences on the work have inspired this book. In "Signs Taken for Wonders," and later in *The Return of the Real*, Hal Foster, for example, argues that neoconceptualism succeeded in emptying out early modern abstraction and reducing it to pure simulacrum, defined by Baudrillard as an image without resemblance.[12] I argue against this reading and offer new ways to examine neoconceptualist work from the standpoint of earlier movements in the postwar era as well as theories of intertexuality, deconstruction, and poststructuralism. This book aims to reconstruct the early histories of these artists, all of whom were living and working in New York in the 1980s; to highlight the commonalities in their work; and to explore their shared reactions to the linguistic, theoretical, art historical, and sociocultural phenomena of the decade. Through detailed analysis, I argue that neoconceptualism's self-referential and insurgent techniques effectively generated new discussions and alternative outlooks on modernism and the history of art as an ideological concept. Too often, art historians and critics offered sweeping castigations of neoconceptualism—supported in part by the same theoretical sources that influenced the artists—without delving deeper into the formal or material specificities of these paintings and sculptures. For this reason, I believe a thorough formal analysis of the work is necessary.

Fredric Jameson's comment on assessing historical frameworks presents a useful way to think about the problems that arise in attempting to establish connections among the neoconceptualist group and their position within the canon of art history:

> to those who think that cultural periodization implies some massive kinship and homogeneity or identity within a given period, it may quickly be replied that it is surely only against a certain conception of what is historically dominant or hegemonic that the full value of the exceptional—what Raymond Williams calls the "residual" or "emergent"—can be assessed. … The "period" in question is understood not as some omnipresent and uniform shared style or way of thinking and acting, but rather as the sharing of a common objective situation, to which a whole range of varied responses and creative innovations is then possible, but always within that situation's structural limits.[13]

Along these lines, the neoconceptual artists explored similar reactions to a set of phenomena of the 1980s, including postmodern theory and the death-of-painting rhetoric, and a willingness to investigate the role of painting and sculpture in commodity culture and the digital age. While the neoconceptual artists related to one another differently on a personal level, I argue that their work nonetheless evinces similar themes and strategies. Neoconceptualism is an art about art history. These artists cited postwar movements including pop, minimalism, and conceptualism, and their work collectively demonstrated a self-reflexive interest in examining the terms, limits, and structures of the canon of art. More specifically, these paintings and sculptures functioned as texts, operating in an intertextual manner. Due to the artists' interest in theoretical source materials, semiotics and visual interplay, and the manipulation of art historical motifs and techniques, their work is laden with references to earlier artists and movements.

First defined by Julia Kristeva in 1966, "intertextuality" is the discursive space surrounding a text (here read as work of art) as it relates to earlier bodies of discourse informing the author.[14] Since texts are considered within the larger systems of knowledge that inform them, Kristeva's notion of intertextuality also applies to broader concepts and fields of study—such as the history of art—and, as such, it provides a useful framework in which to consider neoconceptual art. In her view, every cultural formation represents a text within the general semiotics of culture. Analyzing Bakhtin's notion of dialogism and carnivalesque discourse, Kristeva writes that "any text is constructed as a mosaic of quotations; any text is the absorption and transformation of another. The notion of intertextuality replaces that of intersubjectivity, and poetic language is read as at least double."[15] In this analysis, the spatial coordinates of texts extend horizontally (to encompass the relationship between the text and the reader) and vertically (connecting the text to an exterior body of literature). Neoconceptualism tended to use canonical artworks just so, as intertexts—or predecessors that informed then-current practices—manipulating recognizable motifs and materials of previous artists. These formal components relate at once to the artist's relationship to the viewer in the present moment *and* to earlier historical moments. Neoconceptual works function as multivalent sites of meaning, in which visual elements pointing to previous artists and movements ebb and flow into the viewer's consciousness. This characteristic draws from the example set by conceptualism, with its self-reflexive exploration of the nature of the art object and its surrounding structural framework and the relationship between art and language.

Critic and curator Lucy Lippard revisited the aims of conceptualism as "dedicated to the subversion of art-world assumptions, a need to challenge authority, to question everything, especially the nature of art itself and the context within which it was made, shown and distributed. The artists invented ways for art to act

as an invisible frame for seeing and thinking rather than as an object of delectation or connoisseurship."[16] The subsequent pages demonstrate how neoconceptualism shares these intentions and operates, above all on a conceptual level, even as the work draws affinities to pop and minimalism. *Neoconceptualism* is, I would argue, the most precise name by which to refer to these works and the theoretical impulses that are essential to understanding their formal techniques.[17] Neoconceptualism gave form to the major precepts of conceptualism, even as some practices and works in the earlier movement sought a dematerialization of the art object.

Chapter 1 of this book situates neoconceptualism within the myriad artistic practices taking place in the East Village during the early 1980s. As I will demonstrate, neoconceptual artists were distinguished from others at the time due to the theoretical impulses of their work. Chapter 2 unpacks the artists' ironic and critically minded referencing of previous art movements, artists, and styles. While all the artists might have been discussed in this chapter, I offer focused case studies of work by Bickerton, McCollum, Taaffe, and Levine.

Chapters 3 and 4 explore the group's specific formal connections to the earlier movements of pop, minimalism, and conceptualism. Recent publications on the 1960s, especially on pop and minimalism, paved the way for this study. Neoconceptualism built on the materials and methods of these movements, translating their strategies into commentary rooted in the artistic environment of the 1980s. In chapter 3, I trace the notion of complicity and complicit defiance in neoconceptualism. While neoconceptualism continued pop's engagement with consumerism and commercial culture in ways that called attention to the role of popular culture in society, the younger artists appropriated and reused key forms and styles from the earlier movement in a more tactical manner that called attention to aspects of society, race, and class. Following in the footsteps of Warhol, their work also demonstrated a strategic awareness of the position and role of an art object within the vastly expanded art market of the 1980s. The language of minimalism and conceptualism, meanwhile, inspired neoconceptualism's material strategies and practices, as demonstrated in chapter 4. Conceptualism's emphasis on the work of art as an idea and as situated within language systems inspired the younger group's breaking down of art history into signs that could be rearranged and manipulated at will. At the same time, their work emphasized the strong perceptual properties, the allure of color and form, in ways that emphasized allegorical reading and directly engaged personal, social, and political external references.

Chapter 5 investigates the relationships, both professional and personal, between the neoconceptual artists and those loosely termed the Pictures generation, a moniker assigned to them as a result of Douglas Crimp's famous 1977

exhibition "Pictures" at Artists' Space in New York and, later, curator Douglas Ecklund's eponymous exhibition at the Metropolitan Museum of Art in 2009.[18] Collectively, these groups shared an interest in their theoretical source material, commodity culture, and the media. While commonalities exist, the neoconceptualists were reacting in part to the dry, photography-based approaches of the Pictures and appropriation artists by creating seductive, alluring paintings and sculptures.

Critics assigned neoconceptualism an assortment of designations in part to distinguish these artists from neoexpressionist painters, such as Julian Schnabel and David Salle, and from graffiti artists, such as Keith Haring, Jean-Michel Basquiat, and Kenny Scharf—both groups that also attained high visibility in New York in the 1980s. Neoconceptualism's streamlined, theory-based work stood in stark contrast to the vigorous brushwork and raw emotion of Schnabel and the animated, effervescent work of Haring and Scharf. In 1986, Smith wrote that neoconceptualism "clearly replaces Neo-Expressionist excess with cool calculation, and its emergence is definitely one of the more hyped events in this hype-prone decade."[19] Critic Paul Taylor succinctly summarized the differences as such: "Though its members make Julian Schnabel and Keith Haring look like Old Masters, they are fast becoming the hottest things on the art scene."[20] (The differences among these groups are discussed in more detail in chapter 1.)

Of all the various denominations, *neo-geo* was and still is used with the most frequency, but the term presents problems with regard to the classification of the work. Several of the artists, such as Bickerton, Halley, Levine, and Taaffe, self-consciously used geometric forms to reference early modernist abstraction. However, the strict association of their work with formal geometric impulses was in fact a somewhat nebulous characterization. *Neo-geo* aptly applied to Halley's Day-Glo paintings incorporating what he termed "cells" and "conduits" and, to a lesser degree, to Taaffe's stripe paintings; and the sculptures of Koons and Steinbach displayed an attention to geometry and design in their pristine, symmetrical arrangements of everyday objects, such as kitchen pots, lava lamps, and vacuum cleaners. But the geometrism of these artists' work was not its most predominant characteristic. What the artists did all share is a conceptual bent, an ironic and critical-minded use of form that looks back on art of the past while examining then-contemporary social phenomena. While many of the artists acknowledged connections among their diverse bodies of work, the majority did not (and still do not) support the neo-geo epithet.

Halley and McCollum always considered the term *neo-geo* to be a facetious neologism intended to undermine the seriousness of their work. In 1986, Bickerton mocked the idea of neo-geo in a series of parodistic paintings, including *Abstract Painting for People*. Of these works, he remarked:

This series came about in a moment when the term "Neo-Geo" started being bandied about. Naturally "we" hated the term and I personally felt much more in line with what was being called "Commodity Art" and "Neo-Conceptualism" rather than with the diagrammatic pseudo-abstraction of "Neo-Geo." But then I felt if they're inevitably going to label, I'll give them "Neo-Geo" alright. These works [the neo-geo parody paintings] were actually a direct attempt to expose what I thought was an overly simplistic and somewhat false conceit.[21]

Bickerton's account corresponds with the other artists' general sentiments toward the terminology attached to their practices and toward reviews in general. In 2003, Steinbach recalled Heartney's 1986 article "Neo-Geo Storms New York" and his reaction to it:

Around that time, Eleanor Heartney came knocking on the doors of a number of artists to interview them. She came to my studio, and I carefully went through my history. The next thing you know, there's this big article, "Neo-Geo Storms New York," in the *New Art Examiner*. It didn't deal with the specifics of what I said, because it looked at all the work generally. I mean, it was a three-page article discussing something like twenty artists.[22]

Steinbach felt that critics generally mischaracterized his work and overlooked its critical ambitions, and many of the artists in question shared these sentiments.

Although the neoconceptual artists had been a part of the East Village scene since 1980, the groupings of neo-geo, simulationism, neo-pop, neominimalism, etc., arose at a time when the work was gaining significant popularity. The 1986 Sonnabend show became one of the most talked-about shows of the decade. Described by Taylor in his *New York* magazine review as "the hot four," Bickerton, Halley, Koons, and Vaisman had quickly risen to prominence the previous year after a series of exhibitions at a raw storefront gallery called International with Monument, on East Seventh Street. The gallery's two successive solo shows of work by Koons and Halley in 1985 and '86 had also completely sold out. According to Sonnabend director Antonio Homem, the 1986 show was one of the best attended in the gallery's history, its works quickly claimed by collectors from the United States, Europe, and South America.[23] Although at the time the New York art world was centered, for the most part, on the blue-chip galleries in midtown and on the Upper East Side, the downtown art scene was beginning to be frequented by SoHo dealers such as Ileana Sonnabend, important collectors Eugene and Barbara Schwartz, their son Michael Schwartz, art advisor Estelle Schwartz (no relation), Charles Saatchi, and Jeffrey Deitch (then a vice president and

advisor for Citibank's art advisory and art finance businesses). Eugene and Barbara Schwartz, significant collectors of pop art, were attracted to the high quality and clean look of neoconceptualism, as was Michael Schwartz, a collector focusing on photography by the Pictures artists. Close in age to the artists, Michael Schwartz became friendly with Bickerton, Halley, and Koons while frequenting the East Village, including International with Monument. He collected Bickerton's work beginning in 1984 after seeing his solo show at White Columns in New York, and he considered neoconceptual work to have a stronger critical edge than the more ascetic work of the Pictures group. The artists' strategies of sampling styles and motifs from previous art movements also attracted him: "[Neoconceptualism] had the means of Minimalism and the attitude of Pop."[24]

International with Monument gallery had opened in 1984 as a joint endeavor of three artists: Vaisman, Kent Klamen, and Elizabeth Koury. Vaisman imagined the Sonnabend show as his last venture, after deciding he no longer wanted to be an art dealer. He originally selected Halley, Koons, Steinbach, and himself to be included in the show. When Koons protested, citing the similarity of his work to Steinbach's, Vaisman approached Bickerton instead.[25] Taylor reported that Koury and Vaisman met with several galleries, including Marlborough and Mary Boone, before finally coming to an agreement with Sonnabend, in what was then considered to be a highly orchestrated maneuver.[26] Vaisman summarily left International with Monument, selling his share to his co-owner Koury and Ealan Wingate, and Klamen left shortly thereafter. Wingate, former director of Sonnabend, joined the venture after their departure, opening Khoury Wingate Gallery in SoHo in 1988.

As art historian Alison Pearlman has noted, the success of the Sonnabend exhibition among collectors and the continued coverage of several affiliated artists in the mass media led critics to associate neoconceptualism with the astronomical growth of the art market during the 1980s.[27] Joshua Decter, Foster, Heartney, Donald Kuspit, Peter Plagens, and Carter Ratcliff, for example, viewed the group less as artists and more as highly talented strategists whose savvy manipulations of the market led to high sales. (Roberta Smith's review of the Sonnabend show cast a positive light during a period of otherwise sharp criticism.) Earlier that summer and fall, in part as a result of the artists' rising market popularity, Heartney and Foster employed the varied names for the group negatively, arguing that, as a new rendition of the old, the neoconceptual style could never live up to its art historical precedents. Although Foster acknowledged the importance of neoconceptualism's appropriative technique, he strongly questioned its critical utility within a traditional, preindustrial medium such as painting.[28] For his part, Plagens described the artists' ostensible complicity with the art market as "that particular coy mating dance with our mass-produced objects of desire, … yet another allegedly revelatory brand of hard goods coming down the art world's well-traveled merchandising pike."[29]

In September 1986, the Institute of Contemporary Art in Boston mounted the first museum show on work in this vein, "Endgame: Reference and Simulation in Recent Painting and Sculpture." The exhibition was curated by David Joselit and Elisabeth Sussman.[30] Interestingly, three of the six catalog essayists responded negatively to the work in the show, including Thomas Crow, Foster, and Yve-Alain Bois. In his contribution, "Painting: The Task of Mourning," Bois proclaimed the artists "maniac mourners," stating, "Their return to painting, as though it were an appropriate medium for what they wanted to address, as though the age of the simulacral could be represented, comes from the feeling that since the end has come, since it's all over, we can rejoice at the killing of the dead."[31] Crow audaciously suggested that neoconceptualism should not be considered art at all because the work asserted few distinctions between a fine art object and other saleable goods offered in the marketplace.[32]

Although Pearlman has already very efficiently contextualized the conflicting viewpoints of critics at the time, one point bears noting.[33] Over the decades, the writers in question had witnessed a major expansion in the number of New York galleries, which rose from a handful in the 1960s to 200 in 1976 and more than 560 in 1986. From 1980 to 1986, more than 100 galleries opened in New York's burgeoning East Village alone.[34] Unlike those in SoHo, many of the East Village galleries were open on Sundays, which proved a commercially successful move. Reports of the New York art world boom filled the pages of art journals and magazines, the *New York Times*, and the *New York Times Magazine*. Through the late 1980s, *New York* magazine detailed the East Village galleries' rise, fall, and transition in articles that emphasized the rising prices for the work. In her 1987 article entitled "The Fun's Over: The East Village Scene Gets Burned by Success," Amy Virshup commented, "Koons' now-famous floating basketballs fetch $35,000; two years ago, International [with Monument] couldn't sell them for $3,000."[35] Investing in art became a big business in the 1980s. Competition among collectors, along with inflation, brought prices to record highs. Art was considered a safe method of investment and speculation, and as with stocks, collectors attempted to buy low and sell high.

Articles scripted a terse narrative describing the once-naïve passion of this lively swath of the art world as having been obliterated by two phenomena: the voraciousness of the escalating art market and the stock market crash of October 1987. As Richard Walker reported in *ARTnews* in November 1988, the international wealth flooding U.S. markets, fluctuating exchange rates, and the notion of art as a safe investment, which had first arisen during the 1960s, became commonplace by the 1980s.[36] Neoexpressionist painter Julian Schnabel served as a much-cited example of the market's new capacity to breed financial and critical success. After the young artist's first solo exhibition at Mary Boone Gallery in

1979, the prices of his work reached record levels at auction, as seen in the May 1983 sale at Sotheby Parke Bernet of his plate painting *Notre Dame* (1979) for $93,500. In 1985, Schnabel signed a $1 million contract with Pace Gallery.[37] Similarly, Ross Bleckner's painting *One Wish* (1986), which sold for $30,000 when it was created, attained a price of $187,000 at Christie's in May 1987. In the 1980s, auction houses such as Sotheby's and Christie's began to compete with galleries in the contemporary art market and began lending money to collectors who used their art as collateral. Seen within this context, Heartney's description of neoconceptualism in September 1986 as "the New York art world's latest movement/ trend/tendency (take your pick)" and its "breathtakingly rapid rise within months from back room into the Charles Saatchi Collection" immediately and unfairly characterized the artists as a relatively ephemeral group that had taken advantage of the expanded market.[38]

Neoconceptual artists were, of course, not the first to endure negative critical commentary or to resist labels attached to them by critics. Many of the pop artists also rejected collective labeling and having their work considered as part of a movement. In 1966, Roy Lichtenstein remarked, "I don't think it is a good idea to group everybody together and think we are all doing the same thing."[39] The term *pop* first encompassed a wide variety of artistic techniques and mediums by British and American artists, such as Richard Hamilton, David Hockney, Claes Oldenburg, Andy Warhol, and Tom Wesselmann. Like neoconceptualism, pop was also undermined by some critics who were unable to see the distinctions between the art and commercial objects. The question "Is it art?" came up as early as 1962, in the symposium on pop art held on December 13 at the Museum of Modern Art in New York. Organized by Peter Selz, then curator of painting and sculpture at MoMA, the panel consisted of critics and curators Dore Ashton, Henry Geldzahler, Hilton Kramer, Stanley Kunitz, and Leo Steinberg. Kunitz's words are strikingly reminiscent of the commentary on neoconceptualism: "I am not persuaded that anything is to be gained by treating art as though it were almost exclusively a commodity, pliant to the whims of the market place and subject to the same principle of planned obsolescence as is inherent in the rest of our economy."[40] Kramer agreed: "Its social effect is simply to reconcile us to a world of commodities, banalities, and vulgarities, which is to say an effect indistinguishable from advertising art."[41] Several years later, in 1969, as the movement receded in favor of performance, earth art, and other non-object-based forms, renowned critic John Russell looked back: "'Pop' has joined the great pejoratives: the insults that no one forgives, like 'Cheat!' in a cardroom or 'Revisionist!' in the Kremlin. … Finding an artist who will accept the name of 'pop' is about as easy as persuading a butcher to put his best filet steak on offer as horsemeat."[42] Russell's comment could apply equally well to neoconceptualism's responses to its various monikers and codifications.

By the same token, the diversity of the artists lumped under the neo-geo rubric can be compared to that of the roster attached to the germinal phase of minimalism, when the list of minimalist painters and sculptors ranged widely and changed from critic to critic. In 1965, Barbara Rose used the term *ABC art* to describe minimalist works by Darby Bannard, Ronald Bladen, Lyman Kipp, Anne Truitt, Richard Tuttle, and Larry Zox to distinguish these artists from Robert Morris, Donald Judd, Carl Andre, and Dan Flavin.[43] Two years later, Lippard curated an exhibition called "Rejective Art" that included Joan Baer, Mel Bochner, Robert Mangold, Brice Marden, Agnes Martin, and Robert Ryman, among others. Clement Greenberg, in his 1967 essay "The Recentness of Sculpture," grouped together the work of Andre, Bannard, Judd, Morris, Truitt, and Michael Steiner.[44] Gregory Battcock included Ellsworth Kelly and John McCracken in his discussion of minimalism, which included artists ranging from Georgia O'Keeffe to Morris Louis.[45] Although the Jewish Museum curator Kynaston McShine did not intend it as such, the 1966 "Primary Structures" show is now viewed as the first major exhibition of minimalist work. Critics focused on the more clearly minimalist work in the show, including that of Richard Artschwager, Bladen, Judy Chicago, Flavin, Judd, Kelly, Forrest Myers, Salvatore Romano, Robert Smithson, Truitt, and David von Schlegell. Another common feature that the minimalists and the neoconceptualists shared was that the groups consisted of artists from different generations. Of the neoconceptualists, Steinbach (b. 1944) and McCollum (b. 1944) were the oldest, and Bickerton (b. 1959) the youngest. By comparison, Judd and Irwin were born in 1928, while Flavin, Andre, Stella, and James Turrell were born in 1933, 1935, 1936, and 1943 respectively.

Yet one aspect that distinguished neoconceptual artists from their predecessors of both the 1960s and '70s, as well as from some of their contemporaries, was their association with critical theory. In distinction to earlier movements and to other East Village styles, neoconceptualism's modus operandi generally stemmed from the philosophy of deconstruction and poststructuralist texts by Roland Barthes, Baudrillard, Jacques Derrida, Michel Foucault, and Kristeva. These theoretical sources became easier to obtain in English translations beginning in the 1970s, particularly through the journal *Semiotext(e)*, founded in 1974 in New York by Columbia University professor Sylvère Lotringer, and beginning in 1983 through its Foreign Agents book series.[46] The texts became more universally referenced in the 1980s. At the same time, artists were more likely to attend art school, where they would gain exposure to French theory. Beginning in 1968, the Whitney Independent Study program in New York, a one-year curriculum rooted in theoretical and critical studies of the practices, institutions, and discourses of visual culture, became a platform for the discussion of critical theory for many art historians and artists, Ashley Bickerton among them.

Gilles Deleuze described the impetus of poststructuralism as "a cold and concerted destruction of the subject, a lively distaste for notions of origin, of lost origin, of recovered origin, a dismantling of unifying pseudo-syntheses of consciousness, a denunciation of all the mystifications of history performed in the name of progress, of consciousness, and of the future of reason."[47] Structuralism and poststructuralism both took the arbitrary relation between a signifier and the signified as a point of departure in order to point out further instabilities in systems of thought and social organizations. Neoconceptual work strategically operated along these lines, referencing specific points of weakness and destabilizing art historical and sociocultural paradigms.

Dan Cameron emphasized the conceptual thrust of neoconceptual work in his exhibition "Art and Its Double: A New York Perspective," on view from November 27, 1986, to January 11, 1987, at the Centre Cultural de la Fundació Caixa de Pensions in Barcelona:

> David Salle and the photo-conceptualists at Metro Pictures were obviously not the only artists in New York engaged in representation and the lessons of semiotics. ... Those artists who engage the language of simulation assert that art cannot be manipulated into the passive support of societal hierarchies if it is fully aware of its operative role as a sign within the larger hierarchy of representation.[48]

Cameron's exhibition included the work of appropriation and neoconceptual artists: Bickerton, Sarah Charlesworth, Robert Gober, Halley, Jenny Holzer, Koons, Barbara Kruger, Louise Lawler, Levine, Matt Mullican, Rollins & K.O.S., Peter Schuyff, Cindy Sherman, Steinbach, and Taaffe. The exhibition signaled an acceptance of such work by European curators and institutions that their U.S. counterparts did not share. Referencing Baudrillard, as Halley did in "The Crisis in Geometry," Cameron's use of the term *simulation* in the essay accompanying the show refers to the name *simulationism* but also to the artists' theoretical underpinnings and strategies of appropriating references from art history and the general culture. Baudrillard's writings, in addition to those of Deleuze and Jean-François Lyotard for that matter, on the relationship between signs and referents within late capitalism responded to the socioeconomic changes that commenced at the beginning of the 1960s and concretized in the late 1970s and early '80s—the rise of multinational corporations, the global networking of business and information, the rise of computers and digital technology, and the implementation of planned obsolescence for material goods.

Beginning in the 1970s, some of the most vocal art historians and critics applied structuralist and poststructuralist theories to artistic practice in a

somewhat limited manner, overlooking the theoretical leanings of neoconceptualism. French literary theory was almost exclusively discussed in relation to certain photographic practices of the 1970s and '80s. The development of antiformalist discourse in the 1970s led to critics' predisposition toward photography, video, and certain forms of sculpture that are documented by photography and video. This orientation has negatively affected the study and critical reception of neoconceptualism. However, close analysis of neoconceptualist work, enhanced by interviews conducted in the 1980s with the artists, demonstrates the deconstructive impetus of this group, whose critical ambitions extended from a mere formal engagement with the history of art into sociopolitical and sociocultural realms.

The Pictures group, appropriation artists, and neoconceptual artists were among the first U.S. artists to take up French theories of deconstruction, structuralism, and poststructuralism. French artists certainly had access to these intellectual tools before artists in the United States, since the texts in question were written in the late 1960s, but most English translations did not appear until the 1970s. Among the neoconceptualists' contemporaries, the French artists Bertrand Lavier and Sylvie Fleury and Swiss artist John Armleder engaged with art history and commodity culture in ways that could be seen as aligned. By and large, however, French artists were less interested in French theory. As Lavier puts it:

> Those texts held nothing particularly exotic or attractive for us. Lyotard might have been involved to some extent with the art of the '70s, but not really with that of the '80s. In the U.S. the French thinkers were received in a different way. Philosophy tends to suffer from a kind of jet lag; it seems to take about a decade for a text to cross the Atlantic. At that point things are twisted and distorted—and made productive in a new way. That happened with French thought of the '60s and '70s. Baudrillard was, of course, quite important for people like Peter Halley.[49]

It is beyond the scope of this book to undertake a thorough examination of French and European art during the 1980s—in particular, what has occasionally been referred to as a European version of neo-geo or neoconceptual art—and that art's actual relationship to neoconceptualism and to other artistic practices taking place in the United States. My focus is on demonstrating the extent to which neoconceptual artists as I've enumerated them—Bickerton, Halley, Koons, Levine, McCollum, Steinbach, Taaffe, and Vaisman—engaged with French literary theory, often in ways distinct from their European counterparts. Art and theory merged in new and interesting ways in the work of the Pictures and appropriation artists in the late 1970s and the neoconceptual artists of the early 1980s. These

artists distinguished themselves from the contemporaneous efforts of painters such as Julian Schnabel or Francisco Clemente through the use and manipulation of French theoretical sources. The neoconceptual artists read, discussed, and directly or obliquely referenced French theory. In 2010, Halley indicated:

> I came of age at a very special time, when poststructuralist theory was being disseminated. There was a lot to be excited about. I had had a very traditional liberal arts education, so poststructuralism was my own personal revolution against humanist values. Humanism and enlightenment values were thrown out the window with poststructuralism. Poststructuralist ideas had the aspect of revelation for me. It was also exciting because poststructuralism wasn't Marxist. A lot of people in the original *October* crowd, and their inheritors like Benjamin Buchloh, formed a separate camp in the '80s, centered around the influence of the Frankfurt School. For me, French theory was premised on this great sense of play. It was not so serious.[50]

As Halley's comments indicate, critical theory's greatest impact on neoconceptual artists in the 1980s was that it provided the impetus for greater artistic freedom.

NEOCONCEPTUALISM, THE EAST VILLAGE SCENE, AND THE INFLUX OF CRITICAL THEORY

Within the diverse network of galleries, artists, modes, and styles that characterized the East Village scene, the neoconceptual artists stood out for their serious, intellectually driven work that engaged with previous movements, the precepts of postmodernism, and French critical theory. The artists associated with neoconceptualism arrived in New York at different moments, and some had greater personal and professional connections within the group than others. The arrival and early days of these artists in New York and their relationship to others in the East Village scene form an important part of their story.

Though the neoconceptual artists distinguished themselves by their critical sensibility, their proximity to theoretical source materials—writings by Baudrillard, Derrida, Gilles Deleuze, Michel Foucault—varied. French theory directly informed Sherrie Levine's work, for example, offering her a means of exploring new modes of representation and concepts of authoritative points of view; she quoted Barthes in a statement accompanying a 1982 exhibition at the Vancouver Art Gallery and discussed Baudrillard's ideas in her 1985 interview with Jeanne Siegel. Halley directly referenced Baudrillard and Foucault in his 1984 essay "The Crisis in Geometry." The others, by contrast, did not write directly about critical theory, but as Bickerton later expressed, "Certain ideas were just in the air. We had access to them via osmosis."[1] A second aim of this chapter, then, is to demonstrate how French theory came to the United States and permeated the New York art scene beginning in the late 1970s.

NEOCONCEPTUAL ARTISTS IN NEW YORK AND THE EAST VILLAGE SCENE

Some of the older neoconceptual artists, such as Steinbach, McCollum, and Levine, exhibited in the East Village after multiple exhibitions elsewhere during the 1970s and early '80s. Levine and Steinbach exhibited at alternative spaces in

New York such as The Kitchen and Artists Space, while McCollum showed in California and Kansas City. Jay Gorney Modern Art in SoHo exhibited Levine's and Steinbach's work together in 1986. Others, such as Halley and Koons, made their careers in the downtown scene, then moved on to the more prestigious Sonnabend Gallery in SoHo. Nevertheless, there was a great deal of crossover among the neoconceptual artists, the galleries in which they exhibited, and their rosters. Although far from a unified entity, the artists commingled through various interconnected networks and affiliations. Steinbach socialized with Levine and Halley but remained distant from Bickerton and Koons. Halley was close with Koons and Vaisman at the time but had little personal connection to McCollum. In the early 1980s, Halley, Koons, Vaisman, Bickerton, and Levine all showed at International with Monument (of which Vaisman was a co-proprietor), while McCollum, Steinbach, and Taaffe exhibited at different East Village and SoHo galleries and alternative spaces, including Pat Hearn Gallery (1982–1991), Cable Gallery (1982–1988), Baskerville + Watson (which opened on Fifty-seventh Street in 1979 and then moved to a Broadway address in SoHo from 1985 to 1991), Artists Space, the Kitchen, and White Columns. Halley, Levine, McCollum, and Steinbach exhibited in the East Village at Nature Morte gallery (1982–1988); Halley, Koons, and Levine showed at Baskerville + Watson; and Bickerton, Levine, and Steinbach showed at Cable Gallery.

Group exhibitions throughout the 1980s assembled various configurations of neoconceptual artists, contributing a degree of cohesiveness to the loosely organized group. In 1983, Halley curated the exhibition "Science Fiction" at John Weber Gallery in SoHo, which included his own work as well as that of Donald Judd, Koons, Richard Prince, and Robert Smithson. Beginning in 1984, Metro Pictures gallery, today predominantly associated with the Pictures and appropriation artists, brought neoconceptual and Pictures artists together in a sequence of five exhibitions exploring painting and sculpture, such as the exhibition "Signs of Painting" in 1986. This show included works by Bickerton, Jack Goldstein, Halley, Levine, McCollum, Walter Robinson, and Taaffe, among others. Neoconceptual artists appeared in four additional Metro Pictures exhibitions from 1984 to 1988.[2]

Independent curators and dealers Tricia Collins and Richard Milazzo played a key role in promoting neoconceptual art in a number of exhibitions beginning in 1984, providing the group with support and recognition both before many East Village galleries had opened and after most of them had either closed, around 1987–1988, or moved to SoHo. The couple curated forty-four shows between 1984 and 1993, some of which were accompanied by catalogs that bore lengthy, theoretically informed essays on the work by the duo.[3] In their writings and essays, Collins and Milazzo discussed the referential techniques of the neoconceptual group alongside the tactics of artists exploring similar strategies in

photography and video. They also helped to construct neoconceptualism as a somewhat cohesive group by emphasizing the common elements and themes among the artists' work. In the exhibitions "The New Capital" in 1985 and "The New Poverty" in 1987, for example, the pair linked neoconceptual work to the theoretical discourse on postmodernism and highlighted the artists' use of irony as a critical strategy. Working as private dealers without an actual gallery space, the couple charged commission on the works they sold as a result of their exhibitions, the earliest of which were held at Nature Morte, Cash/Newhouse, and International with Monument. In addition to their curatorial ventures, Collins and Milazzo frequently held salons in their East Village apartment, where older and younger generations of artists could meet and discuss their work. They worked alongside other freelance writer-curators, including Robert Nickas and Dan Cameron, who during this period began organizing shows free of institutional affiliation, helping to create the now-familiar figure of the independent curator.

In the late 1980s, the neoconceptual artists were included in the major museum surveys of the decade, the first of which were "Avant-Garde in the Eighties" (1987) at the Los Angeles County Museum of Art and "The Binational: American Art of the Late 1980s" (1988) at the Institute of Contemporary Art, Boston, which traveled to the Kunstsammlung Nordrhein-Westfalen, Düsseldorf. The first major international exhibitions on neoconceptual art were organized in 1986: "Art and Its Double: A New York Perspective," discussed in the introduction; and "New York Art Now, I and II," which took place at Saatchi Gallery in London.[4] (The latter will be discussed at length in chapter 6.) Other important group shows included "Damaged Goods: Desire and the Economy of the Object," curated by Brian Wallis at the New Museum in 1986 and "Objects for the Ideal Home: The Legacy of Pop" (1991) at the Serpentine Gallery, London.[5]

The neoconceptual artists came from varied backgrounds and arrived in New York at different moments. Levine, one of the older members of the neoconceptual group, moved to New York in 1975 after attending art school at the University of Wisconsin, where she was introduced to the writings of the Frankfurt School through studies in the history department. Like many artists at the time, Levine drew inspiration from a variety of media sources. In her early works, she clipped ads from magazines and experimented with photocollage. Beginning in 1976, she created the *Sons and Lovers* series, using the recognizable silhouettes of the heads of famous presidents, such as Abraham Lincoln or John F. Kennedy. Soon after, she began superimposing the silhouettes over advertising images in works that used these visual associations to pose questions about American history and identity. Levine's inclusion in the 1977 "Pictures" exhibition associated her with a new generation of photography- and media-based artists. Two years later, Levine's *After* photographs, in which the artist photographed the work of

well-known male photographers Edward Weston and Walker Evans, incited much controversy and debate over the terms of authorship and artistic creativity.

Beginning in 1983, to the surprise of many, Levine reintroduced the artist's hand, in works that continued to create a dialogue with preceding artists, artistic forms, styles, and movements. Also called *After*, these were watercolor copies of reproductions of works by famous artists, such as Arthur Dove, Fernand Léger, or Joan Miró, in a scale similar to that of the illustrations in art history books. As her East Village debut, Levine showed watercolors of works by Kazimir Malevich and Egon Schiele in a 1984 exhibition entitled "1917" at Nature Morte. She also began producing geometric paintings, executed in casein paint and wax on mahogany, with purposefully generic stripes, checks, and chevrons that were loosely reminiscent of the work of early modernists such as Piet Mondrian and painters broadly associated with minimalism, such as Frank Stella, Brice Marden, and Ellsworth Kelly. Art historian Howard Singerman discusses Levine's shift away from the Pictures generation to painting as a broader gesture intending to reposition her work in reaction to critics' writings published mainly in *October* magazine.[6] Speaking

FIGURE 1.1
Sherrie Levine, *After Arthur Dove*, 1984. Watercolor on paper, 14 × 11 in. Image courtesy Paula Cooper Gallery, New York. © Sherrie Levine.

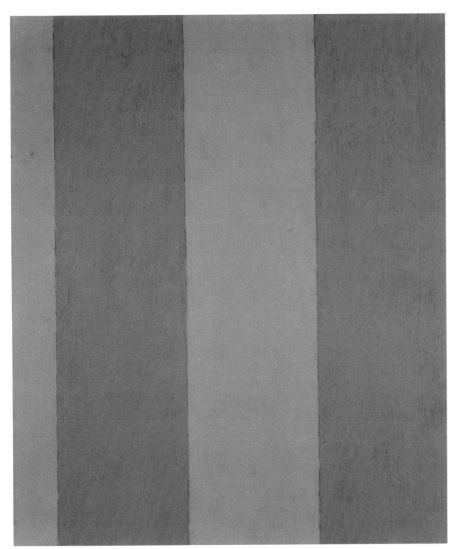

FIGURE 1.2
Sherrie Levine, *Broad Stripe
#12*, 1985. Casein and wax on
mahogany, 24 × 20 in. Image
courtesy Paula Cooper Gallery,
New York. © Sherrie Levine.

about the transition, she said, "I was thinking that what is wrong with a lot of Frankfurt School theory is that it assumes art is about power and that, for me, art is about play."[7] In 1987, she moved, along with Barbara Kruger, to Mary Boone Gallery, which showed Levine's new paintings and photographs in its fall exhibition. In the early 1990s, she extended her dialogue with the canon into sculpture, making multiple cast versions of Constantin Brâncuşi's egg- or head-shaped work *Newborn [1]* (1915).

Like Levine, Allan McCollum moved to New York from California in 1975; that same year, he was included in the Whitney Biennial. In 1969, he had started investigating the visual language of painting by soaking dyed canvases in bleach and constructing works from multiple pieces of canvas that had been individually dyed, painted, or covered with sand. An example of the latter was included in the 1975 Biennial. In 1978, he began his *Surrogate Paintings*. To create these small works, McCollum glued wood and museum board together, then applied multiple layers of paint. In 1982, he switched to fabricating the paintings with rubber molds and plaster in order to achieve a seamless finish between the painting's frame, its mat, and surface. McCollum described the *Surrogate Paintings* and the later versions, called *Plaster Surrogates*, as caricatures of paintings that he created after studying the work of Robert Ryman, Roy Lichtenstein, and Frank Stella. In 1985, McCollum explained his focus, particularly in the *Surrogate Paintings*:

> I'm trying to create a susceptibility, a vulnerability, to that sort of emotional deferral, but stopping short; trying to create the experience of subjectivity rather than creating subjective experience. … This focus grew out of an interest in the area of "defining" painting, the notion of reducing painting to a simple set of essential terms, and then "expressing yourself" within those terms. This was what a lot of painters seemed to be thinking about in the late Sixties and early Seventies. I began to see this sort of thinking as really absurd, somehow. It seemed to me that every conceivable description of painting that one might offer to define its "essence" or its "terms" could always be found to also define some other, similar object which was *not* a painting—except for one: a painting always has the *identity* of a painting; a painting is what it is because it is a convention.[8]

In 1980, McCollum showed the *Surrogate Paintings* in exhibitions at Artists Space and Marian Goodman Gallery. In 1985, he exhibited *Plaster Surrogates* at the East Village galleries Cash/Newhouse and Nature Morte. McCollum also began his *Perfect Vehicles* sculptures in this year. These works consist of painted cast replicas of a single vase, the form of which is imbued with an art historical referent that is familiar, yet difficult to place. The *Surrogates* and *Perfect Vehicles*,

FIGURE 1.3
(artist refused) Allan McCollum, *Collection of Forty Plaster Surrogates*, 1982–1984. Enamel on cast Hydrostone, forty panels ranging from 5 × 4¹/₈ in. to 20¼ × 16¼ in., overall 64 × 110 in. Installation at Cash/ Newhouse.

among other of his series, were individually crafted en masse. This system of fabrication responded to the proliferation of objects within capitalism. It also spoke to the complicity of art objects with this system.

Born in Rehovot, Israel, Haim Steinbach had been living in New York since he moved there at age thirteen in 1957. He received an M.F.A. at Yale University in 1973 and taught at Middlebury College in Vermont from 1973 to 1977 (Robert Gober was one of his students). In the early 1980s, he exhibited with the New York-based artist collaborative Group Material, which opened an exhibition space on East Thirteenth Street in October 1980, and at the alternative art space Fashion Moda, which opened in 1978 in a storefront in the South Bronx. From 1979 to 1996, Group Material produced socially conscious art projects and exhibitions with the aim of resisting the commercial art world. They used various spaces, including their own gallery space in the Lower East Side, and the number of participants in the collective ranged over the years from thirteen to four. In 1975, Steinbach began creating sculptures with used objects found in flea markets, yard sales, and secondhand stores. From this point forward, his work examined the physical and psychological effects of commercial objects. Early on, Steinbach created special display environments for the objects, such as custom shelves

hung on walls covered with wallpaper. Using the languages of minimalism and conceptualism, his sculptures aimed at unpacking the sociocultural structures of capitalism and the ways individuals interact with the things they buy. Explaining his work in 1993, Steinbach commented: "I went through an evolution … from a minimal, reductive language based on the conceptual activity of the late 1960s and early 1970s, toward a point at which a whole other range of discussions began to emerge."[9] Solo exhibitions of his work took place at Artists Space in 1979, Fashion Moda in 1980, Cable Gallery in 1985, Jay Gorney Modern Art in 1986 and 1988, and Sonnabend Gallery in 1987.

Jeff Koons moved to New York toward the end of 1976, after having received his B.F.A. at the Maryland Institute College of Art as well as some graduate training at the Art Institute of Chicago under painter Ed Paschke. Koons began making sculpture in 1979 with his *Inflatable Flowers* series, in which plastic inflatable flowers and rabbits were attached to square mirrors. Koons joined the staff of the Museum of Modern Art in 1977, as artists Sol LeWitt, Dan Flavin, and Robert Mangold had done for day jobs before him. There he famously worked at the membership desk. Around 1982, he began working in sales for a brokerage firm, making cold calls to potential clients. This job helped finance his *The New* series (1980–1987), which at first consisted of household appliances glued to the front of fluorescent bulbs and hung on the wall: "I would glue or bolt an appliance to a modernist background. These pieces were directing themselves to be as objective as possible. They wanted to deal with the history of the readymade, and hopefully to add to that history. And I believe that with the *New* I did add to that Duchampian history."[10] In 1980, Koons showed several Plexiglas-encased vacuums from the series in the front windows of the New Museum on Fourteenth Street. Despite such positive attention, *The New* series failed to garner any sales, and Koons, having invested all his savings in the project, was forced to move briefly out of New York. After returning, Koons began working on his *Equilibrium* series (1983–1993) in which one, two, or three Spalding Dr. J. basketballs were semisubmerged in a fish tank. Two solo exhibitions at International with Monument received widespread attention from collectors and critics and led Vaisman to organize the much-discussed 1986 Sonnabend show. Koons's inclusion in the 1987 Whitney Biennial, along with Halley's, marked a moment when these artists had already achieved national and international recognition.

Born in Barbados, Ashley Bickerton came to New York in 1982 as a recent graduate of the California College of the Arts (CalArts) B.F.A. program, where he briefly studied under Sherrie Levine when she served as a visiting instructor. He enrolled in the Whitney Independent Study Program in 1985 but began showing his work even earlier, with appearances at Artists Space in 1982 and White Columns in 1984, followed by shows at Cable Gallery, International with Monument,

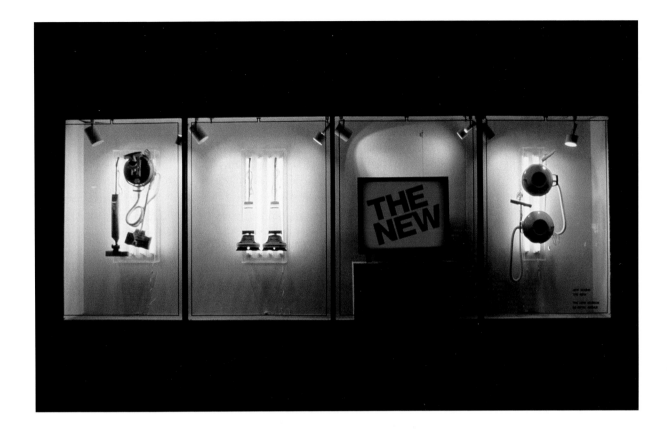

FIGURE 1.4
Jeff Koons, *The New*, window
installation, May 29–June 26, 1980,
New Museum of Contemporary Art,
New York. © Jeff Koons.

and Sonnabend Gallery in 1986 and 1987. From 1982 to 1986, he worked in the studio of Jack Goldstein, who had recently shifted from photographic work to painting. "[Bickerton] knocked on my studio door; he said he had a lot of experience with airbrush and could speed things up for me," Goldstein later recalled. "The process of making the paintings did speed up, and I could even turn part of it over to him. He argued continuously with me about using tape and paper templates for the Neo-Geo work. He said the work would have a graphic look and I'd reply, So What? What's wrong with a graphic look? That's what I want!"[11] Bickerton's own paintings were bulky, boxlike structures loosely reminiscent of Donald Judd's "stacks." He fabricated these works under his "brand name," Susie, throughout the 1980s in what he described as "a full frontal attack on the artist, the artist's work, the artist's identity that is ascribed into the system of information which ultimately manifests itself as history true or false."[12] His *Wall Wall* (1986–1988) and *Monosyllabic "Non-Word" Word* paintings (1983–1986) played with the

idea of the falseness of advertising and language in expressing concepts considered universal. His work began to incorporate ecological themes and natural materials in the late 1980s. Bickerton was included in several important neoconceptual group shows, including "New York Art Now" at Saatchi Gallery and "Cultural Geometry" at the Deste Foundation in Athens in 1987. Bickerton moved permanently to Bali in 1993.

Born in Caracas, Meyer Vaisman came to New York in 1980. He attended Parsons School of Design and cofounded the gallery International with Monument in 1984. While managing the gallery, Vaisman worked as an artist as well and was included in several exhibitions organized by Collins and Milazzo, including "The New Capital" at White Columns in 1984, and "Final Love" at Cash/Newhouse Gallery, "Paravision" at Postmasters Gallery, and "Cult and Decorum" at Tibor de Nagy Gallery (these last three in 1985). In 1986 and 1987, he had solo shows at Jay Gorney Modern Art and at Leo Castelli Gallery. Vaisman's work from the 1980s focused on the conditions, limits, and object quality of painting. The magnified canvas weave, a quintessential aspect of his work from this period, probed the root of painting, suggesting that a literal excavation of the surface would shed light on the direction of the medium within the postmodern period. The canvas weave also conjured the idea of medium specificity espoused by modernist critic Clement Greenberg. Stacked as many as four canvases deep, these paintings invade the viewer's space in a manner that parallels Bickerton's Susie boxes. In the early 1990s, Vaisman shifted directions, creating sculptures from stuffed turkeys and adorning each with clothing, wigs, and jewelry. He showed these works at Leo Castelli Gallery in a 1992 exhibition.

A key figure of the East Village arts scene and arguably the most pivotal of the neoconceptualists, Peter Halley was born in New York and grew up in midtown Manhattan, attending Phillips Academy in Massachusetts and receiving a B.A. from Yale. He went to the University of New Orleans for an M.F.A. and returned to New York in 1980. His leading role in neoconceptualism began in the early 1980s when he began a career as an art critic. He wrote on Ross Bleckner's work in the May 1982 issue of *Arts Magazine*, correlating this slightly older artist with the neoconceptual group. At the time, Bleckner was showing with Mary Boone Gallery in SoHo, along with David Salle and Julian Schnabel. In 1983, Halley curated the aforementioned "Science Fiction" at the John Weber Gallery, which examined technology's impact on society, literature, and utopian ideals. The exhibition included artists of his generation—such as Koons (marking his entrée into the East Village scene), Prince, and Bleckner—as well as artists of the previous generation, such as Judd and Smithson.[13] "Science Fiction" served as an important moment in Halley's early career as an artist-critic, when he was pursuing strong theoretical and sociocultural agendas.

The article for which Halley is probably the most renowned, "The Crisis in Geometry," appeared in the June 1984 issue of *Arts Magazine*. In this and other efforts, Halley seemed to follow the example of artist-critics like Judd, Mel Bochner, and Thomas Lawson. In a manner mildly reminiscent of Dan Graham's photo essay "Homes for America," published in *Arts* in November 1966, Halley's essay outlined the use of geometry and geometric forms from their purportedly neutral standing in early modernism to their disquieting use as structures of control in postwar architecture. Halley's essay largely functioned as an explanatory text, relating his art to his theoretical ideas on the structure of society. His use of geometry mirrored the simulated space of the videogame, the space of the microchip, and the space of the office tower. At the same time, the abstract composition in Halley's painting *The Prison of History* (1981), for example, included art historical signifiers, referencing painters like Josef Albers and Barnett Newman. The title mischievously suggests that the artists of the 1980s were fettered to the past, fettered to predecessors and previous formal advancements. Relying heavily on Foucault's *Discipline and Punish: The Birth of the Prison* (1977), as well as Baudrillard's *Simulations*, Halley argued in his essay that structuralism and poststructuralism were implicit in an understanding of the geometric art of the 1980s.

FIGURE 1.5
Peter Halley, *The Prison of History*, 1981. Acrylic on canvas, 63 × 77 in. Image courtesy the artist. © Peter Halley.

Though Halley was a highly informed writer, the publication of "The Crisis in Geometry" at such an early point in his career functioned to limit the understanding of neoconceptual work. In the 1980s, critics such as Joshua Decter questioned the reductive quality and limited formulation of Halley's writings on painting and accused the artist of propagating conspicuously one-dimensional, flawed theories in a disingenuous manner, commenting: "On one hand, Halley announces that the vocabulary of modernism is retained, but its elements, already made abstract, are finally and completely severed from any reference to any real. On the other hand, Halley views his art practice as a critical (or self-critical) inquiry into geometric structures (the grid, cell and conduit)."[14] Halley's writings and paintings struck a particular chord, and the artist gained notoriety with critics who felt compelled to point out the errors in his thinking. Unfortunately, by including a discussion of his own paintings in "The Crisis in Geometry," Halley set himself up for the proliferation of critics' dismissive, critical reactions to his work. Many art historians and critics did not—and still do not—look beyond Halley's essay, his affinities with Baudrillard in particular. Critics at the time took Halley as a spokesperson for the group, and thus many of their critiques of neoconceptual work were based on his arguments and Baudrillard's ideas. (Eleanor Heartney in fact directly quoted Halley's essay in her 1986 article "Neo-Geo Storms New York.") Reading neoconceptualism through Baudrillard and the totalizing system of simulacra, which negates resistance, led critics to dismiss the group's deconstructive strategies as deflated and empty. In their critiques of Halley's work, Decter and others took the connection between Baudrillard's theories and Halley's work at face value, debasing the artist's attempts to provide an illustrative model of hyperreality.[15] Some had a difficult time coming to terms with the multivalency of Halley's project and its intertextual use of forms, techniques, and materials.

Halley described his works as emphasizing "the role of the model in the simulacrum."[16] In other words, even as he openly referenced earlier artists such as minimalist Frank Stella, Halley also depicted potential models or diagrams of contemporary society, symbolically representing its structural and organizational form. Similar to Guy Debord's society of the spectacle, the simulacrum was defined as the envelopment of societal structures by their own illusory models, which confound reality enough to eventually overcome it. Thus, the spatial structure in Halley's works mirrored simulacral space, with its digital fields of cells and interconnected conduits. "Like the simulated space of the videogame, of the microchip and of the office tower," Halley stated, directly citing Baudrillard, his paintings reflected this "cyberneticized social exchange, in which the social body irradiates with its operational circuits."[17] In this manner, Halley considered his work more diagrammatic than geometric. His paintings were meant to uncover and alert viewers to the structural mechanisms of the simulacra that surrounded

them on a daily basis. Yet, as Dan Cameron pointed out in 1987, curators and critics were unable to see Halley's work as anything but a diagram of Baudrillard's theories, and consequently his work suffered from an overidentification with the philosopher's ideas.[18]

The East Village galleries most associated with neoconceptualism opened successively over the course of the early 1980s and gained reputations for their receptivity to artists whose work exhibited theoretical grounding.[19] Civilian Warfare, known for conceptual painting and sculpture, and Nature Morte, known for art and photography increasingly being defined as postmodern, both opened in 1981. The co-owner of Nature Morte, artist Peter Nagy, described the gallery's mission in his preface to the catalog for the 1985 "Infotainment" show: "Our preference was for a type of art which stood in opposition to the large expressionistic paintings which then dominated galleries and artists' studios, in opposition to the kitsch/funk aesthetics of the East Village and in opposition to the mass-marketing of art in general."[20] One paragraph later, Nagy acknowledges the role of conceptualism as a precedent for the new generation of artists.

Started in 1984 by three artist friends, Kent Klamen, Meyer Vaisman, and Elizabeth Koury, International with Monument gallery resided in a storefront on East Seventh Street between First Avenue and Avenue A, with the name deriving from a partially obscured sign found in the basement.[21] East Village artists were attracted to the gallery's critical edge: Halley brought in slides of his work in January 1984 and received his first solo show there in 1985.[22] Halley took Koons to the gallery after featuring his work in the "Science Fiction" exhibition and "The Crisis in Geometry." International with Monument also showed several artists associated with the Pictures group and appropriation art—Sarah Charlesworth in 1985, 1986, and 1987; Richard Prince in 1985 and 1986; and Laurie Simmons in 1984.

Neoconceptualism did evince commonalities with other East Village styles, such as an interest in the popular media, a commercialized response to the burgeoning art market of the 1980s, and a refusal to be pinned down to one category or another. As with neoconceptualism, the characterizations of other East Village styles and their associated artists shifted frequently from one writer to another. Keith Haring, Kenny Scharf, and Mark Kostabi were labeled either graffiti artists or cartoon artists depending on the critic. Haring and Scharf were also occasionally referred to as street artists, along with Jean-Michel Basquiat, who was also considered a neoexpressionist. Moreover, the commercial art market and surrounding hype affected all East Village artists, not just the neoconceptualists. By the late 1980s, Basquiat, Haring, and Scharf had gained fame (and notoriety) by frequenting the most popular New York nightclubs—the Palladium, Paradise Garage, Mudd Club, Club 57. While the neoconceptual artists and their work remained firmly entrenched in painting and sculpture, Haring used the New York City subway as

his canvas, producing hundreds of drawings between 1980 and 1985 on adver-
tisement panels, covering the locations reserved for paid announcements with
black paper and drawing on them with white chalk. Ephemeral in nature, many of
the drawings were eventually covered by advertisements. In 1986, Haring began
directly selling spinoffs of his artwork to the public in the form of inexpensive com-
mercial merchandise with the opening of his Pop Shop in SoHo on Lafayette
Street, opening a branch in Tokyo two years later. The media hype of the 1980s
that resulted directly in dazzling auction results at Sotheby's and Christie's also
increased general interest in these artists as part of New York's cultural elite.

Neoconceptualists were also not the only artists in the East Village who
played with formal and material traditions. Inspired by Jean Dubuffet's concept of
art brut, Basquiat and Haring created sometimes simplistic and primitivistic fig-
ures and symbols. Scharf's work was reminiscent of aspects of pop in its inclu-
sion of lowbrow imagery from cartoons such as *The Jetsons* and *The Flintstones*.
In 1980, these three artists took part, along with more than a hundred others, in
the "Times Square Show." Located in a former bus depot and massage parlor at
Forty-first Street and Seventh Avenue, the exhibition was organized by the art
collective Colab, or Collaborative Projects, Inc. In stark contrast to the linearity of
Halley's work, Scharf's *Felix on a Pedestal* (1982) displayed recognizable cartoon
characters inhabiting a cosmos layered with brightly colored celestial orbs and
structures. Scharf's playful oeuvre fused kitschy subjects lifted from mass culture
in a pop-like manner with spray-painted forms reminiscent of street or graffiti art.
Pop paragon Roy Lichtenstein's mature practice largely focused on human melo-
drama, teary-eyed females and brave fighter pilots taken from the pages of
comics; Scharf, by contrast, preferred characters from animated cartoons in his
transgressing against artistic conventions. Laughing hysterically, Scharf's Felix
the Cat appears to taunt the viewer with the very fact of his being in an artwork,
the taboo nature of his presence reinforced by the "timeless" quality of the Greek
architectural elements.

Neoconceptual artists were consumed by the conventions of modern art in
ways that differed from other East Village artists, however. In general, they held a
great affinity for their earlier counterparts. Stella used Day-Glo colors in his paint-
ings in the 1960s and so did Halley twenty years later. After Judd forged a posi-
tion for his work within the canon of art history in part through his commentary
and writings, Halley attempted this as well, publishing articles in *Arts Magazine*.[23]
Warhol's fascination with fame led him to found *Interview* magazine in 1969. In
1996, Halley began *Index* magazine, which featured interviews with art world fig-
ures. In comparison to Stella or Judd, however, Halley's colors are not only bright,
but practically blinding. Halley also did not simply write about contemporary art
and art history, he theorized and aggrandized it.[24] These artists were linked by

FIGURE 1.6
Kenny Scharf, *Felix on a Pedestal*, 1982. Acrylic and spray
paint on canvas, 96 × 104 in. Private Collection. Image
courtesy Tony Shafrazi Gallery, NY. © 2013 Kenny Scharf /
Artists Rights Society (ARS), New York.

their manipulation of representation and presentation of key moments in art history. The content and sociopolitical associations in their work vied with the colors and forms, be they abstract or representational. Peter Halley provides a prime example with his *Two Cells with Circulating Conduit* (1986). Deeply rooted in irony, the work appropriates the signature styles and motifs of well-known artists. The interplay of geometry and colors suggests Albers's *Homage to the Square* series (1949–1976). Similarly, the green and blue lines in the center of the work reference Newman's zips, the penetratingly bright lines in his large color field works such as *Vir Heroicus Sublimis* (1950–1951). Not simply diagrammatic, Halley's work enacted a critical rereading of art history, including challenges to the metaphysical symbolism attached to the modernist geometric forms of, for instance, Malevich's suprematist or Mondrian's neoplasticist works. The facetious sampling of forms, colors, and mediums served overall to question previous artistic practices.

FIGURE 1.7
Peter Halley, *Two Cells with Circulating Conduit*, 1986. Acrylic, fluorescent acrylic, and Roll-a-Tex on canvas, 64 × 104 in. Image courtesy the artist. © Peter Halley.

CRITICAL THEORY IN THE NEW YORK ART WORLD

The multilayered references found in neoconceptual work have connections to a wide range of critical sources, which were debated in the 1970s and '80s and eventually dispersed to increasingly wider audiences through academic journals and art magazines. The specificities of postmodern and poststructural theory and deconstruction inspired many artists during a period that was characterized in the Euro-American realm by an influx of digital technology and a shift from an industrial to a so-called postindustrial economy oriented toward technology and service work. The aim of this section is to provide an overview of these ideas and how they reached the East Village scene and heavily contributed to the dialogue within that milieu.

The impact of French theory on literary criticism and in other areas of academia was substantial, particularly in the United States. Derrida's lecture "Structure, Sign, and Play in the Discourse of the Human Sciences" at Johns Hopkins University (in French) in 1966 is often cited as the moment French theory entered the United States; it was published subsequently in English in 1970. Derrida's lecture and his books—in particular *Of Grammatology*, *Writing and Difference*, and *Speech and Phenomena*, all published in French in 1966 and 1967—introduced the practice of deconstruction.[25] A literary tool, methodology, and self-reflexive form of analysis, deconstruction critically examines the presuppositions and hidden agendas within texts and structures of thought.

FIGURE 1.8
Barnett Newman, *Vir Heroicus Sublimis*, 1950–1951. Oil on canvas, 95⅜ × 213¼ in. The Museum of Modern Art, New York. Gift of Mr. and Mrs. Ben Heller, 1969. Image courtesy The Barnett Newman Foundation. © 2013 The Barnett Newman Foundation, New York / Artists Rights Society (ARS), New York.

The effects of structuralist and poststructuralist thought precipitated a crisis within academia.[26] Previously stable concepts and systems of knowledge were called into question, such as Sartre's existentialism and the French intellectual system overall. Sartrean existentialism was concerned with a unitary transcendental subject from which all meaning was derived. Structuralism, on the other hand, promoted a decentering of the subject and polysemy resulting from the interplay of multiple sign systems.[27] Derrida's concept of deconstruction suggested that philosophy concerns not only the notion of Being, as discussed by Sartre, but also those differences that separated individuals. Although Derrida questioned structuralism in *Of Grammatology* and *Writing and Difference*, he shared with French structuralists an inclination toward new ways of thinking within academic disciplines and a desire to break down the accepted boundaries between domains of study. Instead of supporting a linear relationship between sign and signifier, deconstruction promoted multiple associations and meanings within existing linguistic and literary structures. In this way, a deconstructive analysis is, in a sense, complicit with existing systems of thought while at the same time remaining critical and defiant. Uncovering the relativities or exclusions within totalizing concepts and systems of knowledge exposes their inadequacies and allows for the questioning of their assumed infallibility.

Derrida sought to differentiate deconstruction from previous literary methods on the basis of its capacity to effect change by undermining totalizing systems of thought; deconstruction, he argued, had the ability to target and analyze the structural mechanisms of overarching sociopolitical and philosophical structures.[28] It and other new ways of thinking challenged the French academy. Held down by the weight of tradition, the French university system had remained conservative and impervious to change, but the new theories promoted connections between multiple disciplines. All in all, these qualities helped to bring about the aspects of the May 1968 demonstrations that led to modifications of the French academy and social structure. French theorists also sought to incorporate the social sciences into their analyses at a time when the social sciences were struggling to gain recognition by the French academy. Foucault's analysis of classification systems in *The Order of Things: An Archaeology of the Human Sciences*, published in French in 1966, is a signal example of the integration of social sciences and the humanities, one that had a broad impact on many disciplines and the visual arts.

Derrida's lectures and courses at universities throughout the United States allowed him to gain a foothold in the U.S. academy in advance of his structuralist and poststructuralist colleagues. Derrida was a visiting professor at Yale University, New York University, the State University of New York at Stony Brook, and the New School of Economics in New York City, before joining the faculty of the

University of California, Irvine, in 1986. The writings of Derrida, Barthes, Foucault, and Deleuze were translated into English in the 1970s, at which time they and other European theorists began to gain currency in U.S. academic circles.

One fellow European of note was the Belgian-born literary critic and theorist Paul de Man, whom Derrida met at Johns Hopkins. Their friendship continued until de Man's death in 1983. While a professor in the French and comparative literature departments at Yale University, de Man played a pivotal role as a member of the so-called Yale School of deconstruction. The group included de Man and his Yale colleagues Geoffrey Hartman, J. Hillis Miller, and Harold Bloom. Despite their connection, the Yale School's ideas on the concepts of structure and language were distinguishable from the ideas of their French counterparts. The Yale School was concerned with the classification and taxonomic structure of language, while Derrida's theories focused more on the structure of language within larger, overarching systems. Though the Yale School comprised the most recognized proponents of Derrida's writings, a variety of other supporters existed in English, French studies, and linguistics departments across the United States.

Critical theory also gained currency in the United States through several important journals, published writings, and conferences. During the late 1970s and the 1980s, the journals *Critical Theory* and *Semiotext(e)* introduced North American readers to French theory. *Critical Theory* focused on the writings of the Yale School and was founded in 1974 by Wayne Booth, Arthur Heiserman, and Sheldon Sacks, professors at the University of Chicago. That same year Sylvère Lotringer, a professor of French and comparative literature at Columbia University, started the journal *Semiotext(e)*, which introduced French structuralist and poststructuralist philosophy to New York. The Schizo-Culture Conference organized by *Semiotext(e)* in 1975 at Columbia, which included papers by Deleuze, Félix Guattari, Foucault, and Jean-François Lyotard, was a milestone of intellectual exchange between the United States and France, marking these theorists' first public appearance in the United States. For example, the 1978 issue of *Semiotext(e)*, entitled "Nietzsche's Return," featured texts by Derrida, John Cage, Lyotard, Foucault, and Deleuze. The juxtaposition of images and documents from mass culture with the texts in the journal worked to popularize these writings and to draw connections between theory and everyday life. In 1983, Semiotext(e) launched itself as a book publisher as well, beginning with the Foreign Agents series, which included writings by Lyotard, Deleuze and Guattari, and Baudrillard. The pocket size of the Foreign Agents volumes and their commensurately diminutive prices encouraged a young readership and helped to bring French theory to a broader audience. Another important intellectual vector was *Flash Art* magazine, which published interviews with Baudrillard, Hans-Georg Gadamer, Guattari, Fredric Jameson, Kristeva, Lyotard, Louis Marin, Peter Sloterdijk, Philippe Sollers,

and Cornel West between 1983 and 1987.[29] Other notable publications of the period treating French theory include Hal Foster's *The Anti-Aesthetic: Essays on Postmodern Culture* (1983) and *Art after Modernism* (1984), an anthology edited by Brian Wallis that included essays by Barthes, Baudrillard, and Foucault.

Today, Halley cites the Semiotext(e) books of the 1980s as an important source. "Whatever [Semiotext(e)] was publishing," Halley states, "I was reading." In 1982–1983, Halley took part in a discussion group with young artists and critics on a variety of topics including the writings of Barthes and the work of Levine.[30] He recalls first learning about Baudrillard in 1983 from Barbara Kruger. Art historian Jonathan Crary of Columbia University was also a personal mentor in the 1980s. Crary's writings examined the links between art and poststructuralist theory, and in 1986 he helped found Zone Books, a press now internationally noted for its publications in intellectual history, art theory, politics, anthropology, and philosophy, by Foucault, Deleuze, Georges Bataille, and many others. (Crary is still a coeditor.) "At the beginning of the digital age, we were the first group to deal with French theory," Halley says, "which has now been completely assimilated by later generations of artists and academics, who are so well-versed in it."[31]

Included in the 1983 Foreign Agents slate of publications was Baudrillard's *Simulations*, a book that elicited a dramatic response from artists, art historians, and critics. Reworking many ideas found in Marxist theory, the book relies on the structuralist and poststructuralist analysis of signs and referents. In addition to considering Foucault's 1975 *Discipline and Punish: The Birth of the Prison*, Baudrillard analyzes the mechanisms of capitalism and their effects on daily life. When *Simulations* was published by Semiotext(e) in 1983, Lotringer immediately organized a series of lectures for Baudrillard at East Coast universities including Columbia, Yale, and Harvard, although Baudrillard's popularity did not crest in the New York art world until several years later. According to Bill Arning, who served from 1985 to 1996 as the director of White Columns, an alternative exhibition space that occasionally featured the work of neoconceptual artists, "Within two years everyone had read *Simulations*."[32] As a measure of Baudrillard's popularity, and of the vogue for French theory in general, his lecture at the Whitney Museum in 1987 sold out months in advance. Lectures at the Asia Society and at Columbia University were quickly organized, and Koons, Halley, Levine, and Bleckner attended. The same year, however, in an exhibition signaling the polemics surrounding the French theorist's ideas, Group Material organized the show "Resistance (Anti-Baudrillard)" at White Columns, countering what they saw as his "operatively submissive philosophy" with politically driven work.[33]

In the Columbia lecture, Baudrillard directly addressed neoconceptualism: "I cannot get involved in explaining the new art of simulation. … In the world of

simulation, there is no object. There is a misunderstanding in taking me as a refer-ence for this work."[34] Baudrillard's public disavowal of a relationship between his writings and these artists, who had been deemed simulationist by some critics precisely due to their affinity for his writings, appeared to hurt both parties. In a November 1987 article, "The Rise and Fall? of Baudrillard," Grant Kester, an editor at *New Art Examiner*, discussed Baudrillard's comments at Columbia and his intense rise and decline in popularity in the United States. "Until recently, Bau-drillard has exercised a virtual hegemony in the American art world, particularly within the segment of the art world involved in the discussions concerning Post-modernism," he wrote. "One could hardly pick up a current art magazine without finding him quoted, footnoted, interviewed or otherwise invoked. However, the Baudrillard 'effect' has begun to wane."[35] Attempting to analyze the artists' inten-tions, Kester seems to imply that the neoconceptual group rode the coattails of Baudrillard's fame, and that, in citing his theories, they managed to successfully control discussions of their work as well as pique collectors' interest. The main problem with this argument (as we will see in chapter 2) is that neoconceptual work does not exclusively rely on, nor is it entirely concerned with, Baudrillard's ideas about the simulacrum. Kester merely repeated earlier critics' misreading of the work.

The widely circulating ideas and debates on postmodernism in the 1980s involved much more than, as Kester suggested, a discussion of Baudrillard's writ-ings. The term *postmodernism* arose in the late 1950s but was not used with any relative fluidity until the early 1970s.[36] For many, postmodernism signaled the end of modernism, a perhaps purposeful shift in the historical paradigm. In 1975, architectural historian Charles Jencks described the new, playful, ironic eclecti-cism of architect Robert Venturi, a clear contrast to the stark lines of the Interna-tional Style, as postmodern.[37] Several years before Jencks, Leo Steinberg had used the term in his essay "Reflections on the State of Criticism," published in the May 1972 issue of *Artforum*. Originally delivered as a lecture at the Museum of Modern Art in 1968, Steinberg's essay elaborated on his notion of the flatbed picture plane in a series of arguments aimed at Clement Greenberg. In Steinberg's view, postmodern art was characterized by the intermixing of abstraction and representation, and of art and life. Robert Rauschenberg's Combine paintings signaled a shift to postmodernism in their recomposed assortment of random ele-ments.[38] In addition to Rauschenberg, pop painters of the sixties, such as Lich-tenstein, Oldenburg, and Warhol served as Steinberg's examples.

Holding different meanings for different individuals, the term *postmodernism* remained tied to a series of local debates and failed to have any single, cohesive definition. Beginning in the late 1970s, some art historians and critics, who today are viewed as having been the dominant voice of the period, tied postmodernism

to certain photographic and sculptural practices of the 1960s and 1970s, linking this work to French and American theoretical and philosophical ideas. Many of these individuals contributed to *October*, a theoretically oriented art journal that strongly supported the death-of-painting rhetoric of the 1970s and '80s. *October* was founded by Rosalind Krauss, Annette Michelson, and Jeremy Gilbert-Rolfe in 1976, one year after Semiotext(e)'s Schizo-Culture Conference. Beyond its founders, major contributors included Douglas Crimp, who became managing editor of the journal in 1977; Benjamin Buchloh; Craig Owens; and Hal Foster (Owens and Foster also began writing for *Art in America* in 1981). Krauss and the others collectively formulated the staunchest attack on Clement Greenberg's views of modernism, arguing in favor of postmodernism, which in their view encompassed shifts in the sociopolitical, cultural, and artistic realms since the 1960s.[39]

The prolific writings of this group in the late 1970s and early '80s included some of the first examples of an incorporation of French theory into the criticism of contemporary art. In their attempts to distance themselves from Greenbergian formalism, however, these art historians and critics arrived at a strict definition of postmodernism that, for the most part, excluded painting or sculpture. Many of the writers associated with *October* held a bias against these mediums as being characteristic of bygone modernism and hence as inadequate for the postmodern era. Foster, Bois, and Thomas Crow, for example, viewed neoconceptualist manipulations of art historical signs as signaling the emptiness and failure of painting.[40]

Looking beyond the biases of the most-published writers of this period allows a more open-minded, multidisciplinary definition of postmodernism to emerge, one that includes painting and sculpture. In 1987, while the denominations *neo-geo* and *neoconceptualist* were still being debated, Robinson described these specific East Village artists as "postmodern" to signal both their theoretical roots and their critical attitude toward modernism:

> What I like about 'Postmodernism' as an art term is how, about two years ago, it suddenly found its art market meaning. For years nobody understood what it meant except a bunch of critics who read all the time, and they weren't really inclined to explain it … and it turns out that all the dealers' clients are looking for Taaffes and Schuyffs and things like this. … So I thought, the 80s are all done, it's going to be Neo-Expressionism in the first half and Postmodernism in the second half. … But now Baudrillard and some other people have weighed in and they want to call the second-half stuff Simulationism instead. And that may win out because it's more of an art-type term. Another candidate is Neo-Geo.[41]

Postmodernism, for the neoconceptualists, translated into a keen and ironic awareness of the art market, commodity capitalism, and art history as a structured arrangement of neatly packaged artists and movements. This savvy immediately showed through in neoconceptual work, which proposed an underlying set of conceptual questions in visual terms.

In March 1981, the Institute for Architecture and Urban Studies of New York hosted a symposium on postmodernism. At this time, Halley and Koons were still recent arrivals to the New York art scene, while Sherrie Levine, Bleckner, McCollum, and Steinbach were well established. (Bickerton would arrive one year later, in 1982.) Panelists included Levine, art historians Christian Hubert and Craig Owens, and painters David Salle and Julian Schnabel. In his opening remarks, Hubert acknowledged, "The term Post-Modernism gained currency in architecture before taking hold in the other arts, but more recent criticism suggests some very different definitions from what the term has meant for architects."[42] Hubert included painting within the debate over the artistic terms of postmodernism, characterizing the medium as follows:

> Painting today seems in some respects to be attempting to take revenge on the photographic image, to appropriate it, to break its spell. ... One concern [these artists] share is with the appropriation, the possession of the image. Can it be owned by an individual artist who invests his personae into the act of painting? Or do images own and manipulate us?[43]

Thus, as early as 1981, Hubert recognized the critical potential of painting, at a time when many critics held little regard for it. Indeed, at the panel, Owens called Salle's work "pure academicism" and an "attempt to preserve an activity that is moribund." The gradual dematerialization of art, as seen in the postminimalist, earth, performance, conceptual, and media art movements of the late 1960s and early 1970s, had brought new art forms that shied away from the Greenbergian definition of modernism and the materialist concerns of painting. Greenberg's narrow definition of modernism and his longtime belief in painting as the primary, avant-garde medium prompted a reaction from a generation of critics to follow.[44] This antiformalist rhetoric seemed to coalesce in *Artforum*'s September 1975 special issue on the death of painting, which proclaimed that painting had "ceased to be the dominant artistic medium of the moment. ... And we assume that the debates between its two major ideologies, abstract and representational, have outlived their usefulness to the current scene."[45] The years directly following saw a so-called renewal of painting in the form of neoexpressionism, as well as a surge in photographic and video practices and appropriation art. In 1978, the Whitney Museum mounted the "New Image Painting" exhibition,

which focused on the work of ten figurative painters. As Katy Siegel convincingly argued in the 2006 exhibition catalog *High Times, Hard Times: New York Painting, 1967–75*, painting had continued to function as a viable medium during this decade.[46] In the 1980s, certain neoconceptual artists reinvigorated painting practices in ways that reflected that decade's social and cultural environment. Hubert's comment drew connections between the contemporary photographic work of artists in the late 1970s, such as Prince, Levine, and Goldstein, and the painters of the next generation, such as Salle, Halley, and Bickerton. Hubert's remarks suggested the possibility for an alternative reading of the criticism of this period and raised questions about contemporary works that were overlooked by the major art historians and critics of this time.

While the "death of painting" rhetoric flourished during the late 1970s and 1980s, painter and critic Thomas Lawson appeared to be one of the few outspoken supporters of the medium within the dominant critical conversation. The Scottish-born painter moved to New York in 1975 and started *Real Life* magazine with writer Susan Morgan. Published twenty-three times between 1974 and 1993—and with its first cover featuring the work of Levine—*Real Life* became an underground site of literary and artistic exchange for a loose, diverse group of artists and writers of this period. Kruger, Levine, Prince, McCollum, and others published essays in *Real Life* on their own work and that of their colleagues. Lawson described the journal as "a forum for artists to talk about the issues that were of vital importance to them and … a vehicle for a younger generation to speak about each other."[47] Lawson, like *October* contributors Crimp and Owens, attended the Graduate Center at City University of New York, where Krauss was on the faculty. Lawson became involved with East Village galleries, including Nature Morte, and contributed essays to exhibition catalogs, such as that for Collins and Milazzo's "Infotainment." That exhibition included work by Nagy (who also wrote for the catalog), Halley, Steinbach, Laurie Simmons, Gretchen Bender, and others. Several months after the Institute for Architecture and Urban Studies symposium on postmodernism, Lawson made a similar argument for a new, critical type of painting that could be aligned with neoconceptualist work. His article "Last Exit: Painting," published in *Artforum* in October 1981, has come to summarize the death-of-painting rhetoric characterizing this period. Lawson described a dire situation during his own period, where many artists were locked into practices evoking "blind contentment."[48] Thirty years later in his analysis of Lawson's article, Jack Bankowsky noted the discussion that Lawson's "survey-cum-manifesto" incited within the New York art world, which in 1981 was divided between neoexpressionism and the Pictures artists.[49] Lawson summarized the view of many artists and dominant critics who saw contemporary painting as antiquated, or as simply a repetition of older forms and movements. As Lawson saw it,

neoexpressionist painters such as Francesco Clemente, Sandro Chia, Jonathan Borofsky, and Schnabel propagated a co-opted modernist formalism. Lawson argued that painting had become "a funereal procession of tired clichés paraded as if still fresh, a corpse made up to look forever young." The neoexpressionists expressed the "last decadent flowering of the modernist spirit."[50]

Lawson suggested that a number of new artists had managed to work successfully despite the death of painting. In his view, these artists managed to undermine the very institutional structures that were confining the medium. This response to the dilemma of painting in the 1980s entailed a type of subversive complicity, as it were, that is also exhibited in the work of the Pictures group. Lawson advocated using painting as a "camouflage ... a device of misrepresentation, a deconstructive tool designed to undermine the certainty of appearances" — in other words, an art that engaged with aspects of art history, the culture industry, or society at large and as a result elicited multiple readings and responses.[51] Paintings by Lawson and his fellow artist-critic Walter Robinson served as examples of the concept of painting in camouflage. "Last Exit" influenced certain young New York painters, including Halley, who were at that time exploring the critical potential for painting and sculpture and the relationship of those mediums to modernism. Lawson's advice served as a call-to-arms for the neoconceptualists, who challenged the titans of art history in a game of visual interplay. Their work intentionally produced a pluralistic dialogue that relied on overlapping meanings and forms from past and present.

NEOCONCEPTUALISM'S THEORETICAL UNDERPINNINGS 2

Structuralism is not a new method; it is the awakened and troubled consciousness of modern thought.

Michel Foucault, *The Order of Things*, 1966[1]

According to Foucault's observation, structuralist initiatives operated from within existing academic and social systems to perform critical rereadings of ideas, texts, and models of thought. Discarding authorship as a key category, structuralism focused instead on larger, putatively all-encompassing language systems that were said to impose meaning upon texts, a category that was now broadly constructed. Structuralists believed that an author, while constructing a text, was burdened by a preexisting system of language, an idea that contradicted the notion of writing as an original, creative endeavor. Almost fifteen years after the publication of Foucault's *The Order of Things*, neoconceptual artists grappled with structuralist and poststructuralist thought, attempting to translate these broad philosophical ideas into aesthetic terms. Like Foucault, the neoconceptualists generally operated within the existing boundaries of art and society in order to problematize a linear notion of history and to suggest other possibilities for authoritative points of view. As I will argue in this chapter, the modus operandi of neoconceptual work stemmed from the philosophy of deconstruction, and from the distinct arguments made by theorists such as Barthes, Baudrillard, Deleuze, Paul de Man, Derrida, Foucault, and Kristeva. Neoconceptual paintings and sculptures served as platforms for the investigation of intertextual and deconstructive lines of thought and the notion of the author. Neoconceptual artists implicitly suggested other possibilities for art historical and societal structures by highlighting their conventions. While all these artists could be discussed here, this chapter offers four signal case studies of Ashley Bickerton, Allan McCollum, Philip Taaffe, and Sherrie Levine, whose work most clearly illustrates these connections.

Two essays by Yale deconstructionist Paul de Man, "Literary History and Literary Modernity" (1970) and "Criticism and Crisis" (1967), can be correlated to neoconceptualism's critical methods and these artists' examination of larger art historical structures.[2] In these writings, de Man explored the paradoxical relationship between history and modernity in order to ascertain the nature of progress. He presented the notion of "demystification," in which past hegemonic structures are critically assessed to reveal an inner clarity and truth.

Describing the then-current trends in continental criticism, de Man contended that the critics of his period had gotten in the habit of using a language of crisis in their account of new developments in literature.[3] A crisis occurs when a form of literature or domain of study has broken away from the established norms. In this situation, the critic's role was to assess this rupture and to determine the extent of conformity or nonconformity to an established point of origin. In their proclamation of a crisis, critics were inadvertently exposing the "truths," or preconceived points of authenticity, of their respective domains. As de Man finally affirmed, there are no structures that can function validly as a model for other structures; all are equally fallacious and are therefore called myths.[4] Using a language of crisis was therefore contradictory to the objectives of these linguistic developments. Where past domains were based on erroneous "truths" instead of "untruths," de Man asserted that philosophical knowledge could be attained only through self-critique and revisionism. By uncovering the romantic delusions and myths of its past, literature would finally gain an element of legitimacy.

It is useful to think about how de Man's arguments apply to the reception of neoconceptualism in the 1980s: namely that art historians' and critics' inimical consideration of this work actually functioned to highlight its most important aspects. In June 1986, for example, Foster argued that neoconceptualism's painterly appropriation "is not at all derived, genealogically, from critical abstract painting—that is of Stella, Ryman, Marden. … Today the argument that painting can be used deconstructively as a form of camouflage for subversion of other beliefs reads somewhat dubiously."[5] While Foster viewed neoconceptualism's appropriation as an empty gesture equivalent to "camp," I view the group's deconstructive impetus as offering a critical reevaluation of the canon of art history and a new outlook on modernism, its putative boundaries and constraints.

Further, de Man described modernity as a historical structure as well as a humanistic principle that functions to at once prevent and facilitate progress. Human beings are fettered by their remembrance of past events at the same time as they are inspired by their desire to generate change. Modernity therefore recurrently fluctuates between the remembrance of past events and the obliteration of their historical weight. During these singular moments of amnesia, the weight of the past ceases to limit advancement toward the future. De Man remarked:

"Moments of genuine humanity thus are moments at which all anteriority vanishes, annihilated by the power of an absolute forgetting."[6] Calling upon the writings of Friedrich Nietzsche, de Man observed that progress is less an act of obliterating the past than a critical judgment: "as soon as modernism becomes conscious of its own strategies ... it discovers itself to be a generative power that not only engenders history, but is part of a generative scheme that extends far into the past."[7] In these critical moments, modernity temporally transforms rigidity and privilege into criticality and reflection, thereby ensuring progression. De Man argued that this type of critical and analytical revision of dominant historical structures can lead to the attainment of authenticity in our current postmodern era.

Relevant on a more general level, de Man's writings described the intellectual movements of our era as continuously vacillating between historical limitations and spontaneous ruptures. De Man argued against structural formalism, which seemed to ignore modernity's dualistic status as a structural entity as well as a progressive force. On the other hand, he did not promote its distinct bifurcation into creative and analytical parts, with the second passively theorizing the first. Citing writers from the eighteenth century onward, de Man pointed out that a critical regard of history is not a purely modern characteristic. On the contrary, it is a crucial aspect of our natural, historical momentum, consistently fluctuating between the weight of history and the dynamism of modernity. Although the present period is bound to the past for its own insights and development, questioning its structural boundaries conveys accuracy and advancement. Though his work primarily concerned the study of literature, de Man asserted that "demystification" can occur within other domains that contain a linguistic structure, such as art or music. His arguments provoked a desire to progress, as well as an optimistic outlook on the issues of postmodernism, which were typically regarded in a pessimistic manner by many art historians during the 1980s.

De Man's ideas permit a more lucid understanding of neoconceptualists' relationship with the historical entities they struggled against. As these next pages will demonstrate, neoconceptual work illustrated, in de Man's terms, a temporal moment of criticality and reflection, when modernism succeeds in reverting to itself through self-evaluation. Taaffe, for example, shares de Man's cyclical view of history. As Taaffe observed:

> The reason there have been these modernist ruptures is because it was always a way of building upon what was there, by obliterating the existence of the preceding work. It was less about constructing something than it was about rupture, a breaking apart. It was an issue of cataclysmic change that the art was reflecting, but now there are all kinds of different connections that need to be made within our understanding of twentieth century movements

and art history. It's a wider picture. I think that the timeline has expanded. What all of this rupturing has done, and what modernism has shown to us, is that we need a longer perspective. All of these fractures have ended up deepening our understanding of where painting is coming from and why the culture needs it.[8]

Taaffe elaborated on the poststructuralist sensibility of his work, which, in a way comparable to that of other neoconceptual artists, exposed and confronted certain ideological constructs within history, art history, and society at large.

As one of the first groups to grapple with the distinct debates in literary theory, neoconceptualism reflected shifting tendencies in the analysis of history and modernity. These artists employed multiple visual and creative processes to demystify art historical and socioeconomic structures. From this point of view, neoconceptualism's revisionary act of demystification, using de Man's terminology, presented the knowledgeable viewer with a more authentic outlook on art history. These artists playfully updated the forms and materials of pop, minimalist, and conceptualist works to reflect the sociocultural concerns of the 1980s. Steinbach and Koons cultivated new relationships between high and low, as well as between art and the commodity, in ways that textually cited pop art but pointed to the role of objects as markers of cultural and socioeconomic divide. Bickerton, Levine, Halley, McCollum, and Taaffe created "painting produced as a *sign* of painting," to use Foster's terminology (which he meant to be derogatory). These paradigms of paintings are, rather, works that investigate the ongoing role of the work of art and its relationship to art history and to the tenets of postmodernism as it came to be defined in multiple ways in the 1980s. Bickerton's invasive Susie boxes, for example, exaggerated and deconstructed aspects related to the selling, purchasing, and packaging of a work of art. Using strategies of visual irony, Taaffe and Halley pushed the limits of artistic influence by manipulating stylistic aspects of previous artists' works. Linking this diverse group of artists is the notion that a work of art should uneasily question the terms and conditions of art's relation to history and to society.

ASHLEY BICKERTON'S PARADIGMS OF PAINTING

After years of pulling the object off the wall, smearing it across the fields in the Utah desert, and playing it out with our bodily secretions, the artwork has not awkwardly, but aggressively asserted itself back into the gallery context: the space of art—but this with an aggressive discomfort and a complicit defiance.[9]

Ashley Bickerton, *Flash Art* panel, Pat Hearn Gallery, May 2, 1986

Bickerton's use of the term "complicit defiance" suggests the critical potential of painting, which came back into the foreground after the conceptual, earth, and performance art movements and the death-of-painting rhetoric of the seventies. His words point to painting's role as a conceptual agitator, or rather a medium whose agenda is to poke and prod its contextual surroundings. This characteristic stemmed from the example of conceptualism and its analysis of the frameworks surrounding works of art as they are situated within institutional structures. Four years earlier, in an article entitled "Back to the Studio," Craig Owens reviewed a CalArts alumni exhibition and made a similar connection, using the term "subversive complicity" to describe the graduates' return to painting and sculpture after the art movements of the 1960s and '70s.[10] Having graduated in 1982, Bickerton followed in the footsteps of the "CalArts Mafia"—artists such as Ross Bleckner, Troy Brauntuch, Eric Fischl, Jack Goldstein, Matt Mullican, David Salle, and James Welling—who studied with conceptual artist John Baldessari at CalArts and had already moved to New York. Having grown up during a period when the media and commodity capitalism became more prominent, these artists incorporated and manipulated popular sources and materials in their work, from advertisements and films to signs and symbols. Celebrating its tenth anniversary, the California Institute of the Arts invited Helene Winer, previously the director of Artist's Space, then co-owner of Metro Pictures Gallery in New York, to curate the art section of the CalArts alumni show. Her selections included many of the above artists, who she also showed at her gallery.

Although Owens connected a return to painting with the neoconservative movement of the 1980s, an isolated examination of his use of the term "subversive complicity" is helpful in defining the characteristics shared by neoconceptual work. In his view, the advent of post-studio art began with the discussion of phenomenology and perception through minimalist and conceptualist practices. Some artists of the 1970s spent less time isolated in the studio and more time creating art against the backdrop of everyday life. Earth and land artists created work outdoors in remote areas, such as Robert Smithson's *Spiral Jetty* (1969). Robert Morris's *Continuous Project Altered Daily* (1970) consisted of a pile of dirt and objects such as an electrical cord, pieces of metal, grass, and rope that Morris would alter each day. Yvonne Rainer conceptualized a dance piece to accompany the installation, which was performed at the Whitney Museum and recorded by a film crew.

The new generation in the 1980s, although inspired by these earlier artists and their dematerialized art forms, retreated to the studio to create photo-based works and transportable paintings. Owens's description is admittedly problematic, since minimalist and conceptualist practices also involved the creation of art objects, as is demonstrated by Joseph Kosuth's sculpture *One and Three Chairs*

(1965) or Sol Le Witt's oil on canvas *Red Square, White Letters* (1963). However, the younger artists' work was driven by somewhat different intentions. As Owens described the painters' motivations: "more and more often do we hear apologies which invoke the seductive notion of a 'subversive complicity' with art-world institutions; the only way to destroy a painting, we are told, is from within, by exposing its own internal contradictions."[11] Owens's use of the term followed Thomas Lawson's statements on painting in his article "Last Exit: Painting" by several months. Although he had his own biases against the medium, as did Foster, Owens cited the paintings of David Salle as an example of the tactic, for positing the "established conventions against themselves in the hope of exposing cultural repression." Salle's paintings, such as *Gericault's Arm* (1985), combined a set of distinct, fragmentary images in different formal styles that prompted a desire for a more whole or complete figure or meaning. Using images from art history books or mass media, such as fashion magazines, as sources, Salle's appropriation and re-presentation of imagery caused familiar subjects to become unrecognizable. In *Gericault's Arm*, for example, an image of a seminude model is combined with nineteenth-century French painter Théodore Géricault's studies of corpses for his canonical work *Raft of the Medusa* (1818–1819). Salle's work pitted the history of painting against itself by manipulating high and low sources in new ways.

Having studied within this milieu, Bickerton's work, and the work of the other neoconceptualists for that matter, demonstrated an adherence to this critical mode of painting. Similar to Salle's art, his work creates an internal dialogue with art history by looking back at art of the postwar period. In contradistinction, however, Bickerton's work involves an innovative use of materials and extends its critique to include the structural framework surrounding a work of art by exaggerating aspects related to the creation, selling, purchasing, and packaging of an art object in order to indicate its complicit role in the activities of cultural materialism. *Tormented Self-Portrait (Susie at Arles)* (1987–1988) is an immense, jolting work that consists of a black box attached to the wall with large, metal hinges. The front of the canvas is plastered with logos of popular brand names, many of which are still current. Instead of depicting a realistic image of the artist, *Tormented Self-Portrait* sarcastically displayed a plethora of graphic brand names. Moreover, in case the museum visitor missed the label, Bickerton explicitly labeled the work as a self-portrait on the top edge. The labeling and the logos confronted the long history of self-portraiture, while simultaneously presenting an image of contemporary identity during the height of capitalism in the eighties. Listed on the sides of the work are the materials used in its fabrication, an aspect that any conservator would surely find very useful. In his other *Logo* paintings, the work's materials are referenced through their specific brand names. Although they look mass-produced, Bickerton crafted the logos and other parts of the work by hand, in a manner

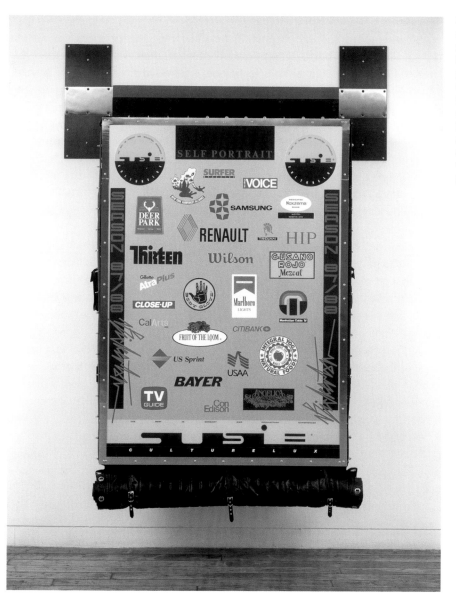

FIGURE 2.1
Ashley Bickerton, *Tormented Self-Portrait (Susie at Arles)*, 1987–1988. Synthetic polymer paint, bronze powder and lacquer on wood, anodized aluminum, rubber, plastic, Formica, leather, chrome-plated steel, and canvas, 89⅜ in. × 68¾ in. Purchase, The Museum of Modern Art, New York. Image courtesy the artist and Lehmann Maupin, New York and Hong Kong. © Ashley Bickerton.

reminiscent of Andy Warhol and James Rosenquist. He gave the paintings a new, streamlined appearance by using synthetic and some industrial materials, such as high-quality acrylic paint, chrome-plated steel, leather, Formica, rubber, and anodized aluminum. Bickerton's technique involved the painstakingly detailed application of finely cut Frisket paper stencils to sanded gesso on wood. This allowed the logos to lie flat on the surface. It took over a month to complete the work, due to the artist's complex process of cutting, layering, and spraying paint with an airbrush. A thin metal frame surrounds the edges of the work in place of a traditional frame. As a visible form of protection, a thick leather covering has been rolled up and attached to the underside.

In 1986, Bickerton explained the philosophy behind his work: "These are not exactly paintings. These are paradigms of paintings resonant with form, content, style and information, yet paradoxically unable to hold or fix meaning."[12] The multilayered work is unable to convey any singular message because it simultaneously adheres to and rejects the traditional definition of a work of art by using a combination of visual irony and hyperbole. *Tormented Self-Portrait* is a strange, hybrid object that hangs from the wall like a painting but is made with industrial paints and materials. While canvas is listed as a material used in the fabrication of the work, it is not visible to the viewer. The facade appears glossy and new, and the logos look fresh and brilliant, just as they would on a billboard or in a magazine. At the same time, Bickerton exaggerated the formal elements of the work. Instead of one or two logos, at least twenty decorate the surface. Also, the painting does not simply hang from the wall; the entire canvas is so thick that it juts out toward the viewer by over fifteen inches.[13] Moreover, the work is physically bound to the wall by the hinges and bolts, as if it were fettered permanently within the gallery. All the visual elements emphasize the contradictory or marginal aspects of artistic production and installation that are typically hidden from the viewer or collector.

Simultaneously functioning as a painting and a "paradigm of a painting," *Tormented Self-Portrait* performs a critical analysis of the history of art from within its boundaries. The conceptual drive inherent to Bickerton's work can be correlated with Derrida's ideas on deconstruction. As demonstrated in *Writing and Difference* and in *Dissemination*, deconstruction involves the careful analysis of texts to demonstrate that linguistic systems are actually founded on or created by the terms they exclude.[14] Within this arrangement, one term consistently dominates the other. For example, in Western society, the values of goodness and truth dominate over evil and error. Similarly, an understanding of being and presence dominates over nothingness. Deconstruction reversed the opposing terms in order to undermine these hegemonic systems of thought. Instead of supporting a linear relationship between sign and signifier, Derrida's methodology promoted

multiple associations and meanings within existing linguistic and literary struc-
tures. Rather than simply accepting the frameworks at hand, deconstruction
works from within to suggest alternative meanings. In this way, a deconstructive
analysis is, in a sense, complicit with existing systems of thought at the same time
as it remains critical and defiant. Uncovering the relativities or exclusions within
totalizing concepts and systems of knowledge exposes their inadequacies and
allows for the questioning of their assumed infallibility.

Derrida saw deconstruction not as a purely literary strategy, but as a method
with sociopolitical implications. In 1982, he summarized the philosophy of
deconstruction:

> Precisely because it is never concerned only with signified content, decon-
> struction should not be separable from this politico-institutional problematic
> and should seek a new investigation of responsibility, an investigation which
> questions the codes inherited from ethics and politics. This means that, too
> political for some, it will seem paralyzing to those who only recognize politics
> by the most familiar road signs.[15]

In this passage, Derrida sought to differentiate deconstruction from previous liter-
ary methods on the basis of its capacity to affect change by undermining totaliz-
ing systems of thought. Deconstruction allowed for the ability to target and
analyze the structural mechanisms of overarching sociopolitical and philosophical
structures. Although criticized for destabilizing the category of authorship at a
time when women and many minority groups sought agency, Derrida's notion of
deconstruction emphasized the concerns of continental philosophy, as well as
the social systems constructing Western ways of life. The effectual aims of a
deconstructive analysis therefore extended from the hermetic field of literary
theory into the political and institutional realm of society at large. The "politico-
institutional problematic" targeted by deconstruction describes the ways this
analysis can also be defined as a general strategy of resistance, which seeks to
reattribute a more powerful position to an inferior entity. Seeking to reverse these
social hierarchies, deconstruction allowed a consideration of the conditions and
structures that compose reality rather than reality itself. Derrida's statement
revealed that the correction enacted by a deconstructive analysis is not always a
peaceful process because it shifts entire systems of thought and notions of
history.[16]

Bickerton's work operates along these lines as a means of critical resistance,
forcing the viewer to notice differences between his work and more conventional
paintings. In an interview describing the work in his 1987 exhibition at Interna-
tional with Monument, Bickerton explained, "when Judd used a screw, it was just

a screw, now it has metaphorical meaning. He is boiling art down to what it is. Something that sits on a wall or gets taken off a wall and shipped. In a way, I've tried to be Stella. He left out the fact that it's bought and sold."[17] Influenced by Stella's literalist treatment of the canvas—as seen in his *Black Paintings* and *Aluminum Paintings* of 1959 to 1960 and 1960 to 1961, respectively—Bickerton raised questions on the idealized conceit of art's autonomy in a way that complicated this debate by situating his work within the constraints of commodity capitalism. He appeared to agree with the judgment set forth by Judd in his 1964 essay "Specific Objects": "The main thing wrong with a painting is that it is a rectangular plane placed flat against the wall. … A rectangle is a shape itself … it determines and limits the arrangement of whatever is on or inside of it."[18] *Tormented Self-Portrait* at once highlights and challenges Judd's assessment by calling attention to painting's limitations. Measuring over seven feet tall, Bickerton's self-portrait dwarfs many modernist works, which tend to remain at the intimate scale of easel paintings. The ample dimensions of *Tormented Self-Portrait* are more closely aligned with abstract expressionist and color field canvases, such as those by Clyfford Still or Barnett Newman. But, in contrast, Bickerton's work draws attention to the conventional techniques of fabrication and methods of installation by differentiation. Instead of presenting a simple canvas hanging neatly from the wall, Bickerton's work consists of an intrusive boxlike metal structure secured with visible bolts and oversized hinges. These mechanical aspects are amplified in ways that detract from the work's overall visual quality. While the surface of the canvas is typically the focal point of a painting, in Bickerton's work, the logos and brand graphics covering the face of the canvas compete with the chrome edges, securing devices, and other material aspects of the work. Large plated hinges, which hold five bolts each, extend several inches from the top and side edges of the painting. A thick leather covering was rolled and fastened to the bottom edge of the painting.

The material aspects of Bickerton's work and the art historical references drawn from them suggest a type of multiplicity that relates to Derrida's concept of textual grafting. Textual grafting can be defined as the splicing and the interposing of lines of arguments on to each other in order to identify points of error and to disrupt traditional habits of thought.[19] Derrida writes, "So too, then, does each sequence of the text, through this mirror-effect that germinates and deforms, comprehend some *other* text each time, which by the same token, comprehends *it*, so that, in one of these parts that are smaller than themselves and greater than the whole they reflect, the theoretical statement of this law is guaranteed a housing."[20] To write or to compose, for Derrida, involves the process of quoting, citing, textual transcription, and a careful study of the material aspects of previous works. Bickerton's *Tormented Self-Portrait* performed textual grafting in its

combination of various formal components that point to previous works from the canon of art history, such as the thickness of the canvas, derived from Stella; the insertion of mass cultural references in the form of logos, derived from James Rosenquist and other pop artists; the brackets, from Robert Ryman; the industrial appeal, from Judd and Stella, and so on. In the tradition of pop, minimalist, and postminimalist works such as Oldenburg's *Soft Pay-Telephone* (1963), Judd's *Untitled* (1968), or Eva Hesse's *Hang Up* (1965–1966), Bickerton's work continued to confuse the boundaries between painting and sculpture. As Bickerton explained:

> The aluminum brackets on the corners of the objects provide some protection in storage and transit. During its time on the wall as an object of authentic reckoning, the brackets serve as a fact of that object's total function. ... There is in the hanging methodology an almost angry assertion that the art object, whether it wants to or not, must sit its ass on the wall and belligerently proclaim meaning. Through the last few decades it has been ripped off the wall and twisted through every conceivable permutation, yet back to the wall it insists on going. So be it, on the wall it shall sit but with aggressive discomfort and complicit defiance.[21]

Hence, the brackets emphasize the limited placement and role of painting as wall decoration, demonstrating that painting has historically been limited to a two-dimensional format. Bickerton's work exists as a painting but also reminds the viewer of the traditional, mechanical, and symbolic aspects of this medium and, more generally, of the work of art. Along with many of the artist's works from the 1980s, *Tormented Self-Portrait* served a dual purpose: it functioned as a work of art, but simultaneously underwent a form of self-criticism. At the same time, the blatantly oversized hanging mechanisms served as an exaggerated reminder of the work of the minimalist painter Robert Ryman, who also used fasteners and mounting devices both for practical reasons and as an aesthetic way to detach his paintings from the purely optical reading proposed by Greenberg and Fried. Bickerton's brackets are approximately two or three times the size of those Ryman used in works such as *Archive* (1979) or *Journal* (1988). The protective leather covering rolled up underneath Bickerton's work also gives it a hard-core, punk edge that is alien to Ryman's work, and reminiscent instead of 1980s fashion and music. While packing materials are usually placed in storage with their crates and other shipping materials, Bickerton's self-sufficient artwork came fully ready to be packed and shipped, for its covering can be easily detached and unrolled from the work.

On the painting's reverse, invisible to the gallery viewer, Bickerton included special jokes for art handlers to see when lifting the work from its crate and installing it on the gallery wall.[22] Amplifying this aspect of Bickerton's work, photographer Vik Muniz's *Verso* series (2008) presents large-scale images of the backs of famous paintings, in a similar effort to acknowledge that the normally hidden aspects of an artwork play an equally important role in the consumption of art. The jokes not only make the possibly tedious job of art installation slightly more enjoyable; they also challenge the work's status as art object. These jokes degrade the work's aura of autonomy, serving as a reminder of the factors and individuals outside of the work itself that contribute to its full meaning and context. As an even more rebellious and dramatic act of subversion, Bickerton stuffed the inside of the work with objects and personal items such as underwear, cryptic images, parking tickets, marbles, chickpeas, and broken glass.[23] As a result, *Tormented Self-Portrait* makes a disconcerting noise when it is moved, a clamor uncharacteristic of any traditional painting. This surprising attribute could give the impression that the work had somehow been damaged or destroyed, or was in the process of self-destructing. Bickerton's stratagem can be traced to a variety of sources, from Duchamp's *With Hidden Noise* (1916), in which a ball of twine is wrapped around a hidden object that mysteriously rattles; to the detritus (cigarette butts, nails, thumb tacks, and coins) embedded in the surface of Jackson Pollock's drip paintings, such as *Full Fathom Five* (1947); and to Jean Tinguely's *Homage to New York* (1960), a work he designed to self-destruct.

Bickerton's *Tormented Self-Portrait* challenged conventional notions of creativity by seeming to live up to only those standards the artist set for the work. The work exhibited creativity in an intellectual sense, where free-flowing impulses or pure visual forms have been replaced by calculated implicit questions about the work of art in the context of an art world environment. Irony and hyperbole played a strong role in this process. Every detail of the work was meant to deconstruct the metaphorical weight imposed upon it by the conventional standards set by art history and by sociocultural conditions such as the art market, critics, and dealers. The mechanical and visual aspects of Bickerton's work questioned established notions of aesthetics and beauty. Brackets, coverings, and other structural mechanisms, which are usually hidden from view in order to enhance a work's beauty, are instead enhanced and aggrandized. While Ryman's paintings still conformed to the standards of modernist painting in that he was committed to exploring painting's self-sufficiency, Bickerton created enormous, metal-box structures made with rubber, plastic, Formica, steel, and car paint, aspects which, along with the work's large size and aluminum encasement, produce uneasiness. The discomfort arises from the work's blatant disavowal of some traditional conventions of painting. Bickerton's *Tormented Self-Portrait* at once relies on and

enhances the self-reflexive painterly gestures of earlier artists, such as Ryman, in its examination of the overlooked structural mechanisms of painting and this medium's role as a cultural object.

Derrida's notion of *différance* involves the interrelation of signs and the extrapolation of meaning through a corresponding set of differences and the resulting temporalization that occurs in the collapse of the future and the past: "each so-called present element … is related to something other than itself, thereby keeping within itself the mark of the past element, and already letting itself be vitiated by the mark of its relation to the future element, this trace being related no less to what is called the future than to what is called the past, and constituting what is called the present by means of this very relation to what it is not."[24] A similar convergence of time, space, and meaning occurs in Bickerton's work, from which previous artists emanate and which he describes as "the ultimate object in all its glory, imploded into one event."[25] All the different stages of a work's life, from its initial fabrication to its evocation of meaning in the present moment and the potential economic exchange that takes place when the work is purchased by a museum or collector, have been collapsed into this single cultural artifact. Inversely, *Tormented Self-Portrait*, admittedly embroiled within a set of cultural paradigms, metaphorically stood for the larger economic and cultural milieu that imposes meaning upon a work of art. Bickerton offered a deconstructive model of a work of art, in which its meaning is consistently deferred to other works of art read as textual sites. Or rather, the significance of *Tormented Self-Portrait* is exclusively derived through comparisons with other paintings. Bickerton's act of self-degradation, or his sardonic declaration that his work is in fact just a cultural luxury, exposed the totalizing system that encompasses works of art, which are caught between the realms of avant-gardism and of the commodity. The creation of a painting that analyzed its own status as an art object seems nonsensical within this dialectic, since the traditional role of the artist is to create avant-garde works, which in theory operate outside of the market. Instead of passively assuming that role, however, Bickerton managed to remain one step ahead by openly declaring his work to have already been co-opted as an art object subjected to the constraints of the museum, gallery, and art world. *Tormented Self-Portrait* advanced this totalizing logic to its most illogical conclusion, exposing the structural constraints governing this system.

ALLAN MCCOLLUM AND THE POWER OF BANAL PAINTING

Suggesting an endless play of substitutions and classifications, Allan McCollum's near replication of small, black paintings in his *Surrogate Paintings* and *Plaster Surrogates* series also played with the visual limits of painting (see figure 1.3). An installation of *Surrogates* at Metro Pictures Gallery in 1984 displayed row after row

of the little black canvases repeated ad infinitum to the point of absurdity. The *Surrogate Paintings* were purposefully hung in a group format with no fewer than five in a group. McCollum cites structuralism as a strong influence on his work from this period, including the *Surrogate* and *Perfect Vehicles* series. Looking back, he commented: "If I were to take an overview of my whole career, I would have to say that you are looking at it from a structuralist angle."[26] McCollum read the writings of structuralist anthropologists, such as Claude Lévi-Strauss, and was influenced by structuralism's questioning of master narratives, or universal concepts. In his catalog essay for McCollum's 1985 show at the Lisson Gallery, Craig Owens drew parallels between McCollum's work and the poststructuralist theory of Gilles Deleuze. For Owens, the *Surrogate Paintings* reflected an empty commodity, the influx of products in the marketplace, and the serialized production that had impacted the domain of art. He comments: "Viewing them [the *Surrogates*] is less like gallery-going and more like window-shopping—or, rather, gallery-going *as* shopping."[27] Within the commercial realm, all store-bought products are the same, indistinguishable from one another. Yet this is not the case in McCollum's work due to its hand-painted quality, which Owens's reading overlooks. McCollum's work continues to be read in terms of emptiness, as if the monochromatic faces of the black paintings are devoid of content and signification.[28] While the repetition evoked the manufactured, serialized quality of commodity capitalism, it also poked and prodded at these concepts. Hung as groups, these apparently identical yet individually painted works emphasized the marginal and the liminal in ways that suggested a range of references and new meanings for painting as a discursive field of inquiry. A deeper look into the connections between McCollum's work and Deleuze's writings allows the *Surrogates* to be seen not as vacuous little paintings, but as imbued with meaning.

For Deleuze, the notion of difference does not involve a negation of sameness but is dependent on repetition as the variation of things: "Modern life is such that, confronted with the most mechanical, the most stereotypical repetitions, inside and outside ourselves, we endlessly extract from them little differences, variations, modifications. Conversely, secret, disguised and hidden repetitions animated by the perpetual displacement of difference restore bare, mechanical and stereotypical repetitions within and without us."[29] Along these lines, McCollum's work created meaning by playing on the relationship between repetition and difference and in particular that which distinguished his *Surrogate Paintings* from each other and from other art historical examples. From 1978 to 1982, McCollum hand-crafted the *Surrogate Paintings* from wood and museum board glued together and covered with multiple layers of paint. Beginning in 1982, the artist made *Plaster Surrogates* by casting select *Surrogate Paintings* in gypsum from a rubber mold. The *Plaster Surrogates* are subsequently hand-painted. In my view,

encountering a wide array of *Surrogate Paintings* is initially visually overwhelming, but leads to a detailed study of the brushwork on each painting and other small, minute characteristics that differentiate them. Associated with an artist's inner psyche and creative force, the brushwork operates on a similar level as Claes Oldenburg's foodstuffs, slathered with paint, or the visible strokes in Jasper Johns's *Flags*, both of which ironically referenced the gestural emotionalism of abstract expressionism. McCollum's strokes exist as an allegorical proposition pointing to this history and to the effusion of the artist's creative energy.

McCollum's *Surrogate Paintings* explode long-respected notions of uniqueness and authorship that have animated the history of art since its inception. They took the self-referential and autonomous qualities of painting, so important to early modernist painters, to an illogical and absurd extreme. These black canvases waver on the cusp between absence and presence. For some, the rows of monochromatic paintings initially lack subject matter and purpose. Yet McCollum's *Surrogate Paintings* also invoke comparisons with certain "masterpieces" of art history, raising questions such as whether the generic black *Surrogates* should be considered on par with, for example, a Malevich or a Stella *Black Painting*. The abstract paintings reference the underlying philosophical concepts attached to early modernist geometric painting. Alexander Rodchenko's *Black-on-Black* paintings from 1918, for example, signaled a tabula rasa for artists. Suprematist and constructivist artists such as Malevich and Rodchenko rejected traditional techniques and realistic modes associated with the medium of painting to focus on its essential qualities, such as form, materiality, and color.[30] As a pure investigation into the visual effects of color, Rodchenko's "5 x 5 = 25" exhibition in Moscow in 1921 presented three monochrome canvases in the primary colors, blue, red, and yellow.[31] In a written statement, the artist proposed the end of painting by pushing the medium to its most logical conclusion—namely, basic colors applied on a canvas in a direct and nonrepresentational manner. In his *Black Square* (1915), Malevich sought to create a radical pictorial language free from any political associations. This work took on a spiritual significance in "0.10: The Last Futurist Exhibition of Paintings" in Petrograd (now St. Petersburg) in 1915, when Malevich hung the painting in the upper corner of the gallery, a location usually reserved for religious icons. McCollum's *Surrogate Paintings* present a tongue-in-cheek response to these idealistic claims of autonomy and the death of painting, responding affirmatively with a serial presentation of row upon row of small black works.

McCollum's paintings also recall and posit themselves as different from the monochromatic investigations in the work of Yves Klein, Ad Reinhardt, and Robert Rauschenberg. In the 1950s, these artists separately reclaimed notions of noncommunicative emptiness that occasionally characterized monochromatic painting. Influenced in part by the concepts of being and nothingness inherent to Zen,

they imbued the Buddhist concept of the void with new meaning by reversing the conditions of meaning associated with painting and by demonstrating that flat planes of color were not empty but full of significance. Klein's electric-blue paintings assaulted the viewer visually and represented the physical manifestation of an intangible cosmic energy. Klein patented the powdery cobalt blue pigment used in these works, calling it International Klein Blue. Reinhardt's black paintings assumed an identical five-foot-square format in 1960. But a closer inspection of his *Abstract Painting* (1963), for example, reveals a wealth of green, blue, and red undertones that fade in and out. Although they seem unvaried and featureless, Reinhardt's works relied on sensual, visual perception and a slow processing of color and forms.[32]

Working at Black Mountain College in proximity to composer John Cage, who shared his interest in Zen, Rauschenberg attached a thick surface of papers to his 1951 *Untitled* [Glossy Black Painting]. Since paper usually contains print and is used to compose books and newspapers, the use of this material could be read as a parody of the illiterate quality of abstract painting. Rauschenberg's *White Paintings* (1951) represented the notion of pictorial space as a receptacle for the outside environment, in parallel to Man Ray's depiction of Duchamp's *The Bride Stripped Bare by Her Bachelors, Even (The Large Glass)* (1915–1923) with a thick layer of dust on it in his 1920 photograph *Élevage de Poussière* (Dust Breeding). As art historian Branden Joseph describes it, the *White Paintings* took on a new significance as the expression of temporality and the perception of duration.[33]

In contrast to these earlier monochromatic paintings, McCollum's work evinced a more cerebral and deadpan quality that relates to its function as an art historical sign. Underneath their simple format, the *Surrogates* conjured the long history of modernist abstraction. McCollum purposefully thwarted perceptual interplay by coating the surface of the *Surrogates* with wide, thick brushstrokes using commercially available enamel paint. He undercut the viewer's conventional encounter with a painting, usually hung on its own, with plenty of breathing space or lit by a spotlight, by purposefully hanging the *Surrogates* in groups. Their meaning lies in their abundance. Instead of looking at a single, solitary painting, the viewer is confronted with a multitude of closely similar paintings. Next to a Reinhardt, McCollum's work may appear dry and heartless, lacking any sensual or engaging quality—and, indeed, his work is frequently read as an empty signifier of painting: a false stand-in for a more impressive work of art. David Joselit writes, "If Levine and McCollum developed two structural axes of painterly transmission (the intensive and extensive; the temporal and spatial), they did so by excising content as a meaningful component of their work; to put it more plainly, they rendered the question of content irrelevant, by on one hand, 'merely' repeating it and, on the other hand, blanking it out."[34] But considering the *Surrogates* as such

ignores their ironic, playful, and theoretical thrust. The negative space implied by the black canvases is replete with meaning and references to the long lineage of art history and the philosophical concepts inherent to suprematism, abstract expressionism, neo-Dada, and the other "isms" of modernism.

Deleuze wrote of repetition: "if repetition exists, it expresses at once singularity as opposed to the general. … In every respect, repetition is a transgression. It puts law into question, it denounces its nominal or general character in favour of a more profound and artistic reality."[35] Freed from the notion of similarity, repetition involves difference and represents for Deleuze multiplicities of transformation residing alongside the actual. Elucidating this idea, the *Surrogates* create meaning through the articulation of repeated difference, since each painting is unique, as well as the differences between these works and a "singular" work of art. The abundance of the *Surrogates* forces the viewer to decide not what these paintings are or what they do, but what they are *not* and what they do *not* do. Faced with a multitude of black facades, each one different from the other, viewers of the *Surrogates* are urged to contemplate the definition of a work of art and how these paintings do not fit into that category. Put simply, these paintings are not serving a decorative role, and, if anything, they detract from the aesthetic sensibility of the space around them. Nevertheless, this transgressive effect, demonstrated by an image of twelve tiny *Surrogates* in a prominent spot in a Chase Manhattan Bank waiting area, carries substantial meaning in that McCollum's work severed the customary link between painting's sign and its referent. By reversing the customary attributes of painting and emphasizing the contradictions of this medium, the *Surrogates* incite questions and produce new aesthetic possibilities for painting within postmodernism.

FIGURE 2.2
(artist refused) Allan McCollum, *Surrogate Paintings*, 1979–1981. Installation, Chase Manhattan Bank waiting area, New York, 1981.

PHILIP TAAFFE'S ENDGAME ART

In parallel to the work of McCollum and Bickerton, Philip Taaffe's work created a dialogue with the art historical past and its avant-gardist models of painterly idealism. In the early 1980s, he appropriated found motifs from artists such as Henri Matisse, Barnett Newman, and Bridget Riley as well as from previous art movements like op art and color field painting. Taaffe's paintings are carefully handcrafted versions of their antecedents, displaying similar painterly qualities of color, line, and form. In several small works from 1983 and 1984, Taaffe reproduced by hand works by the little-known abstractionist Myron Stout. Similar to Levine's decision to rephotograph and hand-reproduce imagery by Walker Evans and Joan Miró in her *After* series, Taaffe's act of replication was a literal example of neoconceptualism's endeavor to broaden or rewrite the canon of art history. In 1987, Taaffe commented: "I am not interested in making a pretty object. It has to be ruthless. … It is obliquely referential. I want to make it into a deeper artifact than either thing itself. I want my paintings to become primeval Riley or, with my Newman paintings, primeval Color Field painting."[36] His statement illustrates deconstructive and intertextual motivations of his work, which contains internal references to other artists and conveys an interest in reconstructing the very foundations of art history through the medium. As art critic Jerry Saltz testified: "Taaffe took the resurrection of painting in a very literal sense … [Taaffe] made the way painters build on previous painting tangible."[37] At the same time, Saltz hailed Taaffe for his "voluptuous touch" and his sense of artistic creativity that extended beyond the act of slavishly reproducing works by preceding "masters."

In *Brest* (1985), for example, the tight, compact, parallel lines and interplay of light and dark colors directly resemble the work of op artist Bridget Riley in her painting *Crest* (1964). As a homonym of the word *breast*, the title of Taaffe's work serves as an allusion to Riley's gender and the influx of op art's patterns into feminine fashion of the 1960s. Nevertheless, Taaffe's painting appears to directly copy Riley's motif, in what would seem to be an artistic form of identity theft. Riley's 1965 statement on behalf of her work also applies to Taaffe's painting: "I want the disturbance or 'event' to arise naturally in visual terms out of the inherent energies and characteristics which I use. I also want it to have a quality of inevitability."[38] The wavy patterns of Riley's and Taaffe's works provoke a physical effect in the viewer, as he or she may be visually unsettled by the pattern. However, *Brest* is less a copy of Riley's painting than an intense study of her work, for Taaffe added brownish and greenish hues. *Brest* was also created in a completely different manner than *Crest*. Taaffe explained the difficult process of creating the work and the long hours required:

FIGURE 2.3
Philip Taaffe, *Untitled II*, 1984.
Linoprint collage, enamel, and
acrylic on paper, 53 × 45½ in.
Image courtesy the artist and
Luhring Augustine Gallery.

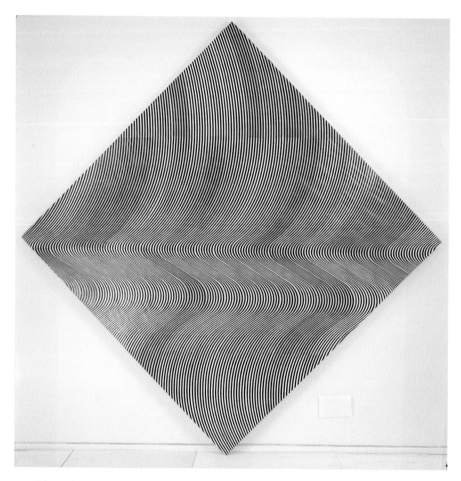

I just thought that I had always wanted to surgically dissect a Bridget Riley painting, or just take it apart and put it back together again, and I thought with all of these rolls of paper and all of the supplies, and I had the wall in my cold water flat in Jersey City, I had one great big wall that I could use, and I just decided to make linoleum carvings and dissect the wave in one of her paintings, and then another one of her paintings, and then a third, and make the carvings based upon projections of these sections of the waves. And they were very carefully engineered and surgically constructed and very similar to how these were made. These were made in very surgical [manner].[39]

In his painstakingly analytical process of deconstructing Riley's painting, Taaffe applied tape layer by layer to the surface of the canvas and then slowly removed it. Taaffe's painting connects to Riley's on a formal and material level, such that

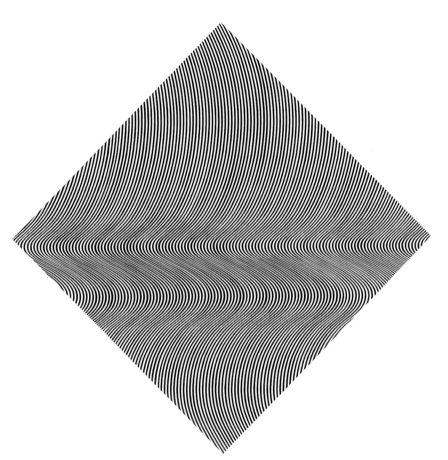

the former is viewed through the lens of the latter. The thought process driving Taaffe's work parallels Kristeva's concept of intertextuality, in which an author's writing is inherently informed by previous bodies of knowledge and one text consists of the assimilation and transformation of another:

> The word as a minimal textual unit turns out to occupy the status of *mediator*, linking structural models to cultural (historical) environment, as well as that of *regulator*, controlling mutations from diachrony to synchrony, i.e., to literary structure. The word is spatialized; through the very notion of status, it functions in three dimensions (subject-addressee-context) as a set of *dialogical*, semic elements or as a set of *ambivalent* elements. Consequently, the task of literary semiotics is to discover other formalisms corresponding to different modalities of word-joining (sequences) within the dialogic space of texts.[40]

Taaffe's painting, then, illustrates a translinguistic site of dialogical operations, in which the formal components—his surgical dissection of lines—serve as textual units mediating between two visual planes: his work and Riley's. The full meaning of *Brest* operates within a dynamic textual and visual set of coordinates that point horizontally to Taaffe's own creative impulses and vertically to those of Riley. In fabricating *Brest* through an analysis of the system of signs composing Riley's painting, Taaffe created an entirely new work that merged past and present in a unique manner:

> And the thing that was important to me about these paintings were the scale of the lines and the infinitude of every point was a very deep point, and every length of line—they're all straight lines—and the length of every line had an incredible sense of scale for me even though they were very limited in size, they grew architecturally to encompass this vast space in terms of what I was imagining was taking place with them. And so it was just a very, very torturous process, and one day I just decided not to make any more.[41]

Taaffe's careful study of Riley's work included an examination of the lines that compose *Crest* as well as the white space interspersed between the undulating black lines, in which the so-called dead space of the painting was given equal importance. A line serves as a visual equivalent to a word, which vacillates between two sets of meaning; the author's/artist's intent and the previous context.

Looking deeper into the previous cultural environment and sign systems raised by Taaffe's painting, Riley and other op artists created a kind of art historical brand from motifs that activate visual perception. In his painting, Taaffe intended to raise questions about the inherent simplicity of op art's formal characteristics. Op art is widely considered to be a comparatively fleeting art movement of the 1960s, disappearing almost as soon as it appeared.[42] The Museum of Modern Art's 1965 blockbuster exhibition "The Responsive Eye" marked the beginning of the movement and its appearance within mainstream media. MoMA featured over 100 artists from fifteen countries. Issues of *Time*, *Life*, and *Vogue* magazines from the same year documented the integration of patterns from op art into the fashion industry. Taaffe's painting speaks to this heightened popularity, but also to the critical failure of op art to make a great impact or to exert influence on subsequent artists or movements. Op artists' use of visual patterns and optical movement evoked an illusion of three-dimensional space at a time when reigning critic Clement Greenberg was hailing the flatness of the picture plane. Taaffe's work brought attention to this somewhat overlooked moment of art history, which has only recently begun to be reexamined by critics and art historians

such as David Rimanelli, Sarah K. Rich, and Pamela Lee. In many ways, Taaffe's painting also sought to attribute new significance to Riley's work. Underscored by the title, *Brest* credits the skill and talents of a female artist who struggled in her own day to gain acceptance within a field dominated by male painters. *Brest* marked an artistic examination of gender relations and the history of painting. It stood as a new point of departure, in which a male painter of a younger generation acknowledges his accomplished female predecessor.

Taaffe continued to engage in an intertextual relationship with the history of art in his painting *We Are Not Afraid* (1985), which looks at color field works of the 1950s and 1960s and irreverently answers the question posed by Barnett Newman's series of four paintings called *Who's Afraid of Red, Yellow, and Blue,* created between 1966 and 1970. The lines, shapes, and colors of *We Are Not Afraid* reflect the style of Barnett Newman and remind the viewer of Newman's monumental painting *Vir Heroicus Sublimis* (1950–1951; see figure 1.8). Taaffe's painting specifically built on the forms and colors of Newman's *Who's Afraid of Red, Yellow, and Blue II* (1967), transforming the symbolic humanism of the earlier work into a visual parody by twisting and contorting the "zip" into oscillating lines. The curving lines in Taaffe's work are reminiscent of a DNA double helix, which perhaps metaphorically connects the two artists within a similar creative genome. Taaffe also retained the scale of the earlier work, which is 120 by 102 inches.

First shown in a solo exhibition at Pat Hearn Gallery in January 1986, Taaffe's *We Are Not Afraid* instantly sparked controversy and multiple interpretations that are vividly recalled more than twenty years later in the exhibition catalog for his midcareer retrospective at the Kunstmuseum Wolfsburg.[43] Many considered the work a "betrayal of the heroic painting of the New York school." When older artist Malcolm Morley viewed Taaffe's work, Morley reportedly said: "You shouldn't have done that, you know."[44] On the other hand, Taaffe reported that Annalee Newman, Barnett Newman's wife, was pleased with the work. The debate surrounding Taaffe's painting can be accurately measured in the 1986 "Endgame" exhibition catalog, where Taaffe's *We Are Not Afraid* is discussed three times by three different essay contributors. Thomas Crow and Yve-Alain Bois viewed this work as devoid of content or as a secondary degradation of Newman's much more important work. Crow dubbed Taaffe's technique "The Fake as More," while Bois claimed Taaffe "refers to Newman's sublime as he empties it of its content."[45] Elisabeth Sussman, on the other hand, saw Taaffe's referential strategy as illustrating a new beginning for modernism.

Looking deeper into the work, we can gain a greater understanding of Taaffe's act through Kristeva's notion of ambivalence, which describes how a text relates to the broader context of the other texts and authors informing it:

FIGURE 2.6
Philip Taaffe, *We Are Not Afraid*,
1985. Linoprint collage and acrylic
on canvas, 120 × 102 in. Image
courtesy the artist and Luhring
Augustine Gallery.

The term "ambivalence" implies the insertion of history (society) into a text
and of this text into history; for the writer, they are one and the same. When
he speaks of "two paths merging within the narrative," Bakhtin considers
writing as a reading of the anterior literary corpus and the text as an absorp-
tion of and a reply to another text. … *The Songs of Maldoror* and the *Poems*
are a constant dialogue with the preceding literary corpus, a perpetual chal-
lenging of past writing. Dialogue and ambivalence are borne out as the only
approach that permits the writer to enter history by espousing an ambivalent
ethics: negation as affirmation.[46]

FIGURE 2.7
Barnett Newman, *Who's Afraid
of Red, Yellow, and Blue II*, 1967.
Acrylic, 120 × 102 in. Staatsgalerie
Stuttgart, Germany. Image courtesy
The Barnett Newman Foundation.
© 2013 The Barnett Newman
Foundation, New York / Artists
Rights Society (ARS), New York.

In a similar sense, Taaffe's painting absorbed and replied to Newman's example, creating a polyvocal site of meaning that manipulated and negotiated the history of art. *We Are Not Afraid* functioned defiantly to mitigate the aura and the genius status of one of the major painters of the color field movement. It also illustrated a linguistic slippage between Taaffe, as the subject of enunciation, and Newman, as the subject of utterance.[47] Taaffe at once proposes and cedes his authoritative voice to Newman, who visually assumes the position of author and subject of the work. For Kristeva, the speaking subject is not characterized by a discrete, unified or stable sense of self, but is always in process, open to and reliant upon

external surroundings. Taaffe's work reflects this fluid transference of current and preceding signifying systems, in which his artistic identity oscillates between himself and his predecessor.

By replacing Newman's quintessential zips with intertwined surrogates, Taaffe also instigated a semiological investigation into how this form functions in the history of art and the extent to which it has turned into an art historical signifier or brand identity for the artist himself. In some of Newman's earlier works, such as *Onement I* (1948), the edges of the tape, which remains on the canvas, served in a way as a visible trace of the hand of the artist. The existence of the tape, which was initially meant to be removed, marked the aleatory or contingent quality of artistic creation. The myth or cult of the artist is built upon such semiaccidental moments of creative genius, when the artist's artistic soul is said to shine through.

In the 1960s, Newman began to use acrylic paints for his large-scale canvases because of its quick-drying quality. He also examined the bright colors and forms in the work of pop artists who had arrived on the New York scene beginning in the late 1950s and 1960s, such as James Rosenquist's and Roy Lichtenstein's large-scale paintings. The origins of the term *zip* have been traced to the pop movement by Sarah Rich.[48] Newman began using the term in the mid-1960s, when he took up acrylic paint with frequency in works such as *Who's Afraid of Red, Yellow, and Blue II*. Newman's work demonstrated a new era of American painting, when American artists attempted to liberate themselves from European influence. Rich argues that the *Who's Afraid* series expressed Newman's anxiety about the future of painting, the continuation of his deeply philosophical ideas on the medium, as well as his own position in the face of a changing art world and a new generation of younger artists. Taaffe's work played into these worries, gently chiding the older artist with a parodic strategy that begged the question: What significance did Newman's formal inquiries hold?

We Are Not Afraid interrogated the spiritual or sublime ambitions of Newman's painting and the very notion of painting as a tabula rasa or open field of pure aesthetics. Taaffe's reuse of Newman's forms inverted the would-be universal and symbolic aspects of the earlier artist's work, which allowed for questioning and critique. The younger artist's zips and paint application suggest a contrived notion of artistic creativity and cast doubt on the strong dualities that metaphorically present themselves in Newman's work, such as life/death, order/chaos, and presence/emptiness. On the one hand, Taaffe's forms question Newman's use of the zip as a metaphor for the human body and for the spiritual origins of life. From another perspective, the twisted, double-helix form, resembling the structure of DNA, points to the basis of a human life and to Newman's foundational role as the progenitor of a new mode of painting, as younger painters, including Taaffe, saw him.

As a follow-up to his painting *We Are Not Afraid*, Taaffe published the article "Sublimity, Now and Forever, Amen," in the March1986 issue of *Arts Magazine*. Here he called attention to the implausibility of Newman's notion of the sublime, deeming it a "negative sublime" and a "Great Refusal of the Sublime."[49] Taaffe cast doubt on the heroic and monumental allure of Newman's *Vir Heroicus Sublimis* by illustrating the essay with his own parody of this painting, *Homo Fortissimus Excelsus* (1985), complete with his twisted version of Newman's zips. A sarcastic *clin d'oeil* at the title of Newman's work, which means "Man, heroic and sublime," Taaffe's painting roughly translates to "Man, strong and superior," using a combination of real and invented Latin words.[50]

Serge Guilbaut and Michael Leja describe painting in the United States during the years after World War II as characterized by an underlying spirituality and a quest for independence from the European avant-garde.[51] New York painters were indebted to their European counterparts, but they also attempted to distance themselves during the postwar years in order to form a uniquely American avant-garde. Leja argues that postwar artists came to terms with the harsh realities of industrialism and the threat of nuclear war through a type of mythmaking and a return to would-be unconscious or primitive forms. Adolph Gottlieb, Still,

FIGURE 2.8
Philip Taaffe, *Homo Fortissimus Excelsus*,
1985. Linoprint collage and acrylic on canvas,
96 × 210 in. Image courtesy the artist and
Luhring Augustine Gallery.

and Pollock used abstraction and invoked myth in their work as a means to address the realities and horror of war and also to communicate universal notions of humanity. Taaffe's paintings from the 1980s somewhat contradict this notion of a generational break, proposing that artistic creation is always fettered by previous artistic influences and the weight of art history.

At the time, Taaffe was strongly influenced by Sherrie Levine's work and the work of contemporary Mike Bidlo, who beginning in the early 1980s produced would-be exact replicas of work by Pollock, Warhol, and Matisse, among others. Bidlo had already been working in New York on appropriation paintings when many of the neoconceptual artists arrived on the scene. In contrast to Bidlo's work, Taaffe's paintings serve as conceptual, philosophical, and psychological ruminations, delving much deeper into issues of subjectivity and aesthetic influence. Taaffe's painting took the concept of artistic influence literally by responding directly to Newman's earlier work and by offering the viewer an open arena where questions are posed but not necessarily answered. Within the disputed territory of the death-of-painting rhetoric, Taaffe's work demonstrated a strong artistic license to manipulate Newman's zips any way he liked.

SHERRIE LEVINE AND THE MULTIDIMENSIONALITY OF APPROPRIATED SPACE

When one examines neoconceptualism, Roland Barthes's 1967 essay "The Death of the Author" immediately comes to mind. As described in the previous pages, Bickerton, Taaffe, and McCollum, as well as Levine, Halley, Koons, and Steinbach, freely borrowed from and manipulated stylistic references to previous artists and art historical movements. Their strategies paralleled Barthes's description of writing and literature as a reciprocal space of liberal exchange, in which several voices converse within any given text and no single voice is dominant. For Barthes, the hypothetical "death" of the author signaled not a moment of strong loss or mourning, but a renewal of the text and liberation from the tyranny of imposed meaning. The author and the reader brought to the text a wealth of intellectual experiences and knowledge of previous, and perhaps related, texts. This interaction between a reader and his or her previous intellectual experiences materialized externally in an open interchange between the reader and the text. For these artists, the importance of Barthes's essay resided in its new perspective on appropriation as a renewal of earlier artistic forms.

Foucault's 1969 essay "What Is an Author?" similarly problematized the notion of the author, which has existed in the West since the Enlightenment, by discussing how definitions of the author have varied over the centuries.[52] For Foucault, writing "unfolds like a game that invariably goes beyond its own rules and transgresses its limits."[53] Like Barthes, Foucault viewed authorship as a platform

for discourse. Foucault's and Barthes's views can be applied to the appropriative characteristics of neoconceptual work. Neoconceptualism's referential use of previous art historical periods and styles did not indicate the extinction of painting or sculpture, but rather, it created a new platform for discussing the notion of creativity and influence within art. Rather than stemming from one author/artist creator, neoconceptualism operated within and among the perceived limits of art history to create a deprivileged space in which several different artistic voices intermingle.

Levine indicated her adherence to Barthes's ideas in 1982 when she paraphrased sections of his essay in an artist's statement: "a painting's meaning lies not in its origin, but in its destination. The birth of the viewer must be at the cost of the painter."[54] Levine had begun to read continental theory in 1977, after her involvement in Crimp's "Pictures" exhibition.[55] On her working method, Levine stated, "Obviously as an artist, I make pictures that I want to make and I look for theory that I think is going to help me in a different kind of language."[56]

Like Taaffe, Levine used the work of other artists as a point of departure for her own creative endeavors. Much discussed is her *After* series, in which Levine expressed the extent of her engagement with the concept of intertextuality and Barthes's concept of the death of the author. As Singerman has poignantly pointed out, the photographs, drawings, and paintings of Levine's *After* series engaged with an endgame or death-of-painting philosophy.[57] In a brief 1981 exhibition at A&M Artworks Levine mounted six high-quality reproductions of paintings by the Blaue Reiter artist Franz Marc. For only two hours, "Six Pictures after Franz Marc" displayed Marc's mounted and framed images under the auspices of Sherrie Levine as both the artist and independent curator of the project. In other works in her *After* series, Levine hand-painted images of signature works from art history textbooks at the same scale as the photographic reproductions. At the 1982 Documenta 7 exhibition in Kassel, Germany, she exhibited eighteen drawings copying the work of expressionist Egon Schiele, among others. The series looked back analytically at major artists and moments of modernism and commented on the futility or impossibility of unfettered creative expression. By reproducing the work of some of the major forefathers of art history, Levine directly inserted herself into the canon of art history. Her replication of existing artworks demonstrates the subtle differences and variations that can occur during the creative process. This phenomenon was demonstrated some twenty years earlier by Robert Rauschenberg in his combine paintings *Factum I* and *Factum II* (1957). Despite Rauschenberg's attempts at verisimilitude, the two paintings maintained their own uniqueness. As Levine's earlier comment "a painting's meaning lies not in its origin, but in its destination …" suggests, her gesture was a form of imitation that critically engaged with overarching concepts of originality, authorship, modernism, and the canon of art history.

Levine's appropriative and self-negating acts opened up new meanings, since any reading of her hand-crafted sketches and watercolors "after" Joan Miró, El Lissitzky, Fernand Léger, Arthur Dove, Schiele, and Stuart Davis had to encompass not one but two creative voices. Levine's *After* series also intended to examine the potential shifts in meaning that occur when the gender of the artist changes from male to female. As described earlier, Levine referenced the history of art and included herself within its structure by the simple act of copying. An interplay of meanings occurs as the viewer simultaneously perceived the reference to the modernist male artist and Levine's reproduction of his work. Levine purposefully selected icons of modern art, creating a visual conundrum for the viewer. Titles such as "After Joan Miró" served to concretize the shifting meaning of the work, which might otherwise be attributed to the prior artist. This specific technique displayed Levine's distrust of the earlier work's authoritative position and her work's correlation with de Man's views on obtaining authenticity through intersubjective demystification.

Levine's *Knot* and *Check* paintings, in contrast, hold the notion of the author in temporary suspense. While the *After* works must be read through the lens of two artists—Levine and whichever artist she has appropriated—the *Knot* and *Check* paintings suggest multiple authors and points of reference, functioning as referential and rhetorical signifiers to be investigated by the viewer. Perhaps more so than the *After* works, these series of paintings bring Barthes's essay to life, in that the formal simplicity in these two series raises questions about the artistic purpose of these works. Levine forfeited the traditional notion of the work of art as a reflection of free-flowing creativity between an object and its maker, in favor of an intertextual form of artistic creation. Her *untitled (Lead Checks: 2)* of 1986/1987 may be said to elicit semiological vibrations, since the purposefully incomplete signifiers allow for multiple connections and readings of the abstract forms. The check pattern in Levine's paintings has a generic, nonspecific quality, resembling a checker or chessboard. Created about the same time as her interview with Paul Taylor (quoted earlier), the game board patterns of the *Check* paintings visually illustrate the artist's philosophy of endgame art. But the construction of *untitled (Lead Checks: 2)*, with lead or casein paint and wax on wood, induces something like the intense sense of materiality that is famously found in, for example, Jasper Johns's *Flag* (1954) or Brice Marden's *For Pearl* (1970), both of which use wax or encaustic. By using a lead or casein paint with the wax, Levine purposefully evoked the sensuous quality of such works. The *Check* works also called forth previous representations of the grid in early modernism, evoking its meaning in a hazy manner.

For art historian Rosalind Krauss, grids functioned both spatially and temporally to denote the evolution from figuration to abstraction.[58] The modernist grid's

FIGURE 2.9
Sherrie Levine, *untitled (Lead Checks: 2)*, 1986/1987. Casein on lead and wood, 20 × 20 in. Image courtesy Paula Cooper Gallery, New York. © Sherrie Levine.

flattened, methodical arrangement denied the natural-looking, perspectival regression that artists had sought in figurative styles since the Renaissance. By asserting an autonomous, antirealistic aesthetic and material quality, modernist grids vehemently opposed all the formal aspects of figuration. More importantly, however, Krauss discussed the symbolic power of the grids as emblems or myths. Beyond its geometric simplicity, a Malevich painting was intended to evoke an inner dimension, which idealistically imbricates spiritual and social harmony. The formal, nonreferential quality of the grid neatly encapsulated these larger philosophical ideas within its organizational structure.

Levine's *Check* paintings promoted a similar reading of the grid as myth, but questioned the inconsistencies of this approach at the same time. The primary colors and simple, geometric forms call to mind works from the early abstraction of the twentieth century. In *Check #2* (1986), Levine's intermingled red and blue squares might remind the viewer of the bold, repeating squares in Mondrian's *Composition with Red, Blue, Black, Yellow and Gray* (1921) or the simple square form in Malevich's *Red Square* (1915). These early modernist works reflected the metaphysical concepts inherent in the work of Mondrian and Malevich, specifically the development of Mondrian's ideas of theosophy and neoplasticism, and Malevich's conception of suprematism. Levine's painting, created almost seventy years later in an entirely different country and cultural context, has been emptied of this spiritual content. Yet by referencing these earlier consequential moments of art history, Levine's *Check* paintings remain charged with a new set of meanings and questions. Levine's work reminds us of the extent to which artists' views on art have shifted since the early twentieth century. In his 1987 reading of Levine's paintings, Robert C. Morgan observed:

> by distancing herself from the subject as expressed within the originary frame, Levine provides access to the cultural infrastructure which is capable of either supporting or deflating meaning. The paintings equivocate between dialectic and decoration; their signification loses its grip when given back to the apparatus of photography.[59]

Morgan describes the process in which Levine's paintings thwart any single authoritative voice, reference, or interpretation, in favor of a multiplicity of voices and readings. These works ambiguously confuse any clear-cut sign-to-referent relationship. The *Knot* and *Check* series require the participation of the viewer to achieve their full meaning and comprehension, as Levine escorts the viewer into, to use Barthes's term, the "multidimensionality" of this space. Faced with the impossibility of attaching any singular meaning to the work, the viewer is confronted with the significance of Levine's indexing of earlier artists, past periods, events, and art historical ideologies.

Similar to the *After* works, the *Knot* and *Check* series disrupt cultural norms and test the conventions of painting. Levine chose not to draw upon the medium's most awe-inspiring characteristics, such as strong painterly bravado, the play of light and shadow, or sweeping brushstrokes on a large canvas. Instead, the *Knot* paintings are humble works of average dimensions. Sometimes displayed in shadowbox frames under Plexiglas, the paintings consist of gold-colored leaves that Levine painted on plywood panels, some covering knots in the wood. Painting on board was common among artists of the late Renaissance, especially in

the northern regions of Europe, who used the wood as a support for realistic still lifes and portraits. Late Renaissance artists expertly concealed the painting's surface under layers of paint. In her *Knot* paintings, though, Levine left the wood largely untouched, giving her work a bare-bones quality. Her works can also be seen as paying tribute to the German artist Blinky Palermo, whose paintings on wood, canvas, and metal paid homage in turn to the modernist avant-garde. Levine directly quoted Palermo in a series of works in the mid-1990s.

The *Knot* paintings may also refer to psychiatrist R. D. Laing's book *Knots* (1970), in which the author poetically relays internal conversations and obsessions that can cause miscommunication between individuals and hinder relationships.[60] Laing uses "knots" to refer to moments of disruption or self-doubt. Levine's paintings promote the notion that postmodernism is one such moment: a period of psychological disruption in the history of modernism, a questioning of the role of earlier artists and their contribution to art history. By painting the leaves over the knots in the wood, Levine created a Duchampian pun with the dual meaning of *Knot* painting and "not painting."[61] In his reading of the *Knot* paintings, Morgan relates Levine's technique to language games described by Austrian philosopher Ludwig Wittgenstein. The witticism can also be correlated with the aims of deconstruction, whose self-subverting process starts with that which is lacking from the text in order to reattribute presence. Similar to McCollum's *Surrogates*, Levine's pun and her *Knot* painting reverse the terms of painting to focus on not what painting is or does, but what painting is not and what it does not do. A knot typically is the weakest, least favorable part of timber, because it can cause the plywood to crack or warp. On the other hand, a knot is composed of stem fibers that form new branches in a tree—meaning that the knots also represent new growth. In a literal and metaphorical manner, the *Knot* paintings examined the overlooked or unfavorable aspects of painting, as well as its possibility for further development.

Levine's simply painted geometric leaves encapsulated an entire discourse surrounding the weight of the historical within painting and the role of the commodity in postmodern society. The painted leaves covering each knot formally hint at Jean Arp's biomorphic sculptures or his 1916–1917 *Untitled* (*Collage with Squares Arranged According to the Laws of Chance*. Their gold color is distantly reminiscent of the gilded retables of the late medieval and Renaissance periods. The use of plywood, a manufactured material, recalls Duchamp's readymades and Judd's plywood boxes. Levine's series played on the dialectic between craftsmanship and industrialization, modernism and postmodernism. Like the past supporting the present, the wood sustains the golden leaves in a symbiotic and fragile relationship.

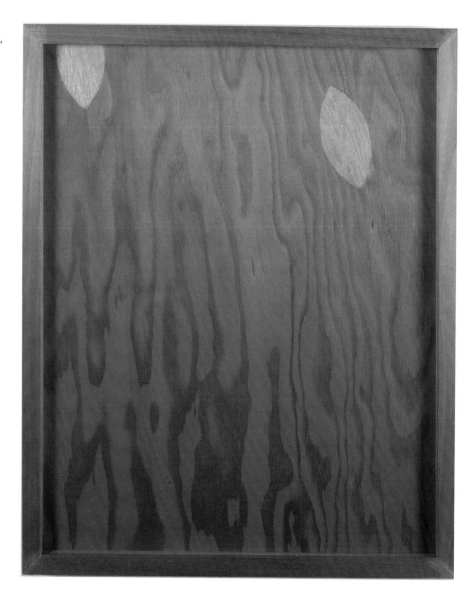

Singerman discusses Levine's *Knot* paintings and her *Chair Seat* series in relationship to synthetic cubism.[62] While Picasso used the top of a café table as the backdrop for *Still Life with Chair Caning* (1912), Levine used an ordinary chair seat as a canvas, on which she painted a broad series of stripes. More specifically, as Singerman argues, Levine's *Knot* paintings reference Braque's use of wood-grain wallpaper in works such as *Fruit Dish and Glass* (1912). (Picasso also used the material, as evidenced in *Guitar, Sheet Music and Glass*, also of 1912.) While Braque painted the faux-wood surface in earlier works by hand, to make *Fruit Dish and Glass*, he turned to prefabricated paper as an illusionistic device that confuses the relationship between sign and signifier. The faux-wood paper presented a visual pun on the nature of representation. Picasso's and Braque's references to industrially fabricated paper parallels Levine's use of commercially manufactured plywood. While the wood Picasso and Braque presented was artificial, Levine painted on actual wood in a gesture that represents a palimpsest for painting, or a reversion that negates the advances made by the earlier avant-garde gestures, at the same time as it suggests a tangible reworking of her predecessors' semiological strategies.

Levine's *Checks* series comment on the contradictory relationship between history and modernity. The geometrically arranged patterned squares of Levine's *untitled (Lead Checks: 2)* evoked the vacillating evolution of past and present in their formal codependency. Levine's work retained its composure as an emblem or myth, but reflected the cultural and artistic concerns of postmodern culture. Her postmodern grid has been purged of modernism's idealistic claims, which many artists of the 1980s felt had become unrealistic and implausible. Speaking during a period of debate on modernism's failure, Levine stated: "We no longer have the naïve optimism in art's capacity to change political systems—an aspiration that many modernist projects shared. As postmodernists we find that simple faith very moving, but our relationship to that simplicity is necessarily complex."[63] Levine's work simultaneously reveled in and parodied these characteristics of modernist abstraction. *Untitled (Lead Checks: 2)* reminds us of previous artists and moments in art history, but the painting also stands on its own as a generic, yet beautifully hand-crafted work. Like an unfinished sentence, *untitled (Lead Checks: 2)* looks back on our art historical past from the vantage point of post-modernism, but fails to make any definite conclusions.

The infinite, invariable repetition of squares in the *Check* paintings functions as a visual metaphor for the mental compartmentalization of knowledge. The organized pattern references the wealth of information and references filed in the brain that are waiting to be called upon. Beyond the unframed boundaries of the canvas, this dialogic space extends into the viewer's mind.

Levine's use of materials such as encaustic, mahogany, metallic, casein, and lead paints makes it difficult to avoid the strong artistic feel and presence of her works. Far from being simple copies or nostalgic for a bygone era of art, these objects require intense viewer observation, and demand to be recognized for their aesthetic and referential qualities. Like Pandora's box, Levine's references are waiting to be unlocked and discovered by the viewer; and they require thoughtful contemplation. On this subject, Levine stated in 1985: "I like to think of my paintings as membranes, permeable from both sides so there is an easy flow between the past and the future, between my history and yours."[64] Levine chose her references carefully, often citing the work of artists to whom she feels a strong connection.[65] Levine especially admired the work of Schiele and Marden, for example. As much personal as referential, Levine's work created an intertextual dialogue with those artists and with the viewer, who is left to interpret her creative synthesis of appropriated signifiers. More than simple art objects, Levine's works represent a careful method of study and analysis. She picked apart art historical structures and searched for their points of weakness. Her research consisted of exposing the authoritative quality of their compositional make-up to the viewer. The concluding thoughts and observations the viewer takes away complete the work.

Neoconceptual artists tended to perceive the history of art as a game, in which the major canonical artists and works serve as the pawns. In their work, neoconceptualists unpacked and questioned assumed formulations within the field of art. In the 1986 *Flash Art* panel at Pat Hearn Gallery, for example, Levine commented: "I think there's a long modernist tradition of endgame art—starting with dada and the suprematists (if you like), and a lot of artists have made the last painting ever to be made. It's a no-man's land that a lot of us enjoy moving around in."[66]

As Levine's comment suggests, the work of these artists signaled a paradigm shift. Undiscouraged by the purported death of modernism, these artists used the death-of-painting rhetoric to their advantage, creating works that opened new platforms for discussing the role of painting and sculpture after modernism. The neoconceptual artists no longer believed in the all-encompassing painterly and spiritual qualities of early modernist abstraction and abstract expressionism. The dialogue surrounding postmodern, structuralist, and poststructuralist thought in the New York art world in the 1970s and '80s provided a fruitful environment for many artists to rethink certain terms and structures of art and art history. The discussion of painting's death engendered questioning of the limits of this medium. If painting had been killed, rhetorically speaking, by the influx of conceptual, photo, and media-based arts of the 1970s, then neoconceptual artists worked within this so-called endgame to breathe new life into the medium.

As traditional painterly methods were revived by the neoexpressionists in the late 1970s, neoconceptual artists doubted that art could return to its previous

seemingly autonomous and venerable position. Their disbelief in the conventional role of art in society is best described as deconstructionist and intertextual in nature. The antiessentialist views of critical theory encouraged artists of the 1980s to think of ways to overturn the apparently imprisoning grasp of art history and capitalism. In 1987, Ross Bleckner commented:

> Unlike those abstract painters who see themselves as defenders of the faith, I do not see myself as the guardian of universal values. ... Current painting— the new abstraction—shares certain kinds of expressions, certain world views, but these refer less to abstraction than to a demystification of the concept of universality and to the equivocal nature of abstract images. Current abstraction, I believe, is trying to create a polyvocal voice.[67]

Sharing concerns similar to the neoconceptualists', Bleckner's statement was less an acceptance of art's failure than recognition of those aspects that art history has overlooked. These artists worked to formulate new perspectives within limits and rules imposed by art history. An appropriative regard for the past inspired new ways of analyzing the canon of art history and formulating historical perspectives.

Within this atmosphere, an analytical attitude or a critical unraveling of the past was necessary to move forward within the endgame frameworks of 1980s criticism. Working within an era heralding the end of modernism and the death of painting, these artists exhibited a complicit defiance of the traditional rules and regulations imposed on the work of art. For the neoconceptual group, complicit defiance consisted of a demystification of the past in order to acknowledge the ineffective or anachronistic aspects of history and art history. They were not simply replacing the historical with its simulative equal or lamenting the death of modernism, as argued by some art historians. Rather, they aesthetically confronted the historical weight of modernism in order to convey a more realistic portrayal of the artist's position during the 1980s. Neoconceptualist work represented a new outlook on modernism as a period in the past as well as on cultural developments and changes that were then current. Philip Taaffe summarized this new attitude: "We've gotten to the point now where it's been proven that painting cannot be killed, you can't kill painting. It won't die, and we have to accept that fact."[68]

Unafraid of nonauthoritative, nonlinear historical and societal structures, these artists delved into key issues and presented them in an analytical, visual manner for the viewer's consideration. Reflecting on this and on his techniques, Halley states:

Doing something eccentric, but not necessarily being an artist in terms of being a virtuoso who can do everything, but pursuing one task that is eccentric, that is interesting to me. The idea of stylistic change is not important to me because I see my work as research into certain issues, rather than as an attempt to create a stylistic statement.[69]

Halley concentrates on the intellectual or historical issues he found the most provocative. The pluralistic character of postmodernism freed him of the need to adhere to one formal style or movement. His subject matter mirrored his own personal interests, not the whims of the art market. Halley's statement also revealed his acceptance of the changing role of the artist as a historical entity. Similarly, Levine stated:

The thing about the art world is that it's not about real power. I think it's highly developed play—for us and also for the people who do have real power. ... I don't think that play is that empty. On the level of the symbolic, it's very important. But it's a different kind of importance from direct political power. I think that artists and critics sometimes confuse the two things and there's a kind of apology for their own limited activity. The notion of an artist does not have as much importance to me as it used to.[70]

Levine describes the type of power dynamic that relates key figures in the art world, where critics, artists, and the art market itself all performed their own, specific roles. Instead of expressing discontent, she confronted her role as an artist and sought out creative ways to engage herself within this network. Neoconceptual artists were not saddened by the loss of the romanticism attached to increasingly tenuous categories such as "artist" or "style"; instead, they recognized these terms as evolving within a larger historical and societal framework. What is questionable, however, is what type of viewer is equipped to recognize the critical component of their work, which depends on a degree of erudition. To the knowledgeable viewer, neoconceptualism's art historical or theoretical references contained a critical, destabilizing quality, both in the 1980s and today.

AMERICAN SIGN PAINTERS

To encounter Bickerton's 1987 *Le Art (Composition with Logos) #2* is to be led through a concise history of artists' materials in the postwar era. The silk-screened labels composing the surface of *Le Art* represent the brand names of the tools and materials used to fabricate the work, such as X-Acto, Liquitex, Pearl, and Formica, and underscore the artist's skills in transforming them into an aesthetic object. Centuries ago, this list might have simply consisted of canvas, different paint binders, and pigments. Emphasizing the technological, scientific, and chemical advancements made during the postwar era, Bickerton's inventory contained a range of products that impacted artistic production.

Liquitex, for example, a brand of acrylic house paint (known for its rapid drying time), launched the first water-soluble acrylic paint in 1955, which was used by a number of artists, including Helen Frankenthaler, Andy Warhol, and Tom Wesselmann. Deeply committed to the medium of painting, Wesselmann executed sometimes hundreds of preliminary drawings; once the composition had been decided, his ideas and pencil sketches coalesced into a color draft or cartoon, executed in Liquitex, that served as an outline for the final painting. After acquiring an opaque projector in 1967, Wesselmann projected and enlarged the Liquitex sketch on canvas to determine the final size of the painting.

Another brand Bickerton referenced was Alcoa, the manufacturer of aluminum, a product frequently used in public art of the postwar era, including the refurbished version of Oldenburg's *Lipstick (Ascending)on Caterpillar Tracks* (1969–1974), and minimalist sculptures such as Judd's 1965 *Untitled* stacks, which were fabricated in galvanized steel or aluminum. Oldenburg's sculpture, fabricated by Lippincott, Inc., underwent multiple renderings, eventually finding form in metal after a vinyl version of the lipstick proved to be too limp.

FIGURE 3.1
Ashley Bickerton, *Le Art (Composition with Logos) #2*, 1987.
Acrylic, bronzing powders, lacquer, silkscreen on plywood,
with chrome-plated brass, anodized aluminum plus Anylux,
34 × 17 × 15 in. Image courtesy the artist and Lehmann
Maupin, New York and Hong Kong. © Ashley Bickerton.

Bickerton's inclusion of these artist-friendly brands pointed to the overlooked history of these materials and their impact on artistic production. It spoke to the close interactions, customized procedures, and experimentation with the conventions of industrial design that occurred between artists, engineers and foundries beginning in the 1960s. From Warhol's collaboration with Bell Labs engineer Billy Klüver on the creation of the *Silver Clouds* (1966), made with metalized laminate Scotchpak, to the mirror-polished stainless steel of Koons's *Rabbit* (1986), postwar art represented a unique interdisciplinary merging of materials, engineering, science, and technology. Further, Bickerton's ironic title, *Le Art*, carries several meanings, pointing simultaneously to the standards of judgment to which works of art are held and to the geographical shift from Paris to New York as the capital of the art world beginning in the 1940s. Perhaps more importantly, the title, combined with the logos and signs, served as textual and visual shorthand for the artist's broader analysis of these substantive changes and their impact on the changing definition of a work of art.

Although Bickerton continued using the hand-painted techniques of many pop artists such as James Rosenquist or Roy Lichtenstein, his logos provided a clean, slick finish that closely resembled graphics seen in advertisements on television and in print as well as those on product labels. Rosenquist's *Nomad* (1963), for example, combined real objects with painted ads in a composition characterized by a fragmented confusion. Images of bright red spaghetti, a picnic table, a light bulb, a microphone, and a patch of green grass float across the canvas. A painted plastic bag hangs from two wooden attachments in the upper right corner of the painting, and a pile of wood lies on the floor underneath the painting. The word *NEW* appears on the left side of the composition in large block letters, hovering above a label for Oxydol cleaner. Rosenquist capitalized on his experience as a billboard painter by creating large-scale, hand-painted works that hinted at mass production through their assimilation of segments of advertisement imagery. Similarly, Bickerton worked as a professional surfboard painter, applying logos on surfboards that signaled corporate sponsorship and financial support of athletic training. Computerized painting replaced hand-painted billboards in the 1970s, allowing for more exact digital renderings of imagery. Bickerton's use of synthetic paint, silkscreen, and lacquer replaced Rosenquist's brushwork, offering a precision and accuracy reflective of the technological age in which he worked. These techniques also relied on advances in graphics and information technology then available to commercial artists and designers, such as bitmap graphics in 1984, and desktop publishing with the release of PageMaker software in 1985. Dot matrix graphics organized colors and brightness into pixels within a grid system that became a cheaper and more efficient means of creating media imagery. Still, a strong sense of motion arises from the wealth of visual motifs on

the surface of *Le Art*, as well as a sense of being visually bombarded with brands and logos through new media outlets like cable television, for example. Bickerton's deadpan appeal responds to the expanded definition of works of art due to the growth of consumer culture in the 1980s and the transition from an analog to a digital age.

The shift from an industrial to a postindustrial society and its increasing spectacularization began more than two decades earlier, in the 1960s. Pop artists such as Lichtenstein, Rosenquist, and Warhol engaged with commodity culture and consumerism, producing works that replicated advertising techniques and integrating consumer products and labels as well as symbols of commercial or so-called popular culture in their work, yet all the while retained a hand-crafted quality that distinguished their art from manufactured goods. This confusion of a work of art with the elements of everyday life stemmed from Duchamp's concept of the readymade. Later artists such as Rosalyn Drexler, Jasper Johns, Lichtenstein, Oldenburg, Robert Rauschenberg, Warhol, Idelle Weber, and Wesselmann built upon Duchamp's notion and continued to cultivate new relationships between high and low art. The "New Realists" show at the Sidney Janis Gallery in the fall of 1962 officially launched the American pop art movement within this environment of burgeoning consumerism. The exhibition featured the work of Peter Agostini, Robert Indiana, Oldenburg, Mimmo Rotella, George Segal, Warhol, and Wesselmann. As Robert Rosenblum observed, pop entailed an authentic, visual vocabulary that was based on mass production.[1] In 1966, Warhol famously stated, "If you want to know all about Andy Warhol … just look at the surface of my paintings and films and me, and there I am. There's nothing behind it."[2] Warhol's comment, in conjunction with his work, spoke to a shift in contemporary art paradigms from a type of metaphysical symbolism or expression of internal angst to an everyday vernacular. It also suggested that the artists of the sixties commingled in a promising economic and commercial environment in ways not previously seen. Warhol's silkscreens of famous celebrities such as Marilyn Monroe or Liz Taylor, for example, consisted of images plucked directly from tabloid magazines. Lichtenstein derived his imagery directly from comic books and other pop-culture sources.

Engaging with the concept of mass production in ways that, in theory, detached the work of art from its autonomous status, Claes Oldenburg opened an environment he called *The Store* in 1961 on East Second Street, where he fabricated painted plaster replicas of some of the cheap commodities sold in shops around New York's Lower East Side. In works such as *Floor Cake* (*Giant Piece of Cake*) of 1962, Oldenburg, with his then-wife Patty Mucha, created a large-scale, sewn replica of a piece of cake from canvas, paint, and latex. Richard Artschwager's work also presented a challenge to the distinctions between art and nonart.

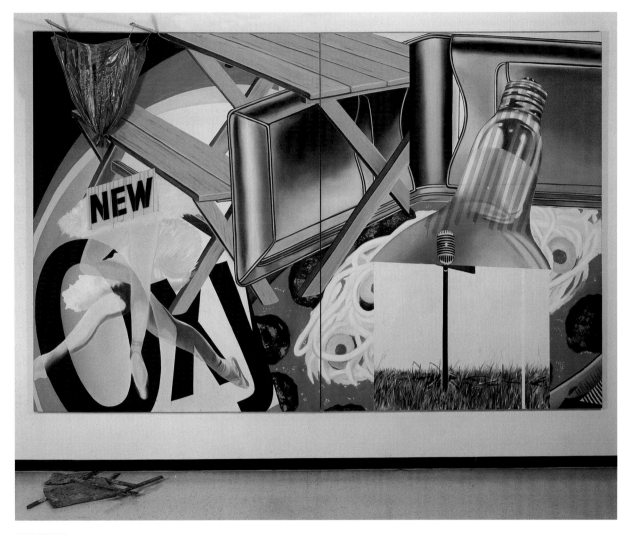

FIGURE 3.2
James Rosenquist, *Nomad*, 1963. Oil on canvas,
plastic, and wood; overall: 90¹/₈ × 140 × 25 in.; each
panel: 90¹/₈ × 70 in. Gift of Seymour H. Knox, Jr.
Albright-Knox Art Gallery, Buffalo, NY. Image courtesy
Albright-Knox Art Gallery / Art Resource, NY. Art ©
James Rosenquist / Licensed by VAGA, New York, NY.

His *Chair* (1966) is fabricated with Formica, a plastic laminate material created in 1912 that became popular during World War II and was used to make airplane propellers. Artschwager's experience as a furniture designer in the 1950s served useful in the creation of a work of art that incorporated many of the characteristics of this everyday object. Unlike Duchamp's readymades, Artschwager's work was designed and fabricated according to the artist's specifications. Pop artists embroiled themselves in the operations of commodity culture, creating hand-crafted work that operated closely within the systems it produced.

Neoconceptual artists were also affected by new techniques of advertising and the commercialism of their age. While pop addressed the surge of postwar consumerism, neoconceptualism pointed to the pervasive structures of commodity capitalism during the late-industrial period. Consumption in the 1950s and 1960s was promoted as a positive reaction to the economic depression of the 1930s and the totalitarian forces that were put to rest during World War II. The 1980s, in contrast, were characterized by the conspicuous consumption, greed, and decadence of the Reagan era. Neoconceptual artists, such as Bickerton, continued to be keenly aware of their own position and the role of the work of art in a vastly expanded art market, and they sometimes strategically manipulated this relationship in an ironic and hyperbolic manner. In contrast to the art of their predecessors, their work demonstrated a more thoughtful and penetrating conceptual critique, offering new perspectives on how cultural signs and objects are embroiled within classification systems as markers of history or class status and distinguishers of taste.

Further, neoconceptualists' art historical references served as a conceptual and theoretical gesture that correlated with the writings of critical theorists circulating during the 1970s and 1980s. Pop artists had also integrated references to earlier artists and movements in their work, but for many pop artists the references to previous "masters" of art history amounted to less of a conceptual enterprise than a commentary on the integration of high art into the domain of everyday life. For example, Lichtenstein ironically aggrandized the putative heroism of expressionism's brushstrokes in *Little Big Painting* (1965), turning de Kooning-like gestural spontaneity into a precise rendering of thick lines and Ben-Day dots. The decisive quality of Lichtenstein's brushstroke contrasted with the free-flowing spirit of abstract expressionism, reducing it to a sign and a lowbrow type of art associated with comic books and popular culture.[3]

Some critics in the 1980s viewed neoconceptualism's use of store-bought products as an endorsement of commodity capitalism. This chapter builds on arguments made on behalf of pop to present a more nuanced reading of the work, arguing that Bickerton's, Steinbach's, and Koons's references to and use of consumer products are less about emphasizing the commercial product as such, or

the allure and appeal of mass-produced objects, than about the art historical and sociocultural ramifications of these items and how they function in society. To see these artists' work as an endorsement of commodity fetishism, as Foster and Crow have argued, overlooks many important formal and contextual details.[4] Strongly vested in its own cultural materialism, including the external references and allegories that can be drawn from these materials, neoconceptual work incorporated everyday goods that reflect the artist's own persona, issues of class and race, and the role of consumer desire and of the art object in the market. Neoconceptualism also spoke directly to the sociopolitical realities of the 1980s, including racism, global technology, and the heightened class divisions characterizing the Reagan era, as the middle class of the immediate postwar era saw a loss of jobs and stagnating wages. Looking at this work through the lens of material culture, we can see that these artists investigated the phenomena of how commercial products, companies, and brand identities come to define who we are as individuals in a capitalist society. By reevaluating neoconceptualism alongside its art historical counterparts, I will argue that there is more to its seeming facetiousness than meets the eye.

In his 1996 book *The Return of the Real*, Foster makes a case for postwar art movements from the 1950s to the 1990s as encompassing a critical aspect of the neo-avant-garde, rather than being a failed return as Peter Bürger argues in *Theory of the Avant-Garde* (1974, English translation 1984). Over the course of several chapters, Foster employs writings by Gilles Deleuze, Fredric Jameson, and Georg Lukács to position pop within the dynamic spread of commodity culture in the postwar era.[5] For Foster, pop's embrace of low culture and its integration of cultural signs reflect the "superficiality of contemporary representations, meanings and experiences" in a postwar phenomenon that marked its zenith in the 1980s with neoconceptualism.[6] Serial production and repetition characterizes minimalism as well as pop in the example of Judd's "stacks" and Warhol's silkscreens, in which the distinction between the work of art and mass production is essential. In Foster's view, the use of images and objects as readymades presented a viable framework for the evasion of traditional composition. He claims that minimalism, and pop to a degree, recognized the power and influence of capitalism in ways neoconceptualism did not, and asserts that the work of these earlier movements manipulated and struck a delicate balance between the work of art and mass production in a subversive manner by producing the concept of difference. These earlier movements called commodity capitalism into question by playfully manipulating the differences between mass-produced objects and art in a subversive manner, while neoconceptualism merely emphasized their signexchange value. Although these 1960s developments produced paintings and sculptures, when considering the latter (referred to in this essay as simulationism),

Foster posed the same question he had asked ten years earlier in "Signs Taken for Wonders": "can these [neoconceptual] artists engage in issues of a postindustrial society in a medium such as painting based in preindustrial craft?"[7]

As one of the only academic publications to address neoconceptualism, Foster's analysis is reminiscent of 1980s criticism of pop, such as Roland Barthes's, Jean Baudrillard's, and, in particular, Jameson's arguments that the movement marked the eclipse of historical depth, and the rise of pastiche and nostalgia.[8] Jameson incorporated a critique of pop in his writings on postmodernism, claiming that postmodern artists mindlessly reproduce the previous styles and movements of modernism, employing an empty form of mimicry, devoid of satirical depth or content. Citing the inspiration of artists such as Jim Dine, Oldenburg, Rauschenberg, and Johns in the triviality of the everyday, Baudrillard remarks that pop "claims to be homogeneous with that *immanent order of signs*—homogenous with their industrial and serial production, and thus with the artificial, manufactured character of the whole environment—homogeneous with the *in extenso* saturation as much as culturised abstraction of this new order of things." His comment echoes critic G. R. Swenson's earlier statement, made in 1962, that pop artists were the "New American Sign Painters":

> Words, trade marks, commercial symbols and fragments of billboards are molded and fused into visual statements organized by the personality of the artist; they cannot be understood through formulas or some conventional pattern of visual grammar one or more remove from experience. ... These painters force a re-examination of the nature of painting and its changing reputation to the world.[9]

Decades after the pop movement began, certain theorists, writers, and critics were still coming to terms with its colloquial characteristics and focus on an everyday vernacular, stemming from the signs of commodity culture. While Baudrillard decried pop's inability to incite a critical dialogue with the culture industry, two decades earlier Swenson attributed greater agency to the artist, whom he viewed as reformulating a contemporary perspective on these new fields of vision in the form of painting.

Foster's comment is also situated within a framework proposed by a group of vocal art historians and critics that began nearly two decades earlier. In the mid 1970s and early 1980s, as the neoconceptual artists processed critical theory and the death-of-painting rhetoric in ways that reasserted the material presence and aesthetic possibilities of painting and sculpture, many critics and art historians called these mediums outdated, comparing physical objects to the nonautonomous, decentered quality of some postwar art and of certain photographic and

sculptural practices of the 1960s and 1970s, including conceptual, performance, and earth art. Writings in *October* magazine, for example, focused generally on the mechanical arts, particularly film and video, viewing these mediums as preeminent in their ability to be easily and widely distributed and therefore to promote radical subject matter. The structuralist and poststructuralist emphasis on the arbitrary quality of signs and signifiers provided backing for art historian Rosalind Krauss's arguments in favor of a strict definition of postmodern art, in which the only painting to be included was Richard Serra's *Casting* (1969).[10] In this performance piece, initially documented via photographs, Serra threw hot molten lead against the walls of Jasper Johns's studio in a manner loosely reminiscent of the process used by Jackson Pollock to execute his drip paintings. (The sculptural performance was eventually remade in 1995 at the San Francisco Museum of Modern Art, and the resulting sculptures were acquired for the collection.) For Krauss, Serra's *Casting* represented a new type of artistic practice beginning in the 1970s that eschewed a complete link between the signifier and signified. The photographs of *Casting* severed the image from the actual performance event. Serra's action painting existed strictly as a performance, the traces of which were, at least initially, seen only through documentary photographs. At the same time, however, some art historians applied poststructuralism's methods of exposing the underlying structural fallacies in a text to the modernist canon of art history. Barthes's writings on the idea of myth, for example, sustained Rosalind Krauss's reworking of the notion of the grid in modernist painting, with his 1957 book *Mythologies* pressed into service to support her argument on the emblematic quality of Mondrian's *Composition with Red, Blue, Black, Yellow, and Gray* (1921) or Malevich's *Suprematist Composition: White on White* of 1918.[11] In this essay, Krauss effectively portrayed modernist painting as infertile ground or as an isolated, hermetic field detached from reality.

As neoconceptual artists took up the task of defining and assessing the continued historical and aesthetic value of traditional mediums such as painting, critics cited its demise. In his 1981 essay "The End of Painting," Crimp promoted a view that the medium refused to suggest meaning or to offer a legitimate subject.[12] As a case in point, Crimp described Daniel Buren's 1974 installation of striped paintings in the Museum of Modern Art, New York, as signaling painting's obsolescence, because the site-specific work required exterior surroundings to convey its full meaning. By deploying his simple striped pattern, Buren relied largely on the notion of institutional critique, or the examination of the structural and visual components of the museum, rather than the medium of painting. Crimp argued that the grand narrative of art history with its neat formulation of artists and movements sustains painting as a mere succession of styles, as seen in the late work of Frank Stella, who moved away from his *Black Paintings* of 1959 to

extravaganzas that read "as a tantrum, shrieking and sputtering that the end of painting *has not come*."[13]

In a discussion of the *October* writers, art historian Thomas Crow summarized the views of these fellow art historians and critics as follows:

> Likewise dissenters from art history's established regime, their [the *October* writers] emphasis lay more centrally on the semiotic turn in the humanities, and their suspicion of painting was thorough and programmatic. Among the *October* writers' shared preoccupations … was the undecidability that they inserted between an original object or gesture and its proliferation of doubles. This theoretical stance did more than undermine the last defenses of unique synthetic creation as a requirement for artistic seriousness (it had pretty much finished anyway); it had the perhaps unintended effect of putting the artwork on the same plane as mass-produced products of all kinds, including, most importantly, the images generated by the entertainment industries.[14]

Crow's comment identifies the nagging fear of the culture industry—a wariness of the effects of mass culture on the fine arts, as memorably expressed by Clement Greenberg in his 1939 essay "Avant-Garde and Kitsch." His comment also reveals the biases affecting the reception and study of neoconceptual work at the time. In the 1980s and '90s, many art historians and critics still viewed the culture industry as pervading all aspects of daily life.

Though Foster claims that neoconceptualism's "fetishism of the signifier delivers this art over to our political economy of the commodity-sign, of which it is an epitome rather than a critique," neither Bickerton's paintings nor Rosenquist's for that matter present commercial signs as such.[15] Instead, their practices rely on the meticulous study of the techniques of drafting, composition, and commercial graphics and a translation of these signs into a painterly mode situated within the philosophical space of art. As Michael Lobel argues, Rosenquist's paintings acknowledged the predominance of the cult of the new in the commodity culture of the 1960s, when viewers were bombarded with media imagery and planned obsolescence.[16] Rosenquist's *Nomad* presented brand names and labels in a fragmented, indirect manner. The artist leaves the viewer to fill in the remaining letters of Oxydol, displaying only the first three letters, "Oxy," and other objects are similarly blocked from view, such as the plate of spaghetti and the light bulb. Playfully taunting the viewer with these brief glimpses, his paintings conjured thoughts about the unabbreviated versions of these items, as they are typically viewed in the grocery store, in restaurants, or at home. The canvas's disjunctive, multipart composition can be viewed as a critique of commercialism, since print, television, and street advertisements normally presented a clear product image

and were meant to be read quickly by passersby. At the same time, the images retain their illustrative quality and largely appear as painted forms on a canvas.

While Rosenquist displays the brand names in a flirtatious manner, requiring the viewer to fill in the missing portions, Bickerton painstakingly replicated the brand names and logo designs in *Tormented Self-Portrait* and *Le Art*. To make the paintings by hand in a manner that was close to mechanically perfect, Bickerton used airbrush and Frisket paper stencils on sanded gesso on wood, which allowed for a clean, flat surface. Acrylic paint applied directly to the face of the painting allowed for richer coloration than that which was found in commercial graphic work. While Rosenquist's work retains its handcrafted quality, Bickerton's boxes elucidate a visual irony: the artist toiled for hours to create a work that provides the look and feel of something that was mass produced and reliant upon commercial culture.

The critical potential of Rosenquist's and Bickerton's work is perhaps more evident in the titles of their works, such as *I Love You with My Ford* (1961) and *Tormented Self-Portrait*, which suggest that emotions and a sense of self can be derived directly from commodities. Both works contain a strong element of autobiography and a willingness to engage with and confront the mechanisms of commodity culture using the techniques of the industry. Although making a claim for the emptiness of pop, Baudrillard picked up on this characteristic of the work, commenting:

> [Pop] assumes an essence of the object, a level of absolute reality which is never that of the everyday environment, and which with regard to it constitutes quite frankly a surreality. … In brief, we are in total confusion, and we find ourselves before a kind of behaviourism arising from a juxtaposition of visible things (something like an impression of consumer society) coupled with a vague Zen or Buddhist mystique of stripping down the Ego and Superego to the "Id" of the surrounding world.[17]

The pop object, in other words, is less a straightforward replication of the signs of commodity culture than a surreal composition causing internal reflection on its visual and social perplexity. *Tormented Self-Portrait* amplifies this aspect of pop, building on the notion of a moral and psychological self that is directly formed by the means of commodity culture. Demonstrating himself to be a literal product of his times, the artist's likeness has been replaced with the signs of commercialism in the form of company and product logos. The title points to a conflicting sense of self within this bewildering atmosphere of competing brand names and products. The logos plastered on the surface of *Tormented Self-Portrait* comment on the formulation of identity within commodity culture, in which

individuals often adorn themselves with brand-name clothing, accessories, and objects. Bickerton, who grew up in Hawaii, was inspired by surfboards from the seventies, which were covered with various emblems referring to the surfer's sponsors, car culture, and other sources that also inspired the California minimalists. Another inspiration was the 1984 Van Gogh retrospective at the Metropolitan Museum of Art; as Bickerton states:

> I found myself at the Metropolitan Museum walking around the Van Gogh retrospective. After what felt like an eternity of innumerable self-portraits, lost in the infinite angst-oozing chasms that were Vincent's eyes, I said, "Hey, I want to do that too!" It wasn't until I put the problem in the context of logos that it all clicked. What is a self-portrait anyway? We wake up in the morning and select our individuality from a finite catalogue of readymade possibilities.[18]

The CalArts logo in *Tormented Self-Portrait* reveals where Bickerton went to art school. But companies such as Samsung, Sprint, and Citibank are paired with brands that many viewers likely encounter on a daily basis in their own lives, such as Bayer aspirin, Close Up toothpaste, *TV Guide*, or Con Edison. Together, the logos paint a picture of the brand competition that plays an important role in capitalism, as well as the resulting conformity. The appearance of these recognizable brands in a noncommercial space, removed from their habitual context, prompts questions about the importance, value, and long-term viability of these products and companies. Bickerton provided a tiny sampling of the thousands of others that assault the viewer on a daily basis and form a pervasive part of TV, magazines, and newspapers. Combining these logos with his own fabricated brand, CULTURE-LUX, or cultural luxury, emphasized their contrived quality and, in turn, potentially affects how these companies are viewed. The logos also served as visual reminders of the financial partnerships between museums and corporations. In her study of the changes in the New York art world from 1940 to 1985, Diana Crane remarked that corporate spending in the arts saw an astronomical increase from 1965 to 1983, jumping from $22 million to $436 million, with museums receiving the largest share of funds. At the same time, the number of museums also drastically increased: 67 percent of all museums in the United States in 1985 were founded after 1940.[19]

In the 1980s, Bickerton went so far as to reduce his own identity as an artist to a brand name. The reference appears in the form of his own invented label, a blue-and-yellow logo reading "Susie" and "Culture-Lux" located at the top at either end and along the bottom of the work. Bickerton's Susie paintings were some of the first works the artist created after arriving in New York in 1982. The

Susie paintings played with the concept of identity and brand, since the name of this series functioned as a personal name and an indicator of the artist's invented brand identity. Bickerton commented:

> It was first realizing that all important art in the catalogue of art history is indexed by the time and place it was made and this is what gives it its value, status, and ultimately because of these factors, its meaning: i.e. Picasso, 1928. ... So when I came up with the SUSIE logo ... I decided that artists are usually catalogued in the formal surname of the father. By choosing a pho-netically casual, female first name, that whole agenda is thrown into some discursive light. In a sense it becomes the artist's name brand. It breaks down the individual creator and they are no more Bickertons than they are Susies.[20]

This conceptual act allowed for further commentary on the inevitable place of art within the market. Susie openly and actively acknowledged that art, and by extension the artist, operated as cultural commodities. Bickerton's motto, "Susie," and the words "the best in sensory and intellectual experiences" appear in small print across the top, a flagrant indication of the work's role within the art market and the culture industry.[21] The Susie logo not only attempted to unpack the system of attribution in the canon of art history, but, in my view, it also assayed a feminist gesture in attempting to ascribe more agency to women and to female artists, without actually following through with these aims.

Tormented Self-Portrait reflects shifts in advertising that occurred over the course of the 1970s and 1980s, as companies increased their strategies for build-ing their brand names and profile. Brands and advertisements, which were origi-nally created to sell products, slowly shifted to selling a particular type of lifestyle.[22] The Marlboro brand and advertisements in the 1970s and 1980s, for example, featured depictions of a lone cowboy in the American wilderness in order to asso-ciate the product with ideas of self-reliance, adventure, and rugged masculinity. Richard Prince called attention to the manipulative techniques of the advertising industry in his own appropriations of the Marlboro ad campaign. Bickerton's work similarly suggests a struggle to come to terms with identity, or a strong and inde-pendent sense of self, when faced with this barrage of media messages.

As Michael Lobel argues in his discussion of Rosenquist's signs and images, the fragmented nature of this work reflected the disjointed visual character of tele-vision, which, at the time, was considered to be showcasing new and exciting means of advertising.[23] While Rosenquist's paintings highlight the large-scale format of billboards and the fragmented visual experience of passing them on the highway, they also call attention to the techniques behind the fabrication of these advertisements. Lobel comments:

By displaying billboard techniques in a fine art context, Rosenquist exposed them to a much different set of viewing conditions. … His images could be examined close up and with the extended contemplation afforded to works of art. … That commercial paint handling underscores the artificiality and vapidness of the depicted emotional state: advertising's smile of pleasure is here transformed into a hollow rictus.[24]

A similar argument can be made about Bickerton's work. By reproducing the techniques of advertising as a work of art, he created a critical space of discernment for the viewing public, who were potentially made aware of the commercial techniques of persuasion. Moreover, by transferring the complex world of brand identity into the domain of art, Bickerton acknowledged and undermined the larger financial systems that encompassed the buying, selling, and creation of works of art. Rosenquist's affinity for the painted billboard format and Bickerton's use of commercial graphics at these critical junctures demonstrate both artists' concerns about the role of painting in the face of relatively new technologies, such as television and computers respectively, and in view of rapid cultural change more generally.

By 1980, there were far more cars, ads, and credit cards and many more ways of expressing oneself through material goods than there had been in 1960. The pressure to expand economic markets in the postwar era incited uninhibited growth of consumption and led to more invigorated forms of advertising that became increasingly ingrained in everyday life. In *An All-Consuming Century*, Gary Cross discusses how the 1960s countercultural ideals of nonconformity and individualism were assimilated by the media and incorporated as advertising strategies. His ideas are echoed in Thomas Frank's book *The Conquest of Cool: The Sixties as Advertising Gimmick*, in which the author points out that the roots of rebellion began in the business and advertising industries in the late 1950s, amid a culture that stressed organized conformism.[25] Frank cites the advertisements of Volkswagen from 1959 to 1967 as the beginning of a countercultural sales impulse that existed well before the counterrevolution movement. Advertisements from late 1960 continued to focus on inciting a rebellious attitude among buyers. The 1970s were sometimes called the "me decade" and were characterized by a loss of idealism among youth and a rise in professional majors, such as business and law, among college students, who were attracted to the promise of high-paying jobs. During the 1970s and 1980s, the baby boomer and hippie generation of the 1960s grew up and joined the work force. At the same time, advertising campaigns became more sophisticated and less tied to one particular radio or television program. Simultaneously, retail chains expanded and became a part of everyday life for most Americans. Older stores located in

downtown areas opened much larger spaces ("big boxes") in the suburbs. It also became common for stores to buy in bulk in order to keep prices down. Shopping malls slowly replaced large-scale department stores, a phenomenon that dramatically changed the nature of the traditional market center. As Cross explains, malls were privately controlled social spaces that lacked a mixing of social, public, and commercial activities.[26] They were typically located some distance from residential zones, promoting a controlled, artificial space of pure consumerism.

This augmentation of material culture also affected the reception of art objects. Bickerton's *The Ideal Collection II* (1988) takes new American sign painting one step further by emphasizing the brand identity of well-known works within the history of art and their role as commodities. *The Ideal Collection II* consists of one of Bickerton's quintessential boxes plastered with many small photographs of works by important artists of the 1960s. Playing the role of curator, Bickerton assembled images that represent for him an "Ideal Collection" of artwork. Underneath the image of each work are candid descriptions, such as "A current Ryman," "A Brillo Box by Warhol," and "An Eva Hesse vertical wall piece." Although essentially subjective, Bickerton's selection included some artists considered to be the

FIGURE 3.3
Ashley Bickerton, *The Ideal Collection II*, 1988. Mixed-media construction, 30¾ × 120¾ × 14½ in. Image courtesy the artist and Lehmann Maupin, New York and Hong Kong. © Ashley Bickerton.

most important contributors to postwar art. His choice emphasized an autobiographical quality by relaying the impact of these particular artists on his own artistic production. At the same time, the tiny images included in *The Ideal Collection* essentially reduced Ryman, Warhol, and Hesse, among others, to art historical brand names. The selection of works stood as concise signifiers pointing to significant moments in the artist's career and their larger contribution to art history. Bickerton's painting also emphasized the monetary value underlying such important works of art, since the most highly regarded works in art history are usually the ones that generate the most money in the art market, or inversely, works that do significantly well at auction can receive new consideration in the canon. *The Ideal Collection* proposed a reversal of the traditional relationship between dealer and collector. Typically, a collector approaches a dealer for advice on purchasing works. In turn, the dealer recommends works and provides reasons for the purchase pertaining to the artist's importance within the field of art history. Bickerton cut this relationship short by providing a list of his own suggestions, thereby proposing an alternative role for the artist. Instead of being a mere creator or fabricator of art work, Bickerton stepped into the role of a critic, a dealer, or another arbiter of aesthetic taste.[27]

While pop, as Baudrillard remarked, was the "first to explore the status of its own art-object as 'signed' and 'consumed,'" an interest in revealing the economic status of the art object turned into an aggressive sociocultural campaign in some neoconceptual work.[28] In *Commercial Piece #3* (1989), Bickerton specifically targeted the New York gallery world and art market. While the front of the work is decorated with an assortment of labels, in this case, instead of merely reproducing the logos, Bickerton sold advertising slots on his work and received compensation for their placement.[29] He created three versions over the course of 1989 and 1990, one of which is owned by Jeff Koons. Reputable New York galleries, businesses, and individuals including Sonnabend, Leo Castelli, Hotel Macklowe, Absolut Vodka, and Nina Ricci Gallery in Paris, as well as fellow artist Koons purchased advertisements on the surface of the work for $1,000 a spot, or via a trade of some kind.

Foster's assertion that neoconceptual work functions as an abstracted, empty vision of consumer culture that fulfills the simulative impetus of postwar art falls short when we examine neoconceptualism's full impact and conceptual underpinnings. *Commercial Piece #3* invalidated the habitual terms of the sale of a work of art by luring companies and individuals to invest in a work that would, in turn, be sold to another individual, institution, or corporation. Bickerton's action disrupted the natural flow of capital and the customary relationships that occur between the artist, the dealer, and the client. Normally, the client purchases the work from a dealer, who in turn splits a percentage of the profits with the artist. In

Bickerton's case, by selling spots on the surface of the work, he ostensibly generated a certain amount of profit for the fabrication of the work before its actual sale. In reality, the artist received little financial gain from the transactions. In exchange for an ad placement, Hotel Macklowe gave Bickerton one free night in the hotel and Absolut Vodka gave him a case of vodka. From a conceptual standpoint, Bickerton took pop's critique of commodity culture one step further by brokering his own deals and by turning his work into a site for advertisements. In some ways, Bickerton's act further advanced the art object into the arena of individual and corporate promotion, in that those who purchased slots supported the artist's activities, but also benefited from the exposure. Considering the nonephemeral quality (and popularity) of his paintings, Bickerton's offer provided a long-term durability that did not exist in other forms of media advertising, such as that found in newspapers and magazines or on television, which are easily disposed or forgotten.

Bickerton was not the first artist since pop to aggressively experiment with the realm of advertising, to examine the ways in which art interacts with commodity culture, or to acknowledge that a work of art is ultimately a saleable object. A few examples are worth noting in brief. Displaying a rapacious interest in the media culture that inspired Warhol, Salvador Dalí designed commercial products, from lipstick and hosiery packaging to department store displays, and confused the boundaries between art and advertisement. In addition to Oldenburg's aforementioned enterprise, *The Store*, another well-cited example of artistic interactions with the realm of commodity capitalism is Food, a restaurant and alternative art space opened in 1971 by artists Gordon Matta-Clark, Carol Goodden, and Tina Girouard. The space served homemade dishes and, as an alternative art space, hosted performances until 1973. Earlier, in 1963, Gerhard Richter, Konrad Lueg, and Sigmar Polke performed *Living with Pop: A Demonstration for Capitalist Realism*. The artists designed a living room for display in the Berges furniture store in Düsseldorf, then presented themselves as commodities within it. They sat in chairs situated on low platforms, while four paintings by each artist hung on the walls. The evening ended with a tour of the store's departments and its wares.

Postwar artists have also engaged in self-promotion through the same commercial means used to endorse and sell goods and services. In the November 1974 issue of *Artforum*, Lynda Benglis published a nude photograph of herself holding a pink dildo as an advertisement for her solo show at Paula Cooper Gallery. The image of her tanned, well-oiled body was a response to minimalist sculptor Robert Morris's photographic self-portrait, which showed the bare-chested artist wrapped in chains, wearing sunglasses and a motorcycle helmet, as an advertisement for his 1974 solo exhibition at Castelli and Sonnabend Galleries. Two of the magazine's editors, Annette Michelson and Rosalind Krauss, in

objection to Benglis's ad, defected from the magazine's editorial board. Benglis's and Morris's methods of self-promotion, like those of Bickerton, set these works apart from the traditional structure and form of art.

Sophie Cras explains that some conceptual artists in the 1970s, including Robert Morris, Lee Lozano, and Dan Graham, had a strong interest in investigating the role of art as an investment and a commodity exchanged in the financial markets.[30] One such conceptual work that draws the strongest parallel to Bickerton's *Commercial Piece #3* is Dan Graham's *Income (Outflow) Piece* (1969), in which the artist intended to establish a corporation in his name and offer himself as an investment to the public at a cost of ten dollars per share. As part of this work, Graham intended to rent works of art to collectors at a rate of 5 percent of the work's gallery price per year. Cras explains, "By offering the greater public information about his financial resources, as well as the possibility of participating in his financing—and thus demonstrating active interest in his work, as shareholders would regard the actions of a fund or company manager—he built a material interdependence between himself and the public."[31] While Graham's work remained largely theoretical in nature, since he never followed through with the establishment of the corporation, Bickerton's conceptual output resulted in the Susie brand identity and, in the case of *Commercial Piece*, three paintings physically documenting the transactions that had taken place.

Art historian Alexander Alberro discusses a performance by conceptual artist Robert Barry that translated an aesthetic experience into an intangible, ephemeral action, but nonetheless relied on media publicity and advertising to generate the audiences viewed as essential to the meaning of the work.[32] In Barry's *Inert Gas Series: Helium* (1969), the artist traveled to the Mohave Desert in Southern California and released measured volumes of inert gas into the atmosphere, which once released maintained its chemical integrity. Photographs of the work taken by the artist ironically captured the landscape, but not the essence of the work itself: the invisible gas. Likewise, the ads generated by the dealer Seth Siegelaub effectively reinstated a dematerialized art performance in the form of publicity in a manner that essentially equated art with media marketability. As Alberro points out, the act "came to posit publicity as art ... the sphere of art expanded to the point where it became coterminous with the market society." Bickerton's work acknowledges the nonideal realities inherent to ephemeral works such as Barry's and reformulates a new conceptual framework around the notion of art's complicity with the market.

Commercial Piece #3 also foreshadowed certain developments that have lately occurred between artists, clients, dealers, and auction houses. Damien Hirst's direct auction of 223 works of art at Sotheby's, in which the artist conveniently cut out the percentage that would normally go to Gagosian Gallery in a regular gallery sales transaction, scandalized the art world.[33] The romantic

concept of the isolated artist working diligently away in his studio, as Pollock did in his farmhouse on the East End of Long Island, New York, for instance, has been replaced by the figure of the artist as entrepreneur and savvy manipulator.

Within this environment of excess, some argued that an autonomous, distanced critique was no longer possible. In a discussion of Sherrie Levine's and Thomas Lawson's work in 1982, art critic Carter Ratcliff commented: "American art is largely a matter of transforming resentments felt toward the culture at large into privileged emblems of that very resentment … in the naïve hope that the result is somehow a defeat for corporate 'depersonalization.'"[34] Ratcliff placed art of the 1980s within the same trajectory as pop and minimalist art of the 1960s. In his view, art of the 1960s was characterized by a reaction to Greenbergian aesthetics and the influx of lowbrow culture into the domain of art. Ratcliff added: "At best, 60s absolutism was an unconscious expression of the resentment from which it tried to flee. Its apodictic 'truths' were sullenly, high flown reworkings of those glamorous, endlessly dubious images which consumer culture endows with such authority." Ratcliff cited Levine and Lawson as artists who "question the ties of the artwork to intention, the intention of the world; artists whose images hint at the way in which 'serious' artistic endeavor is implicated in the consumer world against which 'seriousness' sets itself."[35] But pop and neoconceptual artists' reactions to consumer culture appeared to be less about resentment than about a willingness to experiment with and manipulate the terms of commodity capitalism as a more direct form of critique.

ART AS CONSUMER GOOD: FROM THE BRILLO BOX TO ALARM CLOCKS AND LAVA LAMPS

Warhol's purported dictum, "Art is anything you can get away with," aptly applied to neoconceptual art of the 1980s.[36] It particularly could be said to describe the work of Koons and Steinbach, who worked within and against elements of mass culture by integrating store-bought objects into their work. Neoconceptualism maintained pop's interest in mixing high and low cultural references and the boundaries between art and life. The 1964 "American Supermarket" exhibition at Bianchini Gallery, for example, assembled the work of pop artists Warhol, Lichtenstein, Wesselmann, Artschwager, and Robert Watts in an evocation of an ordinary supermarket complete with food items, a freezer section, aisle markers, and Muzak. Warhol's paintings of Campbell's Soup cans were paired alongside their real counterparts. Robert Watts's *Untitled (Assorted Eggs from American Supermarket* (1964) contributed to a display created by professional food artist Mary Inman. The exhibition drew attention to the similarities between pop art and consumer products in ways that led to a questioning of the definition of a work of art. Visitors could pick up and

examine food products at the same time as they gazed at a three-dimensional painting of a turkey by Wesselmann or Warhol's *Brillo Box* (1964), constructed using methods of hand fabrication and industrial materials and techniques.[37]

Compared to Warhol's *Brillo Boxes* or Oldenburg's plaster products slathered with loosely applied paint, however, Koons's and Steinbach's work appeared slick and mass-produced, with the incorporation of objects plucked from store shelves (Steinbach's lava lamps, enamel pots, and digital clocks, Koons's basketballs floating in tanks of water). Neoconceptual sculpture differed substantially from the hand-painted quality of pop, namely due to the simultaneous influence of conceptualism; as such, it displayed a strong attention to materials and formal choices that emphasized an allegorical or autobiographical impulse distinguishing it from its predecessors. Koons and Steinbach formally manipulated consumer products in order to call attention to issues of class and consumer desire in a conceptual manner by intentionally examining the role certain products play within different levels of society.

In terms of the relationship between art, consumer products, and an artist's aesthetic decisions, Koons's work can be illuminated by Thomas Crow's argument in "Saturday Disasters: Trace and Reference in Early Warhol."[38] Crow asserts that certain formal choices made by Warhol in his *Marilyn Monroe* and *Disaster* paintings manage to overcome and suspend the illusions of fame, grandeur, and fetishism invoked by the media and mechanisms of commodity capitalism. Warhol's *Tunafish Disaster* paintings (1963) illustrate a supermarket can of tuna, alluding to the death of two women in Detroit from tainted cans of tuna. Underneath the image of the can are two media portraits of the victims. Crow comments, "The *Tunafish Disasters* take an established feature of pop imagery [a commercial food item], established by others as well by Warhol, and push it into a context decidedly other than that of consumption. The news of these deaths cannot be consumed in the same way as the safe (one hopes) contents of a can." In another example of Warhol's aesthetic decision making, the artist passed over some of the most famous shots of Marilyn Monroe in favor of a straightforward, frontal image, and cropped the actress's portrait into a tight square, which is described by Crow as "a self-contained unit at odds with the illusions of enticing animation normally projected by her photographs."[39] Having begun these paintings several weeks after the actress's death, Warhol applied the altered rendering onto a gold background, transforming the image into a spiritual icon, a symbol of death and mourning, a powerful allegory of fleeting existence.

Koons's work and other neoconceptual art also involved formal decisions concerning aspects of material culture, a parallel sense of social consciousness, a thorough consideration of how products are consumed by the wider public, and the aesthetic choice to withhold the full expression of these persuasive elements.

In an early series called the *Pre-New*, Koons injected symbolism and pointed allegory into kitchen appliances distinctive of a middle-class sensibility. In *Nelson Automatic Cooker/Deep Fryer* (1979), a deep fryer was attached to the front of two translucent plastic tubes housing vertical fluorescent bulbs, which in turn are hung on the wall. Electrical cords, which can be switched on and off, hang from the bottom of the bulbs. The white light from the bulbs reflects the shiny new metal of the fryer and emphasizes its clean, pristine quality. As a testament to its newness, the fryer's black cord is neatly wrapped and hangs out several inches from the side of the machine. The controls, directly facing the viewer, invite manipulation. Similarly, in Koons's *New Excellence Refrigerator* (1979–1980), a small, cube-shaped refrigerator defies gravity as it hangs from the front of two thin vertical fluorescent bulbs. These visually jarring sculptures create unusual juxtapositions, bringing together two objects normally not seen in such close proximity. They also separate the refrigerator and cooker/deep fryer from alluring store displays and other methods of consumer enticement.

FIGURE 3.6
Jeff Koons, *New Excellence Refrigerator*, 1979–1980. Refrigerator, acrylic, and fluorescent lights, 56 × 18 × 26 in. © Jeff Koons.

Koons's *Pre-New* sculptures emphasize the anthropomorphic, near-otherworldly quality of these objects, a sense of isolation and reverie, as they hang from the walls. In parallel to the gold background of Warhol's *Marilyn*, the light from the fluorescent bulbs provided a glow and an exalted appearance, forming a quasi-halo around these ordinary appliances and imbuing them with a quality loosely reminiscent of religious icons. As an allegorical depiction of commodity fetishism, Koons's appliances deny their use value by serving as art objects. Karl Marx's description of the commodity as "a very queer thing, abounding in metaphysical subtleties and theological niceties" comes to mind when gazing at these works.[40] In all their fluorescent glory, the embellished appliances serve as allegorical stand-ins for the commodity, its mystical qualities, and its power to affect social relations. Imbued with saintly presence, the sculptures underline the role of the objects as intercessors, mediating relationships between individuals, and representing a set of abstract values in society. Working with consumer goods allowed Koons to penetrate the world of commodity fetishism in a manner that altered the objects' typical role in society and yet maintained their tangible presence and connection to reality in a way not possible in two-dimensional imagery.

Continuing to merge the symbolic states of consumerism and death, Koons's 1985 solo show "Equilibrium" at the International with Monument gallery conflated signifiers and the signified, signs and their meanings, in ways that questioned the material reality of objects and allowed for allegorical readings to occur. Viewers of the exhibition were confronted with works such as *Lifeboat*, *Snorkel (Dacor)*, and *Aqualung*, in which ordinary items—all related to activities in the water—were cast in bronze. In his review of the exhibition, art critic Gary Indiana called them "death traps" since the transformation rendered the objects useless—to use the snorkel or lifeboat would cause the swimmer or boater to drown.[41] Yet the material quality gave the works a sense of peculiar importance suggestive of ceremonial or ritual objects. *Lifeboat*, for example, called forth a contemporary version of the ancient Egyptian solar barks that transported the soul of the deceased into the afterlife. Included in Egyptian tombs, these full-sized and smaller model funerary boats were intended to accompany the soul of the dead pharaoh on a divine journey through the heavenly waters. As an artistic medium with a long history, the bronze in Koons's sculptures *Lifeboat*, *Snorkel*, and *Aqualung* equally conjured Greco-Roman sculptures and equestrian statuary. At the same time, for the informed viewer, the bronze casting of these ordinary materials references more recent works such as Johns's *Painted Bronze* (1960), in which the artist cast Ballantine Ale cans in bronze and hand-painted the labels in oil on metal. While Koons's bronze sculptures recalled these associations with works from earlier periods of art history, they similarly elevated everyday materials into the realm of high art. *Lifeboat*, *Snorkel*, and *Aqualung* also invited comparisons with their store-bought

FIGURE 3.7
Jeff Koons, "Equilibrium," 1985.
International with Monument,
New York. © Jeff Koons.

FIGURE 3.8
Jeff Koons, *Lifeboat*, 1985.
Bronze, 12 × 80 × 60 in.
© Jeff Koons.

FIGURE 3.9
Jeff Koons, *Snorkel (Dacor)*,
1985. Bronze, 15½ × 5 × 1¼ in.
© Jeff Koons.

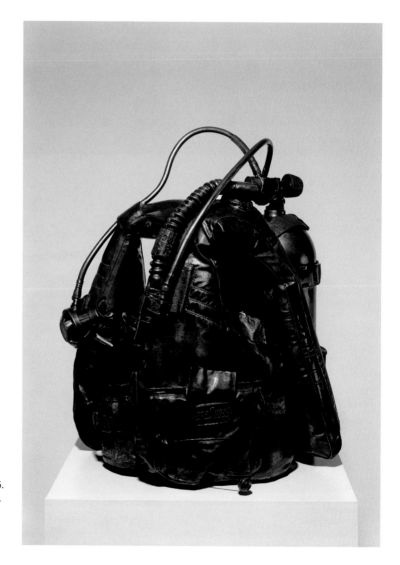

FIGURE 3.10
Jeff Koons, *Aqualung*, 1985.
Bronze, 27 × 17½ × 17½ in.
© Jeff Koons.

counterparts. While a snorkel found in a scuba store might cost ten to twenty dollars, Koons's bronze snorkel costs much more because of its value as high art.

Other works from the *Equilibrium* series displayed basketballs that were halfway or fully submerged within tanks of water, filled to varying degrees.[42] Koons decorated the gallery walls with framed Nike posters of basketball players. He considered these three groups of work an interrelated trinity with allegorical and social connotations: "You have your tools for equilibrium which are the bronzes, you have your tanks, which are this ultimate state of being, you have your sirens. The framing was very important. I spent a lot of time choosing the material and the color."[43]

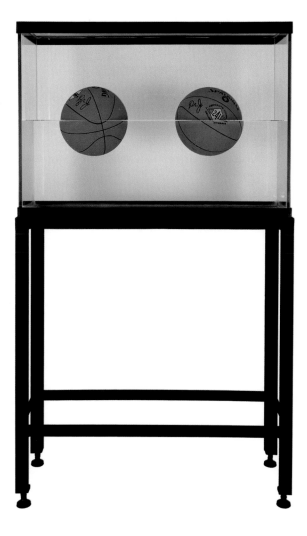

FIGURE 3.11
Jeff Koons, *Two Ball 50/50 Tank (Spalding Dr. J Silver Series, Spalding Dr. J 241 Series)*, 1985. Glass, steel, distilled water, and two basketballs, 62¾ × 36¾ × 13¼ in. © Jeff Koons.

Removed from their habitual location in a basketball court, the balls in Koons's *One*, *Two*, and *Three Ball 50/50 Tanks* floated within a tank, halfway under the surface of the water, submerged with extreme precision. Koons claimed to have worked with over fifty physicists in order to achieve the perfect equilibrium of these works, including Dr. Richard P. Feynman, a physicist who won the Nobel Prize for his work in quantum dynamics. Koons described the process and allegorical content behind the work: "Permanent equilibrium in the tanks is unachievable. The basketballs always sank to the bottom. But I went for it. I pushed it to the limit. I could have created permanent equilibrium with oils. But I wanted to keep it a very womb-like situation with water. I like the purity of water. So I arrived at an equilibrium which is not permanent but very pure."[44] As a result, Koons's *Equilibrium* tanks require diligent maintenance. The shifting balls must be adjusted and the tank must be cleaned and refilled with a mixture of sodium chloride reagent and distilled water.[45] For Koons, the work assumed an organic quality that related to physical existence and the contemplation of life and death: "The equilibrium tanks are very organic to look at. They look like cellular structures, like a brain cell or a fetus or some biological form. I think of them as pre-birth. These are again states of being—to exist in equilibrium which cannot be sustained."[46] Indiana envisioned the allegorical potential of the work, describing the exhibition as "preoccupied with physical gravity and metaphoric entropy," in which the tanks "symbolize an unvarying actual state of things existing beneath the hyperactive surface of life."[47]

The idea of physical, human death in Warhol's paintings is replaced in Koons's work by an allegorical rumination on human psychology, birth, and immortality as well as, in the case of the *Pre-New* series, more grounded notions on the demise of consumer rights, how these inanimate objects programmed for planned obsolescence consume our lives, and individual powerlessness in the face of the megacompanies.

The practice of allegory had been asserted as a specific postmodern sensibility by Craig Owens in his two-part article "The Allegorical Impulse" (1980). Here Owens proposed that the reuse of imagery in works by Troy Brauntuch, Levine, Rauschenberg, and Cindy Sherman simultaneously created and defied meaning in a fragmentary manner. "Postmodernism neither brackets nor suspends the referent, but works instead to problematize the activity of reference," wrote Owens. "When the postmodern work speaks of itself, it is no longer to proclaim its autonomy, self-sufficiency or its transcendence."[48] Citing de Man, Owens describes the shifts in meaning that occur between the signifier and the signified in these works, in which elements of the media or the everyday are appropriated, detached, and repositioned in a new context. The result is the creation of a distinguished space for an allegorical reading to occur. Although Owens mainly discusses photography, he

also focuses on Rauschenberg's *Combine* paintings, with their random assortment of found objects and images—from swatches of fabric to objects such as an umbrella or empty frame—as, in one sense, an allegory of stream of consciousness and unreadability. The fragmented aesthetic proposed by the works serves as a repository for the heterogeneity which parallels that proposed by the human mind. This sense of opacity functions as a characteristic of postmodern allegory: the ability of a work to fluctuate in meaning and to be read on multiple levels. A similar operation occurs in neoconceptualism, in which appropriated objects and forms severed from their habitual circumstances and sites of meaning serve various functions, pointing, in the case of Koons's work, to the history of materials throughout artistic creation, class politics, and the mechanisms of commodity fetishism. Neoconceptual sculpture simultaneously creates and defies meaning, displaying a critical distance from the source material that allows for new readings to take place.

As described by Owens, the allegorical impulse operates within a structural framework that separates signs from their meanings as one text is read through another and the artist-allegorist deciphers the past in order to reread the present. His view parallels Benjamin Buchloh's ideas in his 1982 article "Allegorical Procedures: Appropriation and Montage in Contemporary Art," which similarly relied on Walter Benjamin's concept of the allegory, but used it to describe shifts in the experience of commodity fetishism offered by the Pictures artists and Kurt Schwitters's photomontages. For Buchloh, "The allegorical mind sides with the object and protests against its devaluation to the status of commodity by devaluing it a second time in allegorical practice. In the splintering of signifier and signified, the allegorist subjects the sign to the same division of functions that the object has undergone in its transformation into a commodity. The repetition of the original act of depletion and the new attribution of meaning redeems the object."[49]

Like Koons's sculptures, Steinbach's perform such a semiological fragmentation by separating mass-produced items from their full signification within the constraints of consumer culture and by contributing new levels of meaning that question the social life of objects and their role in the formation of class status. Playing the role of a store associate, in a sense, in *ultra red #1* (1986), Steinbach carefully arranged the objects to enhance their strong visual quality and allure, but with a more artful eye (see figure I.1). While a store might display one item at a time, arranged according to brand name, Steinbach stacks the several red cooking pots within each other according to size. In the second version of the sculpture, the artist removed the second tower of pots and repositioned them to the middle, as opposed to the left-hand side. In both works, rows of the same digital clock are arranged in a zigzag; some toward the front of the shelf, and others toward the back. The red bubbles in the lava lamps echo the clock's red numbers and the saturated red color of the pots.

According to Owens, for a work of art to contain allegorical impulse, as Rauschenberg's work does, it should be viewed a site of meaning, a conceptual proposition that shifts meaning from "history to discourse, from a third or second person mode of address" that "accounts for the centrality which postmodernist art assigns to the reader/spectator."[50] Shifts occur in Steinbach's and Koons's work in the material reality, representation, and perception of mass-produced objects that lead to a conceptual questioning of their position, role, and importance in society. Steinbach's isolation, selection, and regrouping of objects reveal a personal idiosyncrasy that would not be found in a store, where products are sorted according to type and brand name. Each object rests in a fixed location explicitly dictated by the artist. The viewer must question why this placement was chosen, or wonder what the artist had in mind with these juxtapositions. The work is characterized by an obsessive sense of precision and exactness and an idiosyncratic classification system that is not the guiding principle of most commercial stores. The assortment of objects in stores is replaced in Steinbach's work with a sense of individuality and eccentricity based on the artist's personal choice and the psychological ramifications of such decisions. Interestingly, in contrast to the meticulous arrangement of objects, Steinbach's shelves possess a handmade quality that distinguishes them from the industrial metal shelving typically found in stores.

For Buchloh, Walter Benjamin's description of the transformation of the commodity into an emblem was realized in the realm of art with Duchamp's concept of the readymade. Duchamp's selection of a mass-produced object served as an allegorical gesture that separated the appropriated object from its customary meaning, replacing it with the new meaning as allegory. This process takes into account "the hidden factors determining the work and the conditions under which it is perceived. These range from presentational devices and the institutional framework to the conventions of meaning assignment within art itself."[51] Along these lines, Steinbach's objects function as actors, isolated and theatrically aggrandized and spotlit on a stage of his own design.

Pierre Bourdieu's concept of cultural capital, which elucidates the ways power and class relations are inscribed in individuals through social norms and behavior, is also useful in understanding how Koons's and Steinbach's works allegorically operate as sites of meaning. Bourdieu defines capital as "a force inscribed in the objectivity of things so that everything is not equally possible or impossible. And the structure of the distribution of different types and subtypes of capital at a given moment in time represents the imminent structure of the social world, i.e. the set of constraints, inscribed in the very reality of that world."[52] In its objectified state, capital is represented by physical objects and the ways in which they symbolically convey ways of life and class divisions. The objects bought and

sold in society constitute financial wealth at the same time that they partake in a collection of social and behavioral patterns related to particular classes and groups of individuals. Certain objects bestow privilege and advantage for certain members of certain classes, Bourdieu asserts, existing

> as symbolically and materially active, effective capital only insofar as it is appropriated by agents and implemented and invested as a weapon and a stake in the struggles which go on in the fields of cultural production (the artistic field, the scientific field, etc.) and beyond them, in the field of the social classes—struggles in which the agents wield strengths and obtain profits proportionate to their mastery of this objectified capital, and therefore to the extent of their embodied capital.[53]

Steinbach's selection of certain objects highlights their role as key players in the production of cultural capital. According to collector Eugene Schwartz, Steinbach purchased many of the objects used in his work at the Conran Shop, overseen by the influential British designer Terence Conran. Although the New York store is now closed, it sold well-designed household products at prices aimed at high-income buyers.[54] Andrew Sessa of *New York* magazine described the shopping experience as paralleling a walk through the Museum of Modern Art's Design Galleries, with styles sampled from iconic designers and artists such as Isamu Noguchi, Charles Eames, and Arne Jacobsen.[55] Steinbach's *ultra red #1* isolates such objects of high design with an elegance that speaks to their role in producing an upper-class standard of living as portrayed in decorating and architectural magazines.

ultra red #1 appears sleek and impressive when compared to Steinbach's slightly earlier *Shelf with Coach* (1983), in which a painted wood shelf holds a small model of a coach, or *un-color becomes alter ego* (1984), which includes a National Panasonic boom box and two masks of the character Yoda (from the 1980 film *Star Wars: The Empire Strikes Back*). Steinbach began creating the handmade shelves in 1984. At that time, he also began to arrange the objects on the shelves in a purposeful manner. Steinbach commented:

> In each group of objects, a certain relationship of a function, projection, or narrative was underscored. On a formal level, the colors of the plastic laminates covering the shelves were designed to play off of the objects. Objects are designed to deliver certain messages and meanings ... I am interested in how objects are conceived and fashioned, in their look and appeal as well as their social codifications. I wish to get a hold of their appearance, to grasp how they may be recognized and I do that by staging them.[56]

Steinbach's combination of some low-priced articles with then-current electronics or housewares revamped the question of the readymade by representing the cultivation of consumer desires and cultural capital among the different classes and how quickly new objects become obsolete. Introduced in the United States in the mid-1970s, the boom box was already outdated in 1984, when Steinbach included one in *un-color becomes alter-ego*, because the music industry had begun producing compact discs in 1982. When it was first released, the Sony CDP-101 compact disc player carried a price of $700, which was out of reach for many middle- and lower-class consumers. Compact discs in time became outdated as well, with the introduction of digital MP3 files in 1995.

In their 1998 article "Information Technology as Cultural Capital," sociology professor Michael Emmison and English literature professor John Frow apply Bourdieu's notion to demonstrate how advances in technology, and more specifically the home computer, serve as examples of cultural capital that represent significant economic barriers.[57] The professors found that although computers were being promoted as a means of access to economic, political, educational, social, and cultural enlightenment, those who can afford such machines are, for

the most part, the middle and upper classes. The study cited household income as a key impediment: only 19.9% of households with an income of less than $15,000 owned computers, compared to 64.8% of those reporting over $80,000. Emmison and Frow's article provides a concrete example of how certain objects symbolize class barriers and, inversely, how certain types of objects may be viewed from a class perspective.

Considering the date the work was created, it is difficult to avoid the strong sociocultural and socioeconomic associations of the National Panasonic boom box in *un-color becomes alter-ego*. The boom box is redolent of 1980s street culture; it was not uncommon to see urban youth dancing or listening to music on similar audio equipment. At the time Steinbach created the work, the boom box reflected a youthful, inner-city style, and even the birth of hip-hop in the African-American and Latino communities. The machine is credited with having changed the face of hip-hop, since tapes could be easily recorded and passed around. Larger, more expensive boom boxes with new features became symbols not only of status and distinction for the middle and lower classes, but also of style. While today the boom box might be seen as a technological relic, Steinbach's selection of this particular piece of technology points to a segment of society, a phenomenon and way of life for certain communities during a particular moment in history.

The insertion of objects charged with class connotations such as the boom box, which references lower-income, nonwhite communities, is ironic, since members of these communities could not afford to buy art and were not, at least at that point, society's major tastemakers. Considering the influence of hip hop and street culture on the fashion and music industry today, it could be argued otherwise. Steinbach's work causes the viewer to become keenly aware of these socioeconomic limitations and the role such objects play in the production of cultural capital. In another sense, by calling attention to an isolated set of well-chosen objects with specific cultural values and connotations, Steinbach historicizes the present (that is, the time the work was created), documenting the role of material culture in our society. The Yoda masks reference the large business of film marketing and the potential failure of certain objects within a mass market. Catering to the whims of many prospective fans, film production companies undertake a sizable amount of work and financial risk to produce thousands of cheaply made likenesses of film characters. If unsold in the months surrounding the film's release, objects like the Yoda mask could have been found at discount prices at novelty stores. With the last of the original three *Star Wars* films produced in 1983, the mask represents an object with no use or exchange value—a failed consumer product with little mass appeal. The inclusion of two masks underlines the overproduction of valueless objects that flood the market. Finally, the masks point to the subjective and ephemeral whims of consumers, generated

by large corporations that incite consumer desire. The arrangement of the objects reveals a sense of irony, since a similar combination is not likely to be found in a store. Boom boxes would normally be placed with other electronics, and Yoda masks would be seen along with similar novelty items. Also, the nonmatching shelving units, with each section covered with different colors of plywood laminate, add a makeshift feel to the work. In other works by Steinbach, each object or group of similar objects is displayed on a shelf of its own color.

For Bourdieu, taste is a learned attribute, dependent upon the social and economic forces at work in society, or rather, "an acquired disposition to 'differentiate' and 'appreciate,' as Kant says—in other words, to establish and mark differences by a process of distinction which is not (or not necessarily) a distinct knowledge … a practical mastery of distributions which makes it possible to sense or intuit what is likely (or unlikely) to befall—and therefore to befit—an individual occupying a given position in social space."[58] While Kant defined taste as an innate capacity residing in the individual, Bourdieu argues that it is mostly a learned attribute representing, in large part, the interests of the dominant social class, who have the means to dictate cultural standards. Individuals in society are continuously passing judgment on a range of objects and factors in which decisions are made in relation to other classes. Those outside of the dominant cultural hierarchy seek to appropriate certain objects and attributes, thereby gaining access to this power. Steinbach's sculptures raise these issues by presenting a distinctive, lowbrow sensibility and notion of taste that causes tension when examined alongside the highbrow definition of the work of art.

In *Untitled (cabbage, pumpkin, pitchers) #1* (1986), brown, black, and red shelves display a cabbage-like soup tureen, a stuffed pumpkin doll, and three black water pitchers. The stuffed pumpkin doll is an example of kitsch (which will be discussed at greater length in chapter 5), while the design-conscious black pitchers were made by the Hall China Company of East Liverpool, Ohio, whose products were markers of good taste since the early twentieth century. In 1911, Robert T. Hall developed the first successful leadless, single-fire glazing process that produced strong, nonporous ware with a smooth surface. His company expanded during World War I and gained a reputation for its high quality and durability that were especially appreciated by restaurants and institutions. Today, a new Hall water pitcher retails at $300, while Hall china from the early part of the twentieth century is valued by mid- to low-range collectors. The shelves Steinbach uses in *Untitled (cabbage, pumpkin, pitchers) #1* are fabricated from plywood and covered with plastic laminate, similar to Artschwager's *Chair*. While it may once have elicited a high-end sensibility reflecting the most cutting-edge contemporary design, the faux-wood design covering the shelf gives the work a tawdry appearance and feel. The inclusion of these mismatched items, ranging

FIGURE 3.13
Haim Steinbach, *Untitled (cabbage,
pumpkin, pitchers) #1*, 1986. Plastic-
laminated wood shelf, ceramic
tureen, foam-stuffed polyester
pumpkin, three ceramic Hall pitchers,
54³⁄₁₆ × 84 × 27½ in. Mottahedan
Collection. Image courtesy the artist
and his studio.

from refined ceramics to kitsch, is jolting within the context of fine art, since some of these objects are usually seen not in a fine art context but in novelty stores or at garage sales. Likewise, Steinbach's *stay with friends 2* (1986) paired three boxes of Kellogg's Corn Flakes printed in Hebrew and the Israeli cereal Telma with a small collection of Iron and Bronze Age jugs. The ancient jugs emanated an archaic quality pointing to the evolution of mankind and the dawn of civilization across Europe and Asia Minor, while the Kellogg's Corn Flakes boxes conjured associations with states such as Iowa, Nebraska, Kansas, and Missouri where corn has been the predominant agricultural product since the mid 1800s. The juxtaposition of an everyday food item, such as cereal, with vestiges of an ancient civilization ironically calls attention to the low value of the everyday foodstuffs compared to the high value of the art object, purchased by the artist from dealers specializing in archaeological artifacts. It raises questions about which remnants from our current society will be remembered and preserved in coming centuries.

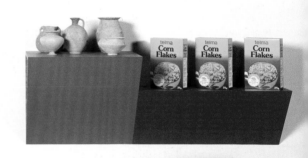

FIGURE 3.14
Haim Steinbach, *stay with friends 2*, 1986. Two plastic laminated wood shelves, Kellogg's and Telma cereal boxes, and Iron and Bronze Age jugs, 33¾ × 61½ × 19 in. (Kellogg's), 32½ × 59 × 18 in. (Telma). The Israel Museum. Image courtesy the artist and his studio.

Finally, the work comments on the intertwined relationship between the United States and Israel and, on a personal level, the artist's Israeli roots. By including low- and middle-value items in proximity to objects of antiquity within a fine-art context, Steinbach's work addresses on a conceptual level the different meanings of taste and value among differing groups of people in society.

In 1980, Steinbach installed *Changing Displays* at the Bronx-based arts organization Fashion Moda. Similarly to Oldenburg's *Store*, he packed the floors, ceiling, and windows with an assortment of items found in secondhand stores and covered the walls with different strips of wallpaper. As the title suggested, Steinbach changed the items on a daily basis. The refreshment of goods pointed to shopkeepers' attempts to keep merchandise looking up-to-date with the latest styles and trends, as changing displays and merchandise is designed to draw and maintain a shopper's interest in the store. As Giorgio Verzotti points out, the innocuous use of the term *display* in Steinbach's work points to the act of showing, organizing, and cataloguing objects for viewing or for purchase.[59] It points to the physical interaction with and examination of objects. The title thus contained a psychological element that relates to the act of discerning the value and purpose of the object as it is being contemplated.

In 1963, critic Ellen Johnson commented: "After seeing Oldenburg's *Store*, or a performance of his theatre, one feels compelled to walk and linger through the Lower East Side, suddenly aware of the curious, tawdry beauty of store-windows full of stale hors d'oeuvres, hamburgers on Reingold ads, stockinged legs."[60] Johnson's statement reflects the ways in which Oldenburg's replica incited in its viewers new feelings toward the actual stores and items on sale in the neighborhood. The artist's parody of consumer culture affected Johnson's perception and experience of commodity culture. Steinbach's displays and objects likewise

FIGURE 3.15
Haim Steinbach, *Display #10—
Changing Displays*, installation view,
1980. Image courtesy the artist and
his studio.

allegorized the process of commodity fetishism, or the superfluous desires attaching to products as they are increasingly separated from their use value, but by isolating the mechanisms of display along with packaging and advertisements, which enhanced the non-use value of commodities and increased the likelihood of fetishization.

In Oldenburg's venture, the prices of the objects ranged from $21.79 to $499.00, replicating the look and feel of a real commercial venue. Steinbach similarly set the prices of his works in conjunction with the assortment and price of the objects that he situated on the shelves. Steinbach explained:

> When my work began to be successful, each piece—the shelves with objects—was priced the way you price a work of art: Here's a work of art, and this is what the price is. Of course, that becomes a problem, because if my work is going for $12,000, what happens when you have a group of

objects worth $30,000? Do you still sell it at the value of the art? I devised a formula by which there would be a price for the work—plus the price of the objects. Let's say a shelf has three cornflakes boxes and six ceramic ghosts on it. If the ceramic ghosts are $10 apiece, that's $60; the boxes, at $2 each, would make $6, bringing the total of the objects to $66. So if the price of a given work is $12,000, that's $12,066.[61]

Referencing works such as *un-color becomes alter ego* (see figure 3.12), Steinbach connected the store-bought objects with the work of art in a strategic manner that undermined the value of the sculpture as high art. He essentially conflated the value of fine art and consumer products by basing the price of his sculptures on the sale amount of the everyday objects incorporated into the work. The lowbrow and the middlebrow objects were therefore attributed a much higher value due to their inclusion within the work of art. Reciprocally, the value of the work of art is dependent on the price of the inexpensive objects included in it.

With the construction of his own mismatched shelves and the idiosyncratic display of the objects on them, Steinbach referenced the techniques of enhancement used to lure buyers. The shelf could also be seen to contain historical associations with the cabinets of curiosity, the *Kunstkammern* or *Wunderkammern*, invented in the sixteenth century, which housed a diverse assortment of precious objects and collections, especially those owned by the ruling classes.[62] The seventeenth-century *Wunderkammer* of Olaus Wormius contained multiple shelves that held sculptures, natural specimens, skeletons, and minerals among many other items. The prized object of the 1980s, Steinbach seems to be saying, is a cheap novelty item or a boom box. The associations evoked by the materials and the feelings aroused in the viewer contribute to the meaning of Steinbach's work. He commented, "The shelf with objects is a nexus of social interaction. I tested the physical presence of an object—something loaded with the patina, evocations, and the markings of its history. People have strong feelings about objects, because they're in their space."[63]

Issues of class consciousness and questions of taste also arise in Meyer Vaisman's *The Uffizi Portrait* (1987), which included a caricature portrait of the artist drawn by a street artist outside the Uffizi Gallery in Florence, Italy. The work consists of three oval cameos showing the same caricature attached to a canvas covered with magnified canvas weave. Costing only a modest sum per drawing, street portraiture is accessible to a wide public, while Vaisman's work was purchased for a much higher price in fine art galleries such as Sonnabend. The inclusion of this inexpensive drawing in Vaisman's work raises questions regarding the value of fine art and the difference between these two works and the two artists' modes of practice. The background of the painting depicts an image of magnified

canvas weave that was applied using a photomechanical silkscreen process. This enlarged weave pattern gives *The Uffizi Portrait* a cheap, inauthentic quality that debases the notion of art as a precious, hand-crafted object. Vaisman's piece provides a tongue-in-cheek criticism of fine art and the role of connoisseurship in determining the value of a work.

The low-quality, run-of-the-mill craftsmanship and moderate prices referenced in Koons's, Steinbach's, and Vaisman's works conceptually respond to issues of taste and class, providing a tacit commentary on the extent to which objects are involved in everyday life. Steinbach comments on his work: "In the mid-1970s, I realized that objects in and of themselves may be considered a material for art, not in the sense of the Duchampian 'readymade,' but rather in the commonly shared social ritual of collecting, arranging, and presenting objects."[64]

FROM HIGHBROW TO LOWBROW: NEOCONCEPTUALISM, CLASS, AND RACE POLITICS

In recent years, several scholars have examined pop art in a new light that counters readings of the work's universal, mass appeal. In her book *A Taste for Pop*, Cécile Whiting discusses class-based references in work that conflated highbrow with middlebrow or lowbrow taste, as in the work of pop artists such as Wesselmann, Oldenburg, and Lichtenstein. She demonstrated how cultural critics of the 1950s used the terms *highbrow*, *middlebrow*, and *lowbrow* to formulate class stereotypes and to separate the criteria for taste among these social groups. Analyzing Wesselmann's paintings depicting distinctively middle-class suburban interiors and décor, which reflect the images of kitchens and interiors displayed in the pages of women's magazines at the time such as *Good Housekeeping* and *Ladies Home Journal*, Whiting comments, "Wesselmann's interiors implicated high art in consumer culture, subordinating the high-art aesthetic to consumer taste."[65]

Anthony Grudin also relates pop to discussions of class that arose during the 1950s and 1960s, specifically looking at Warhol's series of seventy-two brand-image paintings produced from 1961 to 1963.[66] According to Grudin, the national brands used most frequently by Warhol, namely Campbell's Soup and Coca-Cola, held a certain class specificity, since they were enmeshed in a national "branding war" that targeted working-class communities.

Work by Koons and Steinbach referenced these earlier debates on taste ranging from highbrow to lowbrow in their selection of images and objects. Halley's work could also be discussed here, as his use of Roll-a-Tex, a dry element that is added to paint to simulate a stucco finish, has specifically middle- or corporate-class connotations. While Wesselmann's *Still Life #30* (1963) presented middlebrow domestic space as the norm of the 1960s, some of the objects used in

FIGURE 3.16
Jeff Koons, *The Dynasty on 34th Street*, 1985. Framed Nike poster, 45½ × 31½ in. © Jeff Koons.

FIGURE 3.17
Jeff Koons, *Secretary of Defense*, 1985. Framed Nike poster, 45½ × 31½ in. © Jeff Koons.

Koons's and Steinbach's work present a more multifaceted view of class politics in the 1980s. The artists' anthropological regard for material culture informs their work, causing it to function less as a celebration of the fulfillment of the American dream than as a critique of its empty promises.

Koons's *Equilibrium* series commented on socioeconomic challenges and racial biases facing African-Americans, particularly the racist insinuations of a Nike advertising campaign in the 1980s. In the 1985 International with Monument exhibition, the *One*, *Two*, and *Three Ball Equilibrium Tanks* were paired with unmodified, framed Nike advertisements of professional African-American basketball players, three of which were titled *The Dynasty on 34th Street*, *Secretary of Defense*, and *Board Room* (all from 1985). Koons traveled to Nike's company headquarters in Beaverton, Oregon, obtaining permission to use the posters. Established as Blue Ribbon Sports in 1964, Nike became Nike, Inc., in 1978 and had grown over the course of the 1980s to become the powerful company known today.

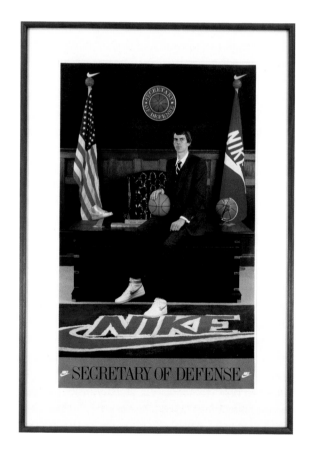

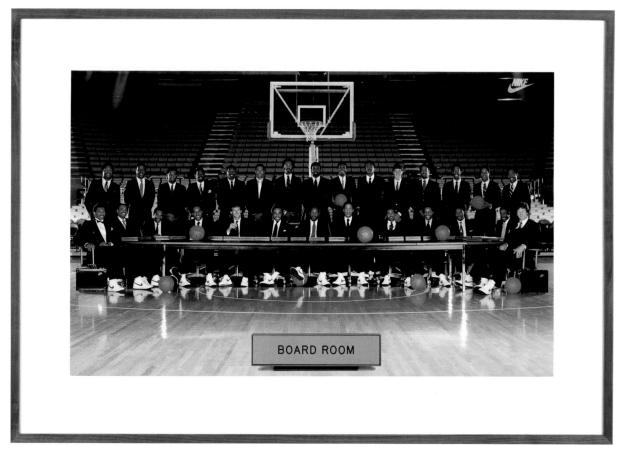

The Dynasty on 34th Street shows a group of amateur African-American bas-ketball players dressed in Nike basketball shoes gathered in a sparse and unpop-ulated outdoor basketball court. The foreground is animated by a single, large crack in the pavement that cuts diagonally across the image, signaling that the court has not been maintained. Adjacent buildings in the background appear to be rundown and in decay, creating an unwelcoming environment. In short, an assortment of visual signals indicates this is not an area one should leisurely enter. The low-angled shot causes the boys to loom large in the camera. Some look defiant, while others motion to the viewer in what appears to be a direct chal-lenge. Their cocky and insubordinate attitudes are evocative of their youth and exude confidence in their abilities and mastery of the game. The caption, "The Dynasty on 34th Street," implies that these boys rule this particular, dilapidated neighborhood court. Seamlessly associating African-Americans with poor, run-down inner-city neighborhoods, the poster's combination of words and image

FIGURE 3.18
Jeff Koons, *Board Room*, 1985.
Framed Nike poster, 31½ × 45½ in.
© Jeff Koons.

provide a verbal warning to those who decide to venture into the neighborhood looking for a game. Although the boys invite challengers, the ad has already framed them as the winners of an imaginary game that takes place on their turf.

In the 1985 International with Monument installation, Koons placed *The Dynasty on 34th Street* directly across from *Secretary of Defense*, which in contrast depicts a white basketball player situated in a luxurious U.S. government office. A lush office rug displays the Nike logo. In contrast to the young African-Americans, the white player is not dressed in his basketball uniform but instead wears a suit and tie. The caption "Secretary of Defense" associates the white man with a governmental position. From 1983 to 1985, white men did dominate the 98th U.S. Congress, in which approximately twenty African-Americans held posts (as opposed to ten in the 91st Congress between 1969 and 1971, and forty in the 103rd Congress from 1993 to 1995).[67] Only 1 percent of Congressmen and women so far have been African-American.[68] The Nike advertisements appear to confirm the fact that a position in the federal government is much more likely to be held by a white rather than African-American male.

Koons's *Board Room* was installed on the wall adjacent to *Secretary of Defense*. The poster displays two professional basketball teams, largely composed of African-American players, formally posing for a portrait shot on a basketball court. While the white player in *Secretary of Defense* wears a suit and tie in a normal office setting, the predominantly African-American team appears out of place dressed in suits and ties and gathered around a large table in the middle of the basketball court. Brand-new, bright white Nike basketball shoes replace their formal footwear, and two briefcases are conveniently placed on either side of the large table. Another witticism is presented in the caption "Board Room" in the form of an office door plaque. Attempting to transfer the power and prestige associated with corporate board rooms to the predominantly African-American NBA teams, the ad suggests that these mostly black players preside over the NBA in the same way a board governs a company. In reality, however, there were, and still are, relatively few African-Americans holding such positions of power in corporate America compared to whites, and the participation of African-Americans within this realm was, and continues to be, fraught with obstacles.[69] The details and accessories—the suits, briefcases, door and name plaques—produce a sense of irony that undercuts the idea that African-Americans could hold such a high-level position.

Collectively, the images insinuate that government and corporate offices are not the domain of African-Americans, who instead belong on the basketball court. Discussing the messages relayed in the ads and his intentions for the work, Koons commented, "In dealing with the Nikes, I am dealing with unachievable sociological states of being. Having my Nike posters there, the great deceivers—with

references to not only Nike [the goddess of victory], but sirens, the mythological temptresses and deceivers: 'Oh come on!' 'I've achieved it!' 'I've done it!' 'I'm a star!' 'You can do it!' 'Go for it!'—and, of course they never have. They're just liars. They're the front men, because if they had, they'd be dead. It's unachievable."[70]

As Carol Stabile points out, in the 1980s and '90s, Nike shifted its target marketing audience from middle-class whites to inner-city blacks in order to broaden its consumer base.[71] The company also associated well-known African-American figures such as Michael Jordan with the Nike brand, in an attempt to provide positive role models for African-American consumers. This campaign worked perhaps too well. In 1989 and 1990, the media, including *Sports Illustrated*, reported that inner-city black youth were killing each other over Nike Air Jordans.[72] As Stabile comments, many Nike ads from these years relied on Stuart Hall's concept of inferential racism—the all too frequent instances where racism is presented as an unquestioned, naturalized assumption within a representation of an individual, culture, or group: "By *inferential* racism I mean those apparently naturalized representations of events and situations relating to race, whether 'factual' or 'fictional,' which have racist premises and propositions inscribed in them as a set of *unquestioned assumptions*. These enable racist statements to be formulated without ever bringing into awareness the racist predicates on which the statements are grounded."[73]

Koons's selection of Nike posters revealed the sharp binaries between amateur or professional sports and corporate America and reinforced the concept of difference or otherness among African-American populations. As Katy Siegel comments, "Nike conjures up a dream, one that the superstars of the NBA embody for millions of people, particularly young black men. ... Koons's choices foreground the way these almost exclusively black athletes are cast not just as stars, but in roles whose claim to power and respect reflects a traditional social system that in fact denies power or respect to most African-Americans."[74]

Unlike Levine and Prince, who clipped segments of ads and illicitly used them in their works, Koons purchased the poster ads and requested permission from Nike, or the advertiser.[75] By framing the actual Nike advertisement posters and presenting them as art, Koons created a new context and environment for viewing the images. Typically seen on the streets, in magazines, or generally within the atmosphere of daily life, the posters selected by Koons were recontextualized within the white-walled space of the art gallery. By isolating the ads outside of their habitual context and positioning them next to each other in different ways, he foregrounded their racist insinuations. His arrangement of the posters emphasized the idea that professional basketball was a means of social mobility and escape for many poor African-Americans, who were often otherwise confined to housing projects. *Board Room*, for example, seemed to suggest that the only way

African-American men would ever reach a level of success comparable to that of a corporate board member was through basketball. Moreover, as works that were purchased by members of the upper class who could afford them, the *Equilibrium* series linked two very diverse worlds.[76] Koons suggested another way of looking at the series in his comment: "I looked at the athletes in those posters as representing the artists of the moment, and the idea that we were using art for social mobility the way other ethnic groups have used sports. We were middle-class white kids using art to move up into another social class."[77] Ironically, while works from Koons's *Equilibrium* series reminded viewers of the situation of some African-Americans, they simultaneously pointed to the artist's own social climbing.

The *Equilibrium* series draws parallels to Warhol's *Race Riot* series (1963), in which the most turbulent moments of the civil rights era—including Charles Moore's *Life* magazine photographs of demonstrators being attacked by police dogs on May 17, 1963—were reproduced in vivid silkscreens. By removing the photographs from their original context and distancing them from the visual noise of our media-saturated society, both Koons and Warhol encouraged reflection on the messages, events, individuals, and communities in these images. Crow's description of Warhol's work aptly summarizes the effect of this technique: "these were instances in which the mass-produced image as the bearer of desires was exposed in its inadequacy of suffering and death."[78]

The conceptual critique exemplified by the use of material goods in Koons's and Steinbach's work reflected specific socioeconomic shifts of the 1980s. Neo-conceptualism came of age in a period when theories of poststructuralism, postindustrialism, and globalism thrived, and in many ways, concretized the social and economic changes that had begun in the 1950s and 1960s. In their article "Dominant Ideology Thesis," sociologists Nicholas Abercrombie and Bryan S. Turner discuss such socioeconomic factors as characterizing the postwar era and leading to a shift from ideological coherence to incoherence, or the lack of any single set of social beliefs the dominant classes hold about the subordinate classes.[79] Expanding on Marx and Engels's *The German Ideology*, the authors describe the manipulation of religious, social, and cultural institutions during feudalism and the early stages of capitalism that have allowed a dominant class to impose a strict set of beliefs on others, thereby inhibiting political dissent. However, since late capitalism, the increasing diversity of individuals' lived world experiences, including legal, moral, and religious codes and values; beliefs in economic progress; and equal opportunity for the lower classes have contributed to an increasingly bewildering social system in which "the subordinate classes are not incorporated into the dominant ideology and … by contrast the dominant classes are deeply penetrated by and incorporated within the dominant belief system."[80] According to Abercrombie and Turner's analysis, the lower classes, or

today's "99 percent," encounter multiple sets of ideologies due to the diversification of social codes and belief systems.

A 1986 comment by Halley responds to this phenomenon: "I see the yielding of the social as a way of getting deeper inside the social, and a lot of younger artists I know do that too."[81] In a later elaboration on this sentiment, he stated, "Rather than fight the culture, you allow the culture in as much as possible. That act of non-judgmental embrace can flip around to become a critical act."[82] As neoconceptualist artists continued pop's blurring of boundaries between high and low art, they were inundated with an assortment of ever-expanding forms of media imagery, persuasive advertising, the pervasiveness of capitalism, and the cult of the new: ideological phenomena describing, in part, the conditions of late capitalism. In 1986, Koons described the impetus behind his work:

> I'm interested in the morality of what it means to be an artist. ... And my next concern is my actions, the responsibility of my own actions with regard to other artists, then to a wider range of the art audience, such as critics, museum people, collectors, etc. Art to me is a humanitarian act. ... I love the gallery, the arena of representation. It's a commercial world, and morality is based generally around economics, and that's taking place in the art gallery. I like the tension of accessibility and inaccessibility, and the morality in the art gallery. I believe that my art gets across the point that I'm in this morality theater trying to help the under-dog, and I'm speaking socially here, showing concern and making psychological and philosophical statements for the underdog.[83]

Working within and amid a more expansive set of cultural ideologies became a means by which Halley, Koons, and the other neoconceptual artists forged new pathways of artistic production.

The New York art market and gallery sector, just beginning to flourish in the 1960s, were burgeoning in the 1980s. As a result, a debate over mass culture and the avant-garde returned to the forefront. In the 1980s, the prices of art rose to a level that had never been seen before. Auction houses also gained increasing power as buyers and sellers of major works of art. In 1987, for example, Van Gogh's *Irises* (1889) fetched a record price of $53.9 million dollars at Sotheby's.[84] In 1988, Leo Castelli commented in an interview with Ratcliff: "Of course, you must allow for inflation in judging these things. But there has been another inflation, an art-inflation, over the past three decades that has raised prices in actual terms. Only real estate is comparable. ... The public has begun to look at prices rather than paintings. In the beginning, when my gallery was small, I sold works for $500 to $1200. Now I am not astonished when I sell one for $1 million."[85]

In this atmosphere, hype became a prominent factor in the 1980s art market, where discussion and gossip among critics, dealers, artists, collectors, and other participants helped establish the level of prices at auctions. In 1988, Jeffrey Deitch, then a vice president of Citibank and initiator of the company's art advisory services, commented: "There is certainly the perception that hype itself is perhaps the most important new medium in the corporate world as well as in the art world. The process of promotion, the selling, the culturalization of art ideas and images has become an art form itself."[86] The art media's coverage of auction results produced sought-after information about the current market stars and their worth. Deitch characterized the rise of the art market and the differences in the art world from the 1960s to the 1980s as follows:

> Fifteen years ago, people didn't expect that there was always going to be a secondary market, even for works by a great artist. If you bought a Carl Andre work you had to buy it just because you believed in it. You couldn't buy it because you thought you could resell it for a profit, or even because you thought you could get your money out of it. Very few collectors thought that way. Now there's this expectation among art collectors that you deserve to get your money back out of everything you buy—at least.[87]

Bickerton, perhaps referencing Oldenburg's well-known 1961 statement, "I am for an art that is political-erotical-mystical, that does something other than sit on its ass in a museum," described his Susie boxes as angrily asserting that the "art object, whether it wants to or not, must sit its ass on the wall and belligerently proclaim meaning."[88] While Oldenburg's comment pointed to the exteriorization of the art object, or its relocation from the museum into the realm of everyday life, the new generation of artists acknowledged the inevitability of a work's commodity status and incorporation into the art market. Faced with the in-built constraints of the work of art as a saleable object, neoconceptual artists continued to experiment with these limitations in targeted and poignant ways that manipulated the hegemonic visual codes inherent to the promotion of consumer culture.

NEOCONCEPTUALISM, MINIMALISM, AND CONCEPTUALISM

<div style="text-align: right">4</div>

In this chapter, I demonstrate how neoconceptualism married the preliminary concerns of pop and minimalism within the theoretical boundaries of conceptualism. Conceptualism's structural and allegorical exploration of the framing conditions behind pictorial signs drove neoconceptual work and led, in turn, to a visual and textual interplay with previous movements of pop and minimalism. Inspired by the institutional critique and linguistic frameworks proposed by artists such as Dan Graham, John Baldessari, Lawrence Weiner, Joseph Kosuth, and Sol LeWitt, the neoconceptualists first built aesthetically upon the techniques of these earlier artists and the possibilities inherent in the breakdown of the artwork into systems of language and philosophical ideas. Similar to conceptualism, neoconceptualism reflexively explored the language, conditions, and framework of art in a semiological manner.

While some conceptual artists drew inspiration from minimal sculpture and its focus on rudimentary systems of found order, the neoconceptual artists exaggerated and played off of the principal techniques of minimalism, very much aware of the history of this movement as entailing a simplified, often geometrically oriented artistic style that relied on industrial materials and their potential connotations.[1] In neoconceptualism, the forms and materials of minimalism are translated into signs that allegorically conjure the ambiguities attached to the earlier movement. The work of Frank Stella, Dan Flavin, and Donald Judd, for example, contributed to the development of neoconceptualism's visual aesthetic and its self-reflexive interrogation of the art object. At the same time, the neoconceptualists reinserted an aesthetic sensibility into their work and mobilized this quality as a tool for formal and social critique. They continued to emphasize a direct material presence on par with minimalism, even as they manipulated the language of conceptualism to highlight the cultural implications of these materials, which were directly and cogently imbued within larger social systems.

Emerging in the United States in the early 1960s around the activities of Fluxus and pop artists working in New York, conceptual art coalesced into a defined movement in 1967 with the publication of Sol LeWitt's "Paragraphs on Conceptual Art" and, later, Joseph Kosuth's "Art after Philosophy" (1969).[2] A major contribution of this movement was its radical rethinking of the art object as a set of linguistic parameters that relied on the semiotic impetus of cubism but moved beyond its pictorial constraints. Cognition became the driving principle of conceptual work, which privileged the idea as the driving force of creation over the formal or aesthetic qualities of a unique work of art. Centering on rational methods of artistic production, LeWitt's proposal offered a set of permutations that dictated the form of the work of art in an effort to eliminate all subjectivity. His wall drawings, for example, relied on the artist's initial creative plan, which was carried out by a number of assistants. Thus, LeWitt's *Plan for a Wall Drawing* (1969) consisted of written instructions for an ephemeral work that was executed by Adrian Piper, Jerry Orter, and LeWitt at Paula Cooper Gallery on May 20, 1969. The focus remained on the process of creation rather than on the final product. Likewise, LeWitt mapped out all 122 possible permutations of a cubic form in his sculptures *Variations of Incomplete Open Cubes* (1974), which relied on the viewer to mentally complete the forms and hence the full cubic structure. While some, including critics Donald Kuspit and Suzi Gablik, read LeWitt's sculptures as illustrating the ideals of Cartesian rationalism, art historian Rosalind Krauss argued in 1976 that LeWitt's abbreviated forms subvert coherent thought and instead present disorganization, systems of obsession, compulsion, and doubt.[3]

Kosuth's philosophy traced the history of modern art to Duchamp's notion of the readymade, which conceptually reduced the work of art to an analytical decision made by the artist. He summarized his ideas in 1969:

> Works of art are analytical propositions. That is, if viewed within their context-as-art, they provide no information what-so-ever about any matter of fact. A work of art is a tautology in that it is a presentation of the artist's intention, that is, he is saying that particular work of art is art, which means, is a *definition* of art. Thus, that art is true *a priori* (which is what Judd means when he states that "if someone calls it art, it's art").[4]

Rooted in a semiotic aesthetic approach, works such as Kosuth's *One and Three Chairs* (1965) thus explored the notion of art as a linguistic tautology. Consisting of three representations of a common household object—a photograph of a chair, a dictionary definition of a chair, and an actual chair—the work references Plato's theory of forms, which dictates that the true idea of a material stems from the thought itself. The written and representational depictions are, for Plato,

secondary. By restaging this philosophical argument in visual form, Kosuth's work illustrates the discrepancies between language, thought, and the object, as well as differing modes of representation.

Despite the movement's adherence to the status of the artwork as idea, conceptualism nonetheless included the production of art objects, in part as a result of the influence of pop and minimalism, in ways that draw later parallels to neoconceptual work. Art historians have written on how photography, video, and other media used to document and posthumously frame the ephemeral practices in conceptual, performance, earth, and land art of the 1960s and 1970s created works and other materials that were subsequently owned by collectors and museums.[5]

More pointedly, art historian Alexander Alberro has pointed out that Kosuth drew from Warhol's example in aspects of his practice by including mechanical production, seriality, a sense of anonymity in aesthetic production, and the integration of high and low forms of culture.[6] Kosuth's serial production of Photostats marked with dictionary definitions of the word *nothing* in his 1968 exhibition at Gallery 669 in Los Angeles paid tribute to Warhol's own series of *Campbell's Soup Cans* paintings. The Photostats relied on an analytical mode that literally transformed art into tautological definitions of commonplace words. Further, as the product of an early projection copier, the Photostats echoed the techniques used in mass media.

Minimalism served as an equally important influence for Kosuth and other conceptualists due to its emphasis on industrial materials, anonymity, repetition, a parts-to-whole credo espoused by Judd, and what LeWitt described as "intuitive mental processes" in his "Paragraphs on Conceptual Art." Although Kosuth looked to Judd's example as a prominent writer-critic and artist who contemplated the history of art when he proposed new advances in sculpture, he criticized Judd's use of materials that carried explicit connotations, instead preferring work that was "abstract, rigorous and ostensibly free of meaning."[7]

Preceding Alberro, in his 1982 article "Allegorical Procedures: Appropriation and Montage in Contemporary Art," art historian Benjamin Buchloh described the dual influence of pop and minimalism on some conceptual artists who advanced pop's disintegration of signs by incorporating elements of institutional critique and by examining the framing conditions behind the art object as it is situated in a museum or gallery context. He cited Michael Asher, Marcel Broodthaers, Daniel Buren, Dan Graham, Hans Haacke, and Lawrence Weiner as artists who merged the readymade aesthetic with a self-referential questioning of the role of the work of art in ways that marked "the beginning of an examination of the framework that determines the pictorial sign and an analysis of the structuring principles of the sign itself."[8] Broodthaers's 1972 installation in Düsseldorf, *Musée de l'Art Moderne, Département des Aigles*, serves as an example of the allegorical deconstruction

of institutional structures, with its presentation of 260 crafted objects, films, and art reproductions arranged within the artist's fictitious museum setting. Broodthaers's project appropriated the semiotic and institutional configuration of the museum in order to question its value, its foundation, and the constraints it placed on the art object. Buchloh's discussion of object-based works such as *Musée de l'Art Moderne, Département des Aigles*, expands to contemporary photography by female artists, some of whom are associated with the Pictures generation—Dara Birnbaum, Louise Lawler, Levine (in the example of her *After* photographs), and Martha Rosler—and firmly situates these artists within the framework of conceptualism.

Neoconceptualism also functions along these lines, continuing a reflexive and semiotic examination of the work of art and the framing conditions and institutional structures that encompass it. In contradistinction, neoconceptual work extends the readymade aesthetic to include specific artists and events within the history of art, as well as targeted sociocultural phenomena such as the effects of technology, commodity culture, and class issues on social structures. It presents the history of modern art as an abridged set of signs that recall poignant moments and formal circumstances and, in doing so, invokes the viewer to conjure the consequences of these occurrences. At the same time, neoconceptualism candidly and unequivocally pulls the work of art into the domain of class politics, causing the viewer to contemplate the role of objects as markers of class status and cultural capital. While much of neoconceptual work demonstrates this characteristic, here I present isolated case studies of work by Jeff Koons and Peter Halley that most clearly operates in this manner.

JEFF KOONS AND GOOD DESIGN

The minimalists walked a fine line between fine art and "good design," to use Greenberg's terminology, in ways that allowed for the social to creep into readings of their work. These artists grappled with many issues concerning the making, materials, and reception of their art. In 1967, Greenberg commented: "Minimal works are readable as art, as almost anything is today—including a door, a table, or a blank sheet of paper. … Yet it would seem that a kind of art nearer to the condition of non-art could not be envisaged or ideated at this moment. … The continuing infiltration of Good Design into what purports to be advanced and high-brow art now depresses sculpture as it does painting."[9] Arising in the years following World War II, the concept of good design was promoted by the Museum of Modern Art in a series of exhibitions from 1944 to 1956 that displayed a range of household objects, appliances, textiles, and graphics by prominent designers such as Marcel Breuer, Charles and Ray Eames, and Eero Saarinen. MoMA also held competitions among designers for printed textiles in

1946, for low-cost furniture in 1948, and for lighting in 1950. Greenberg's use of the term "good design" thus draws connections between minimalist works, domestic furnishings, and popular taste.[10] The minimalists' experimentation with materials and formal techniques engendered a strong object-like quality to their work that Greenberg read as representing a removal of aesthetics and a decline in high quality, a response comparable to that later provoked by neoconceptualism. Minimalism's sleek, simple lines and fabricated appearance prompted confusion among many viewers and critics, who questioned the quality and status of these works as fine art objects, as also happened with pop art. Greenberg continues, "I find myself back in the realm of Good Design, where Pop, Assemblage, and the rest of Novelty Art live. By being employed as tokens, the 'primary structures' are converted into mannerisms."[11] Minimalism's use of rudimentary, found systems of order served to eliminate any gestural components in art. This artistic vocabulary was built on the theories of gestalt and phenomenology, ideas which activated the viewer's space, as well as on an investigation of the integrity of materials. Stella's *Black Paintings* (1959–1960) and *Aluminum Paintings* (1960) evoked a strong sense of repetition and order with their precisely measured lines and symmetrical forms. LeWitt's *Serial Project No. 1* (1966) was similarly fabricated according to an intricate system and permutation of open and closed cubes. Stella's and LeWitt's works explored the artistic possibilities of enamel paint and aluminum and relied on the perception of the interstitial spaces between the lines and the cubes, respectively. In regard to this negative space, Greenberg's comment seems appropriate: "Nor have most of the Minimalists escaped the familiar reassuring context of the pictorial: wraiths of the picture rectangle and the Cubist grid haunt their works, asking to be filled out."[12]

Koons's work textually references this particular debate, taking Greenberg's comments at face value by translating the physical qualities prevalent in minimalist painting and sculpture into store-bought objects. Minimalists, such as Judd, often had their work industrially fabricated in order to replicate the high-quality, finished look and uniform feel of industrial products.[13] This approach allowed the minimalist artists to formulate a forceful reaction to the expressionistic brushwork of the abstract expressionists and give their work a sense of directness, which was in turn read by critics as a sleek, manufactured finish. While Judd initially created his boxes from plywood, he later had many of his boxes produced by a steel or aluminum fabricator in order to achieve a polished look.[14]

Koons and Steinbach continued to use the look and feel of industrial production, while simultaneously accentuating the role of objects as producers of cultural meanings, be they social or art historical. Koons's work, for example, referenced minimalism's interest in direct aesthetic experience and experimentation with material fabrication. In *Rabbit* (1986), for example, the original, inflatable toy was

FIGURE 4.1
Sol LeWitt, *Serial Project No. 1*, 1966. Baked enamel on steel units over baked enamel on aluminum, 20 × 163 × 163 in. Image courtesy Paula Cooper Gallery, New York. © 2013 The LeWitt Estate / Artists Rights Society (ARS), New York.

cast in highly polished stainless steel. Similar to Judd, Koons maintained a high-quality finish and appearance. While Judd's brightly colored Plexiglas is suggestive of the sheen and allure of commodity culture, Koons relays a direct connection to cultural materialism by using actual store-bought products, like an inflated toy rabbit, as source objects. Koons's sculptures also play with the notion of representation and presentation by reproducing the tangible quality of the inanimate objects referenced in his work. The casting process of Koons's *Rabbit* paradoxically allowed the work to maintain both the squishy look of the inflatable toy and the hard feel of metal. In a 1986 comment that echoes the new partnerships which developed beginning in the 1960s between industrial fabricators and artists, Koons stated: "I'm basically the idea person. I'm not physically involved in the production. I don't have the necessary abilities, so I go to the top people, whether I'm working with my foundry—Tallix—or in physics. I'm always trying to maintain the integrity of the work."[15]

By directly incorporating commercial products, neoconceptual art conflates the smooth sleekness of commercial design with minimalism's ambiguous relationship with the art object, all the while highlighting the cultural frameworks in which these mass-produced objects are situated. Koons's *New Excellence Refrigerator* (1979–1980), discussed in chapter 3, ironically commented on the geometric simplicity of minimalism, or to use Barbara Rose's term, "ABC Art." Building on the trope of the grid or the box in minimalist work, Koons incorporated a small, cubic refrigerator into the work, which is hung on the wall and attached to two vertical fluorescent bulbs (see figure 3.6). LeWitt's cubic units, which are made from steel and aluminum, then coated with baked enamel paint, were fabricated with some of the same materials as Koons's refrigerator.

The long, vertical fluorescent bulbs Koons used in *New Excellence Refrigerator* are reminiscent of Dan Flavin's light sculptures from the 1960s and works such as *The Diagonal of May 25, 1963 (To Robert Rosenblum)* of 1963. First exhibited at the Green Gallery in 1964, the latter consisted of a single store-bought fluorescent bulb placed on the wall at a forty-five-degree angle. The material simplicity of the work did not diminish its connection to commodity culture. In "Minimalism and the Rhetoric of Power," art historian Anna Chave describes the associations inherent to minimalism's use of materials that, she argues, are not as distinct from the social and political realms as previously thought. Descriptions of minimalism as a simple, unadulterated art form deny the underlying narratives and materialist connotations found in the work. Chave comments on Flavin's *Diagonal of May 25, 1963*:

> Flavin's *Diagonal* not only looks technological and commercial—like Minimalism generally—it *is* an industrial product and, as such, it speaks of the extensive power exercised by the commodity in a society where virtually everything is for sale. ... Further, in its identity as object or commodity, Flavin's work may arouse our ambivalence toward those ever-proliferating commodities around us for which we have a hunger that is bound to be insatiable, as they will never fully gratify us.[16]

By incorporating bulbs similar to those Flavin used, Koons's *Pre-New* series acknowledges the earlier artist's closeness to mass-produced commercial products and magnifies this association by attaching to the bulbs an assortment of store-bought kitchen appliances. The simultaneous sentiments of religiosity and commodity fetishism at work in Koons's sculpture point to a similar attribute Flavin noted about his own work. Chave remarks: "In Flavin's mind, his *Diagonal* was less a reaffirmation of the possibility for spiritual experience in contemporary society than 'a modern technological fetish.' ... Flavin also knew that his

commercial light fixtures 'differ from a Byzantine Christ held in majesty; they are dumb—anonymous and inglorious.'"[17] Sexual innuendos aside, although these allegorical readings also connect the two artists, Koons's *Pre-New* sculptures exude an anthropomorphic quality not present in Flavin's work that aids in the association. Hung on the wall at eye level, the appliances are bathed in a fluorescent glow that can be compared to the shimmering effect of the glass and gold leaf background in some Byzantine icons. Koons's work invites a similar face-to-face meeting with the viewer, asserting an ironic sense of devotion to these intercessional objects made to improve daily life. Chave discusses the ways in which minimal objects such as Flavin's elicited in viewers a harsh indifference and an inhuman sensibility due to the use of industrial materials and methods of fabrication. Neoconceptual work can be said to lure the viewer back in with its reliance on illusionism and, in some cases, recognizable subject matter.

Koons's work also cites other minimalist sculptures that contained indirect cultural references. Similar to *Variations of Incomplete Open Cubes*, LeWitt's earlier *Serial Project No. 1* (1966) explored a set of permutations or step-by-step modifications of open and closed cubes. The regularly spaced intervals between each open or closed form became the subject of LeWitt's work, which placed equal importance on each square. The pristine quality of LeWitt's white cubic units was echoed in Koons's *New Excellence Refrigerator*. However, since it was displayed on the floor, LeWitt's standardized grid structure recalled the plans or models of prefabricated architectural units, such as those that often make up apartment complexes, schools, hospitals, or postwar housing. Koons played on minimalism's material ambivalence in a tongue-and-cheek manner and took these references one step further by integrating actual objects into his works. The three-dimensionality of Koons's work—and Steinbach's too, for that matter—manipulates the phenomenological effects of minimalist sculpture and promotes an interactive dialogue with the viewer: the work recalls these earlier moments of art history by using an abbreviated set of visual signs, which in turn facilitates a new regard for these store-bought objects. The sculptures require the viewer to look past their objectness to their allegorical meaning and the underlying reasons for the artist's formal decision making.

Koons's *Pre-New* and *The New* sculptures centered on the artist's concept or idea in selecting an assortment of vacuum cleaners and kitchen appliances. His works drew from certain aspects of conceptualism in order to create works of art with cogent sociopolitical connotations that similarly underlined the structural mechanisms at work in consumer culture. Koons used the language of minimalism to comment on social uniformity, in that every kitchen or student dormitory could potentially display the same white cubic refrigerator. In this manner, the store-bought products reflected shifts in the United States from an industrial to a

service and commodity-oriented economy and the challenges faced by rapid growth in Asia, most notably China and Japan. The U.S. trend toward importing rather than exporting goods and services began in the 1980s and continues today. Seriality and limitless product choices remain fundamental principles of capitalism, with its proliferation of identical commodities destined for consumption. In this regard, Koons's *Pre-New* series can be compared to Dan Graham's *Homes for America* (1966–1967). In this conceptual piece created for *Arts Magazine*, Graham photographed prefabricated, postwar housing developments in New Jersey with a Kodak Instamatic camera. In a deadpan, documentary format, Graham's piece emphasized repetition and sameness in style, color, and form, as well as the restrictive choices available to consumers. The repeated images of housing units and architectural elements approached the repetition prevalent in

FIGURE 4.2

Dan Graham, *Homes for America: Early 20th-Century Possessable House to the Quasi-Discrete Cell of '66*, 1966–1967. Published in *Arts Magazine* (December 1966–January 1967). Image courtesy Marian Goodman Gallery.

minimalist sculpture from the point of view of critical social commentary. Graham seemed to indicate that catering to a mass market would result in architectural uniformity and a common aesthetic. Similarly to Koons's work, *Homes for America* also critiqued social divisions based on economic status, since the majority of individuals who purchased houses in the developments in question were of the lower or middle class. Both works ground their analysis of visual signs within social experience and examine industrial modes of production. Further, Graham's and Koons's projects rely on the notion of difference, asking viewers to identify what distinguishes products from each other within the context of everyday life. Following Derrida's logic, the sign for sameness in these works functions as a deferred presence—that is, these works call attention to the notion of sameness by evoking the minute differences in the production and distribution of mass-produced homes, objects, and by default, ways of life in a postindustrial society.

Koons's *Inflatables* series, displaying inflatable toys attached to mirrored squares, continued his commentary on the landscape of commodity fetishism and consumer culture in postwar society. Koons's use of mirrors in his 1979 *Inflatable Flower and Bunny (Tall White and Pink Bunny)* can be related to Graham's *Video Piece for Showcase Windows in Shopping Arcade* (1976), which was

FIGURE 4.3
Jeff Koons, *Inflatable Flower and Bunny (Tall White and Pink Bunny)*, 1979. Vinyl and mirrors, 32 × 25 × 19 in. © Jeff Koons.

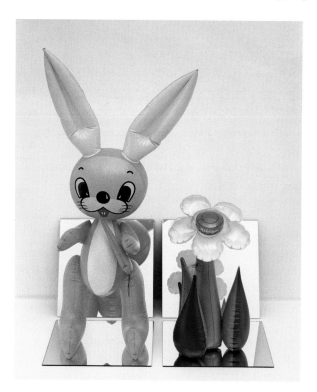

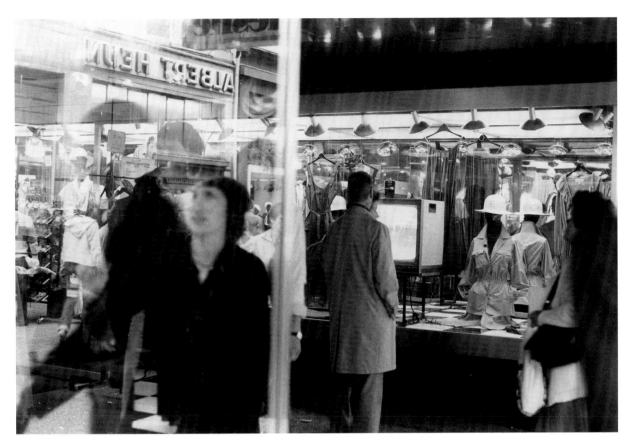

FIGURE 4.4
Dan Graham, *Video Piece for Showcase Windows in Shopping Arcade* (1976). Installed in Groningen, the Netherlands, 1978. Image courtesy Marian Goodman Gallery.

originally set up in Groningen, the Netherlands. In the installation, shop window cases were positioned on either side of a pedestrian passage, and interaction with the work took place when viewers passed back and forth through the site.[18] Each shop window contained a mirror on the back wall that reflected the items in the showcase and the glass window front as well as the viewer. Monitors and video cameras posed in front of the windows recorded the activity in the arcade both in real time and with a few seconds' delay. The mirrors and the monitors thus reflected the viewers' images in relation to the items for sale inside the cases. Viewers saw either their interaction with the objects in the display in real time on the monitors or their interaction in the recent past. The showcase windows and the objects displayed within them add a further element of complication to the viewer's experience and interaction with his or her own projected image, and with the image of other spectators, as well as with the commodified objects. Koons's mirrors functioned in a similar manner, offering a fragmented, discontinuous image of the viewer in relationship to commodities. The flower and rabbit served

as metaphorical stand-ins for the endless range of useless products fabricated within commodity capitalism. The viewer is confronted with the physical objects as well as their representation in the mirrors. Graham's and Koons's works translate cheerful shopping experiences into surrealist nightmares in which the viewer must confront her image in juxtaposition with that of the commodity, essentially equating his or her sense of self with inanimate objects.

Koons also cites postminimalist sculptor and writer Robert Smithson as a strong influence on his work. Although *Inflatable Flower and Bunny* draws parallels to Graham's installation, it specifically references Smithson's sculptures from the late 1960s, such as *Red Sandstone Corner Piece* (1968). Koons comments, "When I ultimately lost interest in painting, I enjoyed seeing art that used display, like Robert Smithson's. My own earliest works present themselves as Smithson-like displays."[19] Smithson used the language of minimalism to create site-specific works that referenced the landscape. In Smithson's *Red Sandstone Corner Piece*, a pile of red sandstone was placed on top of mirrors, which were attached at the edges. The square mirrors formed an open encasement to hold and reflect the pile of rocks. While Smithson's mirrors reflected elements from the natural environment, Koons's mirrors displayed cheap, mass-produced objects. The mirrors were reminiscent of those used in store displays, which made the inflatable toys appear more at home in their surroundings than the sandstone rocks. For Smithson, the mirror functioned on two levels: as a physical object and as a reflection or an abstracted view of reality. The mirror allowed for a fractured, multifaceted view of the rocks, which represented a displaced site or physical location. At the same time, the mirrors allowed the external environment to play a role in the meaning of the work.

Koons's and Smithson's works also spoke allegorically to the dialectic between nature and culture and image and representation. With his site and non-site works, Smithson explored the relationship between consumption and the impossibility of consumption. While *Red Sandstone Corner Piece* was created for a museum or gallery, a number of Smithson's other works, such as *Spiral Jetty* (1970) and *The Yucatan Mirror Displacements* (1969), were placed in isolated or distant locations. These essentially unsaleable works were documented only by photographs or in film. The non-sites or indoor earthworks, such as *Red Sandstone Corner Piece*, abstractly represent the off-site location of Sandy Hook, New Jersey, in the form of earth, rocks, and organic objects taken from the site that are displaced and function as visual signifiers. These materials function semiotically as placeholders indexing the geographical location and the associations it holds. While Smithson transported natural elements inside the white walls of the gallery in *Red Sandstone Corner Piece*, Koons's work spoke to a contemporary experience of nature as mediated through an inauthentic vision of reality, in which

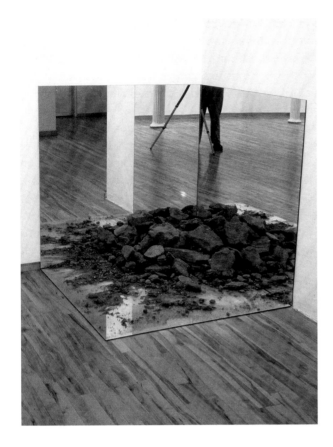

FIGURE 4.5
Robert Smithson, *Red Sandstone Corner Piece*, 1968. Three mirrors and sandstone from the Sandy Hook Quarry, New Jersey; 4 × 4 × 4 ft. Image courtesy James Cohan Gallery, New York & Shanghai. Art © Estate of Robert Smithson / Licensed by VAGA, New York, NY.

plastic flowers and inflated bunnies replace tangible experiences in the outdoors. Smithson's rumination in his essay "A Tour of the Monuments of Passaic, New Jersey" (1967) aptly describes the opposing yet similar dialectic expressed by the two works: "That zero panorama seemed to contain ruins in reverse, that is—all the new construction that would eventually be built. This is the opposite of the 'romantic ruin' because the buildings don't fall into ruin after they are built, but rather rise into ruin before they are built. ... But the suburbs exist without rational past and without the 'big events' of history ... a Utopia minus a bottom."[20] Together, Smithson's and Koons's work suggest a suburban reality increasingly isolated from any tangible substance, material reality, and sense of community, reflecting unlimited consumer desires and the artificial creation of wanton needs that compose a purportedly utopian lifestyle generated by commercial culture. Smithson's comment, echoed in Koons's work, questions whether these phenomena reflect progress or a regression for civilization and whether society is shifting toward or further away from a credible or convincing vision of the future.

Smithson's and Koons's use of mirrors presented a simulated view of the objects that rest on them, which in turn reflect the increasing abstraction of daily life. In 1969 Smithson commented, "The mirror itself is not subject to duration, because it is an ongoing abstraction that is always available and timeless. The reflections, on the other hand, are fleeting instances that evade measure. … Once you start seeing objects in a positive or negative way you are on the road to derangement. … Reflections fall onto the mirrors without logic, and in doing so, invalidate every rational assertion."[21] Smithson described the timelessness of things reflected in mirrors, which produces an alternative moment of perception when objects become "phantoms of the mind." In other words, the mirrors confused the direct relationship between the eye and the object of sight: the mirror presented an image of the object that created a certain amount of distance from the actual object and gave it an intangible quality. The distance created by Smithson's site, non-site, and displacement works replicated the larger notions of entropy, natural history, and shifts within the landscape, which are the result of social or biological changes. In 2001, Graham likewise commented on the use of the mirror in postmodern architecture: "It is a kind of surveillance system, and when it was first used in glass office buildings, the Bauhaus idea of transparency was replaced by surveillance."[22] Koons's sculptures continued this conceptual research into consumption and the structural mechanisms of commodity culture with a material that produced irrational, visual relationships separated from those of everyday life and from temporal reality. Rather than working with natural artifacts as Smithson did, Koons used manufactured plastic objects that spoke to a society in which items are made for obsolescence. Smithson was also interested in the increasing commodification of society and the consequences of urban sprawl, which drastically changed both the urban and natural landscape in the years after World War II. He wrote:

> The slurbs, the urban sprawl, and the infinite number of housing developments of the postwar boom have contributed to the architecture of entropy. … Near the super highways surrounding the city, we find the discount centers and cut-rate stores with their sterile facades. On the inside of such places are maze-like counters with piles of neatly stacked merchandise; rank on rank it goes into a consumer oblivion. The lugubrious complexities of these interiors has brought to art a new consciousness of the vapid and dull.[23]

Smithson linked some minimalist work with the realization of these conditions, such as Flavin's light sculptures; Ronald Bladen's untitled, large-scale leaning sculptures made from aluminum and wood from 1965; and Robert Grosvenor's plain, austere structure, titled *Transoxiana* (1965).

The consumer oblivion described by Smithson and Graham escalated in the 1980s into high-yield junk bonds and leveraged buyouts as seen in the cases of financier Michael Milken and stock trader Ivan Boesky, as well as megamergers and multinational corporations that contributed to the age of consumerism and Wall Street greed. Koons's work suggested that the austere language of minimalism and conceptualism alone could not properly address the cultural concerns of his age. His inclusion of cheap, inflatable toys and other store-bought objects in a fine art context also added a level of commentary on the widening gap between the rich and the poor that began in the 1980s and continues today. During the 1980s, President Ronald Reagan's "trickle-down" economic policies favored the upper class at the expense of the disadvantaged. Income levels rose for the wealthy and fell for the poor, with the number of Americans below the poverty level increasing throughout the decade. More recently, the results from the 2010 census discovered that the gap between the rich and the poor has continued to increase, marking the United States as the country with the greatest income disparity among Western industrialized nations.[24]

PETER HALLEY'S HYPERBOLIC MINIMALISM

Obliquely referencing the economic environment of the 1980s, Halley's paintings, such as *Two Cells with Circulating Conduit* (1986), visually examine social experience by representing a subtle critique of commodity capitalism and its pervasive structure (see figure 1.7). The lines in Halley's work stood for conduits, which support underlying informational and structural components of contemporary society. His geometric configurations generally called to mind the technology boom of the 1970s and 1980s, which facilitated newer, more prolific forms of advertising and business. Halley's forms pointed to the integrated circuit components of computer systems, such as the memory blocks, logic, and input/output pads on computer chips, or the linear grid structure of many major U.S. cities, which are organized into streets and blocks. What Halley called his "cells" and "conduits" also referenced the late modernist architecture of the International Style, advanced by figures such as Walter Gropius, Le Corbusier, and Philip Johnson. This stark, geometric style with an emphasis on the exposed use of industrial materials, such as steel and glass, came to dominate city skylines with buildings such as I. M. Pei's Hancock Tower in Boston (1976) or Skidmore, Owings, and Merrill's Saatchi and Saatchi World Headquarters building in New York (1987). *Two Cells with Circulating Conduit* was also motivated by larger ambitions: Halley wished to incite public awareness of the confining, underlying structures of industrialized society and commodity capitalism.

Halley's paintings simultaneously conjure art historical readings and promote a sense of formal irony through the use of materials and color. The squares and lines in Halley's *Day-Glo Prison* (1982), for example, functioned as a reminder of the breakthroughs made by the modernist grid, as seen in Malevich's *Black Square* (1915) or Mondrian's *Composition with Red, Blue, Black, Yellow, and Gray* (1921); they are also reminiscent of the work of postwar painters such as Barnett Newman, Mark Rothko, Kenneth Noland, and, as this section will demonstrate, in particular the work of Frank Stella as seen in, for example, *Fez (2)* of 1964 or *Gran Cairo* of 1962. Halley builds upon minimalism's use of systems in a new, amplified manner. The simple and sometimes modular forms of minimalist painting and sculpture emphasized the formal and phenomenological relationships between segments, lines, or parts. For Halley—who also cites Joseph Beuys as a major source—this was but one play in a larger game of textual and formal parody.[25]

The work and career of Frank Stella proved to be a particular reference for Halley in developing his affinity for minimalism. One year after graduating from Princeton University, Stella burst on the New York art scene in the Museum of

FIGURE 4.7
Frank Stella, *Fez (2)*, 1964. Fluorescent alkyd on canvas,
79⅛ × 79⅛ in. Gift of Lita Hornick. The Museum of
Modern Art, New York. Image courtesy © The Museum
of Modern Art / Licensed by SCALA / Art Resource, NY.
© 2013 Frank Stella / Artists Rights Society (ARS),
New York.

Modern Art's 1959 exhibition "Sixteen Americans" with four of his *Black Paintings*, including *The Marriage of Reason and Squalor, II* (1959). In this painting, concentric, thin white stripes consisting of reserved (unpainted) canvas form inverted U shapes on the right and left sides of the work. Participating in a panel with the artist at New York University in 1960, the art historian Robert Goldwater snapped, "That man is not an artist, he's a juvenile delinquent."[26] The geometric linearity of Stella's new work stood in stark contrast to the strong, gestural characteristics of much of New York School painting, much as neoconceptualism would be the antithesis of neoexpressionism two decades later. In the 1940s and 1950s, abstract expressionist painting held a dominant presence in the art scene. But, by 1959, three years after the death of Jackson Pollock, the movement seemed to have lost its avant-garde edge, as painting succumbed to the space of everyday

life, as seen in the happenings and neo-Dada work of Jasper Johns, Robert Rauschenberg, and Allan Kaprow. As minimalism gained ground in the early 1960s, Stella's work announced a profound sense of literalism, expressed most forcefully in his famous statement from 1964 that seemed to characterize the movement:

> My painting is based on the fact that only what can be seen there is there. It really is an object. Any painting is an object and anyone who gets involved enough in this finally has to face up to the objectness of whatever it is he's doing. He is making a thing. … All I want anyone to get out of my paintings, and all I ever get out of them, is the fact that you can see the whole idea without confusion. … What you see is what you see.[27]

The rigid composition of Stella's *Marriage of Reason and Squalor* responded ironically to abstract expressionism and to Greenberg's ideas on flatness as the most desirable aspect of painting. It has been suggested that the title of the work spoke to the prominence of the New York School and the new artistic styles of the neo-Dada, pop, and minimalist movements that threatened to displace its reputation as the primary avant-garde movement.[28] The title seemed to propose that a partnership between reason or rationalism and the squalor of abstract expressionism's active, emotional brushstrokes—based partly on the surrealist technique of automatic writing—could have resulted in Stella's geometrically organized paintings. Carl Andre, who shared a studio with Stella at the time, suggested giving the painting this name. Stella's process consisted of penciling in a strict arrangement of lines on raw canvas, then filling in the spaces with black house paint. This cerebral mode of painting pointed to a new direction for the medium among Stella's contemporaries, artists such as Brice Marden and Robert Ryman. In a lecture at Pratt University in 1960, Stella discussed the inherent problems of painting and elaborated on his methods for addressing them, commenting:

> I had to do something about relational painting, i.e., the balancing of the various parts of the painting with and against each other. The obvious answer was symmetry—make it the same all over. … The remaining problem was simply to find a method of paint application which followed and complemented the design solution. This was done by using the house painter's technique and tools.[29]

Stella's composition demonstrated a rigid linearity and an advanced logic of precision in which the pictorial structure of the painting became the main subject of

the work. Drawing parallels between Stella's modular techniques and Russian constructivism, art historian Maria Gough describes Stella's early engagement with literalism as an attempt to eliminate all illusionistic space by rigorously applying repeated lines and brushstrokes.[30] In Stella's *Aluminum* and *Copper* paintings of 1960–1961, the lines and brushstrokes are dictated by the shape of the canvas and exude a relational presence with regard to its notched edges and L, U, and T shapes. Although these works promote a self-reflexive examination of painting's formal qualities, critic Michael Fried argues that their nonillusionistic, painting-as-painting approach pointed to the medium's turn toward the object:

> [Stella's] progression from black to aluminum to copper metallic paint … in conjunction with his use of shaped canvases … can be fitted neatly into a version of modernism that regards the most advanced painting of the past hundred years as having led to the realization that paintings are nothing more than a particular subclass of things, invested by tradition with certain conventional characteristics … whose arbitrariness, once recognized, argues for their elimination … the assertion of the literal character of the picture support manifested with growing explicitness in modernist painting from Manet to Stella represents nothing more nor less than the gradual apprehension of the basic "truth" that paintings are in no essential respect different from other classes of objects in the world.[31]

Fried reduces Stella's modular techniques to an extreme logic connected with the general economy of objects. Stella's early paintings were viewed by some critics as a response, perhaps ironic, to a Greenbergian view of art history, in that they excluded those elements Greenberg deemed unnecessary, including representation and narrative, in favor of a would-be iteration of painting as such. In his 1961 essay, "Modernist Painting," Greenberg discussed the role of flatness and medium specificity as important to painting's continuation. He hailed an avowal of the process and medium of painting as one of most important qualities of modern art.

Art historians Chave, Gough, Caroline Jones, and James Meyer have discussed Stella's complex persona and inability to be pinned down to one style or another during the postwar period, be it Greenberg's illusionism or the minimalist adherence to literalism. Meyer situates Fried's earlier comment within a discussion of the complex trajectory of Stella's work and his shift in the early 1960s to the *Concentric Squares* and *Irregular Polygons* paintings, which represented a dramatic break from his previous pursuits toward an approach more aligned with high modernism.[32] The *Irregular Polygons* demonstrated a rejection of literalism in favor of a concept of painting that Stella described as an "area of gesture or picture-making that had more room."[33] His dissatisfaction with the hard-edge look of

his earlier work led to an increased experimentation with illusionism. But as Meyer describes it, Stella manipulated both sides of the debate, wanting "to be an exemplar of a materialist version of modernism—the 'what you see is what you see'—and to be inscribed in Greenberg's optical account of modernist painting."[34] Jones echoes this sentiment, indicating that the artist's "shifting coloration enabled him to stand out in an increasingly crowded market, and find a place, and defenders, for his difficult art."[35]

Halley's paintings textually cite these early quandaries—namely, an attention to the object quality of painting and a vacillation between literalism and illusionism—by merging and imitating certain formal and material components found in Stella's work. Halley's *Two Cells with Circulating Conduit* repeats the strict geometric sensibility and logic of construction characteristic of Stella's early work. Two large, black squares are lodged within a flat, monochromatic yellow background with lines or conduits departing from either side. The layers of acrylic and Day-Glo paint in Halley's paintings create a flat, two-dimensional surface, characterized by sets of precisely executed lines that form a thick layer on the canvas. Similarly to Stella's work, Halley's painting was composed on a stretcher that was three and a half inches thick, using basic geometry, which gave the work an object-like quality and distinct planar protrusion from the wall. Halley also composed his paintings in two sections: a larger section that represented the cell and a thinner, rectangular section of the same length that was attached below the larger section. In a diagrammatic fashion, the lower panel represented the conduit and situated this form within an imaginary underground. Symmetry played an important role in the structure of the canvas. Like Stella's *Marriage of Reason and Squalor* and some of his *Aluminum Paintings*, such as *Union Pacific* (1960), Halley's painting is symmetrical vertically but not horizontally. The result is a sense of isometric linearity in which the geometric components appear as sectional views of a larger structure. The green and blue colors of the lines prevent them from being read as a single square unit.

In 1991, commenting on his first "prison" works, Halley noted: "I wasn't too worried about Mondrian or Malevich. I was thinking about Stella, Judd, Newman and Rothko. ... Since I began painting in the era of Color Field painting, the idea of putting this terse rigid connotation of a prison on a transcendentalist expanse of raw canvas seemed very funny and tart to me."[36] In fact, the shift from literalism to illusionism in Stella's work inspired Halley's own transition from the early prison paintings to the interconnected networks of cells and conduits. The sense of existential isolation seen in *Day-Glo Prison* represents Halley's own rumination in the early 1980s on Stella's self-reflexive methodology in his early *Black Paintings*, which led Halley several years later to the connectivity and diagrammatic quality of *Two Cells with Circulating Conduit*.

Halley used color as a transgressive element that emanated a deep nostalgia for previous artistic movements, such as pop and, in particular, Stella's paintings from the 1960s. The networked forms and pulsating colors of Halley's paintings conjure works from Stella's *Concentric Square* series, such as *Gran Cairo* and *Fez (2)*, which promote a sense of illusionism with their interlocking bands of vibrant color. Although *Gran Cairo* relied on a similar, rote arrangement of lines on the canvas, the tonal shifts and succession of squares allowed for the suggestion of perspectival space that did not occur in the monochromatic *Black*, *Aluminum*, and *Copper* paintings. Halley's painting translates this sense of spatial recession into a superficial movement across imagined urban and digital topographies.

The bright, multicolored *Gran Cairo* was created with fluorescent and alkyd-based paints. Alkyd paints, typically used to cover wood furniture or the exterior or interior of houses, were known among artists for their hard enamel surface that eliminated all evidence of brushstrokes. Stella's research into the formal qualities of painting reflected a desire to assert the continued dominance of the medium in the face of advances in sculpture made by Judd, Flavin, and Andre. At the same time, this impetus was influenced by the ever-expanding presence of mass culture and cultural production, as shown when Stella, as well as other artists such as Warhol, began to use Day-Glo color, an industrial invention of the 1960s. Stella might not have openly admitted its commercial connotations, but Halley certainly did. Halley also proposed formal and economic inconsistencies in his work by using industrially produced materials, bright colors, and simple forms that recalled the advertising and culture industry. For Halley, Day-Glo contained multiple connotations, referring to the diverse fields of recent art history as well as to its functional, governmental uses, as in warning or preventative signage for streets and workers' clothing.

Combined with the industrial paints and textures, the thick stretchers caused Halley's forms to appear to bounce off the surface of the canvas into the viewer's space. Halley explained: "the idea was to project the painting into relief so that it would have a kind of space projected forward from the real space that it was hung in."[37] Halley's paintings contain a three-dimensional presence caused not only by his choice of stretchers but also by the colors and forms. Imbued with a phenomenological quality, his paintings incite a visual dance as the eyes move from one part of the canvas to another, similar to that demanded by the bright hues and interlocking lines in *Gran Cairo* and *Fez (2)*. The interpenetrating colors and four-quadrant structure of *Fez (2)* in particular create a dynamic sense of opticality that characterizes op art and the work of Bridget Riley and Victor Vasarely, both of whom were included with Stella in the 1965 exhibition "The Responsive Eye" at the Museum of Modern Art. The succession of squares in Stella's *Gran Cairo* were multiplied and layered in a concise spatial and geometric organization.

Visual exaggeration also played a key role in Halley's work and its relationship to contemporary society. In Halley's paintings from the 1990s to today, such as *Supersize* (2000), the seriality and repetition of the simple cell and conduits design of the 1980s gives way to mass confusion that reflects the increasing proliferation of commodity culture, advertising, and computer networks over the decades.

In addition to their pronounced stretchers, Halley's paintings exaggerate the materialist and object-like qualities of Stella's work with the use of Roll-a-Tex. Just as the minimalists experimented with new materials in the 1960s, so did Halley in the 1980s. Roll-a-Tex, a dry element that is added to paint, is essentially a low-budget replacement for a stucco finish, preferred in part for its rapidity and ease of use.[38] In the 1970s, it served as a fashionable way to decorate the walls and ceilings of certain upper- to middle-class homes. Roll-a-Tex is still commonly used in low-rise concrete construction, such as motels or apartment buildings, where it is applied directly to the concrete structure.[39] Halley injected the formal components of his work with new associations, such that the color, material, and form codified creative and linguistic concepts. At the same time, these concepts intertwined and contradicted each other, preventing any singular reading of the work. Roll-a-Tex, for example, directly related to his intended audience, whom he viewed, perhaps mistakenly, as the "progressive bourgeoisie," or "those with the funds to support culture."[40] This material functioned as a form of readymade with connotations pointing to a specific political economy and function. Relying on methods somewhat similar to those of media advertising, Halley at once seduced and repelled viewers with assaults on their senses of sight and touch.

Like Halley's Roll-a-Tex, which remained a relatively new material in the 1980s, Stella chose to incorporate in his work another relatively recent material, aluminum. First used to construct planes during World War II, aluminum proved very useful in the construction of housing during the baby boom years. Unlike the pop and neo-Dada artists, who used forms and materials inspired by the interior, domestic, or commercial realm—as seen, for example, in Tom Wesselmann's *Still Life #30* (1963)—the minimalists used aluminum for its manufactured, mechanized connotation. Aluminum, like Roll-a-Tex, evoked the construction of middle-class housing complexes, motel walls, and some corporate office buildings. The industrial materials in Stella's work, such as house paint, metallic paint, aluminum, and stainless steel, served to counteract the romanticized notion of the artist as creator. Chave's comment on minimalist work could also be applied to Halley and other neoconceptual artists: "By manufacturing objects with common industrial and commercial materials in a restricted vocabulary of geometric shapes, Judd and the other Minimalist artists availed themselves of the cultural authority of the markers of industry and technology."[41] As in minimalism, neoconceptualism's use of industrial, prefabricated materials referenced the realm of the everyday and the

FIGURE 4.9
Peter Halley, *Supersize*, 2000. Acrylic, fluorescent,
pearlescent, and metallic acrylic, and Roll-a-Tex
on canvas, 108 × 118 in. Image courtesy the artist.
© Peter Halley.

work's status as a commodity within the art market. Halley manipulated industrial paints and Roll-a-Tex in a visual manner that was uncharacteristic of their pre-scribed use. In Halley's paintings, as well as Koons's and Steinbach's sculptures, the formal qualities of the materials and objects competed with the larger cultural references attached to them. As Halley noted, "the 'stucco' texture is reminiscent of motel ceilings. The Day-Glo paint is a signifier of 'low budget mysticism.' It is the afterglow of radiation."[42] The formal ambiguity present in neoconceptualism not only pointed to minimalism but also engaged in a diverse range of interactions with the sociocultural and sociopolitical realms.

In "Specific Objects," Judd asserted that "the main thing wrong with painting is that it is a rectangular plane placed flat against the wall. A rectangle is a shape itself; it is obviously the whole shape; it determines the limits and arrangements of whatever is on or inside of it."[43] Judd underlined the limitations and constraints of painting in order to emphasize the importance of new art forms and mediums. Halley's work seemed to take this statement as a challenge, building on and emphasizing the limitations of the square, much as Stella did in his *Black* and *Aluminum* paintings. Stella's reasons for using metallic paint likewise described the artist's voluntary desire to work with and against the conditions of painting in a phenomenological manner: "It was the kind of surface that I wanted. ... I'd have a real aggressive controlling surface, something that would seize the surface. ... I also felt, maybe in a slightly perverse way, that it would probably also be fairly repellent. I liked the idea, thinking about flatness and depth, that these would be very hard paintings to penetrate."[44] Halley took on painting's putatively negative characteristics with aggressive tones and the elimination of nearly all perspective, which gives *Day-Glo Prison* a flat and deadening quality. The monochromatic background and lack of foreground causes the lines and cells to appear strongly one-dimensional. On the one hand, the bright colors and Roll-a-Tex manage to rejuvenate the painting, giving it a vibrant, flashy quality. On the other hand, the artificial quality of the colors appears to memorialize and embalm the rectangle within the flat, superficial space of the canvas.

In *Glowing Cell with Conduits* (1985), Halley played with different shades of Day-Glo to delineate spatial boundaries, proving that Day-Glo contained distin-guishing subtleties in color and hue. The large, central cell was created with a color tone that is ever-so-slightly lighter than the background so that it appears to hover over the surface of the work. This effect, however, was thwarted by the condensed layer of Roll-a-Tex, which clings to its broad surface. Thick, black lines flee from the central stronghold and take a hard right and left turn before leading the viewer's eyes directly off the sides of the canvas. The history of these lines may be found in paintings like Newman's *Onement I* (1948), as well as Stel-la's *Gran Cairo* and *Fez (2)*. The lines' vector-like movement was a reminder of the

FIGURE 4.10
Peter Halley, *Glowing Cell with
Conduits*, 1985. Acrylic, fluorescent
acrylic, and Roll-a-Tex on canvas,
63 × 63 in. Image courtesy the
artist. © Peter Halley.

progress made by Newman and Stella in expanding painting's vocabulary, but also in underlining its limitations and objecthood. Halley's work ironically and indistinctly continues this research into the uniqueness and constraints of this medium. In Halley's paintings, the simple structural delineations of the lines conflict with the bright, gaudy colors, which in turn conflict with the thick, material presence of the Roll-a-Tex.

While the flashiness of Halley's works evoked corporate and media advertising, appearances are deceptive, as even the simplest formal qualities were never quite what they seemed. The bright colors in *Glowing Cell with Conduits* were composed of the more conventional cadmium red in addition to Day-Glo pink. By mixing Judd's preferred color with an even brighter tone, Halley hyperbolized a minimalist palette in what could be called a competitive effort to make his paintings appear more shiny and attractive than Judd's early sculpture. The shimmery blue Plexiglas of Judd's *Untitled* (1968), while covering the work's central, stainless-steel core, asserted a physical and perceptual presence comparable to that in Halley's *Blue Cell with Smokestack and Conduit* (1985). As minimalism coalesced into an aesthetic style in the mid to late 1960s, a debate occurred between Stella, Judd, and Barbara Rose in 1967 in which Stella's relatively newfound adherence to opticality and illusionism brushed up against Judd's commitment to literalism. James Meyer argues that this moment marked a transition in

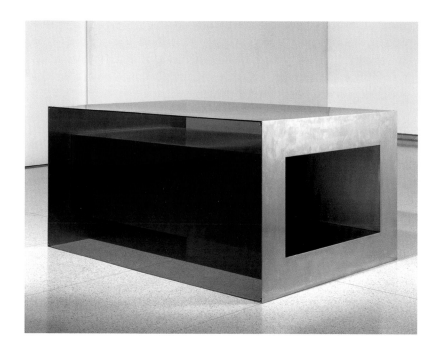

Stella's artistic philosophy, one that shifted him away from his earlier convictions.[45] The colors, forms, and materials in Halley's paintings textually and visually replay these debates. Counter to the traditional rendering of space in perspective, Halley's paintings seemed to reach out to viewers and to directly invade their territory. In opposition to the intensely flat character of the canvas, the dazzling colors actually assist in projecting space outward toward the viewer.

Nevertheless, for some, Judd's sculptures did not appear as simple or empty of materialist references. In many ways, Rosalind Krauss's early analysis of the ambiguous material qualities of Judd's work in her 1966 review, "Allusion and Illusion in Donald Judd," could also serve as a description for Halley's paintings. In spite of the sculptor's adherence to literalism, Krauss found a certain level of formal and material ambiguity in Judd's work that describes Halley's *Blue Cell with Smokestack and Conduit*. Krauss stated that

> in Judd's case the strength of the sculptures derives from the fact that grasping the works by means of their physical properties, no matter how complete, is both possible and impossible. They both insist upon and deny the adequacy of such definitions themselves, because they are not developed from "assertions" about materials or shapes, assertions, that is, which are given a priori and convert the objects into examples of a theorem or more general case, but are obviously meant as objects of perception, objects to be grasped in the experience of looking at them.[46]

Krauss accounted for the phenomenological aspects of minimalist work, in which meaning was accrued though the work's color and material presence. Judd's new type of sculptural object confounded the viewer with its industrial materials, repetition, and order. Comparable to Halley's use of Day-Glo as a visual assault on the viewer, in Judd's *Untitled*, the visual effects of the flashy Plexiglas coating enlivened the strictly rational, geometric format. Judd's depersonalized forms and his emphasis on the space and scale of the work provided a personal experience for the viewer though the visual and phenomenological effects of the shiny, sleek, azure Plexiglas. The color and material served as a reminder of the sculpture's status as an object and were reminiscent of everyday items fabricated with plastic, such as furniture, jewelry, or household items. Yet the work's strictly geometric shape and its inclusion within a fine art context deterred a reading of the sculpture as an everyday object. In Judd's sculpture, as in Halley's paintings, color, form, and material vied with one another for precedence.

Halley translated minimalism's perceptual and physical aspects into aesthetic terms, where the banal quality of the thick Roll-a-Tex and the brilliant colors simultaneously invaded and thwarted the viewer's spatial perception. The

intensity of the Day-Glo demanded the viewer's attention and invoked a phenomenological presence, while the Roll-a-Tex brought any hint of perspectival space to a screeching halt. A superficial layer coated the surface of the square just as Judd's Plexiglas covers its own steel core. The thick, bumpy surface of *Blue Cell with Smokestack and Conduit* added a three-dimensional quality that was immediately counteracted by the strictly rectangular format of the work. With its roots in works like Eva Hesse's *Hang Up* (1966), the material and phenomenological presence of *Blue Cell* combined aspects of painting and sculpture, while forcing itself into the viewer's space.

Halley's use of materials and his references to minimalism engage with the death-of-painting debates of the period and offer a tongue-in-cheek commentary on artists' processes of creation, since the Roll-a-Tex acts as a portable, easy-to-use impasto. This prefabricated, textural material invoked Stella's and the minimalists' workmanlike techniques and industrial processes of fabrication. In works such as *Day-Glo Prison*, Halley openly acknowledged the artificiality of these materials, which suggested that the act of painting had become an increasingly regularized, nonemotional activity. His deconstructive approach represented a new outlook on modernist painting. A statement by Taaffe summarized this new attitude: "We've gotten to the point now where it's been proven that painting cannot be killed, you can't kill painting. It won't die, and we have to accept that fact."[47] While some consider early modernist abstraction a golden age of artistic production, Halley invoked a different view:

> The modernism I grew up with was that it was spiritual, it was about a kind of purity and Emersonian transcendentalism, and that it had a very linear history. Feeling less and less comfortable with that, I decided that for me modernism was really about skepticism, doubt and questioning. Things that we now say are part of a postmodern sensibility.[48]

Due to the light that Halley's paintings shed on the sociocultural and sociopolitical phenomena of the 1980s, the connection between his work and Foucault's writings are worth examining. Halley's first works, with their schematic depiction of prison cells, visually respond to the question raised by Foucault in *Discipline and Punish*: "Is it surprising that prisons resemble factories, schools, barracks, hospitals, which all resemble prisons?"[49] In Halley's *Freudian Painting* (1981), the uniformity of the beige background functioned to reduce all space such that it seems to possess a restrictive, confining hold on the two squares. Frozen within this two-dimensional surface plane, the larger squares are accentuated by smaller, inner squares that display a black prison-bar structure. In this large-scale early work, the two-toned beige conjures up images of the neutral colors

FIGURE 4.13
Peter Halley, *Freudian Painting*,
1981. Acrylic and Roll-a-Tex on
unprimed canvas, 72 × 144 in.
Image courtesy the artist.
© Peter Halley.

habitually used in the decoration of hospitals and offices. Operating as a quick referent to prison cells, the simple, black lines function less to bar off an interior space—for there is no perspectival space in the painting—than to provoke the viewer's reaction. The juxtaposition of the beige with the straight black lines is meant to suggest the mental prisons caused by institutional power structures that restrict thoughts and actions. The normality of the colors and their disinterested tonality is appeasing, while the prison referents and their insinuations can be visually alarming. *Freudian Painting* served as an early example of this key characteristic of Halley's works, namely that the viewer was arguably both attracted to the cultural signs and dismayed at their implication, coerced into witnessing a side of reality he or she did not necessarily want to see.

White Cell with Conduit (1982) evokes aspects of social reality that are customarily concealed. In this work, Halley depicted an underlying superstructure of conduits supporting a larger, unified white cell. Foucault's description of the Panopticon comes to mind: "Our society is not one of spectacle, but of surveillance; under the surface of images, one invests bodies in depth; behind the great abstraction of exchange ... the circuits of communication are the supports of an accumulation of knowledge; the play of signs defines the anchorages of power."[50] Stemming from Jeremy Bentham's nineteenth-century ideas on prison reforms,

FIGURE 4.14
Peter Halley, *White Cell with Conduit*, 1982. Acrylic, fluorescent acrylic, and Roll-a-Tex on canvas, 62 × 48 in. Image courtesy the artist. © Peter Halley.

the Panopticon is a model in which prisoners are separated from each other and under the observation of watchmen in a panoptic tower from which they can see everything. The notion of self-observation arises in that the prisoners do not know when they are being viewed. The idea of constant surveillance served as a model for the technological changes that arose in Halley's day. Baudrillard marked the television as the end of the panoptic vision due to its capacity to collapse the active and passive gaze into a single, all-encompassing virtual world of hyperreality.[51] The rise of the telecommunications industry with its wealth of networks and digitized circuitry presented a new globalized vision of connectedness represented by computer monitors, video games, and databanks. In his 1984 essay "The Eclipse of the Spectacle," Jonathan Crary, who served as an intellectual reference for Halley, outlined this shift and pointed to the semiconductor chip as a "quintessential object of 1980s capitalism … that amplifies and codifies power."[52] Like the integrated circuit boards sending pulses of information every microsecond, Halley's white cell is sustained by a network of lines that reflected the structural mechanisms of this digitalized global configuration. He derived the cell and conduit structure of his work from research he conducted at the New York Public Library on the schematic plans of computers, on building and drainage networks, and on the increasingly complicated structure of cities.[53] Isolated areas of these plans were incorporated into Halley's paintings and, later, into his large-scale installations. Halley commented, "By the time I had codified that system of imagery—of cells and conduits—I began to feel that I had come up with a kind of paradigm, or model, or representation of a very basic kind of space and spatial experience in our society. And the fact that it was so hidden made it seem all the more interesting to me."[54]

Jameson described the period of late industrialism as the "purest form of capital yet to have emerged, a prodigious expansion of capital into hitherto uncommodified areas."[55] Less the social or political utopia that large-scale industry would like us to believe, in Jameson's view postmodern society builds up a massive profusion of technical information while debasing human relations, by compartmentalizing and specializing some aspects of social living. The expansion of global and multinational companies, such as Microsoft, Apple, and Coca-Cola, took place through various networks linking to diverse parts of the world through satellites, the Internet, and other technological systems. This expansion has produced what Jameson calls "high-tech paranoia," or a fear of the uncontrollable or unmanageable aspects of the complex organization of computer circuits and networks.[56] Neoconceptual artists came of age during the microelectronics revolution, when silicon chips replaced the millions of interconnected transistors previously needed for computer mainframes.[57] The number of films produced from the 1980s forward that have touched on the topics of technology and

cyberspace testifies to the fascination with as well as apprehension of technology and global enterprise; as cases in point, consider *2001: A Space Odyssey* (1968); *Tron* (1982); *War Games* (1983); *Electric Dreams* (1984); *Runaway* (1984); *The Terminator* (1984); *Deadly Friend* (1986); *RoboCop* (1987); *Sneakers* (1992); *Hackers* (1995); *The Net* (1995); *Colossus: Forbin Project* (1998); *Enemy of the State* (1998); *Matrix*, (1999); and most recently *Tron: Legacy* (2010). In its own way, Halley's work reflected these new social conditions and his paintings were purposefully meant to conjure up such associations. Thus, the artist specifically mentioned the film *Tron* as influencing his thoughts and work in the early 1980s.[58]

However, the socially driven goals of Halley's art in the 1980s seem as utopian as the modernist impetus that inspired many abstract artists in the earlier decades of the twentieth century. As is also the case with much of early modern abstraction, the question of just how effective Halley's paintings are in their didacticism is still up for debate. Yet to the knowledgeable viewer, Halley's formal, abstract, art historical references vied with larger diagrammatic signs of the external world in a uniquely ambiguous manner. To contemplate Halley's work is to grapple with these obstinate and irreconcilable factors.

For Halley and the other neoconceptual artists, irony and pastiche, or an imitation of previous works, were powerful techniques used to deconstruct overarching ideological constructs. Halley openly identified these qualities in his work, commenting that his paintings contain a great amount of irony and play.[59] Like a marketing guru of the art world, Halley took themes and issues that held specific meanings and connotations in certain sociopolitical settings and transferred them into a different context. He hyperrealized art historical motifs as well, stating "if you take a glowing transcendental image in a Rothko, in my work that is replaced by Day-Glo. I also often say that I've taken Newman's zip and made it into plumbing."[60]

Neoconceptual artists worked within the framework of conceptualism to produce paintings and sculptures that operated as a set of pictorial signs referencing artists and moments in postwar art history as well as the critical debates surrounding these narratives. Two decades after the 1966 "Primary Structures" exhibition at the Jewish Museum effectively launched the minimalist movement, artists working in New York in the 1980s were still caught within a significant art historical and critical debate concerning the relation between the work of art and the commercial market. Like Stella, Halley struggled with formal and material concerns in his work. Halley and other artists working in New York during the 1980s, such as Levine, Bickerton, and Steinbach, built upon the complication of the artistic process propagated by Stella and the other minimalists. Works by Koons, Steinbach, and Bickerton combined the look and feel of consumer goods and of the commodity culture with art that incited questions regarding the boundaries

between these realms. Neoconceptualism does not quite have the look and feel of traditional forms of painting and sculpture, but it does not give way to the form of a pure commodity either. These artists transported the formal vocabulary of minimalism and conceptualism into a new mode of sociocultural existence that referenced the accelerated commercialism and economy of the 1980s.

NEOCONCEPTUALISM AND THE PICTURES GROUP

5

When neoconceptual artists arrived on the New York art scene in the early 1980s, they intermingled with an equally young and ambitious set of artists. Richard Prince and James Welling reproduced segments and clippings of advertisements. Barbara Kruger's large-scale photographic assemblages imitated the strong language and dictates of advertising companies. Cindy Sherman's photographs replicated Hollywood imagery of women in domestic and urban situations. This so-called Pictures generation commented on aspects of history, society, and the culture industry, but from the standpoint of photography, film, media, and advertising.

The aim of this chapter is to demonstrate how this loose group relates to the neoconceptual artists and to examine the commonalities and differences between these United States-based artists. These two groups shared some common artistic sensibilities, as well as some personal and professional connections. Additionally, they showed together in many exhibitions in the mid to late 1980s. Artists associated with the Pictures generation and neoconceptual artists interacted in various ways in New York during this period and developed comparable, theoretically informed strategies that analyzed the terms and limits of historical narratives. All of their work elicited a subversive relationship with the historical tenets of modernism, the art market, mass media, and commodity capitalism. The formal and semiological ambiguities created by these artists' work related to the critique of overarching historical structures by structuralism and poststructuralism.

As is the case with artists associated with neoconceptualism, curators and scholars who have addressed the Pictures generation have encountered a similar difficulty with nomenclature and the categorization of such a diverse range of independent-minded artists who seemingly belonged to one cohesive movement. Certainly, the intercontinental roots of the artists and the proliferation of their artistic activity did not lend itself well to the limitations of historical compartmentalization.

Nevertheless, Douglas Eklund and Ann Goldstein have each made a case for the Pictures generation, arguing that they were the last cohesive movement in contemporary art.[1] In my view, the same might be said about neoconceptualism. Further, Eklund's introductory assessment to the Metropolitan Museum of Art's 2009 exhibition catalog on the Pictures generation also applies, perhaps more so, to neoconceptualism. He comments: "They synthesized the lessons of Minimalism and Conceptualism, in which they were educated, with a renewed (though hardly uniform), attention to Pop art because it chimed with the new, media-driven world they had inherited."[2]

In many ways, neoconceptual work may be seen to have continued the Pictures group's errand of undermining aspects of art history and commodity capitalism. Indeed, many of the artists viewed their work in this manner. Neoconceptual artists were reacting to what some of them viewed as dry and analytical photo-based work.

In addition to the relationships that existed between members of these two groups of artists, they were collectively the first American artists to address theories of poststructuralism and deconstruction in their work. Starting with Douglas Crimp's "Pictures" show at Artists Space in New York City, curators and scholars have examined the theoretical underpinnings of the Pictures artists. However, biases against the mediums of painting and sculpture at the time prevented critics and art historians from perceiving the critical edge of neoconceptual work. As discussed in chapter 2, a thorough examination of the work of neoconceptual artists alongside theoretical sources allows for a reading of the critical strategies used by these artists. Together, the Pictures and neoconceptual artists drew from the example of conceptualism, and both manipulated popular and theoretical sources and the desire to comment on the sociocultural phenomena of their time: namely, shifts in historical paradigms, the rise in media culture, and commodity capitalism.

The 1977 "Pictures" exhibition at Artists Space is cited as generating a new group of artists, who were informed by media imagery and strategies of appropriation. Crimp's exhibition launched the careers of those artists included—Sherrie Levine, Troy Brauntuch, Jack Goldstein, Robert Longo, and Philip Smith—as well as several others who later became associated with the group through Metro Pictures Gallery, including Prince, Kruger, and Sherman. Crimp had been friends with Helene Winer since 1974, and she became director of Artists Space a year later. When Winer opened Metro Pictures in 1980 with Janelle Reiring, it marked a turning point in New York's growing art scene, which had hitherto been concentrated around a handful of artists and alternative art spaces. Metro Pictures' first exhibitions included many of the artists named above. The new gallery accommodated a burgeoning New York collector base and was considered a major

promoter of the work of this new generation of artists. Reiring, who had worked at the Leo Castelli Gallery, forged new markets for their work.

Yet when "Pictures" debuted in 1977, the artists were relatively unknown and Crimp was himself a student at The Graduate Center, CUNY, studying under Rosalind Krauss. The "Pictures" show allowed him to apply the new poststructuralist theories he was studying to contemporary photography. It also allowed Crimp, who became managing editor of *October* magazine in 1977 as well, to advance the premises of the journal by promoting a theoretically informed construction of the content of new photographic and media-based art. Crimp argued that many of the Pictures artists commented critically on the media and on commodity capitalism by manipulating the favorite mediums of these industries, namely photography and film.

Crimp has since appeared in the historiography of the period as the promoter of a new, deconstructive mode of photography, film, and new media that drew from recognizable imagery in media advertising in a new form of insider critique. Pictures and appropriation artists putatively used the strategies of the culture industry against itself in ways that called attention to its covert mechanisms of persuasion and control. Using examples of work by Sherman, Longo, and Brauntuch, Crimp argued that these artists' manipulations of historical and commercial imagery simultaneously fetishize and criticize their sources, in that their appropriative acts created distance from the original image and, in turn, a space for critique. Although Crimp cited Barthes's 1977 book *Image, Music, Text* in his articles on "Pictures," he never fully discussed the connections between appropriation and French theory. In his 1979 follow-up to the "Pictures" show, Crimp promoted the work of the Pictures artists as illustrating a "predominant sensibility" among a new generation of artists whose work "is not confined to any particular medium; instead it makes use of photography, film, performance, as well as traditional modes of painting, drawing, and sculpture."[3] But, one year later, Crimp hailed photography as the quintessential medium for evoking the conditions of postmodernism.[4]

Recent exhibitions, such as Douglas Ecklund's "The Pictures Generation" (2009) and "Jack Goldstein x 10,000" (2012), and publications such as Richard Hertz's *Jack Goldstein and the CalArts Mafia* (2003), to name a few, have recounted the early days of Metro Pictures and the artists associated with the gallery, some of whom studied at CalArts under John Baldessari and Allan Kaprow. Another group, which included Cindy Sherman and Robert Longo, came to New York from Buffalo, joining artists such as Laurie Simmons and Louise Lawler, who were already working in New York. Somewhat less discussed, however, is the role painting and sculpture played among this group and the diverse exhibition roster at Metro Pictures in the early 1980s, which also included the

painters Walter Robinson and Thomas Lawson, and several group shows featuring neoconceptual artists Ashley Bickerton, Allan McCollum, Peter Halley, Haim Steinbach, and Sherrie Levine. In addition to Levine's photography, Metro Pictures also showed the paintings she created beginning in 1985.

While some work by Koons and Steinbach grappled with art history and class politics, Goldstein and Brauntuch delved into historical source material from World War II. These Pictures artists manipulated imagery associated with the Nazi regime in two of their works, Goldstein's *The Jump* and Brauntuch's *Untitled (Mercedes)*, both of 1978, in ways that raised questions about the presentation of history. Goldstein's now famous film *The Jump* was included in Crimp's "Pictures" exhibition. Goldstein manipulated the original footage from Leni Riefenstahl's chronicle of a diver from the 1936 Berlin Olympics, a fact not mentioned in Crimp's early essays.[5] In the film, the figure performs a somersault from a high board. By isolating the figure in gold tint and removing the contextual background imagery, Goldstein made the shimmery diver appear to perform leaps and turns in midair. Crimp states, "In making this picture of a dive, Goldstein is performing a set of operations that isolate, distill, alter and augment the filmed recording of an actual event. He does this in order to impose a distance between the event and its viewers because, according to Goldstein, 'it is only through a distance that we can understand the world.'"[6] Goldstein's simple yet subversive technique shifted the relationship between the sign of the diver and its customary referent. The realistic image of a diver was replaced with a newly aestheticized rendering that emphasized the movement of the figure—an act that is based on Riefenstahl's own aestheticized representation of the Olympians' idealized, muscular bodies. Underneath the glittery lights that compose the figure, reminiscent of the flashing illumination found on street signs and discotheques in the 1970s, lies the darker history of Riefenstahl's association with Nazi Germany.

The 1936 Olympics marked the height of Hitler's regime. While other European countries suffered from the aftermath of economic depression, Germany's economy was on the mend. Thanks in part to American businessmen including Henry Ford, Nazi Germany maintained a stable economy and low unemployment rates. In 1936, Hitler was a highly regarded figure, and signs of the pending Nazi aggression were not yet visible. Yet construction had already begun on several concentration camps, and Jewish citizens were beginning to leave Germany. The participation of an all-white, non-Jewish German Olympic team accentuated the ethnocentric underpinnings of Hitler's regime. At the same time, African-American track and field athlete Jesse Owens broke the racial divides by winning four gold medals in the 100- and 200-meter races, the long jump, and the 100-meter relay.

Deferring this broader historical context, Goldstein's video relayed only the physical motion of the diver's body. It's likely that most viewers watched his

FIGURE 5.1
Jack Goldstein, *The Jump*, 1978.
16 mm, color, silent, 26 min. Image
courtesy Galerie Buchholz, Berlin/
Cologne and The Estate of Jack
Goldstein.

FIGURE 5.2
Troy Brauntuch, *Untitled
(Mercedes)*, 1978. Photo C-prints,
three prints: 72 × 96 in. TB
08/035. Image courtesy the artist
and Petzel, New York.

doctored film clip from the 1936 Olympics without knowledge of or attention to its historical circumstances. Goldstein reworked the original imagery to such an extent that any reference to Riefenstahl's original footage was not discernible. Moreover, Crimp did not mention the connection to Riefenstahl's film, but merely referred to Goldstein's source material as "stock footage."[7] As Eklund and Philipp Kaiser have since pointed out, Goldstein did not openly reveal the source.[8] His work relied on a knowledgeable viewer in order to contemplate its full meaning and generate a possible critical dialogue. Without access to these historical connotations, *The Jump* remained simply a short art film. Building on Crimp's analysis and taking the historical source into account, Goldstein's appropriation contaminated or weakened the political context and effect of the original image. This attenuation allowed for shifts in focus from the representation of reality to an examination of the structural operations behind it.

Brauntuch's three-part work *Untitled (Mercedes)*, first exhibited in a solo show at the alternative art space The Kitchen in New York in 1979, reexamined the documentation of the Nazi regime during World War II. It consisted of two vertical images framed in black, bracketing both sides of a horizontal image framed in red. On the left side of the center panel is a photograph taken from the back seat of a car, composed of the driver and a passenger in the front seat. Wearing an old driving cap, the passenger's head is slumped, as if he has passed out. To the right of the photograph is a close-up of a building that appears in the background of the image in the car. In a technique similar to Levine's early photographic work, Brauntuch rephotographed the 1934 photograph *Hitler Asleep in His Mercedes* from Albert Speer's memoir *Inside the Third Reich*, published in 1970. Speer, who was Hitler's chief architect and a government minister, provided insight into the inner workings of the Nazi party in his bestselling book. The vertical side images of *Untitled (Mercedes)* reproduced the vertical light effects used to illuminate Speer's 1937 Zeppelinfeld Stadium on the Nuremberg parade grounds, which the architect surrounded by 130 antiaircraft lights. On an adjacent gallery wall at The Kitchen, Brauntuch displayed *Play, Fame, Song* (1975–1976) next to appropriated drawings by Hitler.

Within the full context of their source imagery, Brauntuch's and Goldstein's works can be seen as perhaps a *clin d'oeil* to earlier artists' use of highly charged words and symbols. Unlike neoconceptual work, however, the Pictures artists are less involved in an intertextual sampling of earlier styles than pursuing a common interest in subject matter that had been taken up over a decade earlier. Minimalist painter Frank Stella referenced the Nazi Party in the titles of two of his *Black Paintings*: *Die Fahne hoch!* (1959), which refers to the first phrase of the Nazi anthem, "The Flag Up High," used from 1930 to 1945; and *Arbeit Macht Frei* (1968), which translates as "Work will make you free" and refers to the slogan

FIGURE 5.3
Troy Brauntuch, *Play, Fame, Song*, 1975–1976. Photo C-prints on white wood shelves, each part (triptych) 11 × 8 in. TB 08/023. Image courtesy the artist and Petzel, New York.

placed at the entrance to a Nazi concentration camp.[9] Walter De Maria's *Museum Piece* (1967) consisted of a swastika fabricated in aluminum. The geometric arms of the potent symbol served as channels for an aluminum ball that potentially rolled along the track. While these earlier works reflected the postwar climate of Greenbergian formalism, which favored discussions of the formal qualities of art, the later generation questioned the seamless and linear accounts of historical moments.

As Kaiser and Johanna Burton have briefly discussed, Goldstein's and Brauntuch's works convey renewed interest in topics related to World War II during the early to mid 1970s.[10] Susan Sontag's essay "Fascinating Fascism," published in the *New York Review of Books* on February 6, 1975, also focused on this revival of interest. In her discussion of Riefenstahl's book of photographs *The Last of the Nuba* (1974), Sontag argues that the publication conveniently manipulates history, glossing over the filmmaker's involvement with the Third Reich in an effort to promote her artistic work. While Sontag's essay reads as a personal attack on Riefenstahl, her comments also contain a broader cultural assessment of fascism, which had begun to attract, rather than repel, U.S. audiences in the mid 1970s, due to the generational distance from the tragedies of World War II.[11] She comments, "For those born after the early 1940s, bludgeoned by a lifetime's

palaver, pro and con, about communism, fascism—the great conversation of their parents' generation—represents the exotic, the unknown."[12] As evidence, Sontag cites cultural markers of the period exhibiting fascist themes, such as Robert Morris's self-portrait advertising his 1974 solo exhibition at Castelli and Sonnabend galleries, in which the bare-chested artist is wrapped in chains and wears a Nazi helmet.

The Pictures generation, having had less physical and emotional proximity to the war and the holocaust, turned to this once off-limits subject with a fresh set of eyes and a new frame of reference. At the root of De Maria's sculpture and the title of Stella's painting are linguistic exchanges between sign and signifier demonstrating that the subject of fascism was on the minds of the earlier generation as well, but with greater urgency and resonance. While viewers may not have well understood Stella's *Black Paintings* at the time, they would likely have recognized the allusions in the form of the painting's title. De Maria's symbolism was similarly overt. Further, the latter's work turned the Nazi symbol into a game with several potential connotations. The ball and its course of movement suggest amusement and frivolity that contrast with the sculptural form and its symbolic associations. As such, the work is intended to shock. Since the swastika conjures the death and torture of millions of Jews, De Maria's gesture suggests the Nazis played with millions of lives for their own amusement. In Stella's case, he may have been looking at the same sources as Goldstein several years later. Commenting on the significance of the titles to William Rubin, the curator for his 1970 MoMA exhibition, Stella stated: "The feeling of the painting seems to me to have that kind of quality to it—Flags on High—or something like that. ... The thing that struck in my mind was the Nazi newsreels—that big draped swastika—the big hanging flag— has pretty much those proportions." Rubin noted that Stella recalled seeing Riefenstahl's film footage in documentaries.[13]

The Pictures artists addressed the subject in a slightly more studied and less communicative manner that related to the persuasive, subliminal messages of the media. While Goldstein directly samples stills from Riefenstahl's film, he masks them with the flashing rotoscope technique. Brauntuch's rephotographed image of Hitler underwent cropping and the artist's collage technique. As Goldstein indicated, his focus was the display: "Many of the images I used were from the Third Reich. I was interested in spectacle and war is spectacle; the Third Reich was pure spectacle. They certainly understood the media, didn't they?"[14] Goldstein's fascination with fascism as theater supports Sontag's arguments. His film transformed Riefenstahl's already aestheticized renderings into the equivalent of Hollywood media glamour. In fact, Goldstein used Hollywood props and professional technicians to enhance Riefenstahl's presentation of the Olympic Games as a world spectacle of athletic achievement by transforming the diver into a flashy

version of the original. A sparkling, twisting form representing the latest techno-logical image enhancements replaced the old black-and-white imagery of athletic competition. Likewise, Goldstein's *Metro-Goldwyn-Mayer* (1975) showed the movie studio's trademark lion roaring ad infinitum, locked within a two-minute film loop. As curator Chrissie Iles points out, Goldstein's early films are characterized by a high degree of professionalism and expertise.[15] They were shot in 16mm, as opposed to Super 8, which required little technical expertise. In the execution of his film *Shane*, Goldstein tinted the film gold to make a German shepherd dog's coat appear more polished and shiny. In short, Goldstein availed himself of the resources of the Hollywood film industry, much as Steinbach and Koons availed themselves of commercial products. Similarly, Richard Prince saved sections of advertisements during his day job as a "clipper" monitoring advertisements for Time Life magazines, and simply reproduced them in works such as *Untitled (Living Rooms)* of 1977 or *Untitled (Fashion)* of 1982–1984. Prince's work then consisted simply of his decision to reproduce an advertisement and position it within a museum or gallery setting.

The underlying subject of Goldstein's *The Jump* was his act of appropriation and rewriting this small moment in history. Although Crimp did not discuss the work exactly in these terms, when it is viewed as a manipulated version of Riefen-stahl's film, *The Jump* raises questions about the authority of the original images, and essentially turns the historical imagery back onto itself. *The Jump* replaced one mediated vision of reality with another disruptive version, prompting the knowledgeable viewer to rethink how history is presented. Likewise, Brauntuch's twice-removed photograph added new meanings to Speer's memories of Hitler and the remnants of the Nazi regime. The physical and temporal distance between Speer's and Brauntuch's photographs allowed for contemplation of the historical and social changes that had occurred since the image of Hitler was taken in 1934.

Comparable to Sherrie Levine's *After* series or Philip Taaffe's paintings bor-rowing from little-known artists such as Myron Stout (discussed in chapter 2), Goldstein's and Brauntuch's work displayed the desire to question or rewrite the terms of history. Crimp argued that the work gave viewers a chance to visualize their world differently: "For their pictures, these artists have turned to the available images in the culture around them. But they subvert the standard signifying func-tion of those pictures, tied to their captions, their commentaries, their narrative sequences—tied, that is, to the illusion that they are directly transparent to a sig-nified."[16] This subversion or distance between the original and the manipulated image arguably exposed the structural mechanisms behind the creation of media imagery and photographic representations of the everyday. Crimp asserted that the theatricality of minimalism—with its "literal temporality and presence of the-atre"—was "reinscribed" in the work of Sherman and the Pictures generation,

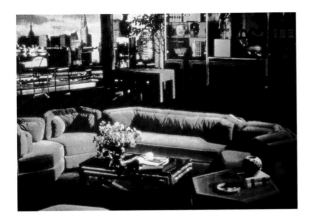

FIGURE 5.4
Richard Prince, *Untitled (Living Rooms)*, 1977. Set of four Ektacolor photographs, each 20 × 24 in. © Richard Prince.

FIGURE 5.5
Richard Prince, *Untitled (fashion)*, 1982–1984. Ektacolor print mounted on sintra, 67⅞ × 39¾ in. © Richard Prince.

which was equally grounded in the performance art of the 1970s and the work of Bruce Nauman, Dan Graham, and Peter Campus.[17] Crimp specifically linked the postmodern principles of phenomenology and duration to the medium of photography as opposed to painting and sculpture, which he associated with a modernist tradition.

While some of Goldstein's early films examined the repercussions of reusing historical imagery, other Pictures artists manipulated advertising and commercial print media sources. In a more playful tone, Sherman's now-renowned film stills, in which the artist dressed and posed in shots reminiscent of scenes from B films of the 1950s, can be read as critiquing aspects of the structure, including the voyeuristic quality, of mainstream film. But as with McCollum's *Surrogate* paintings, Sherman's *Untitled Film Still* (1978), to cite one example, raised more questions than it answered. Art historian Arthur Danto pointed out that the artist's fictitious film stills celebrate a bygone era of Hollywood cinema.[18] By the time they were produced, Danto commented, the type of stills Sherman fabricated or simulated were more likely to be found in a film archive than in mainstream cinemas. Sherman's focus on the female figure stirred up questions about the role of women as weak sex objects on the "big screen." On one hand, the re-creation of such scenes by a female artist arguably attributed a level of agency to women. Similar to the technique of 1920s surrealist photographer Claude Cahun, Sherman's self-portraiture might be said to subvert the operations of a straight male's gaze on a passive female subject. In these photographs, Sherman acted as an agent by choosing to position herself as the object of desire. On the other hand, despite Crimp's celebration of Sherman's images for their fragmentary and deconstructive quality, it could be argued that these images simply reproduce the tropes of the culture industry and effectively reinforce such feeble roles for women. So imperceptible are the distinctions between many of Sherman's photographs and the imagery of Hollywood cinema that some viewers reportedly claim to know the films from which the stills were taken.[19]

Goldstein's, Prince's, and Sherman's work muddied the boundaries between the culture industry and the work of art to the point that only context allows any distinctions to be made. In some cases, the museum or gallery within which these works are placed functions as the sole distinguishing factor separating them from the everyday world of commercial advertising or the film industry.

Although Crimp's "Pictures" exhibition has since gained art historical importance for launching a new generation of photography- and video-based artists, it presented a very limited representation of the larger body of work, including painting and sculpture, that was being produced by CalArts graduates and other artists working in New York during the late 1970s. Artists Space's policy of not showing the work of an artist more than once affected some who otherwise could

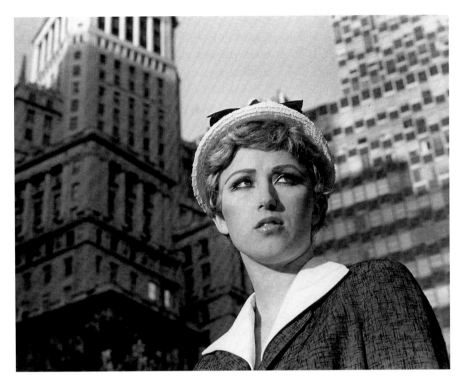

FIGURE 5.6
Cindy Sherman, *Untitled Film Still*, 1978. Gelatin silver print, 8 × 10 in. (image size). Edition of ten (MP #21). Image courtesy the artist and Metro Pictures.

have been included in "Pictures." CalArts graduates and painters Matt Mullican and David Salle were left out, for example, despite their relevance to the Pictures group.[20] After completing an M.F.A. at CalArts in 1975, Salle moved to New York and had his first show at Artists Space in 1976. Although he is predominantly known as a painter who benefitted from the tutelage of Baldessari, Salle's early work consisted of manipulating or appropriating advertising imagery in work such as *Untitled* (1973). In this series of six prints, Salle recreated the look of advertising by snapping wistful shots of his female friends in the kitchen drinking coffee, and then affixing coffee labels to the bottom of each image. In contrast with Prince's practice in his 1978 *Untitled (Couple)* or *Untitled (Fashion)* (see figure 5.5), the attachment of the labels to the bottom of the image gave the series a collage-like, handmade quality that prevented these particular works from being read as straight advertisements.

Although from today's perspective the Pictures group, neoconceptual artists, and artists using appropriation seem to have been distinctly separate groups, there were many connections and overlaps among the artists. In 2003, Sherman commented:

> I didn't think of it as appropriation, that idea hadn't crystallized at the time. All those ideas that came down, and continue to come down—I never really gave a thought to them until I read them. In the later '80s, when it seemed like everywhere you looked people were talking about appropriation—then it seemed like a thing, a real presence. But I wasn't really aware of any group feeling. It was a pretty competitive time. It wasn't just photographers or appropriation artists versus painters; there were so many different factions—the Mary Boone artists versus the Metro Pictures, the neo-geo ...[21]

In the years before and following the "Pictures" exhibition, Winer, then the director of Artists Space, organized many noteworthy photography and video exhibitions of work by artists Dara Birnbaum, Barbara Bloom, Prince, Laurie Simmons, and Michael Smith. Neoconceptual artists were also being shown at Artists Space during this period, including Steinbach in a solo exhibition in 1979 and Bickerton in a solo exhibition in 1984. Koons was included in several group shows at Artists Space, such as "Hundreds of Drawings" in 1983, also with Steinbach, and "A Likely Story" in 1982. Halley was included in the "Selections" show in 1984, and Levine was in Artists Space's "Tenth Anniversary" show, also in 1984. Metro Pictures Gallery—typically regarded as promoting only the work of the Pictures artists—showed the work of several neoconceptual artists in five different exhibitions between 1984 and 1988.[22]

After the major economic recession of 1981–1982, the SoHo-based Metro Pictures Gallery, once a strong supporter of Pictures artists, began showing neo-expressionist painting, which was generating stronger sales.[23] As the younger East Village artists tried to gain the attention of blue-chip galleries in SoHo, some Pictures artists such as Levine, McCollum, and Prince moved into the East Village. Prince and Levine began showing at Baskerville + Watson Gallery. Howard Singerman describes Levine's reverse transition to the younger, more energetic, and bohemian East Village scene as a "move that worked to align her quite specifically with a different generation and a younger set of names," that is to say, neoconceptualism.[24] The work of the Pictures artists was shown alongside neoconceptual work in some exhibitions at this time. For example, the 1984 "Science Fiction" exhibition at the SoHo-based John Weber Gallery featured the work of Prince, Halley, Koons, Judd, Smithson, R. M. Fischer, Taro Suzuki, Jim Biederman, and David Deutsch. International with Monument featured Prince's work in a

solo show in 1985. The East Village gallery also showed the work of Halley, Sarah Charlesworth, Koons, Peter Nagy, and Laurie Simmons in a group show in 1986. Similarly, the exhibition "Spiritual America" curated by Trisha Collins and Richard Milazzo at the CEPA Gallery in Buffalo, New York, also in 1986, included the work of Gretchen Bender, Charlesworth, Nancy Dwyer, McCollum, Halley, and Koons, among others. Some neoconceptual artists were directly involved with appropriation art in the late 1970s, in the case of Levine and McCollum, or they were taught by appropriation artists, as was true of Bickerton.

Although the Pictures generation is now considered to encompass mostly photography-based practices, this was not necessarily the case at the time. In fact, photography was one of many mediums being explored during this period of experimentation from the late 1970s to the mid 1980s. As mentioned earlier, David Salle produced photographs before turning to painting, which became his signature medium. Robert Longo became famous for his 1979 *Men in the Cities* series, which consisted of large charcoal-and-graphite drawings of individuals in various contorted poses. Created by projecting film stills onto paper, these works merged the two mediums of film and drawing in a new, thought-provoking manner. Some of Longo's early works, such as *The Silence* (1977), use the same industrial materials as Bickerton's paintings and display a similarly fresh and shiny appearance. *The Silence* is a cast-aluminum relief, lacquered with coats of bright red automobile paint. Brauntuch and Goldstein also produced sculptures, drawings, sound recordings, and paintings during this time, in works such as Brauntuch's *Three Effects* (ink rubber-stamped on paper) and Goldstein's *A Suite of Nine 7-Inch Records with Sound Effects* (sound recordings on colored vinyl discs), both from 1977.

Goldstein turned to the traditional medium of painting in 1979 (like Levine a few years later), remarking, "I didn't want to be this guy who did these performances and films, and that's how people would talk about me. All these other guys were painters. Troy [Brauntuch] was a painter. ... So it was just a matter of moving into still images."[25] In 1984, Goldstein exhibited his paintings at the East Village gallery Cash/Newhouse. His paintings were based on found imagery and were actually produced by Bickerton for four years while he assisted Goldstein in his studio. After Bickerton left his studio, the paintings were produced by commercial artists. Comparable to Levine's appropriative strategies in her *After* works and *Check* paintings, Goldstein's act thwarted notions of authenticity and autonomy that are commonly attached to the medium of painting. His technique was meant to fully detach the hand of the artist from the creation of the work. The paintings were produced with spray guns, as Jules Olitski had done a decade earlier. The airbrush technique intensified this distance, as did the forms themselves, which were generated by computer, and the artist's decision to sign the works using stencils.

Eklund's 2009 exhibition "The Pictures Generation: 1974–1984," and its catalog, explored that group's early beginnings at CalArts. In his review of the exhibition, Singerman points out that Eklund's construction of an "Oedipal narrative" allowed the curator to "bring out a ready-made … cast of characters to enact an old art-historical narrative: the relationship of fathers and sons."[26] Eklund's narrative somewhat complicated Crimp's account of the Pictures group as débuting with his 1977 "Pictures" show. Baldessari's witty video *I Will Not Make Any More Boring Art* (1971), for example, featured the artist writing out the work's title on lined paper for thirteen minutes like a punished schoolboy. Baldessari's ironic work *What Is Painting* (1966–1968) textually described the basic components of painting using words painted on canvas, instead of images. In Eklund's account, works such as Baldessari's *The Spectator Is Compelled …* (1966–1968) served as a precursor to the work of the Pictures group due to its incorporation of text and images in a similarly unconventional, structuralist manner. *The Spectator Is Compelled …* played with the associations between an image and its caption by displaying a photograph of a man, facing away from the camera, standing in the middle of a street in Los Angeles. Below the image are the words, "The spectator is compelled to look directly down the road and into the middle of the picture." Baldessari's work caused the viewer to contemplate the meaning of the words in association with the image. Baldessari's works, created by professional sign painters hired by the artist, focused on ideas, language, and actions rather than the formal components of painting.

Critic Eleanor Heartney now describes Pictures work as dry and analytical and as constituting an anti-aesthetic, in contrast to neoconceptualism's seductive, object-based approach. Neoconceptual works were more hedonistic, incorporating flashy colors, materials, and new objects, and responded ambivalently to the rise in the market over the course of the early to mid 1980s. These market changes were not yet apparent during the height of the Pictures group in the mid to late 1970s. In an interview, Heartney recalled:

> There was a kind of asceticism to [the Pictures group]. It was not meant to be seductive. It was anti-seductive. [The Pictures group] would take these seductive images but then deal with them in a more analytical way. The *sentiment* of desire was in quotes, but was taken away from the actual artworks. Whereas the notion of desire was inherent to Neo-Geo works. They were about seduction. It was about making seductive objects and how objects seduce us, for commodity purposes, but also psychologically, how we surround ourselves with objects and how they provide us with a sense of who we are. Neo-Geo was also concerned with the notion of art as an object that is seductive. That was an important part of the work. Pictures gave Neo-Geo a critical framework, but it had a very different dialogue.[27]

Neoconceptual work generally addressed the issues of simulation, representation, and consumer desire in a more tangible manner than the Pictures work, which also incorporated visual signs and commodities taken from everyday life. As discussed in chapter 4, Halley created paintings using Day-Glo paint and Roll-a-Tex, a building material used to coat the walls and ceilings of office buildings and homes. While some Pictures artists left advertisements effectively untouched when incorporating them in their work, some neoconceptual sculptors used store-bought commodities along with, in Steinbach's case, distinctive shelves made of mass-produced materials, such as Formica. The objects used in sculptures such as those by Koons and Steinbach, for example, are distinguished from the general economy by their placement within a museum or gallery context. Many critics used this characteristic as a strong point of attack against neoconceptualism, while overlooking the fact that it had also characterized much work of the Pictures generation. For their part, Steinbach and Koons directly sampled material goods, creating artworks out of basketballs, aquariums, lava lamps, and inflatable toys, as in, for example, Steinbach's *ultra red #1* (see figure I.1). The result was work that responded to the phenomenon of cultural materialism in a distinct and comparatively direct manner.

Koons and Prince met in New York in 1978.[28] They shared a fascination with material goods and the cult of the new in commodity culture. In contrast to Koons's work, Prince replicated the same simulated version of reality provided by the media and advertising industries. Prince's early photographs, such as *Untitled (Living Rooms)* and *Untitled (Fashion)*, are derived directly from advertisements reflecting the ideals of everyday living. In *Untitled (Fashion)*, a series of close-up images of female fashion models clipped from magazines such as *Allure* prompts viewers to analyze standards of beauty as perpetuated by mass media (see figure 5.5). As Crimp noted, Prince's technique focused "directly on the commodity fetish, using the master tool of commodity fetishism of our time."[29] Turning mass advertising against itself, Prince removed the ads from their original context, thereby thwarting their ability to relay the aura of the commodity. For Crimp, the detached image contained a ghostly presence. *Untitled (Fashion)* relied on repetition to emphasize seriality and mass production in the fashion industry as it cultivates aspiration and yearning for luxury goods. Koons's early sculptures from his *Inflatables* series, created around the same time as Prince's photographs, such as *Inflatable Flower and Bunny (Tall White and Pink Bunny)* of 1979, entailed a related bracketing of the mechanisms of commodity fetishism that were separated from the context of everyday life (see figure 4.3). Prince's and Koons's work both provided commentary on consumer desire, but, at least in this comparison, from opposite ends of the class spectrum. While Prince's work focused on images of opulence and the media's presentation of fictitious standards of living, Koons's

Inflatables series commented on kitsch and the modest use value of certain commodities.[30]

The notion of kitsch arose in the nineteenth century alongside industrial production and the massive proliferation of commodities.[31] Defined, in part, as a source of pleasure for a mass audience, kitsch is typically discussed in a pejorative manner as an inferior copy of a high-art original. It can also refer to an outlandishly excessive style or mode of creation. In the 1960s, pop art was poised at the center of a debate that addressed the interchange between high, low, and middlebrow culture, which had been anticipated by Clement Greenberg in his 1939 article "Avant-Garde and Kitsch," published in *Partisan Review*. Formulating a strong dialectic between the high art of the avant-garde and the low art or kitsch produced for the middle and working classes, Greenberg placed kitsch in opposition to the work of Picasso, Braque, Mondrian, and Kandinsky, for example—artists who were critical of the bourgeoisie, yet paradoxically dependent on them for support. As a product of the industrial revolution, kitsch—or in Greenberg's words, "popular, commercial art and literature with their chromeotypes, magazine covers, illustrations, ads, slick and pulp fiction, comics, Tin Pan Alley music, tap dancing, Hollywood movies, etc."—existed largely as a mode of consumption for the masses.[32] Kitsch reinforced a shared set of cultural sensibilities that appealed to mass taste. While Greenberg believed the lower classes remained largely indifferent to high cultural production, he called upon the avant-garde to defend itself against this invading force, since "the precondition for kitsch, a condition without which kitsch would be impossible, is the availability close at hand of a fully matured cultural tradition, whose discoveries, acquisitions, and perfected self-consciousness kitsch can take advantage of for its own ends. ... It draws its life blood, so to speak, from this reservoir of accumulated experience."[33] As a debased version of high art, kitsch was, for Greenberg, dependent on the whims and forces of capitalism as well as on the avant-garde for its inspiration. Adorno similarly viewed kitsch as a threat to the last remnants of high culture and a means of lulling the masses into ideological submission. He comments: "Its [cheap commercial entertainment] being patterned and pre-digested serves within the psychological household of the masses to spare them the effort of that participation (even in listening or observation) without which there can be no receptivity to art. ... The promoters of commercialized entertainment exonerate themselves by referring to the fact that they are giving the masses what they want. This is an ideology appropriate for commercial purposes."[34]

These types of class stereotypes were problematic, in part because they framed an elitist role for art, a role that failed to account for certain developments at the time. These arguments also unrealistically posited art as a cultural phenomenon that was separated from simultaneously occurring social, political, and

economic events. In his 1975 essay "The Cultural Politics of Pop," Andreas Huyssen discussed the democratization of art that was putatively instigated by the pop art movement with its emphasis on play and frivolity.[35] Art movements of the 1950s onward played with the concepts of kitsch and popular culture in diverse and interesting ways that reflected the sociopolitical environment of the time.

Indiana University professor of comparative literature Matei Calinescu addresses the relationship between kitsch and economic development, in which kitsch depends on the whims of the marketplace and, in turn, on rapid obsolescence.[36] Kitsch is tied to notions of luxury, in that it reproduces an object that once existed as unique and autonomous, transferring the original object's sense of value and status to the new owner. It debases high-art originals to lower standards that are affordable for more people. Cultural historian Celeste Olalquiaga describes kitsch as a "suspended memory whose elusiveness is made ever more keen by its extreme iconicity. Despite appearance, kitsch is not an active commodity ... but rather a failed commodity that continually speaks of all it has ceased to be—a virtual image, existing in the impossibility of fully being."[37] With little or no use value, kitsch can be intimately linked to personal memory, nostalgia, and experience, Olalquiaga argues.

Koons's sculpture taps into these notions of kitsch and deliberately approaches camp through the ironic and playful sensibility evoked by the bunny's large eyes, hot-pink skin, and off-center ears. According to Calinescu, camp, "under the guise of ironic connoisseurship, can freely indulge in the pleasures offered by the most awful kitsch" and "contributed substantially to the kitsch renaissance in the world of high art."[38] In her 1961 essay, "Notes on Camp," Sontag offered an alternative way of perceiving camp that celebrated a sense of pleasure in the popular arts. Sontag appreciated camp as a style because of its excessiveness, artifice, and frivolity.[39] The playful, irreverent *Inflatable Flower and Bunny* represented cheap, mass-produced objects with little use value that are created for broad appeal and purchase. Addressing only superficial desires or the whims of the marketplace, inflatable toys represent the height of commodity fetishism. A cartoon made flesh, the *Inflatable Flower and Bunny* celebrates this irrationality and ridiculousness. At the same time, as an artificial representation of a living plant and animal, it exudes nostalgia for the natural world.

If kitsch "is something with the external characteristics of art, but which is in fact the falsification of art," as Italian critic Gillo Dorfles defines it, then *Inflatable Flower and Bunny* reinscribed kitsch into the realm of high art and in so doing put the general public's aesthetic sensibilities under examination. The sculpture isolates the sentiments of pure enjoyment and frivolity demanded by the concept of kitsch, and as philosopher Tomas Kulka puts it, "the universality of the emotions it elicits."[40] By creating art with such an obvious example of kitsch, Koons was

commenting on the inability of original works of high art to be owned by broad audiences, since they are typically bought and sold at prices that are out of reach to the middle and lower classes. Nevertheless, Koons intended to target the masses in his works, commenting: "And they will be accessible to all, for art can and should be used to stimulate social mobility. … In my work the situation is set up so that the individual from the lower classes feels economic security in a fake situation. … My work is functioning on a wide basis, which means it affects all of society, encouraging a leveling of class differences. At the same time, it tries to reveal the pain of the individual, the dissatisfaction with the system as it exists today."[41] Ironically, *Inflatable Flower and Bunny* was immediately purchased and collected by members of the upper class.

As Roberta Smith summarized the critical operation at work in Koons's sculpture: "Koons's forté is a dazzling visual and conceptual equilibrium in which a recognizable object is drastically transformed, its social function interrupted and supplemented by an esthetic one so that we are forced to weigh both anew."[42] In other words, Koons's *Inflatables* no longer existed as mere blow-up toys, but became metaphorical stand-ins for the unquantifiable aspects of consumerism in postwar society, including the role of kitsch as harbinger of lower-class taste. As Calinescu describes kitsch: "We are dealing here indeed with one of the most bewildering and elusive categories of modern aesthetics. Like art itself, of which it is both an imitation and a negation, kitsch cannot be defined from a single vantage point."[43] Similar to Prince's photographs, then, Koons's sculptures evoked the notion of wanton desire or a physical attraction toward consumer goods that is a regular feature of life in the United States: the objects, values, and lifestyles that beckon consumers.

Koons's more mature works, such as *Rabbit* (1986), continued to play on these issues, but involved a pointed investigation into materiality and illusionism that differed from *Inflatable Flower and Bunny*. Although *Rabbit* appeared to be an inflatable object, it was fabricated in stainless steel. The shiny reflective surface invited a range of comparisons, from everyday kitchen items to liturgical or ceremonial objects.

Koons might be seen to have some commonalities with appropriation artist Barbara Kruger. Kruger's photomontages appropriated the look and feel of advertising with their large-scale format and bold words. While Prince's and Koons's work emphasized the sensuality and appeal of consumer products, Kruger's work functioned in a more piercing manner. Works such as *Untitled (I Shop Therefore I Am)* of 1987 and *Untitled (You Are Not Yourself)* of 1982, drew from the visual vocabulary of advertising to uncover the inner workings of commodity fetishism. In *Untitled (You Are Not Yourself)*, broken mirrors display a fragmented view of a woman as she attempts to gaze at herself. The work brings to mind images of

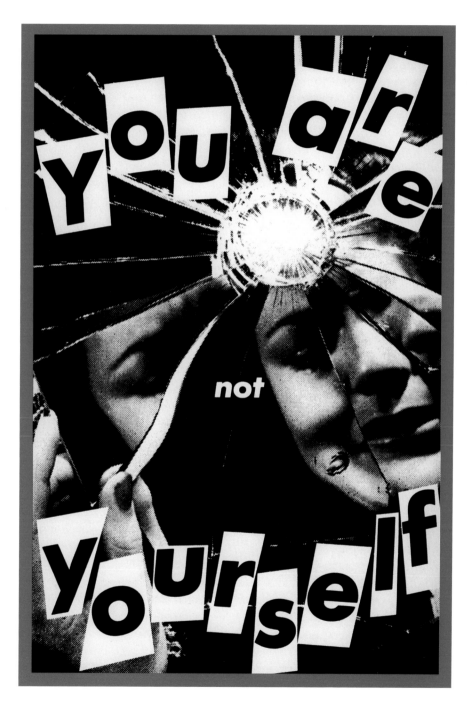

FIGURE 5.7
Barbara Kruger, *Untitled (You are not yourself)*, 1982. Photograph, 72 × 48 in. Image courtesy Mary Boone Gallery, New York. © Barbara Kruger.

women trying on clothes and accessories in department store dressing rooms. In 1992, Mignon Nixon argued that Kruger's fragmented images of female bodies effectively destabilized dominant notions of subjectivity and broke social stereotypes, while also creating the desire to visually reconstitute the image.[44] Nixon commented that the "double displacement not only disturbs the security of conventional viewing positions … but also sets up a different scene by reframing looking as loss or as masochism."[45] In other words, the image reframes the hegemonic vision of women as objects and adds a violent dimension to this point of view. The broken mirror discourages the purchasing of commodities by thwarting any allure they might have had. The statement "You Are Not Yourself" reinforces this attitude of deterrence, suggesting the artifice and falsity of advertisements for the fashion and makeup industries as they promote an unnatural portrayal of women's bodies.

Kruger's *Untitled (I Shop Therefore I Am)* operates on a simpler level, presenting the viewer with an ironic dictum that initially seems to encourage consumerism. A simple gray background highlights a hand holding a sign marked with the words "I Shop Therefore I Am." Kruger reworked the famous statement of René Descartes, "I think, therefore I am," and applied it in a degraded manner to the realm of commercialism. Descartes's statement supported scientific knowledge and reason over sentiment and religiosity during the Enlightenment. Kruger's appropriation of his words suggests the public is unable to think or to reason within capitalism's stronghold, which encourages impulse buying and excessive spending. By taking Descartes's words and applying them in a new manner, Kruger's dictum might seem funny or sardonic to most viewers. Her gesture was based on a strong level of irony that could cause reflection on the artificial fabrication of individuality through clothes or accessories and the ways in which purchased items have the capacity to promote certain facets of an individual's personality.

However, in his review of Kate Linker's large-format book on Kruger, published in 1991, John Loughery questioned the deconstructionist stance of Kruger's artwork-*cum*-advertisements, asking, "How radical a 'social commentator and political agitator' can anyone be who is represented by New York City's high-profile Mary Boone Gallery and whose billboard images are mounted in cities across the world?"[46] He asserted that an installation of Kruger's photographs in a SoHo gallery or in a "lavish coffee-table book," such as Linker's, deflated the critical impact of the work. An image of Kruger's *I Shop Therefore I Am* was even reproduced on tote bags sold by the Whitney Museum of Art. Furthermore, Kruger's long-time background as a designer, art director, and picture editor for Condé Nast Publications can be seen as affording a basis from which to question her work's seemingly adversarial stance toward the advertising industry.

Nevertheless, in a press release for a 1981 exhibition at The Kitchen, called "Pictures and Promises: A Display of Advertisings, Slogans, and Interventions," Kruger described the full spectrum of her work as "magazine and newspaper advertisements, artists' works, television commercials, posters, 'commercial' photography, corporate insignia and public signage ...". But she added, "The quotational qualities of these words and pictures [in her artwork] remove them and their 'originals' from their seemingly natural position within the flow of dominant social directives, into the realm of commentary."[47] Kruger admitted to borrowing the language of commodity capitalism, and described her strategy as a complicit yet critical commentary on these operatives. She reused operations created by capitalism to give the viewer insight into the occasional subversive intentions of this economic system.

While Kruger and Prince mined commercial photography and advertising for their source imagery and visual techniques, Koons and Steinbach mined stores for actual commodities. These artists explored the cultivation of consumer desire, the relationships between individuals and commodities, and the important role objects play in everyday life, as well as in the development of personal or collective identities. Unlike Kruger's and Prince's photographs, however, Koons's and Steinbach's sculptures contained pointed art historical references to previous artists and works. The neoconceptual sculpture functioned in part by drawing from and aggrandizing aspects of the work of earlier, influential artists. In 1988, Koons commented on the differences between his sculpture and Prince's photographs and artistic persona, "Richard and I have been friends for many years. His work is more involved in the appropriation aspect—the aspect of theft—while my work comes from the history of the ready-made."[48] Koons's and Steinbach's sculptures updated the concept of the readymade to study the effects of material culture, how objects function in society, and the external values placed on them.

In 1986, participating with other neoconceptual artists in the *Flash Art* panel, Koons explained the importance of aesthetic contingency within his own work:

> I would like to offer up a term that has vital currency in the process of my own thinking: contingency. I think that through this procession of contingencies, discourses are being pulled together into the object itself, promoting an awareness of the fact that all meanings are contingent upon some other meaning, where meanings are appropriated for their relationship to external forces, the larger social schema in which they're involved.[49]

Koons's description of how an artwork is received and how it relates to the external world comments on the value and placement of art within the art market of the 1980s. Contingency allowed neoconceptual work to carry multiple references

and to produce multiple readings. Koons's work relied on this concept due to its manipulation of the meanings already assigned to ordinary objects and their position inside as well as outside the realm of art.

Peter Halley has said that he now considers his work and that of his neoconceptual contemporaries during this period to be the "Pictures generation two."[50] But, despite their shared theoretical underpinnings and their common attentiveness to contemporary culture, neoconceptual artists distinguished themselves from some Pictures artists by their continued interest in the traditional mediums of painting and sculpture. In the late 1970s, Salle, Goldstein, and Brauntuch paved the way for the younger artists with their transition to painting. Further, Eklund's characterization of the Pictures generation as "the first born into the swarm of images spawned by the rapidly expanding postwar consumer culture" also applied to the neoconceptual artists, many of whom were of similar ages.[51] However, many of the neoconceptual artists specifically reacted to the photo-based work of the appropriation artists and the Pictures group. They intended to create works in other mediums that functioned on a theoretical and general level to address art historical and contemporary concerns. In 2003, referring to the Pictures group, Taaffe stated, "I think that a lot of people felt that some of the photo-based, appropriative work was a little dry, and that mine was concerning itself with the romance of painting, the facture of painting and craft. I think it was intriguing to people that someone could have a strong conceptual bias and yet make something that held up as a crafted painting."[52] The "conceptual bias" behind Taaffe's work and neoconceptualism in general stemmed from conceptualism and these artists' familiarity with critical theory. Taaffe's comment on the "romance of painting" alluded to the strong aesthetic qualities of certain neoconceptual works and their innovative reinvention of the so-called traditional mediums of painting and sculpture. Taaffe's works evinced a strong formal presence in their combination of several different graphic and painterly techniques. Halley's work also resourcefully combined Day-Glo paint and Roll-a-Tex in an interesting visual manner; and the latter became a signature textural surface covering the cell forms in his paintings.

In the 1986 *Flash Art*-sponsored panel at Pat Hearn Gallery, Steinbach asserted:

> I feel the Pictures group was after a particular deconstruction or breakdown of the process of the corruption of truth, whereas at this point I feel we are utilizing that process of corruption as a poetic form, a platform or launching pad for poetic discourse itself. … The Pictures group was essentially deconstructive and task-oriented in its spectacular didacticism. It was a cool approach to hot culture, whereas this new work of which we speak has more

to do with information in general, specifically the schism that exists between information and assumed meanings, particularly how formal elaborations of information necessarily affects its possible meanings.[53]

Bickerton followed this comment with: "We're now able to step back and merge, in fact, to *implode* a variety of different strategies and epistemologies into the total art object that is capable of speaking of its own predicament as well as in general." In other words, although the neoconceptual artists came to New York through diverse routes and at different points in the late 1970s and early 1980s, they shared a reaction to photo-based techniques and a desire to forge ahead in new artistic ways. Similar to Koons's remark, Steinbach's statement illustrated a desire to create work that specifically commented on the state of society and culture in the 1980s. In Steinbach's words, neoconceptual painting and sculpture functioned as a "platform or launching pad" for the theoretical and contemporary discourse of the period.

Despite these proximities, many neoconceptual artists felt the photo-based techniques of the appropriation and Pictures artists did not address current issues in contemporary culture appropriately or accurately. These groups were united in their use of irony and contingency to examine assumed meanings about the role of art. But Steinbach expressed the neoconceptualists' desire to "return" to painting and sculpture and to use these mediums in a critical manner. The "process of corruption" that he mentioned relates to poststructuralism's internal critique of larger institutional structures. While the Pictures and appropriation artists used photography to target the corporate media and advertising industries, neoconceptualism used painting and sculpture to perform a related but intertextual commentary on the history of art, aesthetics, and commodity culture.

CONCLUSION

The East Village art scene was touted in the 1980s as a true rags-to-riches story of the gentrification of an underdeveloped area of Manhattan.[1] Yet as early as 1984, Walter Robinson and Carlo McCormick were already predicting the scene's demise, calling it "so much a 'ready-made' that it seems uncanny, a marketing masterpiece based on felicitous coincidences."[2] By 1987, the most successful East Village galleries had already relocated or planned to relocate to SoHo, including International with Monument, Jay Gorney, and the Pat Hearn Gallery. The artist owners of Cash/Newhouse had been planning to move but instead closed the gallery to focus on other aspects of their careers. The bohemian character that the East Village scene at once relied on and benefited from was threatened by the rapid gentrification of "Lower Manhattan's last slum."[3]

Nevertheless, neoconceptual work continued to gain popularity and influence in international art circles, especially in Europe. From September 1987 to January 1988, at his new gallery in St. John's Wood, London, Charles Saatchi organized a series of two exhibitions, "New York Art Now I" and "New York Art Now II," which included sixty-four works Saatchi had acquired by the East Village artists.[4] Two years earlier, he had christened his new space with an exhibition of work by Judd, Warhol, Marden, and Cy Twombly. In his review of "New York Art Now" in the *Burlington Magazine*, Tony Godfrey remarked: "Given that neo-expressionism often had a rather simplistic notion of the relationship between form and content, perhaps it was also predictable that the New York riposte should be deeply ironic, intellectual rather than emotional and, seemingly obsessed with the surface of the art work."[5] Neoconceptualism's finish fetish, or strong attention to the material presence of the work, and its conceptual emphasis on the semiotic quality of objects and stylistic and formal motifs would prove to be its most influential characteristics.

The first of Saatchi's "New York Art Now" exhibitions ran at the same time as Dan Cameron's "Art and Its Double" show at the Centre Cultural de la Fundació Caixa de Pensions in Barcelona. The confluence of shows of works by this group of New York artists marked the beginning of an alternative reception of neoconceptualism. The London and Barcelona exhibitions signaled the strong interest of European institutions and audiences in neoconceptual art in the decades to come that was not present in the United States. Several of the artists, including Levine, Halley, Steinbach, and Taaffe, had major exhibitions in Europe that did not travel to the United States, despite these artists' strong New York roots.[6] Likewise, many of the strongest collectors and dealers of neoconceptual work, with the exception of Michael Schwartz and Don and Mera Rubell, reside in Europe, including Thomas Ammann in Zurich, Switzerland; Bruno Bischofberger, also in Zurich; and Rafael Jablonka in Cologne, Germany.

Saatchi's support of the burgeoning New York art scene of the 1980s influenced a younger generation of British artists, now known as YBAs, or Young British Artists. In fact, the renowned collector soon shifted his support to this new scene, selling much of his East Village work, although it continued to maintain an impact on the new generation of artists. In 1992, Saatchi mounted a similar two-part show called "Young British Artists I" and "Young British Artists II," for which he commissioned Damien Hirst's *The Physical Impossibility of Death in the Mind of Someone Living* (1991), a fourteen-foot tiger shark floating in a tank of formaldehyde. As a student at Goldsmiths College in London, Hirst had had the opportunity to see the influential "New York Art Now" shows at the Saatchi Gallery and other exhibitions of minimalist work by Judd, LeWitt, and others. In his essay for the Tate Gallery's Hirst retrospective in 2012, Andrew Wilson commented, "Hirst's clarity of presentation, memorably described by Calvin Tompkins as a 'mating of minimal art and Grand Guignol,' had its beginnings in his encounter with the New York artists, Jeff Koons, Haim Steinbach and Ashley Bickerton at the Saatchi Gallery in London in 1987. ... This was work that was attractive and formally structured yet that also presented objects as a part of critical discourse, however contradictory that discourse may have been."[7] The latter part of Wilson's statement refers to neoconceptualism's alleged complicity with the mechanisms of commodity culture and its desire, much like pop art, to formulate a commentary utilizing these very objects and means.

Hirst's early sculptures drew from the formal approaches of Koons and Steinbach, sharing the earlier artists' attachment to minimalism as a stylistic source. Beginning in 1988, he created *Medicine Cabinets*, which consisted of prefabricated white shelves mounted on the wall displaying various medicine bottles, boxes, and anatomical models. Hirst's thesis show at Goldsmiths consisted of a series of twelve of these works. The shelving units appeared to be directly

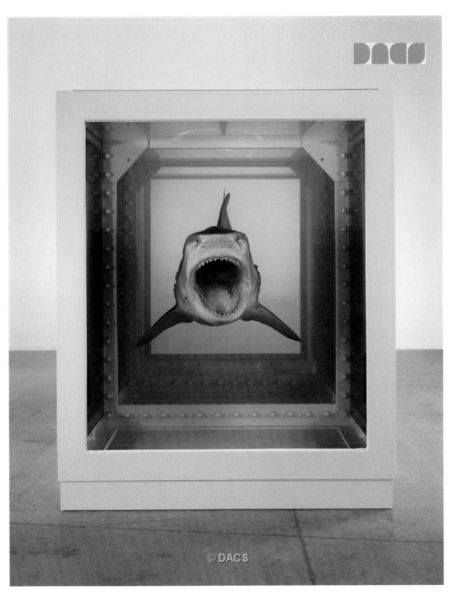

FIGURE 6.1

Damien Hirst, *The Physical Impossibility of Death in the Mind of Someone Living*, 1991 (front view). Glass, steel, silicon, formaldehyde solution, and shark, 85⅜ × 213⅜ × 70⅞ in. (217 × 542 × 180 cm). © Damien Hirst and Science Ltd. All rights reserved, DACS, London / ARS, New York, 2014. Photographed by Prudence Cuming Associates Ltd.

transported from a hospital or medical office. Similar to Steinbach's works, the manufactured quality of the *Medicine Cabinets* emphasized an attention to the formal properties of the objects displayed, namely an array of bottles of various colors, sizes, and shapes, and relied on the industrial look and feel of Judd's boxes. However, Steinbach's incorporation of objects relaying a kitsch sensibility leads to a meditation on class politics that is not present in Hirst's work. Instead, the clinical, detached character of the *Medicine Cabinets* built on the ascetic feel of minimalist sculpture, with the row upon row of neatly stacked pharmaceuticals, with each bottle of a different size and shape displaying a different label and type font. Although the *Medicine Cabinets* are more closely reminiscent of Steinbach's work, Hirst commented, "I'd seen Jeff Koons' hoovers, and that was what got me to do the Medicine Cabinets. I just badly wanted to do it myself. I felt like I'd sort of stolen his idea but done it in my own way."[8] By the early 1990s, Hirst's small wall cabinets expanded to multiple, floor-to-ceiling shelves, stark white desks, and chairs within large installations.

A full discussion of Hirst's sculpture is not the intention here. However, comparison of the artist's earliest animal specimen with Koon's *Equilibrium* sculptures bears noting. *The Physical Impossibility of Death in the Mind of Someone Living* replicates the sleek, austere lines found in minimalism, which are echoed in the white painted steel and glass windows forming the tank's edges and body. In the *Equilibrium* series, Koons playfully adjusted minimalism's trope of the box, forming glass tanks that held basketballs suspended at mid-level (see figure 3.11). Hirst's work relies on a similar aggrandizement of technique, materials, and form, citing Koons much as Koons cited minimalism. The Zen-like homeostasis of Koons's tank, with the basketballs perpetually floating at mid-height in their own amniotic fluid, is transformed in Hirst's work into an allegorical depiction of death in its most brutal fashion. The tactility and material presence of Koons's sculpture, with its allegorical manipulation of the most banal objects, takes on an emphatic presence in Hirst's sculpture. While the scale of Koons's *Equilibrium* tanks echo the human body, Hirst's tank looms over the viewer at an intimidating scale. The shark's massive jaws and cavernous mouth promote the idea that such an animal could tear the viewer limb from limb. The exposed interior steel edges reveal a series of large rivets that hold the tanks together. The sheer size of Hirst's container—composed of three large tanks put together—and the implied power and force of the bloodthirsty animal dwarf Koons's basketballs. The younger artist's work exudes a one-upsmanship in the face of his New York counterpart.

While of the neoconceptualists Halley had been a critic and writer as well as an artist, Hirst worked as an independent curator. In his second year at Goldsmiths College, Hirst organized the exhibition "Freeze," which included work by friends and artists in his program.[9] In 1994, he included Ashley Bickerton's

sculpture *Solomon Island Shark* (1993) in the show "Some Went Mad, Some Went Away" at the Serpentine Gallery in London. The exhibition toured internationally to the Nordic Arts Center, Helsinki; Kunstverin, Hannover; Museum of Contemporary Art, Chicago; and the Portalen, Copenhagen. In 2006, Hirst curated an exhibition of work from his own collection at the Serpentine Gallery that also toured. It included a nurse painting by Prince, sculpture by Steinbach, and Koons's *Three Ball 50/50 Tank* (1985), among other works.

Learning from the neoconceptualists, Hirst took on the role of savvy manipulator of the fine line between art and commerce, which has been met with some alarm and critique. Like his predecessors, Hirst has been accused of catering to the whims of commodity capitalism. One example is Hirst's two-day sale in 2008 of 224 works at Sotheby's in London; occurring the day before the collapse of Lehman Brothers, it still managed to generate over $200 million, breaking the record at the time for sales at a single-artist auction. Four years earlier, in what the London *Telegraph* called a "clearance sale," Hirst sold the contents of his Notting Hill restaurant called Pharmacy through Sotheby's for $17 million. As a provocateur, he relied on the example of the earlier neoconceptual artists, augmenting certain strategies to new levels on par with an ever-rising art market.

Ever since neoconceptual artists gained visibility in the art press in 1986, art historians and critics have questioned their ability to confront large ideological issues within traditional, preindustrial mediums such as painting. During the 1980s, the critical tactics and strategies of deconstruction and intertextuality were associated almost exclusively with the photography and media-based techniques of the Pictures generation. Many of the most-recognized critics and art historians welcomed new art that addressed postmodern and contemporary culture, but only that which corresponded to a particular modality.

This book has demonstrated that neoconceptual works did not function as mere simulacra of putatively more important contributors to the canon of art history. On the contrary, these works of art posed questions and invited multiple readings. As art historian E. H. Gombrich has pointed out, even the act of slavish copying is dependent upon a complex relationship of perception and illusionistic device.[10] Throughout the history of art, style has been subject to divergent modes of seeing in different periods. For example, though they were completed just a few decades apart, Van Gogh's 1890 rendering of Millet's *The Cornfield* of 1867 is easily distinguishable from the original. Van Gogh's so-called copy of Millet's painting is based on an individual sum total of experiences, interactions, impressions, and skills learned over the course of a lifetime. Along these same lines, neoconceptualism displayed a distinct mode of visual representation and set of artistic strategies that diverged from the previous periods and artists referenced in this work as well as from commodity culture. Applying Gombrich's terms,

neoconceptual works muddled the clear distinctions between "making" and "matching" a work of art.[11] For Gombrich, the artist's inherent desire to make a picture preceded the need to adhere to the visual conventions imposed by society. In his view, art historical advances were made when the artist, responding to an internal creative force, worked within and against these conventions in an improvisational back-and-forth between perception and observed reality. In this sense, the neoconceptualists' analytical techniques entailed less an act of copying or matching one work of art to another than a creative manipulation of compact references to past artistic movements. Bickerton, Koons, Halley, McCollum, Steinbach, and Taaffe directly engaged with art history by sampling the colors and forms already made famous by their predecessors. The art historical references exuded by Levine's *Check* paintings, likewise, are too numerous and too difficult to pin down; certainly the works do not answer to the description of an exact copy. The unsettling artistic acts by these artists functioned to disturb the complacency that surrounds the major artists and works of art within the canon of art history. Works in Levine's *After*, *Knots*, and *Checks* series deconstructed traditional notions of authorship, artistic creativity, and originality. Her reproductions in the *After* series severed ties to earlier, highly valued works of art by presenting the viewer with a hand-reproduced version. At the same time, Levine's source imagery stemmed from the form of art that most individuals can see and afford: illustrations in art history textbooks or poster reproductions. Taaffe's reuse of Newman's zip exposed the readymade quality of these abstract forms. His paintings interrogated the notion of authorship, the underlying would-be emotional force of those lines and the metaphysical ideas often attached to Newman's painting. Neoconceptualism's intertextual approach to painting disrupted the canon of art history and created a multivocal, polysemous space for art.

NOTES

INTRODUCTION

1. Quoted in Peter Nagy, "*Flash Art* Panel: From Criticism to Complicity," *Flash Art* (International Edition) 129 (Summer 1986): 49.

2. Roberta Smith, "Art: Four Young East Villagers at Sonnabend Gallery," *New York Times*, October 24, 1986, C30.

3. Donald Judd, "Specific Objects," *Arts Yearbook* 8 (1965), rpt. in *Donald Judd: Complete Writings, 1959–1975* (New York: New York University Press, 1975).

4. Smith, "Art: Four Young East Villagers," C30.

5. See Eleanor Heartney, "Neo-Geo Storms New York," *New Art Examiner* 14, no. 1 (September 1986): 26; Hal Foster, "Signs Taken for Wonders," *Art in America* 74, no. 6 (June 1986): 80–91. The earliest use in print of the term "commodity art" that I have found is in Daniela Salvioni, "Interview with McCollum and Koons," *Flash Art* (International Edition) 131 (December 1986–January 1987): 66–68.

6. Peter Halley, "The Crisis in Geometry," *Arts Magazine* 58, no. 10 (June 1984): 111–115.

7. Grace Glueck, "What Do You Call Art's Newest Trend: 'Neo-Conceptualism' Maybe," *New York Times*, July 6, 1987, 13.

8. In the introduction to the show included in the exhibition catalog, Richard Armstrong, Richard Marshall, and Lisa Phillips wrote: "Impatience with the melodramatic excesses of Neo-Expressionism has caused a highly touted shift toward a cool, hard-edged brand of abstraction variously dubbed 'Smart Art,' 'Simulationism,' and 'Neo-Geo.' But sloganeering has once again temporarily obfuscated the significant work in this genre and distorted the total range of types of abstraction." The authors did not attempt to link the neo-geo artists, their techniques, or strategies in a cohesive manner and continued to broadly describe the various styles of abstraction included in the exhibition among a wide range of artists. See Richard Armstrong, John G. Hanhardt, Richard Marshall, and Lisa Phillips, *1987 Biennial Exhibition, Whitney Museum of American Art* (New York: W. W. Norton, 1987), 12.

9. See Grace Glueck, "Art: Tastemakers," *New York Times Magazine*, August 30, 1987; Andy Grundberg, "When Outs Are In, What's Up?," *New York Times*, July 26, 1987; and Douglas Ecklund, *The Pictures Generation, 1974–1984* (New Haven: Yale University Press, 2009).

10. In their 1986 essays (note 5 above), Heartney and Foster included several artists in addition to those I have identified who were predominantly known at the time for video and

photographic work, such as Gretchen Bender, Jack Goldstein, and James Welling. To incorporate them in the neo-geo rubric, the authors essentially selected somewhat anomalous, geometric examples of their work. Although Welling was trained as a painter at California School of the Arts, he worked primarily in photography and video, as did Goldstein. Both were included in Douglas Crimp's 1977 "Pictures" show and showed at Metro Pictures gallery, though in a surprising shift, Goldstein turned to painting in 1986, much as Levine had done one year earlier. Mixed-media artist Annette Lemieux was occasionally associated with neoconceptualism, in exhibitions curated by the independent curatorial team of Trisha Collins and Richard Milazzo, and she had some connections to the East Village scene, having shown her work in three solo exhibitions at the East Village gallery Cash/Newhouse in 1984, 1986, and 1987. In *Arts Magazine*'s March 1986 special section on neo-geo, Jeanne Siegel included Ross Bleckner, Ellen Carey, and Welling in her examination, in addition to Halley, Levine, and Taaffe. See Jeanne Siegel, "Geometry Desurfacing: Ross Bleckner, Alan Belcher, Ellen Carey, Peter Halley, Sherrie Levine, Philip Taaffe, James Welling," *Arts Magazine* 60, no. 7 (March 1986): 26–32. Since 1983, Carey had been working predominantly with a Polaroid large-format, 20-by-24-inch camera, and in her article, Siegel discussed Carey's *Self-Portraits* (1978–1984), in which the artist projected geometric designs onto her body. Bleckner produced geometric stripe paintings beginning in 1981, but he was less involved in the East Village scene, having had solo shows in 1983, 1986, 1987, and 1988 at Mary Boone Gallery, a prominent SoHo gallery associated with neoexpressionism. As Halley recalls (conversation with the author, New York, January 31, 2013), Bleckner's 1984 exhibition at Nature Morte gallery included his monumental canvas *The Oceans*, which measures 10 by 14 feet and profoundly impacted the younger generation of East Village artists.

11. Molesworth's exhibition opened at the Museum of Contemporary Art, Chicago, and traveled to the Walker Art Center, Minneapolis, and the Institute of Contemporary Art, Boston. Cameron's exhibition opened at the New Museum in New York.

12. Hal Foster, *The Return of the Real: The Avant-Garde at the End of the Century* (Cambridge, Mass.: MIT Press, 1996).

13. Fredric Jameson, "Periodizing the 60s," *Social Text*, no. 9/10 (Spring/Summer 1984): 178.

14. Julia Kristeva, "Word, Dialogue, and Novel" (1966), in Kristeva, *Desire in Language: A Semiotic Approach to Literature and Art*, ed. Leon S. Roudiez, trans. Thomas Gora, Alice Jardine, and Leon S. Roudiez (New York: Columbia University Press, 1980); originally published as *Recherches pour une semanalyse* (Paris: Éditions du Seuil, 1969).

15. Kristeva, "Word, Dialogue, and Novel," 66.

16. Lucy Lippard, "Six Years … Forty Years Later," preface to Catherine Morris and Vincent Bonin, eds., *Materializing "Six Years": Lucy R. Lippard and the Emergence of Conceptual Art* (Cambridge, Mass.: MIT Press, 2012), xii.

17. In essence, the neoconceptual group received the "neo" epithet due to the artists' reuse of previous historical styles. In a 1986 article, Robert Pincus-Witten used the term "neoconceptual" to describe "a motival pillage of history [that] leads to iconographic reformulations," while Holland Cotter commented, "The neoconceptualism currently in ascendancy … is annotated art, and assumes not only that you are familiar with its (structuralist) bibliography, but that in general you find the footnote as absorbing as the text it purports to serve." See Robert Pincus-Witten, "Entries: The Scene That Turned on a Dime," *Arts Magazine* 60, no. 8 (April 1986): 20–21; and Holland Cotter, "Peter Halley International with Monument," *Flash Art* (International Edition) 129 (Summer 1986): 68. Others did not describe the artists' work in a positive manner. As Alison Pearlman has pointed out in *Unpackaging Art of the 1980s* (Chicago: University of Chicago Press, 2003), many critics of neoconceptualism opposed the pluralistic quality that the work engendered. Foster and Donald Kuspit, for example, associated pluralism with a loss

of history, authority, and identity. In "Young Necrophiliacs, Old Narcissists: Art about Death Art," *Artscribe International* 57 (April-May 1986): 27–31, and later in *The Cult of the Avant-Garde Artist* (Cambridge: Cambridge University Press, 1993), Kuspit describes the new, pseudo avant-garde as opposed to the true character of its historical processor. Ratcliff describes the work of Koons and Steinbach as a "marriage of art and money" that stood in opposition to the position of earlier movements in art history. Carter Ratcliff, "The Marriage of Art and Money," *Art in America* 76, no. 7 (July 1988): 76–84. Some critical assessments centered on the medium of painting. Benjamin Buchloh's 1981 essay "Figures of Authority, Ciphers of Regression: Notes on the Return to Representation in European Painting" (*October* 102 [Spring 1981]: 39–68) offered an argument on the inadequacies of painting. Buchloh bemoaned the then-current trend in neoexpressionist painting of signaling what he characterized as an absence of political instrumentalism compared to the return to figuration that occurred in Europe between the world wars. The neoclassicism of the interwar period, Buchloh argued, symbolized a regression that led directly to National Socialism and Fascism. He compared this relapse to painting of the 1980s in its support of the ever-expanding grasp of the bourgeois spectacle of availability. For Buchloh, the "neo" painting of the 1980s was associated with the neoconservatism of the Reagan era and contained little critical value as it functioned only in the service of commodity capitalism. In *The Return of the Real* (14), Foster revisits and reclaims this discussion on "Neo" painting and the return of the neo-avant-garde, addressing Peter Bürger's idea in *Theory of the Avant-Garde* (1976) that postwar movements reiterate the failure of modernism. Foster makes a substantial case that neo-Dada, minimalism, conceptualism, and what he defines as "critical mimicry" (as seen in the work of contemporary artists such as Robert Gober, Sherrie Levine, and David Hammons) are all neo-avant-garde movements; he argues that these movements are differentiated from the historical avant-garde by their critical means of addressing dominant paradigms, from institutional critique to an exploration of the parameters of art's production and reception. *The Return of the Real* is one of the few to address neoconceptual work; however, Foster is not able to envision neoconceptualism's critical framework, as he views the group as aligned with the culture industry. Critical distance and new scholarship on neo-avant-garde movements, such as Branden W. Joseph's *Random Order: Robert Rauschenberg and the Neo-Avant-Garde* (Cambridge, Mass.: MIT Press, 2007), in which Joseph reclaims the importance of neo-Dada as a neo-avant-garde movement, allows for a new consideration of neoconceptual work.

18. Douglas Crimp, *Pictures: An Exhibition of the Work of Troy Brauntuch, Jack Goldstein, Sherrie Levine, Robert Longo, Philip Smith* (New York: Committee for the Visual Arts, 1977); and Douglas Crimp, "Pictures," *October* 8 (Spring 1979): 75–88.

19. Smith, "Art: Four Young East Villagers," C30.

20. Paul Taylor, "The Hot Four: Get Ready for the New Art Stars," *New York*, October 27, 1986, 3.

21. Ashley Bickerton, unpublished personal notes, undated, collection of Ashley Bickerton.

22. Quoted in Tim Griffin, "Haim Steinbach Talks to Tim Griffin," *Artforum* 41, no. 8 (April 2003): 54–55. Nevertheless, Heartney still today, as before, characterizes Bickerton, Halley, Levine, McCollum, Taaffe, Koons, Steinbach, and Vaisman as painters and sculptors who created seductive works that dealt with issues of consumer desire, commercialism, representation, and simulation. Eleanor Heartney, conversation with the author, New York, May 25, 2010.

23. Cited in Eleanor Heartney, "The Hot New Cool Art: Simulationism," *ARTnews* 86, no. 1 (January 1987): 32.

24. Michael Schwartz, conversation with the author, New York, May 12, 2010.

25. Peter Halley, conversation with the author, New York, January 31, 2013.

26. Taylor, "The Hot Four," 51–52.

27. See Pearlman, *Unpackaging Art of the 1980s*, 20–24.

28. Foster, "Signs Taken for Wonders," 86.

29. Peter Plagens, "The Emperor's New Cherokee Limited 4 x 4," *Art in America* 76, no. 6 (June 1988): 23.

30. The exhibition included Richard Baim, Gretchen Bender, Ross Bleckner, General Idea, Halley, Perry Hoberman, Jon Kessler, Koons, Levine, Joel Otterson, Steinbach, and Taaffe.

31. Yve-Alain Bois, "Painting: The Task of Mourning," in Elisabeth Sussman and David Joselit, eds., *Endgame: Reference and Simulation in Recent Painting and Sculpture* (Boston: Institute of Contemporary Art, 1986), 47.

32. Thomas Crow, "The Return of Hank Herron," in Sussman and Joselit, *Endgame*, 18.

33. Pearlman, *Unpackaging Art of the 1980s*, 9–30, 105–145.

34. Cited in Douglas C. McGill, "The Lower East Side's New Artists," *New York Times*, June 3, 1986, 13, C13. See also Lisbet Nilson, "Making It Neo," *ARTnews* 82, no. 7 (September 1983): 64.

35. Amy Virshup, "The Fun's Over: The East Village Scene Gets Burned by Success," *New York*, June 22, 1987, 54.

36. Richard Walker, "Inside the Art Market," *ARTnews* 87, no. 9 (November 1988): 130.

37. Gerald Marzorati, "Julian Schnabel: Plate It as It Lays," *ARTnews* 84, no. 4 (April 1985): 69.

38. Heartney, "Neo-Geo Storms New York," 26. Note Heartney's use of parentheses in this citation.

39. Quoted in Bruce Glaser, "Oldenburg, Lichtenstein, Warhol: A Discussion," *Artforum* 4, no. 6 (February 1966): 22.

40. Stanley Kunitz, quoted in "Special Supplement: A Symposium on Pop," *Arts Magazine* 37, no. 7 (April 1963): 41.

41. Hilton Kramer, quoted in "Special Supplement: A Symposium on Pop," 39.

42. John Russell, "Pop Reappraised," *Art in America* 57, no. 4 (July 1969): 79.

43. Barbara Rose, "ABC Art," *Art in America* 53, no. 5 (October-November 1965): 57–69.

44. Clement Greenberg, "The Recentness of Sculpture," in Maurice Tuchman, ed., *American Sculpture of the Sixties* (Los Angeles: Los Angeles County Museum of Art, 1967), 24–26.

45. Gregory Battcock, "The Art of the Real: The Development of a Style, 1948–1968," *Arts Magazine* 42, no. 8 (June/Summer 1968): 44–47.

46. Jacques Derrida, *Of Grammatology*, trans. Gayatri Chakravorty Spivak (Baltimore: Johns Hopkins University Press, 1976), originally published as *De la grammatologie* (Paris: Éditions de Minuit, 1966); Jacques Derrida, *Writing and Difference*, trans. Alan Bass (Chicago: University of Chicago Press, 1978), originally published as *L'écriture et la différence* (Paris: Éditions du Seuil, 1967); Michel Foucault, *The Order of Things: An Archaeology of the Human Sciences* (New York: Pantheon Books, 1970), originally published as *Les mots et les choses* (Paris: Gallimard, 1966); Michel Foucault, *Discipline and Punish: The Birth of the Prison*, trans. Alan Sheridan (New York: Pantheon Books, 1977), originally published as *Surveiller et punir* (Paris: Gallimard, 1975).

47. Gilles Deleuze, as cited in Richard Macksey and Eugenio Donato, eds., *The Structuralist Controversy: The Languages of Criticism and the Sciences of Man* (Baltimore: Johns Hopkins Press, 1970), x.

48. Dan Cameron, "Art and Its Double—A New York Perspective," *Flash Art* (International Edition) 134 (May 1987): 57–72.

49. Quoted in Daniel Birnbaum, "Bertrand Lavier Talks to Daniel Birnbaum," *Artforum* 41, no. 8 (April 2003): 66.

50. Peter Halley, conversation with the author, New York, January 7, 2010.

CHAPTER 1

1. Jeanne Siegel, ed., *Art Talk: The Early 80s* (New York: Da Capo Press, 1988), 255. Baudrillard and Foucault are frequently cited in Peter Halley's essay "The Crisis in Geometry," *Arts Magazine* 58, no. 10 (June 1984): 111–115. Ashley Bickerton, quoted in Steve Lafrenière, "Ashley Bickerton Talks to Steve Lafrenière," *Artforum* 41, no. 7 (March 2003): 240–245.

2. These included "Group Show," December 1984–January 1985, with Bickerton, Halley, McCollum, Nature Morte's coowner Peter Nagy, and Gretchen Bender; "Selected Works," September 1985, featuring Halley, Robinson, Cindy Sherman, Robert Longo, and Goldstein; "Group Show," December 1985–January 1986, with Bickerton, Halley, Louise Lawler, McCollum, and Nagy; and "Hover Culture," May-June 1988, featuring Halley, Levine, Prince, Steinbach, Jennifer Bolande, and Jiri George Dokoupil. Halley and Steinbach were also selected for the 1985 touring exhibition "Infotainment," curated by Nagy.

3. This statistic comes from Dan Cameron, "Collins and Milazzo," *Artforum* 38, no. 2 (October 1999): 125.

4. "Art and Its Double" included Bickerton, Sarah Charlesworth, Robert Gober, Halley, Jenny Holzer, Koons, Barbara Kruger, Lawler, Levine, Matt Mullican, Tim Rollins & K.O.S., Peter Schuyff, Sherman, Steinbach, and Taaffe; and "New York Art Now" included Bickerton, Bleckner, Carroll Dunham, Gober, Halley, Ti-Shan Hsu, Jonathan Kessler, Koons, Jonathan Lasker, McCollum, Tim Rollins & K.O.S., Schuyff, Doug Starn, Mike Starn, Steinbach, Taaffe, and Vaisman.

5. "Damaged Goods" included Judith Barry, Bender, Barbara Bloom, Andrea Fraser, Koons, Justin Ladda, Lawler, Ken Lum, McCollum, and Steinbach; and "Objects for the Ideal Home" included Edward Allington, John Armleder, Bickerton, Mike Bidlo, Grenville Davey, Gober, Halley, Tim Head, Holzer, Cecile Johnson, Mike Kelley, Martin Kippenberger, Koons, Bertrand Lavier, Lawler, Simon Linke, Levine, Michael Craig-Martin, McCollum, Cady Noland, Julian Opie, Steinbach, Sturtevant, Rosemarie Trockel, Vaisman, and Richard Wentworth.

6. Howard Singerman, *Art History, after Sherrie Levine* (Berkeley: University of California Press, 2012), 169.

7. Levine, quoted in Paul Taylor, "Sherrie Levine Plays with Paul Taylor," *Flash Art* (International Edition) 135 (Summer 1987): 55.

8. Quoted in D. A. Robbins, "An Interview with Allan McCollum," *Arts Magazine* 60, no. 2 (October 1985): 41.

9. Quoted in Joshua Decter, "Haim Steinbach," *Journal of Contemporary Art* 6 (Winter 1993): 111.

10. Jeff Koons, interview by Anthony Haden-Guest, in Angelika Muthesius, ed., *Jeff Koons* (Cologne: Benedikt Taschen, 1992), 1314.

11. Quoted in "Jack Goldstein: Helene Winer: Artists Space and Metro Pictures," in Richard Hertz, ed., *Jack Goldstein and the CalArts Mafia* (Ojai, Calif.: Minneola Press, 2003), 93.

12. Quoted in Shaun Caley, "Ashley Bickerton: A Revealing Expose of the Application of Art," *Flash Art* (International Edition) 143 (November/December 1988): 80.

13. The accompanying catalog, published in *New Observations*, no. 17 (September 1983), was edited and introduced by Halley; it included a reprint of Smithson's 1968 essay "The Establishment," courtesy of Nancy Holt.

14. Joshua Decter, "Peter Halley," *Arts Magazine* 60, no. 10 (June 1986): 110.

15. In his essay, Halley described his paintings as reflections of current society and culture in relation to Baudrillard's notion of hyperreality. In the French theorist's view, hyperreality is the postmodern, postindustrial inability to distinguish reality from nonreality, or fantasy. Baudrillard's concept involved a characterization of contemporary society as based on the interchange of signs or images, as seen, heard, or read on television, the radio, in email messages, telephone conversations, text messages, or video chat, rather than through a tangible presence or contact. For Baudrillard, hyperreality is an extensive, totalizing, or all-encompassing system that does not allow for any form of critique. In this somewhat defeatist view, the state of hyperreality, or simulation, converts all forms of representation into a simulacrum, making visual critique impossible. Without any direct means of communication, information is exchanged by means of indirect images and messages. The putatively identical status of these ancillary exchanges within hyperreality does not allow for critical evaluation. See Jean Baudrillard, *Simulacra and Simulation*, trans. Sheila Glaser (Ann Arbor: University of Michigan Press, 1981). A related version was published as *Simulations*, from the Foreign Agents Series, trans. Phil Beichman, Paul Foss, and Paul Patton (New York: Semiotex(e), 1983), originally published as *Simulacre et Simulations* (Paris: Galilée, 1981). Several critics have found fault with Baudrillard's unilateral characterization of contemporary society. See Christopher Norris, *Uncritical Theory: Postmodernism, Intellectuals and the Gulf War* (London: Lawrence and Wishart, 1992); Alan Sokal and Jean Bricmont, *Fashionable Nonsense: Postmodern Intellectuals' Abuse of Science* (New York: Picador, 1998); and Douglas Kellner, *Jean Baudrillard: From Marxism to Postmodernism and Beyond* (Stanford: Stanford University Press, 1989).

16. Peter Halley, "The Crisis in Geometry," *Arts Magazine* 58, no. 10 (June 1984): 114.

17. Ibid., 103. Halley was criticized by many critics for being overly dependent on Baudrillard's theories. See Decter, "Peter Halley," 110; Dan Cameron, "In the Path of Peter Halley," *Arts Magazine* 62, no. 4 (December 1987): 70–73; and Rosalind Krauss, "Theories of Art after Minimalism and Pop," in Hal Foster, ed., *Discussions in Contemporary Culture* (Seattle: Bay Press, 1987), 76, 82.

18. Cameron, "In the Path of Peter Halley," 72.

19. See Walter Robinson, "Eye on the East Village," in Jeanne Siegel, ed., *Art Talk: The Early 80s* (New York: Da Capo Press, 1988), 177–183; and Walter Robinson and Carlo McCormick, "Report from the East Village: Slouching toward Avenue D," *Art in America* 72, no. 6 (June 1984): 134–161.

20. Peter Nagy, preface to Alan Belcher, *Infotainment* (New York: J Berg Press, 1985), 2.

21. Dan Cameron, "International with Monument," *Artforum* 32, no. 2 (October 1999): 127–128.

22. Paul Taylor, "The Hot Four: Get Ready for the New Art Stars," *New York*, 27 October 1986, 52.

23. See Peter Halley, *Collected Essays: 1981–87* (Zurich: Bruno Bischofberger Gallery, 1988).

24. See, for example, Halley's notion of the impact of abstraction and geometry in modernism in "The Crisis in Geometry" and "Against Postmodernism: Reconsidering Ortega," in *Collected Essays*.

25. Jacques Derrida, *Speech and Phenomena, and Other Essays on Husserl's Theory of Signs*, trans. David B. Allison (Evanston: Northwestern University Press, 1973), originally published as

La voix et le phénomène: Introduction au problème du signe dans la phénoménologie de Husserl (Paris: Presses universitaires de France, 1967).

26. See François Dosse, *History of Structuralism*, trans. Deborah Glassman, 2 vols. (Minneapolis: University of Minnesota Press, 1997), 1:191–201; and Andrea Loselle, "How French Is It?" in Sylvère Lotringer and Sande Cohen, eds., *French Theory in America* (New York: Routledge, 2001), 218–235.

27. Dosse, *History of Structuralism*, 1:382–393.

28. While French theory prompted new understandings of a Western history and historical consciousness, a backlash against French theory and the loss of the subject entailed new thinking about the exclusion of minorities, so-called non-Westerners, women, and other subjects often excluded from dominant Western accounts. Key texts include Edward Said, *Orientalism* (New York: Pantheon Books, 1978); Homi K. Bhabha, *The Location of Culture* (New York: Routledge, 1994); and Linda Nochlin, *Women, Art and Power and Other Essays* (New York: Harper and Row, 1988).

29. Singerman discusses this point in *Art History, after Sherrie Levine*, 18–19.

30. Peter Halley, conversation with the author, New York, January 7, 2010.

31. Ibid.

32. As cited in Sylvère Lotringer, "Doing Theory," in Lotringer and Cohen, *French Theory in America*, 148. White Columns featured the work of Halley and Koons in the "New Capital" exhibition in 1984.

33. Cited in Group Material, "Resistance (Anti-Baudrillard)," artists' statement, February 6–28, 1987, White Columns Digital Archive, http://www.whitecolumns.org/archive/index.php/Detail/Object/Show/object_id/93. Artists in the exhibition included John Ahearn, Doug Ashford, Conrad Atkinson, Julie Ault, Bruce Barber, Gretchen Bender, Joseph Beuys, Dara Birnbaum, David Cronenberg, Honoré Daumier, Kruger, Mike Glier, Leon Golub, Jean-Luc Godard, George Grosz, Hans Haacke, Margaret Harrison, Edgar Heap of Birds, John Heartfield, Janet Henry, Jenny Holzer, Oskar Kokoshcka, Louise Lawler, Susan Meiselas, Brad Melamed, Sister Gertrude Morgan, Tim Rollins & K.O.S., Nancy Spero, Carol Squiers, Carrie Mae Weems, Conrad Merz, Krzysztof Wodiczko, Martin Wong, and Bill Woodrow.

34. Quoted in Eleanor Heartney, "Reluctant Prophet," *ARTnews* 86, no. 7 (September 1987): 18.

35. Grant Kester, "The Rise and Fall? of Baudrillard," *New Art Examiner* 15 (November 1987): 20.

36. See Christopher McAuliffe, "Idées Reçues: The Role of Theory in the Formation of Postmodernism in the United States, 1965–1985" (Ph.D. diss., Harvard University, 1997), 7, 34.

37. Charles Jencks, "The Rise of Post-modern Architecture," *Architectural Association Quarterly* 7, no. 4 (October-December 1975); see also Jencks, *The Language of Post-Modern Architecture* (New York: Rizzoli, 1977).

38. Leo Steinberg, "Reflections on the State of Criticism," *Artforum* 10, no. 7 (May 1972): 37–49. See also Branden W. Joseph, *Random Order: Robert Rauschenberg and the Neo-Avant-Garde* (Cambridge, Mass.: MIT Press, 2003).

39. See, for example, Rosalind Krauss, "Sculpture in the Expanded Field," *October* 8 (Spring 1979): 30–44; or Krauss, *Passages in Modern Sculpture* (New York: Viking Press, 1977).

40. See Hal Foster, "Signs Taken for Wonders," *Art in America* 74, no. 6 (June 1986): 88; Foster, *The Return of the Real: The Avant-Garde at the End of the Century* (Cambridge, Mass.: MIT Press, 1996), 100–101; Thomas Crow, "The Return of Hank Herron" (1986), in Crow,

Modern Art in the Common Culture (New Haven: Yale University Press, 1996), 18; and Yve-Alain Bois, "Painting: The Task of Mourning," in *Endgame: Reference and Simulation in Recent Painting and Sculpture* (Boston: Institute of Contemporary Art, 1986), 29–49.

41. Robinson, "Eye on the East Village," 183. Geometric abstract painter Peter Schuyff showed at the Pat Hearn Gallery with Taaffe. Foster and Heartney associated Schuyff with neoconceptualism in 1986 and 1987, respectively.

42. Christian Hubert, "Post-modernism: A Symposium," rpt. in Miriam Katzeff, Thomas Lawson, and Susan Morgan, eds., *Real Life Magazine: Selected Writings and Projects, 1974–1994* (New York: Primary Information, 2006), 89–95.

43. Ibid., 89.

44. See Clement Greenberg, "Avant-Garde and Kitsch" (1939), "Towards a Newer Laocoon" (1940), "The Crisis of the Easel Picture" (1948), and "American Type Painting" (1955), in *Clement Greenberg: The Collected Essays and Criticism*, ed. John O'Brian, 4 vols. (Chicago: University of Chicago Press, 1986).

45. General letter from the editors, *Artforum* 14, no. 1 (September 1975): 26.

46. Katy Siegel, *High Times, Hard Times: New York Painting, 1967–75* (New York: Independent Curators International, 2006).

47. Thomas Lawson, "GI Symposium: Painting as a New Medium," *Art and Research* 1, no. 1 (Winter 2006): 1.

48. Thomas Lawson, "Last Exit: Painting," *Artforum* 20, no. 2 (October 1981): 40–47.

49. For a discussion of Lawson's article and the dialogue it engendered, see Jack Bankowsky, "October 1981," *Artforum* 40, no. 2 (October 2001): 60.

50. Lawson, "Last Exit: Painting," 40, 41.

51. Ibid., 45.

CHAPTER 2

1. Michel Foucault, *The Order of Things: An Archaeology of the Human Sciences* (New York: Pantheon Books, 1970), 208.

2. Paul de Man, "Literary History and Literary Modernity," *Daedalus* 99, no. 2 (Spring 1970): 384–404; and "Criticism and Crisis," originally published as "The Crisis of Contemporary Criticism," *Arion* 6, no. 1 (Spring 1967): 38–57; reprinted and revised in de Man, *Blindness and Insight: Essays in the Rhetoric of Contemporary Criticism*, rev. ed. (Minneapolis: University of Minnesota Press, 1983), 150.

3. Ibid., 8.

4. Ibid., 10.

5. Hal Foster, "Signs Taken for Wonders," *Art in America* 74, no. 6 (June 1986): 82–83.

6. De Man, "Literary History and Literary Modernity," 388.

7. Ibid., 390.

8. Philip Taaffe, interview by Elisabeth Sussman, New York, undated (1998), typescript courtesy of Ramond Foye.

9. Ashley Bickerton, quoted in Peter Nagy, "*Flash Art* Panel: From Criticism to Complicity," *Flash Art* (International Edition) 129 (Summer 1986): 49.

10. Craig Owens, "Back to the Studio," *Art in America* 71, no. 1 (January 1982): 99–107.

11. Ibid., 102.

12. Quoted in "Ashley Bickerton," press release by Cable Gallery, New York, undated (1986), artist's file, Museum of Modern Art, New York.

13. For comparison, Frank Stella's early paintings and Peter Halley's paintings from the 1980s are three and a half inches thick.

14. Jacques Derrida, *Dissemination*, trans. Barbara Johnson (Chicago: University of Chicago Press, 1981), originally published as *La dissémination* (Paris: Editions du Seuil, 1972); Derrida, *Writing and Difference*, trans. Alan Bass (Chicago: University of Chicago Press, 1978), originally published as *L'écriture et la différence* (Paris: Editions du Seuil, 1967).

15. Jacques Derrida, "The Conflict of Faculties," in Michael Riffaterre, ed., *Languages of Knowledge and of Inquiry* (New York: Columbia University Press, 1984). Also cited in Jonathan Culler, *On Deconstruction: Theory and Criticism after Structuralism* (Ithaca: Cornell University Press, 1982), 156. It is important to note that the term "deconstruction" was coined not by Derrida but by the Yale literary theorists Paul de Man and J. Hillis Miller; see Roland A. Champagne, *Jacques Derrida* (New York: Twayne, 1995), xii.

16. Contemporaneous examples of this type of reversal of hierarchies from within a sociopolitical realm may be found within the women's and gay rights movements or in postcolonial literature, which seeks to ascribe agency to groups oppressed as a result of colonialism.

17. Quoted in Kim Levine, "Package Tour," *Village Voice*, June 2, 1987, 88.

18. Donald Judd, "Specific Objects" (1964), *Arts Yearbook* 8 (1965); repr. in *Donald Judd: Complete Writings, 1959–1975* (New York: New York University Press, 1975), 181–189.

19. Jacques Derrida, *Of Grammatology*, trans. Gayatri Chakravorty Spivak (Baltimore: Johns Hopkins University Press, 1976), 102.

20. Derrida, *Dissemination*, 355.

21. Quoted in "Ashley Bickerton," Cable Gallery press release.

22. Ibid.

23. Ibid.

24. Jacques Derrida, "Différance," in Derrida, *Margins of Philosophy*, trans. Alan Bass (Chicago: University of Chicago Press, 1982), 13, originally given as an address before the Société française de philosophie, January 27, 1968, published simultaneously in the *Bulletin de la société française de philosophie* (July-September 1968) and in *Théorie d' ensemble* (Paris: Editions du Seuil, 1968).

25. Ashley Bickerton, unpublished personal notes.

26. Allan McCollum, "A Conversation with Allan McCollum," lecture, New York Public Library, Stephen A. Schwartzman Building, October 6, 2009.

27. Craig Owens, "Repetition and Difference," in *Allan McCollum: Surrogates* (London: Lisson Gallery, 1985), 6.

28. See, for example, Trevor Starke, "Allan McCollum," in *This Will Have Been: Art, Love, and Politics in the 1980s* (New Haven: Yale University Press, 2012), 96–97; and David Joselit, "Signal Processing: David Joselit on Abstraction Then and Now," *Artforum* 10, vol. 49 (Summer 2011): 356–430.

29. Gilles Deleuze, *Difference and Repetition*, trans. Paul Patton (New York: Columbia University Press, 1994), xiiii.

30. See Christina Lodder, *Russian Constructivism* (New Haven: Yale University Press, 1983).

31. See also Benjamin H. D. Buchloh, "From Factura to Factography," *October* 30 (Fall 1984): 82–119.

32. See Branden W. Joseph's discussion in *Random Order: Robert Rauschenberg and the Neo-Avant-Garde* (Cambridge, Mass.: MIT Press, 2003), 24–71.

33. See William Rubin, *Ad Reinhardt* (New York: Rizzoli, 1991); Yve-Alain Bois, "What Is There to See? On a Painting by Ad Reinhardt," *MoMA* 8 (Summer 1991): 2–3.

34. Joselit, "Signal Processing," 360.

35. Deleuze, *Difference and Repetition*, 3.

36. Quoted in Lily Wei, "Talking Abstract, Part Two," *Art in America* 75, no. 12 (December 1987): 122.

37. Jerry Saltz, "Pattern and Dissipation," *Village Voice*, June 22, 1999, 159.

38. Bridget Riley, "Perception Is the Medium," *ARTnews* 64, no. 2 (October 1965): 32–33.

39. Taaffe, unpublished interview by Bob Nickas, 2003, transcript courtesy of Raymond Foye.

40. Julia Kristeva, "Word, Dialogue, and Novel" (1966), in Kristeva, *Desire in Language: A Semiotic Approach to Literature and Art*, ed. Leon S. Roudiez, trans. Thomas Gora, Alice Jardine, and Leon S. Roudiez (New York: Columbia University Press, 1980), 66.

41. Taaffe, interview by Bob Nickas.

42. For brief critical reviews of op art, see David Rimanelli, "Beautiful Loser: Op Art Revisited," *Artforum* 45, no. 9 (May 2007): 315–326; and Sarah K. Rich, "Allegories of Op," *Artforum* 45, no. 9 (May 2007): 315–326. Rich counters Rosalind Krauss's dismissive review of op art in 1965 by examining recent studies of the movement in the 2007 exhibitions "Optic Nerve: Perceptual Art of the 1960s" (Columbus Museum of Art) and "Op Art" (Schirn Kunsthalle, Frankfurt). For Krauss's review, see Rosalind Krauss, "Afterthoughts on Op," *Art International* 9, no. 5 (June 1965): 75–76. See also Pamela Lee, "Bridget Riley's Eye/Body Problem," *October* 98 (Autumn 2001): 26–46.

43. Brooks Adams, Holger Broeker, and Markus Brüderlin, *Philip Taaffe: The Life of Forms: Works, 1980–2008* (Ostfildern: Hatje Cantz, 2008), 6.

44. As quoted by Taaffe in his interview by Bob Nickas.

45. Taaffe's *We Are Not Afraid* was discussed by Bois, Crow, and Sussman in their contributions to the "Endgame" exhibition catalog; see Yve-Alain Bois, "Painting: The Task of Mourning," in *Endgame: Reference and Simulation in Recent Painting and Sculpture* (Boston: Institute of Contemporary Art, 1986), 47; Thomas Crow, "The Return of Hank Herron," in *Endgame*, 15; and Elisabeth Sussman, "The Last Picture Show," in *Endgame*, 64.

46. Kristeva, "Word, Dialogue, and Novel," 69.

47. Kristeva, *Desire in Language*, 74–76.

48. Sarah K. Rich, "Bridging the Generation Gaps in Barnett Newman's *Who's Afraid of Red, Yellow, and Blue?*," *American Art* 19, no. 3 (Fall 2005): 17–39. See also Ann Temkin, "Barnett Newman on Exhibition," in Temkin, ed., *Barnett Newman* (Philadelphia: Philadelphia Museum of Art, 2002), 69.

49. Philip Taaffe, "Sublimity, Now and Forever, Amen," *Arts Magazine* 60, no. 7 (March 1986): 18–19.

50. The title of Taaffe's painting might also reference the AIDS crisis, which hit a peak during the time it was created.

51. Recent substantive work on Newman is in Temkin, *Barnett Newman*. See also Serge Guilbaut, *How New York Stole the Idea of Modern Art: Abstraction, Freedom, and the Cold War*, trans. Arthur Goldhammer (Chicago: University of Chicago Press, 1983), 101–165; and Michael Leja, *Reframing Abstract Expressionism: Subjectivity and Painting in the 1940s* (New Haven: Yale University Press, 1993).

52. Michel Foucault, "What Is an Author?," in Foucault, *Language, Counter-Memory, Practice*, trans. Donald Bouchard (Ithaca: Cornell University Press, 1977), 113–138.

53. Ibid, 102.

54. Levine's "Three Statements" were first published in *Style* (March 1982) to coincide with the exhibition "Mannerism: A Theory of Culture" (Vancouver Art Gallery, March-April 1982). Her statement was later reprinted in Brian Wallis, ed., *Blasted Allegories: An Anthology of Artists' Writings* (New York: New Museum of Contemporary Art, 1987), 92, and in Charles Harrison and Paul Wood, eds., *Art in Theory, 1900–1990: An Anthology of Changing Ideas* (Cambridge, U.K.: Blackwell, 1992), 1066–1067.

55. Howard Singerman, "Sherrie Levine Talks to Howard Singerman," *Artforum* 41, no. 8 (April 2003): 191.

56. Quoted in Paul Taylor, "Sherrie Levine Plays with Paul Taylor," *Flash Art* (International Edition) 135 (Summer 1987): 55.

57. Howard Singerman, "Seeing Sherrie Levine," *October* 67 (Winter 1994): 82. See also Singerman, "Sherrie Levine's Art History," *October* 101 (Summer 2002): 96–121, and for a more in-depth discussion of Levine's paintings, Singerman, *Art History, after Sherrie Levine* (Berkeley: University of California Press, 2012), 97–138. Singerman considers Levine's *Checks*, *Stripes*, and *Chevron* paintings as collages in order to approach these works as both of and about painting, a notion that stems from Deleuze's definition of collage as painting's double. While my argument asserts a dynamic, multivalent movement between the work of previous artists and Levine's work, Singerman argues that an image of painting is immobilized in Levine's paintings. See Singerman, *Art History*, 133; and Gilles Deleuze, *Difference and Repetition*, trans. Paul Patton (New York: Columbia University Press, 1994), xxii. For his consideration of Levine's *Knot* paintings as a nod to cubist collage and the work of Picasso and Braque, see Singerman, *Art History*, 134.

58. Rosalind Krauss, *The Originality of the Avant-Garde and Other Modernist Myths* (Cambridge, Mass.: MIT Press, 1985), 9.

59. Robert C. Morgan, "Sherrie Levine: Language Games," *Arts Magazine* 62, no. 4 (December 1987): 88.

60. R. D. Laing, *Knots* (New York: Penguin Books, 1970).

61. Regarding Levine's paintings from the 1980s, see Stephen Melville, "Not Painting: The New Work of Sherrie Levine," *Arts Magazine* 60, no. 6 (February 1986): 23–25.

62. Howard Singerman, "Sherrie Levine: On Painting," *RES: Anthropology and Aesthetics* 46 (Autumn 2004): 216.

63. Quoted in Jeanne Siegel, "After Sherrie Levine" (1985), in Siegel, ed., *Art Talk: The Early 80s* (New York: Da Capo Press, 1988), 270.

64. Quoted in Susan Krane and Phyllis Rosenzweig, *Art at the Edge: Sherrie Levine* (Atlanta: High Museum of Art, 1988), 5.

65. Siegel, "After Sherrie Levine," 268.

66. Levine, quoted in Nagy, "*Flash Art* Panel," 49.

67. Quoted in Lily Wei, "Talking Abstract, Part One," *Art in America* 75, no. 7 (July 1987): 84.

68. Taaffe, quoted in Nagy, "*Flash Art* Panel," 49.

69. Quoted in Michèle C. Cone, "Peter Halley," *Flash Art* (International Edition) 126 (February-March 1986): 36.

70. Quoted in Taylor, "Sherrie Levine Plays with Paul Taylor," 59.

CHAPTER 3

1. Robert Rosenblum, "Pop Art and Non Pop Art," *Art and Literature* 5, no. 3 (Summer 1964): 89.

2. Quoted in Robert Hughes, "The Rise of Andy Warhol," *New York Review of Books*, February 18, 1982, 7. The quotation is taken from Gretchen Berg, "Andy Warhol: My True Story," *East Village Other* (November 1, 1966).

3. For Cécile Whiting, Tom Wesselman's incorporation in his work of reproductions of post-cards and posters of commentary on famous paintings equates high art with consumer culture. See Cécile Whiting, *A Taste for Pop: Pop Art, Gender, and Consumer Culture* (Cambridge: Cambridge University Press, 1997), 58.

4. See Hal Foster, "Signs Taken for Wonders," *Art in America* 74, no. 6 (June 1986): 88; Foster, *The Return of the Real: The Avant-Garde at the End of the Century* (Cambridge, Mass.: MIT Press, 1996), 100–101; Thomas Crow, "The Return of Hank Herron," in *Endgame: Reference and Simulation in Recent Painting and Sculpture* (Boston: Institute of Contemporary Art, 1986), 15; and Crow, *Modern Art in the Common Culture* (New Haven: Yale University Press, 1996), 18.

5. Foster, *The Return of the Real*, 62, 127–130.

6. Ibid., 101. Foster's 1986 essay "The Crux of Minimalism" was revised and republished as the second chapter in *The Return of the Real*. See Foster, "The Crux of Minimalism," in Howard Singerman et al., eds., *Individuals: A Selected History of Contemporary Art, 1945–1986* (Los Angeles: Los Angeles Museum of Contemporary Art, 1986), 162–183.

7. Foster, "Signs Taken for Wonders," 88.

8. See Roland Barthes, "That Old Thing, Art," and Jean Baudrillard, "Pop—An Art of Consumption?," in Paul Taylor, ed., *Post-Pop Art* (Cambridge, Mass.: MIT Press, 1989), 21–31, 34; and Fredric Jameson, *Postmodernism; or, The Cultural Logic of Late Capitalism* (Durham: Duke University Press, 1991). As Sylvia Harrison points out, poststructural theories did not impact the critical studies of pop until the 1970s, when these writings were translated into English. These theories incited new perspectives and debates on the movement and its ability to critically reflect commodity culture. Taylor's publication provides a good synopsis of the essays written on pop in the 1980s, which in turn shed light on the reception of neoconceptualism. See also Harrison, *Pop Art and the Origins of Post-Modernism* (Cambridge: Cambridge University Press, 2001), 13.

9. Baudrillard, "Pop—An Art of Consumption?," 38, and G. R. Swenson, "The New American Sign Painters" *ARTnews* 61, no. 5 (September 1962): 45.

10. Rosalind E. Krauss, "Notes on the Index: Seventies Art in America," *October* 3 (Spring 1977): 68–81; Krauss, "Notes on the Index: Seventies Art in America, Part Two," *October* 4 (Fall 1977): 58–67. In his piece *Casting*, Serra threw pots of molten lead against the studio walls. Krauss argues in favor of this work's indexical quality, or its act of severing a sign from its referent.

11. Rosalind E. Krauss, "The Originality of the Avant-Garde: A Postmodern Repetition," *October* 18 (Autumn 1981): 8–23.

12. Douglas Crimp, "The End of Painting," *October* 16 (Spring 1981): 72.

13. Ibid., 81–82.

14. Thomas Crow, "Marx to Sharks: Thomas Crow on the Art-Historical 80s," *Artforum* 41, no. 8 (April 2003): 45.

15. Foster, *The Return of the Real*, 104.

16. Michael Lobel, *James Rosenquist: Pop Art, Politics and History in the 1960s* (Berkeley: University of California Press, 2009).

17. Baudrillard, "Pop—An Art of Consumption?," 34.

18. Ashley Bickerton, unpublished personal notes. See also "Ashley Bickerton," press release by Cable Gallery, New York, undated (1986), artist's file, Museum of Modern Art, New York; and Ronald Pickvance, *Van Gogh in Arles* (New York: Metropolitan Museum of Art, 1984).

19. Diana Crane, *The Transformation of the Avant-Garde: The New York Art World, 1940–1985* (Chicago: University of Chicago Press, 1987), 4–5.

20. Quoted in Shaun Caley, "Ashley Bickerton: A Revealing Exposé of the Application of Art," *Flash Art* (International Edition) 143 (November-December 1988): 79.

21. Irving Sandler, *Art of the Postmodern Era: From the Late 1960s to the Early 1990s* (New York: Icon Editions, 1996), 487.

22. See, for example, Naomi Klein, *No Logo: Taking Aim at the Brand Bullies* (New York: Picador, 2000).

23. Lobel, *James Rosenquist*, 48.

24. Ibid., 15.

25. Thomas Frank, *The Conquest of Cool: The Sixties as Advertising Gimmick* (Chicago: University of Chicago Press, 1997).

26. Gary S. Cross, *An All-Consuming Century*: *Why Commercialism Won in Modern America* (New York: Columbia University Press, 2000), 171–172.

27. Bickerton raised this question in his unpublished personal notes. Although relatively common today, the notion of the artist-critic and artist-curator arose in the 1980s.

28. Baudrillard, "Pop—An Art of Consumption?," 36–37.

29. See the brief discussions in Sandler, *Art of the Postmodern Era*, 487; and Kay Larson, "Nature's Nobleman," *New York*, November 13, 1989, 128.

30. Sophie Cras, "Art as an Investment and Artistic Shareholding Experiments in the 1960s," *American Art* 27, no. 1 (Spring 2013): 2–23.

31. Ibid., 17.

32. Alexander Alberro, *Conceptual Art and the Politics of Publicity* (Cambridge, Mass.: MIT Press, 2003), 118.

33. Many critics of the 1980s wrote about the booming art industry, the rising prices, and the insidious or questionable relationships between dealers, auction houses, artists, museums, and corporations. More recently, *New York* magazine critic Jerry Saltz has become one of the most prominent spokespeople about the changing relationship between art and money as illustrated in exhibitions such as "Giorgio Armani" at the Solomon R. Guggenheim Museum in 2000 or "Skin Fruit: Selections from the Dakis Joannou Collection" at the New Museum in

2010. "Skin Fruit" was curated not by museum staff but by an artist, Jeff Koons, and high-lighted the work of a single collector. See, for example, Douglas Davis, "The Billion Dollar Picture?," *Art in America* 76, no. 7 (July 1988): 21–23; J. M. Montias, "On Art and Economic Reasoning," *Art in America* 76, no. 7 (July 1988): 23–33; Lisbet Nilson, "Making It Neo," *ARTnews* 82, no. 7 (September 1983): 62–70; Andrew Decker, "Inside the Art Market" *ARTnews* 87, no 9 (November 1988): 130–133; and Jerry Saltz, "Has Money Ruined Art?," *Village Voice*, October 7, 2007.

34. Carter Ratcliff, "Art and Resentment," *Art in America* 70, no. 6 (Summer 1982): 9.

35. Ibid.

36. For the origin of the Warhol quote, see Marshall McLuhan and Quentin Fiore, *The Medium Is the Massage* (London: Penguin Books, 1967), 132–136.

37. The *Brillo Boxes* were initially made with cardboard. Warhol, unhappy with the unprofessional visual effect, eventually had the boxes constructed from wood by trained carpenters. The boxes were then painted white and sent to Aetna Silk Screen Products in Manhattan, which produced the screens and sent them back to Warhol's studio, called The Factory, where his assistants Gerard Malanga and Billy Linich silk-screened them. Although silk-screening evoked the repetitive processes of industrial production, Warhol often emphasized its potential for imperfections by using too much ink or slightly offsetting the printing. These techniques gave Warhol's *Brillo Boxes* a somewhat hand-crafted appearance. See Michael J. Golec, *The Brillo Box Archive: Aesthetics, Design, and Art* (Hanover, N.H.: University Press of New England, 2008), 109; and Arthur Danto, *Andy Warhol* (New Haven: Yale University Press, 2009), 50–56.

38. Thomas Crow, "Saturday Disasters: Trace and Reference in Early Warhol," in Crow, *Modern Art in the Common Culture*, 49–68.

39. Ibid., 60, 53.

40. Karl Marx, *Capital: A Critique of Political Economy*, ed. Frederick Engels (Chicago: Charles H. Kerr, 1906), 81.

41. Gary Indiana, "Jeff Koons at International with Monument," *Art in America* 73, no. 11 (November 1985): 163.

42. The basketballs are filled with distilled water and submerged in a tank two-thirds full of a solution of distilled water and salt and one-third distilled water. The correct proportions of salt and distilled water allow the basketballs in Koons's *One-, Two-, and Three-ball 50/50 Tanks* to float either halfway or fully submerged. See Ingrid Sischy, "Jeff Koons' World," in Hans Werner Holzwarth, ed., *Jeff Koons* (Cologne: Taschen, 2009), 12; and Katy Siegel, "Equilibrium, 1983–1993," in ibid., 146.

43. Jeff Koons, quoted in "Interview with Thomas Kellein," in Thomas Kellein, ed., *Jeff Koons: Pictures 1980–2002*, exh. cat (Bielefeld: Kunsthalle Bielefeld, 2001), 19.

44. Koons, interview by Anthony Haden-Guest, in Angelika Muthesius, ed., *Jeff Koons* (Cologne: Taschen, 1992), 18.

45. Jude Palmese, senior associate registrar of collections, Institute of Contemporary Art, Chicago, letters to author, June 9 and June 17, 2010.

46. Quoted in Jeanne Siegel, "Jeff Koons: Unachievable States of Being," *Arts Magazine* 61, no. 2 (October 1986): 68.

47. Indiana, "Jeff Koons at International with Monument," 163.

48. Craig Owens, "The Allegorical Impulse: Toward a Theory of Postmodern Art, Part 2" *October* 13 (Summer 1980): 80.

49. Benjamin Buchloh, "Allegorical Procedures: Appropriation and Montage in Contemporary Art," *Artforum* 21, no. 1 (September 1982): 43–56.

50. Owens, "The Allegorical Impulse," 67, 70.

51. Buchloh, "Allegorical Procedures," 46.

52. Pierre Bourdieu, "The Forms of Capital," trans. Richard Nice, in John G. Richardson, ed., *Handbook of Theory and Research for the Sociology of Education* (New York: Greenwood Press, 1986), 241–242; originally published as "Ökonomisches Kapital, kulturelles Kapital, soziales Kapital," in Reinhardt Kreckel, ed., *Soziale Ungleichheiten* (Goettingen: Otto Schartz, 1983).

53. Ibid., 247.

54. Danita Smith, "Art Fever," *New York*, April 20, 1987, 38.

55. Andrew Sessa, "The Conan Shop," *New York*, http://nymag.com/listings/stores/conran_shop/, accessed April 25, 2013.

56. Quoted in Joshua Decter, "Haim Steinbach" (1993), in Arnold Grossmann, Jean Pierre Dubois, and Trevor Smith, eds., *Haim Steinbach* (Klagenfurt, Austria: Ritter, 1994), 101–102.

57. Michael Emmison and John Frow, "Information Technology as Cultural Capital," *Australian Universities' Review* 41, no. 1 (1998): 44.

58. Pierre Bourdieu, "Classes and Classification" (1979), in Bourdieu, *Distinction: A Social Critique of the Judgment of Taste*, trans. Richard Nice (Cambridge, Mass.: Harvard University Press, 1984), 466.

59. Giorgio Verzotti, "Object, Sign, Community: On the Art of Haim Steinbach," in Ida Gianelli et al., eds., *Haim Steinbach* (Milan: Charta Books; Rivoli: Castello di Rivoli, Museo d'arte contemporanea, 1995), 55–56.

60. Ellen Johnson, "The Living Object," *Art International 7* (January1963):43.

61. Quoted in Tim Griffin, "Haim Steinbach Talks to Tim Griffin," *Artforum* 41, no. 8 (April 2003): 230.

62. Verzotti, "Object, Sign, Community," 56.

63. Steinbach, quoted in Griffin, "Haim Steinbach Talks," 55.

64. Quoted in Decter, "Haim Steinbach," 101.

65. Whiting, *A Taste for Pop*, 72.

66. Anthony E. Grudin, "'A Sign of Good Taste': Andy Warhol and the Rise of Brand Image Advertising," *Oxford Art Journal* 33, no. 2 (2010): 213–232.

67. Jennifer E. Manning and Colleen J. Schogan, *African American Members of the United States Congress* (Washington, D.C.: Congressional Research Service, 2010), 2.

68. Ibid., 3.

69. In 2010, for example, blacks represented 8.77 percent of directors in Fortune 500 companies, holding only one seat out of every eleven corporate board seats. See Senator Robert Menendez, *Corporate Diversity Report*, August 2010, p. 10, available at http://www.menendez.senate.gov/imo/media/doc/CorporateDiversityReport2.pdf. See also Samantha Bomkamp, "Survey: Corporate Boards Lack African-Americans," *Chicago Tribune*, February 13, 2013, http://articles.chicagotribune.com/2013-02-27/business/ct-biz-0227-board-diversity -20130227_1_corporate-boards-board-members-board-seats.

70. Quoted in Siegel, "Jeff Koons," 68.

71. Carol Stabile, "Nike, Social Responsibility, and the Hidden Abode of Production," *Critical Studies in Media Communication* 17, no. 2 (June 2000): 193.

72. Ibid., 187.

73. Stuart Hall, "The Whites of Their Eyes: Racist Ideologies and the Media," in G. Bridges and R. Brunt, eds., *Silver Linings: Some Strategies for the Eighties* (London: Lawrence and Wishart, 1981); repr. in Gail Dines and Jean M. Humez, eds., *Gender, Race and Class in Media* (Thousand Oaks, Calif.: SAGE Publications, 1995), 20.

74. Siegel, "Equilibrium, 1983–1993," 148.

75. Ibid.

76. Collector Michael Schwartz owns at least one of Koons's framed Nike advertisements.

77. Koons, interview by Haden-Guest, in Muthesius, *Jeff Koons*, 19.

78. Crow, "Saturday Disasters," 51.

79. Nicholas Abercrombie and Bryan S. Turner, "The Dominant Ideology Thesis," *British Journal of Sociology* 29, no. 2 (June 1978): 161–163.

80. Ibid, 149.

81. Quoted in Michèle C. Cone, "Peter Halley," *Flash Art* (International Edition) 126 (February-March 1986): 38.

82. Quoted in Kathryn Hixson, "Interview with Peter Halley," in *Peter Halley: Oeuvres de 1982 à 1991* (Bordeaux: Musée d'art contemporain de Bordeaux, 1992), 20.

83. Klaus Ottmann, "Jeff Koons," *Journal of Contemporary Art* 1, no. 1 (Spring 1988):18.

84. Carter Ratcliff, "The Marriage of Art and Money," *Art in America* 76, no. 7 (July 1988): 81; Sandler, *Art of the Postmodern Era*, 425.

85. Quoted in Ratcliff, "The Marriage of Art and Money," 78.

86. Sandler, *Art of the Postmodern Era*, 431; and Jeffrey Deitch and Martin Guttman, "Art and Corporations," *Flash Art* (International Edition) 139 (March-April 1988): 79.

87. Quoted in Gilda Williams, "Interview with Jeffrey Deitch," *Flash Art* (International Edition) 153 (Summer 1990): 169.

88. The quotation from Oldenburg is from Claes Oldenburg, "Documents from *The Store*" (1961), in *Store Days* (New York: Something Else Press, 1967); and Ashley Bickerton, unpublished personal notes.

CHAPTER 4

1. See, for example, Benjamin Buchloh's account of the minimalist roots of conceptualism in "Conceptual Art 1962–69: From the Aesthetic of Administration to the Critique of Institutions," *October* 55 (Winter 1990): 107–113.

2. Sol LeWitt, "Paragraphs on Conceptual Art," *Artforum* 10 (June 1967): 79–83; LeWitt, "Sentences on Conceptual Art," *Art Language* 1 (May 1969): 11; and Joseph Kosuth, "Art after Philosophy, Part I," *Studio International* 178, no. 915 (October 1969): 134–137; "Art after Philosophy, Part II," *Studio International* 178, no. 916 (November 1969): 160–161; "Art after Philosophy, Part III," *Studio International* 178, no. 917 (December 1969): 212–213.

3. Donald Kuspit, "Sol LeWitt: The Look of Thought," *Art in America* 63, no. 5 (September-October 1975): 42-49; Suzi Gablik, *Progress in Art* (New York: Rizzoli, 1976); Rosalind Krauss, "LeWitt in Progress," *October* 6 (Autumn 1976): 46–60.

4. Kosuth, "Art after Philosophy, Part I," reprinted in *Joseph Kosuth: The Making of Meaning: Selected Writings and Documentation on Investigations on Art since 1965* (Stuttgart: Staatsgalerie, 1981), 155.

5. See Amelia Jones, *Body Art*: *Performing the Subject* (Minneapolis: University of Minnesota Press, 1998); Monica McTighe, *Framed Spaces: Photography and Memory in Contemporary Installation Art* (Lebanon, N.H.: University Press of New England, 2012); and Craig Owens, *Beyond Recognition: Representation, Power, and Culture*, ed. Scott Bryson et al. (Berkeley: University of California Press, 1992).

6. Alexander Alberro, *Conceptual Art and the Politics of Publicity* (Cambridge, Mass.: MIT Press, 2003), 31–32.

7. Ibid, 34.

8. Benjamin H. D. Buchloh, "Allegorical Procedures: Appropriation and Montage in Contemporary Art,"*Artforum* 21, no 1 (September 1982): 47.

9. Clement Greenberg, "The Recentness of Sculpture" (1967), in Greenberg, *The Collected Essays and Criticism*, ed., John O'Brian, vol. 4 (Chicago: University of Chicago Press, 1993), 253.

10. The Museum of Modern Art mounted the exhibition "What Was Good Design? MoMA's Message, 1944–56," from May 6 to November 30, 2009. See "MoMA Revisits What 'Good Design' Was Over 50 Years Later," press release, April 29, 2009, Museum of Modern Art, New York.

11. Greenberg, "The Recentness of Sculpture," 254.

12. Ibid.

13. For a brief history of industrial fabrication and artistic practice from the 1960s to the present, see Michele Kuo, "Industrial Revolution: Michele Kuo on the History of Fabrication," *Artforum* 46, no. 2 (October 2007): 306–315, 396.

14. Judd's early work was produced by Bernstein Brothers Sheet Metal Specialties, in Long Island City, New York; Treitel-Gratz, also in Long Island City; and Milgo Industrial (now Milgo/Bufkin), in Brooklyn.

15. Quoted in Klaus Ottmann, "Jeff Koons," *Journal of Contemporary Art* 1, no. 1 (Spring 1988): 18.

16. Anna C. Chave, "Minimalism and the Rhetoric of Power," *Arts Magazine* 64, no. 5 (January 1990): 45–46.

17. Ibid, 45.

18. As described in Dan Graham, *Video, Architecture, Television: Writings on Video and Video Works, 1970–1978*, ed. Benjamin H. D. Buchloh (New York: New York University Press; Halifax: Press of the Nova Scotia College of Art and Design, 1979), 48.

19. Quoted in Katy Siegel, "Jeff Koons Talks to Katy Siegel," *Artforum* 41, no. 7 (March 2003): 252.

20. Robert Smithson, "A Tour of the Monuments of Passaic, New Jersey" (1967), in *Robert Smithson: Collected Writings*, ed. Jack Flam (Berkeley: University of California Press, 1996), 72.

21. Robert Smithson, "Incidents of Mirror-Travel in the Yucatan" (1969), in *Robert Smithson: Collected Writings*, 122–124.

22. Graham, interview by Mark Francis, in *Dan Graham*, ed. Birgit Pelzer, Mark Francis, and Beatriz Colomina (New York: Phaidon, 2001), 20.

23. Robert Smithson, "Entropy and the New Monuments" (1966), in *The Writings of Robert Smithson*, ed. Nancy Holt (New York: New York University Press, 1979), 11–12.

24. Hope Yen, "Income Gap Widens: Census Finds Record Gap between Rich and Poor," *Huffington Post*, September 28, 2010, http://www.huffingtonpost.com, accessed November 20, 2010. Many other news sources, including ABC and NBC, reported this story as well.

25. Jean-Marc Avrilla, Jean-Louis Froment, Marc Sanchez, and Kathryn Hixson, *Peter Halley, Oeuvres de 1982 à 1991* (Bordeaux: Musée d'art contemporain de Bordeaux, 1992), 13.

26. See Caroline Jones's account of the story in Jones, *The Machine in the Studio: Constructing the Postwar American Artist* (Chicago: University of Chicago Press, 1996), 115.

27. Frank Stella, quoted in Bruce Glaser, "Questions to Stella and Judd," *ARTnews* 65, no. 5 (September 1966): 55–61.

28. Irving Sandler, *American Art of the 1960's* (New York: Harper & Row, 1988), 6. See also William S. Rubin, *Frank Stella* (New York: Museum of Modern Art, 1970), 26.

29. Frank Stella, "The Pratt Lecture" (1960), in *Frank Stella: The Black Paintings* (Baltimore: Baltimore Museum of Art), 78.

30. Maria Gough, "Frank Stella Is a Constructivist," *October* 119 (Winter 2007): 94–120.

31. Michael Fried, "Three American Painters: Noland, Olitski, Stella" (1965), in Michael Fried, *Art and Objecthood* (Chicago: University of Chicago Press, 1998), 255.

32. James Meyer, *Minimalism: Art and Polemics in the Sixties* (New Haven: Yale University Press, 2001), 119–128.

33. Stella, as quoted in Gough, "Frank Stella Is a Constructivist," 117, from archival material.

34. Meyer, *Minimalism*, 124.

35. Jones, *The Machine in the Studio*, 119.

36. Halley, as quoted in Kathryn Hixson, "Interview with Peter Halley," in *Peter Halley: Works from 1982 to 1991* (Bordeaux: CAPC Museum of Contemporary Art, 1991), 17.

37. Quoted in Giancarlo Politi, "Interview with Peter Halley," *Flash Art* (International Edition) 150 (January-February 1990): 84.

38. It was and still is used as a cheap, quick fix for traditional plaster work or tape-and-mud dry wall methods. Roll-a-Tex can be rapidly applied in several different grades, from fine to very coarse, to walls that are in poor condition, have been patched, are uneven, or have cracks. In recent years, Roll-a-Tex has been replaced by an Orange Peel finish, which is applied with a machine and presents a somewhat smoother appearance.

39. Information about the history and uses of Roll-a-Tex provided by Dustin Struckmeyer, LEED AP, interior design instructor, Madison College, Madison, Wisconsin, email to author, November 12, 2010.

40. Quoted in Politi, "Interview with Peter Halley," 87.

41. Chave, "Minimalism and the Rhetoric of Power," 44.

42. Peter Halley, *Collected Essays: 1981–87* (Zurich: Bruno Bischofberger Gallery, 1988), 23.

43. Donald Judd, "Specific Objects" (1964), *Arts Yearbook* 8 (1965); repr. in *Donald Judd: Complete Writings, 1959–1975* (New York: New York University Press, 1975), 207.

44. Stella, quoted in Emile de Antonio and Mitch Tuchman, *Painters Painting* (New York: Abbeville, 1984), 140.

45. Meyer, *Minimalism*, 127.

46. Rosalind Krauss, "Allusion and Illusion in Donald Judd," *Artforum* 4, no. 9 (May 1966): 24–26.

47. Quoted in Peter Nagy, "*Flash Art* Panel: From Criticism to Complicity," *Flash Art* (International Edition) 129 (Summer 1986): 49.

48. As cited in Mark Rosenthal, *Abstraction in the Twentieth Century: Total Risk, Freedom, Discipline* (New York: Art Publishers, 1996), 96. Halley's paintings also relate to his own writings, in particular "The Crisis in Geometry." See Halley, "The Crisis in Geometry," *Arts Magazine* 58, no. 10 (June 1984): 111–115. According to Halley's largely neo-Marxist critique, the historic, putatively spiritual role of geometric abstraction was dubious, considering the art object's fundamental character as an element of materialist culture within a rapidly developing capitalistic society. Constantly driven by a quest for novelty, capitalism, as a socioeconomic phenomenon, strives toward the goal of accumulating ever increasing amounts of capital through whatever means necessary. Discussing the role of art within a capitalistic society, Halley asserted that minimalist works operated against capitalism's mechanisms of social control and placed his own paintings within this context. His view paralleled Anna Chave's observations on the materiality and scale of minimalism and its connection with the hegemonic authority of capitalism and masculinity. Nevertheless, Halley's account improperly implicated the early modernists in the developments of postwar capitalism. His essay removed the work of these early geometric abstractionists from their original social, political, and cultural contexts and placed it within the constraints of his own arguments.

49. Michel Foucault, *Discipline and Punish: The Birth of the Prison*, trans. Alan Sheridan (New York: Pantheon Books, 1977), 228.

50. Ibid., 217.

51. See Jean Baudrillard, "The Ecstasy of Communication," in Hal Foster, ed., *The Anti-Aesthetic: Essays on Postmodern Culture* (Port Townsend, Wash.: Bay Press, 1983), 126–133.

52. Jonathan Crary, "The Eclipse of the Spectacle," in Brian Wallis, ed., *Art after Modernism: Rethinking Representation* (New York: New Museum of Contemporary Art, 1984), 293.

53. See Politi, "Interview with Peter Halley," 82, 86.

54. Quoted in Hixson, "Interview with Peter Halley," 18.

55. Fredric Jameson, *Postmodernism; or, The Cultural Logic of Late Capitalism* (Durham: Duke University Press, 1991), 35–36.

56. Ibid., 38.

57. See Tom Forester, *The Microelectronics Revolution: The Complete Guide to the New Technology and Its Impact on Society* (Cambridge, Mass.: MIT Press, 1981).

58. See Jeanne Siegel's interview with Halley, "The Artist/Critic of the 80s: Peter Halley," in Siegel, ed., *Art Talk: The Early 80s* (New York: Da Capo Press, 1988), 236.

59. Quoted in Hixson, "Interview with Peter Halley," 17.

60. Halley, in Nagy, "*Flash Art* Panel," 49.

CHAPTER 5

1. Douglas Eklund, *The Pictures Generation*, exh. cat. (New Haven: Yale University Press, 2009), 18; and Ann Goldstein, "In the Company of Others," in *Louise Lawler: Twice Untitled and Other Pictures (Looking Back)*, exh. cat. (Cambridge, Mass.: MIT Press, 2006), 133.

2. Eklund, *The Pictures Generation*, 18.

3. Douglas Crimp, "Pictures," *October* 8 (Spring 1979): 75.

4. Douglas Crimp, "The Photographic Activity of Postmodernism," *October* 15 (Winter 1980): 91–101.

5. See Eklund's discussion of *The Jump*, which briefly touches on the roots of the rotoscope technique used by Goldstein in relationship to Hollywood imagery, in *The Pictures Generation*, 121.

6. Douglas Crimp, *Pictures: An Exhibition of the Work of Troy Brauntuch, Jack Goldstein, Sherrie Levine, Robert Longo, Philip Smith* (New York: Committee for the Visual Arts, 1977), 3.

7. Ibid., 6.

8. Eklund, *The Pictures Generation*, 121; Philipp Kaiser, "Why Not Use It? Painting and Its Burden," in *Jack Goldstein x 10,000*, exh. cat (New York: DelMonico Books, 2012), 130.

9. See Anna Chave's discussion of Stella's *Die Fahne hoch!* and *Arbeit Macht Frei* in "Minimalism and the Rhetoric of Power," *Arts Magazine* 64, no. 5 (January 1990): 47–48.

10. See Kaiser, "Why Not Use It?"; and footnote 14 in Johanna Burton, "Familiars: On the Work of Troy Brauntuch," in *Troy Brauntuch* (Zurich: JRP Ringier, 2010).

11. Carl Rollyson, "Fascinating Fascism Revisited: An Exercise in Biographical Criticism," *Journal of Historical Biography* 5 (Spring 2009): 1–22; available at http://www.ufv.ca/jhb/volume_5/volume_5_rollyson.pdf, accessed January 22, 2013.

12. Susan Sontag, "Fascinating Fascism," *New York Review of Books*, February 6, 1975, republished in *Under the Sign of Saturn* (New York: Farrar, Straus and Giroux, 1980), 101.

13. Cited in William Rubin, *Frank Stella* (New York: Museum of Modern Art, 1970), 44.

14. Quoted in Richard Hertz, *Jack Goldstein and the CalArts Mafia* (Ojai, Calif.: Minneola Press, 2003), 97.

15. Chrissie Iles, "Jack Goldstein's Moving Pictures," in *Jack Goldstein*, exh. cat. (Cologne: Walther König, 2009), 79.

16. Douglas Crimp, *Pictures: An Exhibition*, 5.

17. Crimp, "Pictures," 77.

18. Arthur C. Danto, *After the End of Art: Contemporary Art and the Pale of History* (Princeton: Princeton University Press, 1997), 43.

19. Ibid. See Crimp, "Pictures," 80, and Crimp, "The Photographic Activity of Postmodernism," 99.

20. See Eklund, *The Pictures Generation*, 66.

21. Sherman, quoted in David Frankel, "Cindy Sherman Talks to David Frankel," *Artforum* 41, no. 7 (March 2003): 54–55.

22. The exhibitions were "Group Show," December 7, 1984–January 18, 1985, which included work by Bickerton, Halley, McCollum, Peter Nagy, and Gretchen Bender; "Selected Works," September 7–28, 1985, which included works by Halley, Walter Robinson, Sherman, Longo, and Goldstein; "Group Show," December 7, 1985–January 18, 1986, which included works by Bickerton, Halley, Louise Lawler, McCollum, and Nagy; "Signs of Painting," April 5–26, 1986, which included works by Bickerton, Goldstein, Halley, Levine, McCollum, Robinson, Taaffe, John Miller, and Gerwald Rockenschaub; and "Hover Culture," May 28–June 25, 1988, which included works by Halley, Levine, Prince, Steinbach, Jennifer Bolande, and Jiri Georg Dokoupil.

23. Metro Pictures featured a solo exhibition of Dutch painter René Daniels, from March 31 to April 21, 1984, and a group exhibition with works by Werner Büttner, Martin Kippenberger, Albert Oehlen, and Markus Oehlen, from October 20 to November 17, 1984.

24. Howard Singerman, *Art History, after Sherrie Levine* (Berkeley: University of California Press, 2012), 105.

25. Jack Goldstein, "Interview with Meg Cranston," in *Jack Goldstein x 10,000*, 209.

26. Howard Singerman, "Language Games," *Artforum* 48, no. 1 (September 2009): 259.

27. Eleanor Heartney, interview by the author, May 25, 2010.

28. Eklund, *The Pictures Generation*, 162.

29. Crimp, "The Photographic Activity of Postmodernism," 100.

30. For definitions of kitsch, see Harold Rosenberg, "Pop Culture: Kitsch Criticism," in Rosenberg, *The Tradition of the New* (New York: Horizon Press, 1959), 259–268; Gillo Dorfles and John McHale, eds., *Kitsch: The World of Bad Taste* (New York: Universe Books, 1969); and Tomas Kulka, *Kitsch and Art* (University Park: Pennsylvania State University Press, 1996).

31. For a history of kitsch, see Celeste Olalquiaga, *The Artificial Kingdom: A Treasury of the Kitsch Experience* (New York: Pantheon Books, 1998).

32. Clement Greenberg, "Avant-Garde and Kitsch" (1939), in Greenberg, *The Collected Essays and Criticism*, ed. John O'Brian, vol. 1 (Chicago: University of Chicago Press, 1986), 5–22.

33. Ibid., 12.

34. See Theodor Adorno, "On Popular Music," *Studies in Philosophy and Social Science* 9, no. 1 (1941): 38.

35. Andreas Huyssen, "The Cultural Politics of Pop: Reception and Critique of U.S. Pop Art in the Federal Republic of Germany," *New German Critique*, no. 4 (Winter 1975): 77–79. See also Andreas Huyssen, *After the Great Divide: Modernism, Mass Culture, Postmodernism* (Bloomington: Indiana University Press, 1986).

36. Matei Calinescu, *Five Faces of Modernity: Modernism, Avant-Garde, Decadence, Kitsch, Postmodernism* (Durham: Duke University Press, 1987), 226.

37. Olalquiaga, *The Artificial Kingdom*, 28.

38. Calinescu, *Five Faces of Modernity*, 230.

39. Susan Sontag, "Notes on Camp" (1961), in Sontag, *Against Interpretation, and Other Essays* (London: Vintage, 1994), 275–292.

40. Kulka, *Kitsch and Art*, 27.

41. Koons, quoted in Giancarlo Politi, "Luxury and Desire: An Interview with Jeff Koons," *Flash Art* (International Edition) 132 (February-March 1987): 72, 74.

42. Roberta Smith, "Rituals of Consumption," *Art in America* 76, no. 5 (May 1988): 164.

43. Calinescu, *Five Faces of Modernity*, 232.

44. Mignon Nixon, "You Thrive on Mistaken Identity," *October* 60 (Spring 1992): 58–81.

45. Ibid., 61.

46. John Loughery, review of *Love for Sale: The Words and Pictures of Barbara Kruger* by Kate Linker, *Women's Art Journal* 12, no. 1 (Spring/Summer 1991): 56.

47. Barbara Kruger, press release for "Pictures and Promises: A Display of Advertisings, Slogans, and Interventions," exhibition at The Kitchen, New York, January 8–February 5, 1981; quoted in Kate Linker, *Love for Sale: The Words and Pictures of Barbara Kruger* (New York: Harry N. Abrams, 1990), 17.

48. Quoted in Klaus Ottmann, "Jeff Koons," *Journal of Contemporary Art* 1, no. 1 (Spring 1988): 18–23.

49. Quoted in Peter Nagy, "*Flash Art* Panel: From Criticism to Complicity," *Flash Art* (International Edition) 129 (Summer 1986): 48.

50. Peter Halley, interview by author, January 7, 2010.

51. Eklund, *The Pictures Generation*, 16.

52. Quoted in Bob Nickas, "Philip Taaffe Talks to Bob Nickas," *Artforum* 41, no. 8 (April 2003): 181.

53. Quoted in Nagy, "*Flash Art* Panel," 46.

CONCLUSION

1. Deborah Phillips, "Bright Lights, Big City," *ARTnews* 84, no. 7 (September 1985): 82–91.

2. Walter Robinson and Carlo McCormick, "Report from the East Village: Slouching Toward Avenue D," *Art in America* 72, no. 6 (June 1984): 134–161.

3. Ibid., 135.

4. The exhibitions featured work by Bickerton, Bleckner, Carroll Dunham, Robert Gober, Halley, Ti-Shan Hsu, Jonathan Kessler, Koons, Jonathan Lasker, Tim Rollins & K.O.S., Peter Schuyff, Starn Twins, Steinbach, Taaffe, and Vaisman.

5. Tony Godfrey, "London, 'New York Art Now' and Other Exhibitions," *Burlington Magazine* 129 (December 1987): 822.

6. See David Deitcher and Jeanne Siegel, *Sherrie Levine* (Zurich: Kunsthalle Zurich, 1991); Jean-Marc Avrilla, Jean-Louis Froment, Marc Sanchez, and Kathryn Hixson, *Peter Halley, Oeuvres de 1982 à 1991* (Bordeaux: Musée d'art contemporain de Bordeaux, 1992); Arnulf Rohsmann, Jean Pierre Dubois, and Trevor Smith, *Haim Steinbach* (Klagenfurt, Austria: Ritter, 1994); and Brooks Adams, Holger Broeker, and Markus Brüderlin, *Philip Taaffe: The Life of Forms: Works, 1980–2008* (Ostfildern: Hatje Cantz Publishers, 2008).

7. Andrew Wilson, "Believer," in *Damien Hirst* (London: Tate, 2012), 208.

8. Damien Hirst, in "Nicholas Serota interviews Damien Hirst," in *Damien Hirst*, 93–94.

9. The exhibition included Steven Adamson, Angela Bulloch, Mat Collishaw, Ian Davenport, Angus Fairhurst, Anya Gallaccio, Gary Hume, Michael Landy, Abigail Lane, Sarah Lucas, Lala Meredith-Vula, Stephen Park, Richard Patterson and Simon Patterson, and Fiona Rae.

10. E. H. Gombrich, *Art and Illusion: A Study in the Psychology of Pictorial Representation* (New York: Pantheon Books, 1960), 365.

11. Ibid., 63–74, 99–100.

INDEX